THE PORTRAITIST

The Portraitist

FRANS HALS AND HIS WORLD

Steven Nadler

The University of Chicago Press
Chicago and London

The University of Chicago Press, Chicago 60637
The University of Chicago Press, Ltd., London
© 2022 by The University of Chicago
Published 2022
Printed in the United States of America

31 30 29 28 27 26 25 24 23 22 1 2 3 4 5

ISBN-13: 978-0-226-69836-6 (cloth)
ISBN-13: 978-0-226-69853-3 (e-book)
DOI: https://doi.org/10.7208/chicago/9780226698533.001.0001

Library of Congress Cataloging-in-Publication Data

Names: Nadler, Steven M., 1958– author.
Title: The portraitist : Frans Hals and his world / Steven Nadler.
Other titles: Frans Hals and his world
Description: Chicago ; London : The University of Chicago
 Press, 2022. | Includes bibliographical references and index.
Identifiers: LCCN 2021057670 | ISBN 9780226698366 (cloth) |
 ISBN 9780226698533 (ebook)
Subjects: LCSH: Hals, Frans, 1584–1666. | Painters—
 Netherlands—Biography. | Portrait painters—Netherlands—
 Biography. | Netherlands—History—17th century. | Haarlem
 (Netherlands)—History—17th century. | LCGFT: Biographies.
Classification: LCC ND653.H2 N33 2022 | DDC 759.9492 [B]—
 dc23/eng/20220112
LC record available at https://lccn.loc.gov/2021057670

⊖ This paper meets the requirements of ANSI/NISO
Z39.48-1992 (Permanence of Paper).

[Portraiture is] that branch of art that is the wondrous compendium of the whole man—not only man's outward appearance but in my opinion his mind as well.

CONSTANTIJN HUYGENS, 1630

Contents

Illustrations

All works are by Frans Hals unless otherwise indicated.

FIGURES

PLATES (FOLLOWING PAGE 132)

Introduction

A deal is a deal, or so thought the officers of the Saint George civic guard company of Amsterdam's District 11. They wanted a portrait of themselves to commemorate their service to the city, as was customary. It had to be dignified, reflecting their virtues as brave and responsible citizens, but without being stuffy and formal, like the old civic guard portraits. In those earlier group paintings, everyone appeared in the same stiff pose, and they all looked so much alike it was hard to tell one person from another. No, these leading men of the great city of Amsterdam wanted something lively and colorful to hang in their headquarters—something modern.

Ordinarily, Amsterdam civic guards hired Amsterdam painters for such an important commission. The Saint George officers, however, broke with tradition. They went beyond the city limits and sought out a celebrated master painter from Haarlem. The terms of the agreement were clear: the artist was to come to Amsterdam on a regular basis, and the sixteen guardsmen would take turns posing for him in a borrowed studio. He was to be paid sixty guilders per figure.

Everything should have gone smoothly. Travel from Haarlem to Amsterdam was relatively easy now that there was a canal between the two cities. The painter could take a barge or go by land along the tow path. Overnight stays in Amsterdam would be necessary, but not too much of an inconvenience. Moreover, this was an experienced painter of civic guard portraits; he had already completed three of them for Haarlem companies and was about to start work on his fourth. He could give the Amsterdam militiamen just what they were

looking for, since what they were looking for was just what they had seen in his paintings.

In the end, though, it did not work out well. Things took a bad turn when, after a number of sessions in Amsterdam and making good progress on the large canvas, the painter suddenly stopped coming to the city. He refused to leave his Haarlem home and studio. It was too much trouble, he complained, and his lodgings in Amsterdam were costing him a lot of money for which he was not getting reimbursed. If they wanted the painting finished, they would have to come to him.

That was certainly not the arrangement, the officers argued as they filed the first of several legal complaints against him. He could not possibly expect all of them to travel to Haarlem. Come to Amsterdam and finish the painting, they demanded, or they would have another artist finish it. Still hopeful that they could persuade the painter to resume his work, they sweetened the pot and offered him an additional six guilders per figure.

By 1637, four years after the commission, negotiations had broken down completely. Much to the dismay of the Amsterdam guardsmen, Frans Hals would not budge. He was leaving more than a thousand guilders on the table, a significant amount of money for any seventeenth-century artist but especially for a man with financial problems. But he could not afford to be away from Haarlem so often, or so he said—he had apprentices to supervise, other projects to attend to, and a family to care for. He called their bluff. Let someone else finish the damn painting.

It was not the first time that a brilliant but stubborn and irascible artist had aggravated a client—Michelangelo famously caused splitting headaches for the popes he served (and vice versa)—nor would it be the last; Rembrandt, a contemporary of Hals, was a difficult character, and Picasso was best avoided when he was in "one of his moods."[1] We do not know how typical such behavior was for Hals. But one thing is certain: never again would a commission from an Amsterdam civic guard company come his way.

*

This book offers a portrait of one of the greatest portrait painters in history. The name of Frans Hals may not be as familiar as other marquee names of early modern art, especially the outstanding portraitists of the seventeenth century: Velázquez, Rubens, Van Dyck, and Rembrandt. And yet, those who have seen Hals's work in museums or in art history books will immediately recognize his style. Whether or not they know of Hals, they know "Hals"—that rough, loose brushwork, not unlike what we find in later Impressionist paintings, that when viewed up close seems like nothing but abstract daubings, but when seen from a distance so beautifully captures the well-to-do citizens of the Dutch "Golden Age."[2]

It is a style like none other in the period. Rembrandt, of course, put his own mark on portraiture with a painterly manner that grew coarser over the years. One contemporary critic—the painter Gerard de Lairesse, whose portrait Rembrandt did late in his own life—complained that the paint in Rembrandt's works "runs down the piece like shit [drek]."[3] Hals and Rembrandt were likely working side by side in the same Amsterdam workshop for a brief time, and no doubt Rembrandt was impressed by what Hals, his elder by almost twenty years, was doing with paint on his panels and canvases. But there is no mistaking a Hals for a Rembrandt. Hals may have painted in what was by then a well-established tradition, but he had an approach to rendering sitters that was all his own.

Over the course of a long career, more than fifty years as a master konstschilder (fine art painter),[4] Hals changed people's ideas and expectations as to what portraiture can do—indeed, what a painting should look like. A portrait by Hals, with its visible brushstrokes and bold execution, might lack fine detail and a smooth finish, but it more than made up for this with a sense of the sitter's animated presence, captured with unprecedented energy and immediacy. Some dismissed his works as "sloppy" and "unfinished." For others, they were fresh and cutting-edge. Connoisseurs or collectors—the Dutch called them liefhebbers; the term, derived from the word for love and used for art lovers generally, could also be translated as "amateur" (which comes from the Latin amator, lover) but without the pejora-

tive sense (in contrast with "expert") it often carries today[5]—sought him out for portraits that they could proudly hang on the walls of their homes and boardrooms and impress visitors with their cultivated taste. To his contemporaries, in Haarlem and beyond, Hals was, for several decades at least, the modern painter par excellence.

<div align="center">*</div>

Of course, I love Rembrandt. Everyone loves Rembrandt. There is a depth to Rembrandt's portraits and anonymous head studies (au naturel or in costume) unmatched by any other painter. It has been said many times—perhaps too many times—that what makes Rembrandt's pictures so special is that they "reveal the soul of the sitter."[6] While such a romanticized and spiritualized view of Rembrandt's art has given way over the years to more sober, pragmatic, and historically grounded assessments of him and his place in Amsterdam's art world, with greater attention paid to the painted surface than to the depth of depiction, still, it is hard not to be moved while standing in front of his portraits, especially his many self-portraits.[7]

Hals's portraits and genre pictures also draw us in, but in a very different way—in fact, in a variety of ways. They invite, entertain, provoke, engage, tempt, amuse, and instruct; they show us a range of affects and attitudes, including pride, joy, lust, affection, wit, and intelligence. The Haarlem burghers in Hals's paintings can be as contemplative and reflective as Rembrandt's Amsterdammers. But the subjective penetration of a Rembrandt portrait can have the effect of creating a distance between us and its sitter. Occupied with their own thoughts and feelings, Rembrandt's introspective characters are often not there for us. We can love and admire the magnificent painting from 1654 of Jan Six, perhaps Rembrandt's finest portrait, but there is really no communion between Six and us; whatever he is pondering as he puts on his gloves he ponders alone. Hals's people, on the other hand, are fully present. Even as their attention is drawn elsewhere and we fail to catch their eye, we are, so to speak, in the same place.

Fortunately, we do not have to choose. It is not like the exclusive alternatives imposed upon us by the sixteenth-century Flor-

entine artist and writer Giorgio Vasari: Florence or Venice, *disegno* or *colore*, draftsmanship or color. (For the biased Vasari, there was no question: *Disegno!*) There may have been artistic rivalry and economic competition between Rembrandt and Hals. Their contemporaries who wanted to be portrayed did have to opt for one or the other (or one of the many other great portraitists in Amsterdam and Haarlem). We, on the other hand, do not have to take sides. We can enjoy the virtues, and virtuosity, of both artists.

<div align="center">*</div>

I have long been a fan of Hals's paintings. But my interest in actually writing about him came about, oddly enough, through my work on a French philosopher who was a contemporary of Hals and even at one time resided near Haarlem (and who makes a cameo appearance in this book). It all started with a chance encounter in Paris in the world's largest art museum.

It is a remarkable thing about the Louvre. In what can often seem to be the most popular and crowded tourist destination on the planet, it is possible to enjoy wonderful works of art, even some of the greatest paintings and sculptures ever made, in blissful solitude, as long as you avoid the big-ticket items for which visitors are willing to stand in line for hours and to which they rush immediately upon entry. Thus, alone one day in one of the museum's rooms devoted to seventeenth-century Dutch art while the mobs with their selfie sticks rushed to see the *Mona Lisa*, I stood before a painting that was once labeled *Portrait de René Descartes*. (It was a picture with which I and other scholars of early modern philosophy were quite familiar, as it typically serves as the cover illustration for books on Descartes and his philosophy.) For a long time, the Louvre believed that it had an original portrait of Descartes by Frans Hals. However, by my visit this time, they had downgraded the work to a copy *d'après Hals* (after Hals). This is right, and long overdue, since the painting bears none of the trademark features of a Hals. The brushwork is smooth, even invisible, and the figure finely drawn. But then, where *was* the original? The best candidate, it turned out, was in Copenhagen, in the Statens Museum for Kunst: a small, very rough oil painting of

Descartes that was both undeniably a Hals and obviously the model for the Louvre portrait.

My quest to understand the circumstances that gave rise to that unusual painting of a seventeenth-century intellectual celebrity—we do not have many portraits from life of the great philosophers before the nineteenth century—led me, ultimately, to write a book titled *The Philosopher, the Priest, and the Painter: A Portrait of Descartes.*[8] This philosophical/biographical/art historical study brought together Descartes, Hals, and a Haarlem Catholic cleric named Augustijn Bloemaert, who there is good reason to believe commissioned the portrait from Haarlem's best portraitist as a keepsake before his dear philosopher-friend departed Holland for Sweden, where he would die within just a few months.

As an obsessive academic constitutionally incapable of allowing questions to go unanswered, I was unsatisfied with the relatively cursory treatment in that book that I gave Hals and the city that was his base of operations. As big a part of the story as the painter and his milieu were, it was not enough. He was too interesting a figure, and Haarlem too important a place in Dutch history and art history. There was so much more to learn, and so much more to be said: not just about his paintings, but about his family history, his training, his personal life, his profession, his clientele, and his reputation. There were no two ways about it. At some point, I was going to have to do a life of Hals, if only to satisfy my own curiosity.[9]

<p style="text-align:center">*</p>

The subject of this book is an artist, but it is not a work of art history. I offer little stylistic analysis of paintings, technical details of materials, or discussion of iconography or symbolism. I do consider some of the artistic influences upon Hals and put his work in a broader art historical context, but such matters are not a large part of the project; I leave all that kind of work to art historians, trained experts who can do a much better job of it than I can.[10]

This book is, rather, a biography, one that I hope tells a good historical story and gives the reader a well-drawn picture not only of Hals's life, but also of the artistic, social, political, and religious mi-

lieus in which he lived and worked. As much as Rembrandt (though born in Leiden) was of Amsterdam, and Rubens (born in Germany) was of Antwerp, so Hals (born in Antwerp) was of Haarlem. His youth, his training, his business model, the tradition of portraiture that he so creatively adapted, the overwhelming bulk of his clientele, indeed everything that was familiar and important to him belonged to the city in Holland in which he spent his life from boyhood on.

There are many challenges facing a biographer of Hals. Even the most basic facts are uncertain. We do not know when exactly he was born, when his family left Flanders in the southern Netherlands, when they arrived in Haarlem in Holland, and what his native religion was. There is some certainty as to the master painter with whom he trained, but even that is based on hearsay. What kind of husband was he? What kind of father? And why did he have lifelong money problems? There is, regrettably, no solid basis on which to answer these baseline biographical questions.

Then there is the oeuvre. Hals painted nothing but portraits; even his temporary foray into genre painting consisted of portrait-like pictures of anonymous characters. But there is little agreement among Hals scholars on how many paintings he did and when he did them. Estimates range from just over a hundred to over three hundred panels and canvases. And forget about putting an exact year to most of his paintings; it is hard enough to place them securely in this or that decade. Really, the best that can be done for the majority of his extant works is arrange them in a rough chronological order. Even this is mostly guesswork based on biographical information about the sitters, clues in the fashions they are wearing or on stylistic assumptions.

The task is complicated by the known unknowns, as well as some unknown unknowns. There are certain paintings that we *know* are lost; we have historical evidence of their existence, and sometimes even a visual record (in an engraved reproduction), but no longer any trace of them.[11] There are many other paintings we do not know about that, if not destroyed, lie hidden away in an attic somewhere or are ruined beyond recognition. Then there is the problem of misattributions. Hals rarely signed his paintings, and when he did it was

with a monogram. Moreover, like many master painters of his time, Hals had a workshop in which he trained pupils and apprentices, some of whom made copies of his paintings or unsigned works of their own imitating his style.[12]

So, in the end, there is not a lot to go on, and a lot to lead one astray. Other than the paintings, we have nothing by Hals's own hand: no diary, no letters, no written documents whatsoever. In this, he could not have been more different from his contemporary Rubens, who left behind a wealth of professional and personal correspondence. The quantity of information on Hals pales compared even with what we know about Rembrandt;[13] it is more like the spotty record we have for Vermeer (which was sufficient for John Michael Montias's masterful study of that painter's life and his relations).[14]

With Hals, the most important sources are official documents, almost two hundred of them: baptism records (but not one for Hals himself), marriage banns, death and burial notices, estate inventories, records of auction and lottery sales, notary statements of debts and other legal proceedings, and collection holdings. These have been discovered and transcribed by Hals scholars working in the archives over the last century and a half, and conveniently compiled (although not in complete transcriptions) by Irene van Thiel-Stroman.[15] (My debt to Van Thiel-Stroman's work is evident in the large number of references to the documents in Van Thiel-Stroman 1989.) Unfortunately, and with just one exception, what we do not have are records of portrait commissions for Hals, which would provide crucial information on who his clients were and how much he charged them.

So yes, there are enormous gaps in what we know, and can know, about Hals's life and personality. Imaginative reconstruction will take us only so far. And yet, despite the obstacles, there is indeed a story to be told about this remarkable painter—a biographical story, built on the extant documents, generations of careful scholarship, and, of course, the paintings, that provides a sense of the man, a familiarity with the pictures he made and the clients he served, and an understanding of the Netherlandish society and early modern Europe within which he worked.

The Dutch Republic in the seventeenth century was arguably the most cosmopolitan, innovative, and tolerant place in Europe. So much of what we now consider "modern" can be traced back to what the Dutch accomplished in the political, economic, military, technological, and cultural domains. These achievements are all the more remarkable given that many of them took place in a brand-new nation still engulfed in an *eighty-year* struggle for independence. (The American Revolution lasted a mere eight years.) From the philosophical and scientific advances of Descartes, Huygens, and Van Leeuwenhoek to the extraordinary "history" paintings, portraits, landscapes, still lifes, marine scenes, and genre pieces of thousands of artists, from the engineering feats that created land from sea to the military and mercantile maritime prowess that allowed the Dutch to compete with the other great powers of Europe—it is no wonder that the most creative period of a small but uncommonly gifted and improbably powerful territory continues to fascinate us today.

At the same time, we must not romanticize, much less idealize, either the Dutch Republic or this early Enlightenment period. Europe in the seventeenth century saw great material and intellectual progress, and the arts flourished under all manner of regime. But there was also great misery brought about by political conflict, religious strife, and morally abhorrent practices, not to mention the forces of nature. People lived through what must have seemed like endless warfare. They suffered multiple outbreaks of the plague. During the so-called Little Ice Age, they endured long, unusually cold winters made even harsher by famine and economic instability. The Europeans also enslaved Africans and slaughtered indigenous peoples of the lands their armies and trading companies invaded. It was a brilliant but also cruel era, and the Dutch were no exception.

This, for better and for worse, was Hals's world. A proper portrait of his career demands putting the reader into the streets, homes, churches, headquarters, and taverns of Haarlem, the city that nurtured his art. It also requires following the difficult birth pangs of a young nation divided by political and religious allegiances and the turbulent and unpredictable Realpolitik of post-Reformation Europe. All too often, Hals himself may disappear from view. But his

paintings, portraying the good people of Haarlem, Amsterdam, and other cities—men and women; merchants, preachers, writers, other artists; married (and sometimes unmarried) couples and whole families; town regents; the civic guardsmen who kept order in the streets; boards of governors of public institutions; laughing children and merry drinkers—are always there to remind us that he contributes as much to our image of the Dutch "Golden Age" as his more famous competitor, Rembrandt.

<div align="center">*</div>

A number of things may be unfamiliar to readers not versed in the details of seventeenth-century Dutch life:

Names: Early modern Dutch individuals typically used a patronymic as an identifying second name. Thus, Jan Pieterszoon was "Jan, Pieter's Son," and Lysbeth Reyniersdochter was "Lysbeth, Reyniers's daughter." The patronyms were conventionally abbreviated as "-sz" or "-dr"; thus, Jan Pietersz and Lysbeth Reyniersdr. As the seventeenth century progressed, it became more common to add a family name: for example, the painter Frans Pietersz de Grebber and his son Pieter Fransz de Grebber. Often that family name indicated the person's place of origin: the painter Cornelis Cornelisz van Haarlem was "Cornelis, Cornelis's son, from Haarlem."

Political organization: The Dutch Republic was a federation of provinces. There were seven provinces—Holland, Utrecht, Zeeland, Gelderland, Friesland, Overijssel, and Groningen—along with the county of Drenthe and the "generality lands," territory owned by the Republic at large. Holland was the largest and most powerful province, which is why the Republic is often referred to (inaccurately) as "Holland." I use the term "Holland" to refer only to the province. I use the terms "Dutch Republic," "Republic," and "United Provinces (of the Netherlands)" interchangeably to refer to the political entity established by the Union of Utrecht in 1579 (although the Union's constituent provinces and borders would change over subsequent decades). On the other hand, I avoid using the unqualified, modern term "the Netherlands" to refer to the Dutch Republic (the northern Netherlands), since in the seventeenth century there were also the

southern Netherlands, the provinces that, still ruled by Spain, were not a part of the Republic.

Each province had central executive, legislative, and judicial bodies. The "States" of a province was its executive body. Thus, the States of Holland governed that province. Each city in a province sent representatives to the provincial States. The Republic as a whole also had the States General, attended by representatives from each province.

For most of the seventeenth century, there was also a *stadhouder*, or stadholder. This was a hereditary (but appointed), quasi-monarchical position. The stadholder—always a member of the House of Orange-Nassau—was the political leader of several provinces at a time and the supreme military commander of the Republic's armed forces. The dominant stadholder was the one who held the position jointly in Holland, Utrecht, Zeeland, Gelderland, and Overijssel.

A city was governed by its *vroedschap*, or city council. From the *vroedschap* were appointed *schepenen*, who made up the board of aldermen, and four sitting *burgemeesters*, burgomasters or mayors.

Currency: The main currency in the Dutch Republic was the guilder (in Dutch: *gulden*) or Carolus guilder. It was also called the florin (from *fiorino d'oro*, the gold coin of the Republic of Florence in the Middle Ages), and so was typically abbreviated as "fl." One guilder was worth twenty stuivers; and a stuiver was worth about sixteen pennings. A skilled laborer in the first half of the seventeenth century would earn about one guilder per day. In terms of purchasing power in today's currency, a guilder is generally estimated to be equivalent to about sixty US dollars/forty pounds/fifty euros.

CHAPTER 1
Exile

Franchois Hals knew that it was time to leave Antwerp. Like many other residents of the city, he saw that there was no future there for him, his wife, Adriana, and their sons Frans and Joost. Daily life had become too risky, both economically and, for a large number of its citizens, personally. This once flourishing entrepôt would soon be the first major casualty of the Eighty Years' War. The military leaders of the revolt by the northern Netherlandish provinces made sure of that, with a good deal of help from their Spanish overlords and foes.

Located in the southern Dutch-speaking region of the Low Countries—in the Duchy of Brabant, close by the border with the lands of the Count of Flanders—Antwerp was by far the biggest and most cosmopolitan city in the Netherlands in the 1500s. With a population approaching eighty thousand by midcentury, it was also, after Paris (which had nearly three hundred thousand inhabitants), the second-largest urban center on the Continent north of the Alps.[1]

Antwerp was governed by a clique of financiers and aristocrats who oversaw an economy that made it among the richest cities in Europe. The source of its wealth was diverse: banking and money lending; international trade over a wide array of raw materials and products; manufacturing, especially textiles; and a number of small, homegrown industries—including painting and tapestry by artisans whose work was highly coveted by Europe's elite. Antwerp was the headquarters of numerous mercantile firms, hosting business representatives and diplomatic corps from all over the Continent and beyond: not just Spain, to whose empire all of the Low Countries still

belonged, but Italy, Portugal, France, England, and the German, Baltic, and Scandinavian lands, as well as states and colonies in Asia and in the New World. The city's harbors, at the estuary of the Scheldt River, saw the arrival of hundreds of ships each day, some bearing sugarcane from South America and the Caribbean to be processed in local refineries. Bulk goods—wood, wheat, and fruit—shared warehouses with luxury items, such as spices, fur, fabrics, and jewels. In the mid-sixteenth century, Antwerp was the heart of European trade, an international center of high finance and commerce open "to the merchants of all nations."[2]

For just these reasons, Antwerp was also an essential component in the economy of the Habsburg Empire. Which is why the Spanish were so outraged to see it join the Dutch Revolt.

*

Things had been growing increasingly unsettled in the Spanish Low Countries for some time. Government from afar—even when mediated by sympathetic, locally based regents—is rarely well exercised, and never well tolerated.

Antwerp and the rest of the Burgundian Netherlands—present-day Belgium, the Netherlands, Luxembourg, and some of northeast France—became part of the extensive and widely dispersed Habsburg realm in 1477, when Mary of Burgundy married Maximilian of Austria, who would soon be crowned as Holy Roman emperor. Maximilian and Mary had a son, Philip the Fair, who became Duke of Burgundy. After Philip's marriage to the daughter of Ferdinand of Aragon and Isabella of Castile, Joanna of Castile—she was also known as "Juana la Loca," or Joanna the Mad, a nickname she earned because of her erratic behavior, probably from mental illness[3]—and the death of his mother-in-law in 1504, Philip was crowned Philip I, king of Castile. He brought his sovereignty over northern territories with him to the Spanish throne. Philip did not live long after his coronation, however, and was succeeded by his son, Charles. When Charles—who, in addition to being Charles I, king of Spain, was also archduke of Austria; Charles II, Duke of Burgundy; and Charles V, Holy Roman emperor—abdicated all of his royal positions in 1556

for a life of monastic retreat, he divided his domains among his family. Spain, as well as Holland, Brabant, Flanders, and the other Burgundian provinces, passed to his son Philip, who reigned as Philip II, king of Spain and lord of the seventeen provinces of the Spanish Netherlands.

Charles, at least, had been born in Flanders, in Ghent. He knew the Dutch language, and he knew the people. He was one of them. His son, born in Valladolid, Castile, was not. Philip was less empathetic than his father to local sensitivities and did not rule the Dutch lands with the consideration to which they had become accustomed. Subjects always regard taxation as heavy, but Philip burdened his northern provinces to an extreme, in part to finance his many wars. He also reduced local political autonomy while stationing Spanish troops in their cities and towns, and ignored rights and prerogatives traditionally enjoyed by the landed nobility and urban burghers.

Of perhaps even greater consequence, the king and his governors, Catholics one and all, severely persecuted Protestants. Followers of the Reformed faith were a growing and influential minority in much of the Netherlands, much to the dismay of the Spanish court. Philip regarded these Calvinists and Lutherans as a serious threat not just to the confessional unity of his domains, but to the provinces' loyalty to his rule. Ignoring decades of relative restraint and tolerance, Philip went so far as to institute an Inquisition in the north to root out this "foreign heresy."[4]

By the late 1560s, Philip's harsh and repressive behavior had become too much to bear. The Dutch rose up against the heavy-handed Spanish governance. William of Orange (William I, also known as William the Silent), whose Dutch lands had been confiscated by the king, led an insurgency of nobles and commoners in 1568. This first uprising did not have broad support, and it was soon put down by the forces of Fernando Álvarez de Toledo, the Duke of Alba, on behalf of the Spanish crown. The Dutch were not so easily pacified, however, and by 1572 the revolt was back on, again under William's leadership but this time with the combined forces of Holland and Zeeland behind him. These provinces were later to be joined in the Union of Utrecht of 1579 by Utrecht, Gelderland, Groningen, Friesland, and

Overijssel, as well as a number of Flemish and Brabantian cities, including Ghent, Brussels—and, most important of all, Antwerp. The "Spanish Fury" of 1576, when Philip's troops, angered over their lack of pay, went on a murderous rampage against Antwerp's citizens and set the city on fire, turned even devoted subjects against their foreign ruler.

The rebellion of the Netherlandish provinces against Spain was now in full swing, although Philip was still too distracted by other military engagements, especially against the Ottoman threat in the east, to devote all his resources to putting it down. The conflict will last for decades, with major consequences for the subsequent political, economic, military, and cultural history of Europe.

*

Franchois Fransz Hals—Franchois, Frans's son—was born around 1550, not in Antwerp but Mechelen, a town just to the south. His parents, our painter's grandparents, were Frans Hals (d. 1571), a textile dyer, and Barbara de Witte, whom Frans had married in 1526.[5] Around 1562, Franchois and his brother Carel went to Antwerp to find work. Soon after he arrived in the city, Franchois married a woman named Elisabeth Baten. Over the next dozen years, they had four, possibly five children: Carel (born in 1567), Clara (1569), Johannes (1572), Maria (1574), and, perhaps, another girl who was named Barbara. It may have been too much for Elisabeth, for she died in the fall or early winter of 1581, possibly while giving birth to yet another child. (Franchois's brother Carel also married an Antwerp woman, Cornelia Wils. His fate was not a happy one: apparently an alcoholic and ne'er-do-well, Carel died bankrupt in 1581, the same year as his mother; Cornelia, who supported the couple by working as a washerwoman—there were no children—died a year later.)[6]

Following in his father's footsteps, Franchois worked in Antwerp's booming textile industry. He was employed as a *droochscheerder*, or cloth cutter—a job that involved using shears to make decorative patterns in material woven out of wool coming from England and Spain or linen made from imported flax.

It could not have been easy being a widower with four young children and trying to make a living. Within several months of Elisabeth's death—and before April 1582—Franchois married his neighbor Adriana van Geertenryck. Adriana, a widow, was around thirty years old at the time,[7] and had one or more children of her own from her first marriage to Henrick Thielmans, a tailor. It is possible that the wedding had to take place in secret. This is because between 1581, shortly after the city joined the Dutch Revolt, and 1585, when it was retaken by Spain, the Protestants were in control and Catholic services were banned, and one contemporary document—part of the census of civic guard companies made by the Spanish—indicates that Franchois was (or at least claimed to be) a Catholic.[8]

In April 1582, the newlyweds sold their interest in the house "Saint Jacob" on Rozenstraat that Adriana had inherited from her late husband. The buyer was Jan de la Flie, a pastry baker, who also owned the house two doors down that Franchois had been living in.[9] The couple continued living on Rozenstraat in a house rented from De la Flie—either the one sold to him by Adriana or the one rented by Franchois before their marriage. This is where Adriana gave birth to their first son, Frans—named after his paternal grandfather—in 1582 or 1583. A second son, Joost, was born two years later. There is no record of either son being baptized, neither as Catholic nor as Protestant. Because their births coincided with that brief period of Protestant domination in Antwerp, Catholic baptisms were not publicly recorded, and even Protestant baptismal records from this time are not extant.

The house on Rozenstraat must have been pretty full, then, with at least five other children from first marriages. The oldest of Frans's half siblings, Carel, would have been only fifteen by the time Frans was born, and now there was a toddler and an infant. As combined households go, it may not have always been a peaceful domain; we know there was never enough money.

The Hals family occupied the Rozenstraat dwelling for only a couple of years; by July 1586, there was a new tenant, Thomas van Oudendijck.[10] By this point the family was probably gone from Antwerp altogether. Why did they leave so suddenly? What was so trou-

bling about this great city that they, and many others, felt they had no choice but to pick up their lives and settle elsewhere?

<div align="center">*</div>

Relations between Antwerp's Catholic majority and its Protestant communities, made up mainly of Calvinists and Mennonites (Anabaptists), with some Lutherans, had long been strained. Periods of accommodation, motivated in part by economic interest, alternated with repression and persecution. As Protestant congregations grew in size and power—especially after iconoclastic riots in the summer of 1566, when Protestant mobs attacked Catholic churches and destroyed their "idolatrous" *beelden*, or images—the city's leaders, hoping to forestall even greater unrest, but against the wishes of the Spanish governors, granted more religious freedom to Calvinists (but not to Mennonites). They allowed public worship and even outdoor preaching. What was once a tolerated underground movement became a publicly recognized denomination.[11]

The civic peace did not last long. Philip's local regent, Margaret of Parma, and especially her less indulgent successor, the Duke of Alba, took various measures to restore the more repressive status quo ante and push Protestant worship back behind closed doors. But these efforts, like those elsewhere in the Dutch provinces, did little to restrain the growing number and power of the Calvinists—so much so that when the Protestants did temporarily take over the Antwerp city council, they not only banned Catholic religious services but instituted a purge of Catholics from public and ecclesiastic office, and even from the guilds. Another iconoclasm in 1581, less violent than the earlier one but fairly thorough nonetheless, emptied the local churches of many valuable images.

At this point, King Philip, no longer distracted eastward by the Ottomans, could turn his full attention to the north and implement more forceful measures to put down the uprising in his Low Countries. The fight was now on for good. This was Philip's land, Habsburg and Catholic, no matter what the locals thought. He was not about to hand it over to heretical upstarts speaking a language he did not understand.

Philip dispatched Alessandro Farnese, the Duke of Parma (and Margaret's son), to retake the rebellious Dutch provinces. After gaining control of the rest of Flanders and Brabant, Farnese finally set his army upon Antwerp. In the summer of 1584, his troops surrounded the city and blockaded the Scheldt River, which was the main waterway for its commercial traffic. The siege lasted over a year. The Dutch insurgents from the north tried to free the city and relieve the suffering of its citizens, but to no avail. In August 1585, Antwerp surrendered to the duke. Spain—and the Catholics—were back in charge of the city.

This prolonged ordeal was the beginning of the end for Antwerp. Despite Farnese's relatively gentle treatment as he restored Spanish control, Antwerp's glory days as northern Europe's greatest port city, a jewel in the crown of the Habsburg Empire, were over. In large part this was due to the migration from Antwerp and other southern Netherlandish cities that began with the Dutch Revolt, increased during the Spanish siege, and became a mass exodus in the years after capitulation. In this period, an estimated one hundred thousand to 150,000 people, for a variety of reasons—economic, religious, social, political, even artistic—left the Flemish lands for "greener pastures."[12] Some headed to England or the Rhineland, especially in the early years of the revolt.[13] But a large number of families from Antwerp fled northward, to Holland and the other "liberated" territories, now proclaiming themselves the Dutch Republic of the United Provinces (although it would take another sixty-odd years of conflict for the Dutch to finally win their formal independence).

For many of the exiles, the departure from Flanders, while under some duress, was voluntary. The motive was money. With the siege and the closing of the Scheldt estuary, Antwerp's trade essentially came to a standstill. After the city was returned to the Spanish fold, Parma's maritime blockade was replaced with one imposed by the Dutch. The *Watergeuzen*, or "Sea Beggars," as they called themselves—essentially privateers led by the Dutch nobility—sought to choke the city and cut off an important lifeline for the Spanish provinces of Flanders and Brabant and, thereby, a crucial source of income for the Habsburg throne. Without access to the

sea, Antwerp was isolated from practically all the international commerce on which it depended.

Already weakened by the Spanish onslaught and intramural religious and political strife, the city now faced an uncertain future. Its mercantile activities and manufacturing industries were doomed as long as the Dutch war for independence continued. Families who relied especially on the textile trade—importers of wool, flax, and silk; spinners and weavers; bleachers; cloth cutters, tailors, and other artisans responsible for making garments, household cloths and linens, sails, and other items; export merchants and their agents—all knew it was time to seek their livelihood elsewhere.

Antwerp's Protestants, on the other hand, had little choice in the matter. The Spanish authorities saw no need to tolerate unorthodoxy and gave Calvinists and others four years either to convert to Catholicism or get their affairs in order and depart. If they chose the latter, they had to leave all their property behind.

(Other religious minorities were likewise affected by these changes in the city's political, economic, and confessional fortunes. Perhaps most important of all, in terms of Antwerp's future, were the *converso*, or "New Christian," families, descendants of Jews who had been forcibly converted to Christianity in Spain and Portugal. Many of them had fled the Iberian peninsula and settled in Antwerp to be further removed from the dungeons of the Spanish and Portuguese Inquisitions, which suspected that the conversions were not entirely sincere. Despite being ostensibly Catholics, these "Portuguese merchants," as they are called in contemporary documents, also thought it wise to relocate after the Spanish recapture. Many of them had continued practicing Judaism in secret and were eager to return openly to their ancestral religion. To do so, they went to Hamburg or Venice, which had established Sephardic congregations, as well as to Amsterdam, where they would soon create a brand-new and flourishing Jewish community. The Portuguese Jews took with them their lucrative business networks, especially in the New World, further hastening the demise of Antwerp's economy.)

The clear winner of this combination of economic upheaval and religious intolerance in the southern Low Countries and the con-

sequent massive emigration was the Dutch Republic. One scholar has called it a "hand-and-brain drain to the north."[14] In the last two decades of the sixteenth century, Antwerp lost almost half of its citizens—mainly to the province of Holland.

<p style="text-align:center">*</p>

Why did Franchois Hals and his family pack up their things—at least those they were allowed to take with them—and leave? Was it for economic or religious reasons? If Franchois was in fact a Protestant who was only pretending to be Catholic when the Spanish took that census of Antwerp's guard companies in 1585—and there would have been good, prudential reasons to dissemble on this point—then there was no question; the truth would have come out eventually, and so they had to go. They did have the option of converting to Catholicism, but in such a tense situation—war against the Dutch Protestant enemy—that probably would have worked no better to put them above suspicion for being insincere in the faith than it did for the Portuguese conversos. The Inquisition never let down its guard.

But maybe Franchois really was a Catholic. After all, he married his first wife, Elisabeth, in Antwerp's Saint Jacob's Church; and all the children from that marriage were baptized there. One or two of those children ended up staying in or returning to Antwerp even after it reverted to Catholicism—not a wise, or even permissible, choice if they were Protestants. The family's decision to leave is not, by itself, evidence one way or the other, since many Catholics joined the exodus, opting to abandon a city in decline. Unless some further material turns up in the archives, the question of the faith into which Frans Hals was born must remain uncertain.

Regardless of their religious persuasion, the most likely reason the Hals family left Antwerp, shortly after the capitulation to the Duke of Parma and well before the four-year deadline for Protestants to leave, is that it was simply a matter of following the textile trade wherever it went.

Sometime during the summer of 1586, then, Franchois Hals, Adriana, and most of the children from both of Franchois's marriages—including two- or three-year-old Frans and his younger

brother Joost—left Antwerp and the southern Netherlands for good. The clan would retain connections to the city, and Frans would be known in later years as "Frans Hals of Antwerp."[15] Indeed, Hals's Flemish origins will continue to play a significant role in his life, and especially in his art. But except for his half sister Maria, who would marry an Antwerp tailor and settle there, and possibly another half sister (Barbara), as far as we know no member of Franchois Hals's immediate family would ever again reside in the Spanish southern Netherlandish provinces.[16]

There was still the question of where to go. To the northern provinces, of course, like everyone else. That is where the best opportunities were for Dutch speakers. But where? Many Antwerpers ended up in Amsterdam.[17] But for someone seeking in those Dutch lands employment in the textile industry—and that is all that Franchois knew—there were really only two possibilities. Leiden had developed into a major center for the production of cloth. The Hals family, however, following many other southerners in the trade, opted for Haarlem.

CHAPTER 2
Haarlem

In the late 1660s, Jacob van Ruisdael, an artist active in Amsterdam, began a series of paintings depicting the landscape around Haarlem, the city of his birth. The panoramic works, known at the time as *Haerlempjes*, are dominated by dramatic Dutch skies. Covering almost two-thirds of the canvases, the massive, billowing clouds of white and gray float over a background of varying blues (fig. 1).[1] In the more muted foreground of some of the paintings, among the greens and browns of woods and meadows and framed by the shadows cast by the clouds, are bleaching fields. Long strips of linen—small, thin white lines in the paintings—are shown stretched over tawny late season grass to lighten in the sun. The woven fabric has already gone through several cycles of being washed with soap and water; treated with lye, potash, or cow dung; and, most important of all, soaked for days in buttermilk to soften. Sunlight has managed to break through the thick clouds to highlight the cloth bolts as they dry and fade in the summer air.

Despite the atmospheric spectacle above and human industry below, the viewer's eye cannot but be drawn to the center of Van Ruisdael's paintings. There, sitting right on the distant horizon, where blue sky meets the reddish shades of a city's rooftops, is an edifice that, while dwarfed by the heavens, is of considerable size, large enough to dominate its urban and natural surroundings. It looms over the houses around it, its onion-domed spire extending far higher than any of the nearby towers.

Unlike Johannes Vermeer's *View of Delft*, which presents a quiet morning by the water in front of the city's gates, Van Ruisdael's

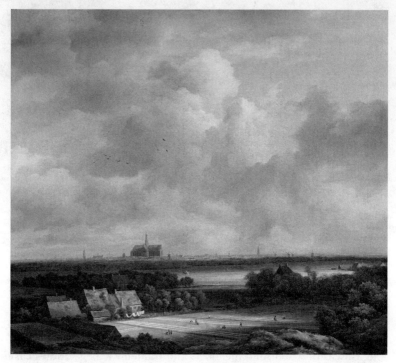

1. Jacob van Ruisdael, *View of Haarlem with Bleaching Grounds*, ca. 1670–75, Mauritshuis, The Hague.

Haarlempjes do not provide much detail of Haarlem itself. You can see along the horizon an expanse of steeples, windmills, and houses that make for an impressive skyline, but almost nothing that would allow you to identify it with certainty as Haarlem—nothing, that is, except that massive structure rising above everything else: the Sint Bavokerk (Church of Saint Bavo), at this point called by the town's Protestants the Grote Kerk (Great Church).[2] A traveler in the seventeenth century, coming along country lanes like those in the paintings, perhaps approaching the city from the shore of the Haarlemmermeer (Haarlem Lake) that lies between Haarlem and Amsterdam to the east, would spy the church's roof and spire from far off, well before any other landmarks. It helped that the land around Haarlem was exceedingly flat, flatter even than most of the Netherlands. In those preindustrial days, there was little in the countryside, besides

trees and the occasional hillock, to keep one from seeing all the way to the horizon.

*

Haarlem was originally settled in the early Middle Ages, on some high ground at a bend in the Spaarne River. (The name is often taken to be a contraction of "Haar," "lo," and "heim," meaning "elevated home on a forested dune.") The meandering waters of the Spaarne afforded access to the IJ Bay and, eventually, the North Sea. The first extant mention of the town occurs in a document from the tenth century.[3] Haarlem later became the seat of the Counts of Holland, and in 1245 it was granted its *stadsrecht*, or city right (somewhat akin to incorporation today) from Count Willem II. In 1270, after the city found itself under siege, it was fortified by walls. When these mud and wood battlements proved insufficient to contain and protect the city as it expanded over the next hundred years, they were rebuilt, with a canal moat added for good measure.

During this later medieval period, Haarlem became a major mercantile hub, conveniently situated on the busy route between Leiden and Alkmaar. It was also the second most populous city in the province of Holland, after Dordrecht. (Dordrecht and Haarlem were the two oldest cities in the province, which gave their representatives to the States of Holland the honor of the right of first address at that body's meetings.) However, by the end of the sixteenth century, Haarlem's economic importance was eclipsed by that of Amsterdam, which had grown rapidly in size after the Union of Utrecht in 1579 and the start of the war for Dutch independence, helped along by the subsequent decline of Antwerp. At the same time, Haarlem developed into the province's center of several notable and highly profitable industries—among them, linen.

*

Van Ruisdael's "Little Haarlem Views"—whether they should be called landscapes, cityscapes or skyscapes—are somewhat misleading. The bleaching of linen, both of the yarn and the woven fabrics, took place

not right outside the city, as depicted in these works, but on the dunes and grass fields by the villages along the coast, from Egmond in the north to Katwijk further south, in the vicinity of, but still a bit of a way from, Haarlem.[4] Nonetheless, the paintings reflect the pride that Haarlem took in its linen production, and the activity carried out on the coastal sands was called *Haarlemmer bleek*, or Haarlem bleach. One contemporary writer, Samuel Ampzing, provides a rather idyllic picture of the process in his *Beschryvinghe ende lof der Stad Haerlem* (Description and praise of the city of Haarlem), published in 1628:

> On this side of the dunes are beautiful green meadows, where the dunes lend their pure rain, that gushes out of their veins as if from a fountain; and with a sweet rustling, flows out of their breasts. This is where the linen is made white. Here the gray thread is bleached, and the weavings made to be as if snow white; and see how, again, so many youths and maidens [are] busy in their work in many forms: Here one bleaches the linen goods; there it has been pressed, covered with milk to soak away the grayness; they wash it in the tub before treating its blue skin, and rub such residue out with the fist; they rinse it out again and lay it out in the fields, and fasten it with pins and sprinkle it with silver rains of dew, until it becomes white and soft; then it is taken from the bleachery and carried back to the city.[5]

Haarlem's linen industry—not just the rural bleacheries themselves, but the manufacturers and merchants who oversaw the import of raw material, the weaving of fabric and the exporting of wares, whether as bolts of whole cloth or as finished goods such as clothing and household furnishing—was, by the early seventeenth century, a mainstay of the area's economy. Quality control of the final product was overseen by the directors of the city's weavers guild. Haarlem's superior (and expensive) white linen, the finest and softest available, was soon in high demand throughout Europe. Garments made from Haarlem linen clothed royal and aristocratic bodies in Spain, France, England, and elsewhere; its bedsheets covered noble

beds; and its tablecloths and napkins sat on many courtly tables. The Dutch themselves—at least, those who were able to afford it—could not imagine a life without fine linen. As Ampzing notes,

> What do you think? Should not one clothe one's naked limbs with linen and other stuffs? How can one be clean at his meals, and have no linen goods, and have no table cloth? What? So he goes to sleep and has no linen sheets? In short, can one exist well without linen? Or do you wish that one shall stink and perish?[6]

To most ordinary citizens in Haarlem, the local linen, a luxury, was not only out of reach financially but out of sight, either bleaching near the North Sea dunes or, after being woven in private homes, stored inside the city's warehouses. What the Haarlemmer on his daily rounds could not avoid, though, was the Saint Bavo Church. As it is the focal point of Van Ruisdael's paintings, so it was the true center of the city: geographically, religiously, and, with its surrounding marketplace and proximity to the Spaarne, commercially and socially. A resident of Haarlem likely crossed the cobblestone square outside the Gothic building several times a day. Here he found fruit and vegetable sellers, cheese mongers, bread and pastry bakers, dairymen, poultry and beef farmers, fishermen, and flower merchants all hawking their wares at the top of their voices. It would have been a treacherous march through the market in wooden shoes, the stones slippery with detritus from the stalls—cabbage leaves, rotten produce, fish scales—and run-off water.

If our stroller went inside Saint Bavo's, he might have been a member of the Dutch Reformed Church on his way to prayer. Or perhaps he was meeting a friend or business partner in one of the church's aisles or side chapels, where a private conversation could be held away from the din of the market. Or maybe he was someone out on errands, going from one end of town to the other and taking a shortcut through the church's nave or transept.

Bavo was for a long time the patron saint of Haarlem, as well as of the southern Netherlandish cities of Ghent and Lauwe. Born in 622 to a rich aristocratic family in Brabant, Bavo, after the death of

his wife, came to realize the vanity of the pursuit of worldly goods. He decided to give it all up for a life of faith and good works. After distributing his lands and wealth to the poor, Bavo took off for missionary work throughout the Low Countries. The legend relates that he eventually became a hermit and lived out his days in a forest near an abbey in Ghent.

Bavo was an inspiring model of piety and perseverance to Dutch Catholics, especially those in Haarlem. This city of mixed faiths had, by the beginning of the seventeenth century, reached a tolerably peaceful religious modus vivendi, but not without some difficult years. Haarlem was not spared the kind of sectarian troubles that Antwerp and so many other northern towns experienced in the wake of the Reformation and during the long Dutch war for independence. The city's turbulent religious affairs in the period are reflected in the changing ecclesiastic status of the structure named after its patron saint.

The Saint Bavo Church was originally a Roman Catholic church, its earliest parts dating to the late fourteenth century.[7] It was commissioned as a cathedral in 1559 by Pope Paul IV and served the bishopric of Utrecht. After the province of Holland took the lead in the Dutch Revolt, in 1572, Haarlem was put under siege by the Spanish; the foreign forces were abetted by civic guard soldiers from Amsterdam, which alone of Holland's cities was still loyal to the distant crown. The blockade lasted until July 1573, with the citizens suffering all the physical hardship and plunge in morale that a sustained military assault brings. A brief but failed effort at resistance and a largely unsuccessful attempt at iconoclasm of Saint Bavo's by Haarlem's Protestants only exacerbated the misery.

When Haarlem finally surrendered to the Spanish that summer, Philip's exhausted but voracious army sacked the city. The soldiers plundered homes and carried out violent reprisals against the citizens, including beheading the leaders of the resistance and drowning many of their followers in the Spaarne. To make sure his defeated Dutch subjects got the message, the king, as was his practice, levied a series of heavy financial penalties. He also directed his agents to

restore, and protect, the city's Catholic character. In Saint Bavo's, religious imagery that had been removed by Calvinists (as well as by Catholics, for safekeeping)—altarpieces, paintings, statues—were returned to their proper places.

Still, if Philip's goal was to ensure Haarlem's future as a loyal Catholic possession, his campaign was a failure. When the Spanish troops withdrew a few years later, broke and demoralized after an unsuccessful assault on Alkmaar, the Protestants did not waste a moment.[8] During the so-called *Haarlemse Noon* of 1578, Calvinists, while still outnumbered by Catholics, went on the attack. They took over Saint Bavo's, forced the clergy to flee and once again emptied the church interior of its visual treasures. (To get a sense of how a Protestant iconoclasm can "cleanse" a Catholic church, one need only look at the Haarlem artist Pieter Saenredam's paintings of the interior of Saint Bavo's from the first half of the seventeenth century; the whitewashed, ostentatiously bare walls are devoid of any religious imagery.) The erstwhile Cathedral of Saint Bavo, now the Grote Kerk, would henceforth be a Protestant house of worship.[9]

Haarlem's two main denominations eventually came to an irenic if short-lived understanding. The city leadership would remain in Protestant hands, with the Catholic bishop and his flock swearing allegiance to William I rather than Philip II. But Catholics were to enjoy equal rights, including the right to public worship. At least, such was the original plan. Within a few years, however, the comity broke down. This was in part because of immigration. Haarlem's Protestant population swelled as exiles poured in after Spain's reconquest of the southern Netherlands in 1585. By the end of the century, Protestants (or, at least, Protestant fellow-travelers, if not actual members of the Dutch Reformed Church) would constitute a majority in the city. But it was also due to pressure on city councils from the States of Holland, the governing body of the province—and which itself was under pressure from the Synod of the Reformed Church and its ministers—to clamp down on Catholic life and make things difficult for those Papists whose loyalty to the Dutch Republic was suspect. Already in 1583, the States had issued a province-wide

edict forbidding Catholics even from holding public office, and it would remain in effect through the early decades of the seventeenth century.

This put Haarlem in a difficult situation. It could go only so far in refusing to accommodate its Catholic population. The city's economic life, benefiting as it did from the Flemish exodus, was too dependent on industries employing large numbers of Catholics. Still, within little more than a decade, Catholicism went from being Haarlem's public faith to being only a tolerated religion. The city may have been more open to Catholics than other Dutch municipalities; and, as the historian Jonathan Israel puts it, the practice of Catholicism "retained more vitality" there than elsewhere in Holland.[10] Various Catholic life-cycle events that were outlawed in other cities were allowed to continue, albeit with some discretion. Catholic priests were permitted to carry out baptisms, and it was "perhaps more or less possible" to be married by a Catholic priest (with civil weddings for Catholics and Mennonites performed in the town hall).[11] Nonetheless, despite this relatively tolerant environment, Haarlem's Catholics now found themselves in what Israel calls an "untenable position."[12] Having lost the opportunity for everyday public worship and repeatedly denied their requests to celebrate mass and the sacraments together in a church, they had become second-class citizens reduced to holding religious services in more or less clandestine *schuilkerken* (hidden churches). To these gatherings in the attics and basements of private homes, the city's Calvinist authorities at best tended to turn a blind eye.[13]

*

By the time Franchois and family were settled in Haarlem, Calvinists had a firm grip on the city—indeed, on the whole province. Did the members of the newly arrived Hals clan join those local Catholics forced to observe their rites behind closed doors? Apparently not. Although Franchois identified himself to the Spanish as a Catholic during the 1585 civic guard census in Antwerp, perhaps as a precautionary move, the baptismal register of Haarlem's Grote Kerk, which of course did not keep track of Catholic affairs, suggests a different

story. The record book states that on March 19, 1591, "a child named Dirric [Dirck] is baptised; the father Franchois Hals, the mother Adriana Hals; the witnesses are Dirric van Offenberch, Nicolaus Snaephaen, Maria van Loo."[14] Franchois and Adriana had brought their new son to the Dutch Reformed Church for his christening. Dirck would be the first member of the family born in Haarlem and the first to be baptized in the city's dominant faith. This baptismal record is also the earliest extant evidence of the presence of Franchois, Adriana, and their children in Haarlem.

We do not know where the family first lived in the city. Despite the great influx of south Netherlanders in the final decades of the seventeenth century, there was no housing shortage in Haarlem. The rebuilding that took place after the great fire of 1576 destroyed hundreds of buildings, a conflagration started by Spanish shelling, made sure of that. Moreover, the city now owned ecclesiastic properties—monasteries, cloisters, chapels—that had once belonged to the Catholic Church, and made them available to house ordinary citizens. Haarlem was well prepared to accommodate the large number of immigrants.

Franchois and Adriana managed to rent something, but it was certainly not in Haarlem's more upscale district. It is not that they were destitute. Their departure from Antwerp, coming well before the five-year deadline, was likely voluntary and not especially hasty. This must have left them time to gather their property (or at least as much of it as they were allowed to take), sell some things, and secure their affairs. Still, there is reason to believe that not all was well financially. They had trouble meeting their most basic obligations.

In February of 1599, we find Franchois and Adriana paying a visit to a notary's office. They were hoping to come to agreement with Jan Pietersz, a cattleman and butcher who had sold them half an ox at a recent Saint Luke's fair. They still owed him thirty-seven guilders and two stuivers, and Jan Pietersz was after them to pay the balance. In their testimony, Franchois and Adriana thank Jan Pietersz for his patience—he could have pressed them for payment much earlier—and, with witnesses present, "confer into his [Jan Pietersz's] hands . . . all their furniture goods" and tell him that he may do with

them as he likes.[15] We do not know whether the meat merchant actually took possession of the Hals's property or only used it as collateral until they paid up, but the affair does reveal that the family was, at the time, not quite flush with funds.

Franchois was at least gainfully employed in Haarlem's textile trade. In documents from this period—where he is identified as "Franchois Hals van Mechelen"—he is again called a *droogscheerder* (cloth cutter) or, occasionally, a *lakenbereyder* (cloth preparer). He must have found a position doing just the kind of work he had been doing back in Antwerp, only now in a city where that industry had a bright future.

Franchois seems even to have gained some standing in the community, as he was asked in June of 1592 to serve as a witness on behalf of one Huybrecht de Wit, a fellow cloth dresser. Huybrecht wanted to be released from his promise of marriage to Tanna Sweenen, whom he had asked to marry him when he was "light-hearted and drunk." Franchois and the other witness swore, before the notary, that they heard Tanna release the inebriated romantic from his vow.[16]

It would not have been difficult in Haarlem to get work, especially for a skilled cutter like Franchois and with the city's rapid expansion and economic growth. The first wave from the south arrived in 1578, mostly Mennonites from Kortrijk (Courtrai) fleeing persecution by Catholics. The more substantial immigration of Protestants occurred between 1585 and 1590, in the wake of the Spanish reconquest and expulsion edict. Between 1575 and 1600, Haarlem's population almost doubled, with over half of the city's now thirty thousand residents being Flemish émigrés.[17] Still, the situation for Franchois might have been a little competitive, since many of the refugees from the south were also textile workers—by some estimates, over six hundred of the Flemish families that settled in Haarlem by the end of the century were involved, in one way or another, in textiles.

The social process of absorbing the south Netherlanders did not always go smoothly. There were, as to be expected, some tensions between natives and newcomers. Immigrants typically generate re-

sentment and suspicion, even insecurity, among established citizens, and this was no less true in Haarlem, as we shall see. But there was room and resources for everybody. For the most part, Haarlem was perfectly happy to welcome these wealthy businessmen and skilled craftsmen. The fact that it was a religiously mixed, Dutch-speaking city with an existing infrastructure for textile manufacture and trade made the transition for the southerners relatively easy. (There may also have been mutual empathy between the two groups, since Antwerp and Haarlem had both suffered grievously under Spanish siege and occupation.) As a further enticement, the Haarlem city council, seeing the economic benefits to come, offered subsidies and land grants to Flemish arrivals. With this influx of merchants and labor, Haarlem's linen and cloth production grew rapidly; by the end of the sixteenth century, it was the city's second-largest industry—after beer.[18]

Far more than wine, beer was the drink of preference across the Dutch provinces. It was an essential beverage for those who lived in the cities, where the water was pretty much undrinkable. Men and women, adults and children, regularly drank beer at their meals—breakfast, lunch, and dinner (with the young ones given a watered-down, low-alcohol "small beer")—as well as to sustain them at work, to celebrate their many festivals, and just to pass the time in taverns and at home. Construction contracts often stipulated how many barrels of the beverage were to be provided per day for the workers. By one estimate, the average annual per capita consumption of beer in Holland was several hundred liters, with adults regularly drinking more than four liters a day.[19]

A good many of these liters were provided by Haarlem's brewers. Beer had long been Haarlem's mainstay industry, well before the expansion of the textile trade in the wake of the Flemish immigration. In the early 1500s, there were almost a hundred breweries in the city. Although their number was down to about twenty by the time the Hals family had settled in, things would rebound in the early 1620s, with over fifty establishments producing beer for both local consumption and domestic export.[20] That amounts to one brewery for

every eight hundred people. By comparison, Rotterdam, second in beer production, had thirty breweries; Amsterdam, the largest city in Holland, a mere fifteen.

In the city quarter on the Spaarne between the Saint Catherijne Bridge and the Saint Nicolaes Bridge alone there were ten breweries, including firms with such picturesque names as "The Two Lilies," "The Glasses," "The Fire Iron," and "The Leaping Horse." A brewery just beyond this neighborhood, and seeking to one-up its competitor, was called "The Three Lilies." There were "The Ship," "The Two Ships," and "The Small Ship," as well as "The Acorn" and "The Two Acorns." Those who did not want their beer from "The Anchor" could go to "The Two Anchors," "The Small Anchor," or even "The Great Anchor." Best of all, at least in name, was a brewery called "The Two Herrings."[21]

At the beginning of the seventeenth century, these local breweries were running more than two thousand brews per year, with each brew consisting of around eighty liters of beer.[22] Over the following two decades, Haarlem brewers will average fifty-seven million liters of beer annually, more than any other European city except London.[23]

While taxes on the production, sale, and consumption of such quantities of beer were a major source of income for the municipal coffers, it was the profits on beer exports that made the brewers very wealthy citizens indeed. (One Haarlem specialty was a hop beer made from a secret recipe. It was a luxury product intended primarily for export and carried a premium price.)[24] The many rich brewer families—along with the local landed gentry, urban professionals, and bulk and rich-trade merchants—formed a substantial part of Haarlem's governing elite. They also played a large role in the city's art patronage throughout the first half of the seventeenth century and made a considerable contribution to the success of Frans Hals's long career.

*

None of Franchois and Adriana's sons followed in their father's professional footsteps as a cloth cutter. In fact, they did not go into any of the textile trades. Neither did they become brewers. Frans, Joost,

and Dirck would all find their calling in the third industry for which Haarlem was famous: art.

Joost appears to have been the least successful of the three. He died as a relatively young man, and no works by him have been identified.[25] Dirck, on the other hand, will be celebrated for his "merry company" paintings showing festive gatherings of citizens, both well dressed and less elegantly attired, as they revel in taverns, ballrooms, and outdoors. Frans will enjoy even greater success, becoming not just one of the greatest Dutch portrait painters of the seventeenth century, but—along with his contemporaries Rembrandt, Rubens, Velázquez, and Van Dyck—one of the greatest portraitists in history.

Art in Haarlem, as in Antwerp, was indeed an industry, a major one that, like textiles, grew significantly during the first half of the seventeenth century. In 1600, when the population of Haarlem was around 30,000, there were nineteen fine art painters registered in the local guild of artists and artisans. This was not an especially large number, especially when compared to other major Dutch centers of painting. Leiden's population was 25,000, and it had ten painters, while Delft, with a population of 17,500, had twenty painters. By 1625, however, Haarlem had, in absolute terms, more painters than Amsterdam, Delft, Utrecht, Leiden, or Rotterdam. Haarlem's residents then numbered about 38,000, and its cohort of painters had grown to forty-four. While Leiden's population had by then surpassed Haarlem's and was close to 45,000 individuals, it had only twenty-seven painters; among Delft's 21,000 denizens, there were thirty-six painters. By 1650, more than ninety of the almost 50,000 people living in Haarlem were painters; while of Leiden's 67,000 residents, only fifty-one were painters; and of the 24,000 people in Delft, there were forty-four painters.[26]

Numbers aside, what distinguished the art world in Haarlem from that in other Dutch cities and towns was its deep and celebrated traditions. The city's reputation as a center of painting and graphic work went back to the late fifteenth century. Throughout Haarlem's Catholic period, the high quality of the etched and engraved prints and the luminous oil panel paintings coming out of its studios was, like the brilliant white of its linen, recognized across Europe.[27]

Haarlem artists were producing altarpieces and other religious and devotional works—depicting stories from the Hebrew Bible, the Christian Gospels, and lives of the saints, including annunciations, nativity scenes, Holy Families, and crucifixions and other episodes of Christ's Passion—as well as solo and, by the late sixteenth century, group portraits for a broad religious and secular clientele. The city's renown for fine art, including magnificent works of High Renaissance style, would only grow in the decades to come.

<p style="text-align:center">*</p>

Karel van Mander was one of the recent Flemish émigrés to Haarlem. He was born in 1548, in Meulebeke, just north of Kortrijk. Though raised in a noble family—his father was in the entourage of the local lord—he was set on a career in painting and printmaking. After apprenticeships in Ghent and Kortrijk, and some very well-spent time in Prague, Florence, Rome, and Vienna, he returned to his hometown. It was not a religiously peaceful time in Flanders, as we have seen, and Catholic extremists, whom Van Mander's anonymous early biographer, writing in 1618, calls "the Malcontent Walloons," made life in the area unbearable for Protestants.[28] Van Mander himself, although born a Catholic, had become a Mennonite and as a result faced harassment by these zealots.[29] At one point he was, his biographer tells us, "set upon by a number of Walloons and stripped naked." The brigands put a rope around his neck and were about to hang him from a tree when he was saved by a man passing by on horseback. When this rider, who happened to be Italian, inquired what was going on, Van Mander spoke to him in Italian and informed him that he was a painter, and that he had spent some time in his country. The rider, after looking closely at Van Mander, recognized him as someone he had met in Rome. The Italian thus "drew his short-sword and set about the Walloons, saying 'Remove that noose instantly, let my friend go and give him back his clothes.'"[30]

Van Mander narrowly escaped with his life and returned to his father's lands. Rather than wait around for the next attack, though, in 1582 he left the area altogether and headed with his family first for Bruges and, subsequently, Haarlem.

But since there was no peace [in Bruges] either, with the [Spanish] enemy approaching nearer each day, and a severe plague beginning to rage in the city, Karel departed with his wife, her mother and his children, taking ship to Holland, and settled in the ancient and glorious city of Haarlem, where he was engaged to make paintings and drawings.[31]

Much of Van Mander's art was in a mannerist tradition, combining Italian and Flemish influences. His richly colored paintings of biblical, mythological, and allegorical scenes—dominated by greens, blues, and bolts of red and yellow—are densely populated with highly stylized figures. They act out their historical dramas, typically in period dress, in lush and fantastic landscapes. His prints, meanwhile, depict elongated, muscular bodies in fabulous encounters and uncomfortably torqued positions. Van Mander's work as a painter and printmaker enjoyed some respect, if not great popularity, among his contemporaries. But his reputation, like mannerism generally, took a downward turn in the seventeenth century and never really recovered.[32] His real claim to fame was his role as a Netherlandish Vasari. He is known primarily not for any great works of art but for his *Schilder-Boeck* (Painter book), which includes an opinionated but judicious survey of the lives and careers of hundreds of historical and contemporary painters—not unlike *Le Vite de' più eccellenti pittori, scultori e architettori* (Lives of the most excellent painters, sculptors and architects) written in the mid-sixteenth century by Giorgio Vasari of Florence, whom Van Mander met during his time in that city. To underscore the lessons that might be learned from his history of painting, Van Mander supplemented the *Schilder-Boeck* with an influential treatise, composed in verse, on the art of painting.[33]

In the *Schilder-Boeck*, Van Mander relies a great deal on earlier sources: Pliny's *Natural History* for the painters from antiquity and Vasari's *Le Vite* for the artists of Italy. But when it comes to the biographies of "the illustrious Netherlandish and German painters," from the fifteenth century on—starting with Jan and Hubert van Eyck—Van Mander is on his own. The result is a remarkable survey of the art and artists of his time.

Van Mander makes no attempt to hide his partisanship for his adopted city. In his profile of the Haarlem native Cornelis Cornelisz (1562–1638), who was so closely associated with the city that he was also known as Cornelis van Haarlem, he boasts that

> the ancient, distinguished town of Haarlem was an admirable spectacle before the whole world and everyone talked and spoke of how she, during the time of the thirty-one week siege, withstood the great, horrifying Spanish might with feeble ramparts, stout hearts and the fist.[34]

Van Mander goes to great lengths to highlight Haarlem's rich artistic tradition and has nothing but high praise for the artists of a place where, he says, "there had always been great painters." He does not hesitate to name names.

> It has long been rumored that of old, even in very early days, very good or even the best painters of the entire Netherlands lived in Haarlem in Holland, which cannot be denied or exposed as untruthful but can rather and far better be proven true with the previously mentioned old masters, [Albert van] Ouwater and Geertgen tot Sint Jans, as well as with Dierick [Dirck] van Haarlem.[35]

The prose here is a bit of exaggeration for rhetorical effect. Van Mander did not really think that Ouwater was a better painter than Jan van Eyck, who worked in Bruges; and he devotes twice as much space to Rogier van der Weyden, another Fleming, than he does to Dirck van Haarlem.[36] Still, Van Mander notes, in his entry on the native Haarlemmer Jan Mostaert, that "in Holland the ancient and important city of Haarlem has brought forth many good spirits in our art."[37]

The city is especially renowned, he says, "for the best and earliest manner of landscape painting."[38] And yet, the reader of Van Mander's text will find that this is hardly the only genre for which Haarlem deserves acclaim. Among the local masters profiled by Van Mander is Maerten van Heemskerck. Van Heemskerck was not a

Haarlem native but came to study with its masters, and he eventually settled there. Van Mander devotes a fairly long entry to this important printmaker and painter of religious works in the mid-sixteenth century—a man, Van Mander says, with "a very subtle manner in drawing with the pen, and very precise in shading, with a deft, light way of handling," and gifted with "a special light for art in his time."[39] But Van Heemskerck also excelled at straight portraiture; although it was a minor part of his output, he helped to establish Haarlem's early reputation for brilliance in that area.

While Van Mander's local favoritism, even prejudice, is undeniable, his praise of Haarlem would have been seconded by many of his contemporaries. From the late sixteenth-century engraved prints of Van Mander's friend Hendrick Goltzius (1558–1617)—who was born in Brüggen, in the German lands, but arrived in Haarlem in 1577 and never left—with their mannerist depictions of improbable musculature and elongated features, to the verdant seventeenth-century landscapes of Esaias van de Velde (active in Haarlem in the 1610s), Haarlem outshone practically all cities of the northern Netherlandish provinces in the quality of its artistic output in the final period of Spanish rule and the decades of the Dutch Revolt.

<div style="text-align:center">*</div>

The early, homegrown Dutch talent—men like Mostaert and Van Heemskerck—was one thing. But Haarlem's art world also received a significant boost from the southern provinces.[40] A large number of artists, art dealers, and others in associated trades—frame makers, auctioneers, and appraisers, not to mention a cohort of wealthy art consumers—arrived with the Flemish exiles in the decades after the Spanish reconquest. Some of the newcomers were Flanders born, others were native sons returning to Haarlem after several years making a successful living in Antwerp.

There was Van Mander himself. And Cornelis Cornelisz van Haarlem, the son of a draper, was coming home to his native city after six years abroad: three in Rouen and, when he fled that French city because of the plague, three in Antwerp, where he trained with Gilles Coignet, a history painter.[41] Cornelis's own history works—

paintings of episodes from the Bible, like his 1591 *Massacre of the Innocents*, and scenes from ancient mythology, such as *The Wedding of Peleus and Thetis* from 1593 or the horrific *Dragon Devouring Two Followers of Cadmus* of 1588 (of which Goltzius made an engraved print that same year)—set a high standard for Haarlem artists looking to specialize in that genre. During the final decades of the century, Cornelis, as we shall see, also enjoyed favor as portraitist to Haarlem's militia companies. Ampzing, turning in his Haarlem encomium to the city's artists, offers the highest praise for Cornelis's skill and inventiveness: "first place to you must all concede, a painter by name, a painter by his deeds."[42]

Over the next few decades, and in the wake of Van Mander, Goltzius, and Cornelis—arguably Haarlem's three most prominent artists in these years—there arrived, among many others, the engravers Dirck Volckertsz Coornhert and Jacob (Jacques) de Gheyn the Younger, the latter an Antwerper who, after six years in Haarlem (from 1585 to 1591), moved on to Leiden, Amsterdam, and then back to Leiden, finally finishing his career in The Hague. Somewhat later, Haarlem welcomed the marine painter Jan Porcellis, originally from Ghent but who arrived in the city in 1621 after five years in Antwerp; Pieter Claesz, a Catholic from Berchem, just outside Antwerp, and painter of brilliant still lifes; the Haarlem native Pieter Soutman, another Catholic, who returned to the north in 1624 after several years in Antwerp; and Adriaen Brouwer, also Catholic and likewise arriving from Antwerp (but originally from Oudenaarde), a genre painter of raucous tavern scenes who was in Haarlem only briefly and would return to his Flemish home in 1631.

In 1600, among the nineteen painters listed in the membership of Haarlem's artists' guild, one-third were émigrés from the Spanish Low Countries. There must have been many more, since in these early years of Dutch quasi-independence not every painter in the city registered with the guild.[43] According to one database, more than 17 percent of the painters and printmakers in Haarlem between 1565 and 1630 were born in Antwerp.[44] As a pair of recent scholars put it, between the immigrant textile workers and the relocated art world, by 1600 "Haarlem . . . was in effect Antwerp transferred."[45]

While these Flemish artists and the themes and styles they brought north would flourish in Haarlem's artistic and economic environment and contribute enormously to the expansion of the city's art market—practically all of the art dealers there either came from Antwerp or were descendants of Antwerp families[46]—the transition for individual artists was not always and immediately a smooth one. For one thing, they had to get along without their usual forms of patronage. Back in the southern Low Countries, an important source of commissions was the royal court: portraits of the Spanish king and queen and their retinues, their regents and entourages in the Low Countries, their offspring and their titled relatives. Perhaps more important, artists in Flanders, as in most Catholic lands, could count on ecclesiastic support. Altarpieces and other religious works—paintings, statues, glassworks, tapestries—were needed to decorate the altars, walls, and pillars of churches and chapels.

In Holland and the other rebellious Protestant provinces, none of this existed. There was no longer a king or queen, and the Catholic Church was, in most places, forced into hiding. Artists had to seek their living elsewhere: from the wealthy burghers of the cities, from guilds and companies, and from what was left of the noble families. But there were also independent dealers, auctions, lotteries, art markets, and fairs. There was certainly no lack of demand for art, but in the Dutch Republic it did not come from court or cathedral. The artists from the south, once settled in Haarlem, had to get used to a new way of doing things.

<p style="text-align:center">*</p>

Within a few years of his arrival in Haarlem in 1583, Van Mander established himself as a major presence on the city's art scene. Along with Cornelis, who had returned that same year, and Goltzius, he set up a kind of school and workshop in Haarlem—his anonymous biographer calls it "an academy"—to teach aspiring artists "to study from life."[47]

It was not an art academy or art school proper. It did not have the endowment, organization, or formal curriculum of more established institutions elsewhere in Europe, such as the Accademia di

Belle Arti in Florence, founded by the Medicis in the mid-sixteenth century, or, later in the seventeenth century, Paris's Académie Royale de Peinture et Sculpture. Rather, it was just a trio of local, like-minded artists—two Catholics and a Mennonite convert—with different but complementary skills and interests who, with the support of a patron, the Amsterdam art dealer and collector Jacob Rauwert, collaborated on art production, teaching, and theory.[48] Goltzius was making engraved prints after Cornelis's mannerist paintings, with Van Mander, when he was not himself painting, providing theoretical foundations, and interpreting literary source material for their work. The three artists may even have shared studio space. It was a relatively short-lived enterprise, ending perhaps in 1603, when Van Mander left Haarlem (and he died soon thereafter, in 1606), and certainly with Goltzius's death in January of 1617.[49] Still, the Haarlem group, in its brief lifetime, was well known throughout Holland and was not without some influence on art practice and theory. It attracted talented students from all over the province—from Haarlem, but also, if Van Mander's biographer is to be believed, from Amsterdam, Delft, The Hague, and elsewhere.

Was Franchois's gifted son Frans among the pupils working with Van Mander, Goltzius, and Cornelis? There is, in fact, hardly anything that we know for certain about Frans Hals's earliest training as a painter, least of all the master with whom he spent his formative years as a pupil and apprentice.

Among the Dutch painters Van Mander profiles in his *Schilder-Boeck*, he discusses three whom his biographer (but not Van Mander himself) refers to as his "students [*discipulen*]."[50] Van Mander has nothing but high praise for all of them, although it is not clear whether they apprenticed with him personally or were students whose work he, along with Goltzius and Cornelis, oversaw in the "academy." Jacques de Moschero from Delft, Van Mander notes, is "accomplished and experienced in all aspects of art"; Evert Krijnsz, now working in The Hague, acquired in Italy "a beautiful, rapid and lively manner of painting both in histories and in portraits"; and "Cornelis Enghelsen" (that is, Cornelis Engelsz, also called Cornelis Versprongh) from Gouda is "a very good painter and an outstand-

ing portraitist."[51] Surprisingly, Van Mander does not include an entry for, or even any mention of, Karel van Mander II, his eldest son and, later, an accomplished painter in his own right, whom he must have taught (as the biographer—who may be Karel II himself—confirms for us).

Neither is there any mention in the original edition of the *Schilder-Boeck* of Frans Hals, not even among the brief notes devoted to "various Netherlandish painters presently alive." This is likely because when Van Mander was writing, in 1604, the twenty-one-year-old Hals was not someone worth mentioning among the "illustrious" and "renowned" artists who interested him. Hals had not yet joined the local artists' guild and so was not a master painter—he was a journeyman at best, if not still an apprentice. It all depends upon when he began his requisite entry-level work in the profession.

According to the 1590 charter of the Haarlem guild—and this charter was still in effect in the first decade of the 1600s and would not be replaced by new regulations until 1631—an apprenticeship was to last no less than three years.[52] This had to be followed by at least one additional year of work with a master as a journeyman before one could apply to become a master painter oneself. It was not uncommon, though, for a young painter to take up to nine years to become a master and open his (or her) own workshop with apprentices.[53] In 1604, Hals, wherever he may have been in his preparatory period, was still a nobody—a talented nobody, perhaps, but not yet someone who would attract much notice outside of the workshop in which he was training or assisting.

It was a different story fourteen years later, after Van Mander had passed away but when his biographer was writing for the second edition of the *Schilder-Boeck*. Hals had become a master painter by this point and made enough of a name for himself finally to earn a mention.[54] The biographer describes him—along with Van Mander's oldest son—as having been one of Van Mander's "pupils":

He [Van Mander] had various pupils, some of whom became good masters: Jacques van Moschero; Jacob Martensz.; Cornelis Enghelsen; Frans Hals, portrait painter of Haarlem; Evert Krijnsz. from

The Hague; Hendrick Gerritsz. Oost-Indiën; François Venant; and many others, too many to mention, and also his eldest son Karel van Mander, who was born in Haarlem and lives in Delft. All deserve esteem and praise for their rich invention and accomplished manner of painting and drawing.[55]

If Van Mander's son, Karel II, is indeed the author of the biography, he can be trusted on this matter, for he surely would have known who among the now celebrated painters in Holland worked under his father.

Many years later, a German painter and younger contemporary of Hals named Matthias Scheits (ca. 1625–ca. 1700) wrote a brief biographical sketch of Hals on the flyleaf of his own personal copy of Van Mander's *Schilder-Boeck*. Scheits had been in Haarlem from 1640 to 1650—as a student of Philips Wouwerman, who in turn had been Hals's pupil—and no doubt knew Hals personally. He thus had the opportunity to correct what Van Mander's earlier biographer said about Hals's training. Instead, he only reiterates that "the excellent portrait painter [*conterfeiter*] Frans Hals of Haarlem learned from Carel Vermander van Molebeke."[56]

There is yet a third contemporary witness, one who was only reminding his audience of what was, among his Haarlem compatriots, common knowledge. Giving a toast in 1686 at the Guild of Saint Luke's annual New Year's banquet, this anonymous speaker tells the company how

it was the love of art that drove Van Mander, so that he left Flanders to go and live in Haarlem, where he flourished for twenty years with his clever brush. And this he taught Frans Hals, proud Prince Apelles, to perfection.

The speaker adds that the reason why Van Mander left Haarlem for Amsterdam is that "this Phoenix [Hals] has surpassed him in fame."[57] (We will have to make allowance for the kind of exaggeration encouraged in speeches at such affairs, especially when the speaker is

likely already deep in his cups after many other toasts; Van Mander left Haarlem well before Hals even joined the guild as a master.)

On the basis of the contemporary record, then, it seems fair enough to conclude that Hals studied painting under Karel van Mander.

If Hals, whose family arrived in Haarlem just two years after Van Mander, received his training from the great art theoretician and poet, either as a member of the "academy" or as one of Van Mander's own apprentices, then he presumably received fine painterly and graphic training in his teacher's preferred style. Van Mander's early biographer indicates that in teaching his pupils Van Mander "showed them the Italian manner."[58] What that meant, at least for Van Mander, was the style of Titian. In his biographical entry on Dirck Barendsz, "excellent painter of Amsterdam," Van Mander says that Dirck, who traveled to Italy and even trained with Titian,

> was a born painter and besides enjoyed the breast of the great Titian and became such a man that one might truthfully say that he was the most important person to have brought the pure and unalloyed correct manner from Italy to the Netherlands.

"There is," he continues, "presently in Gouda in the friary a painting by him, a 'Nativity,' astonishingly well handled in the Italian manner," and he notes that in this and other works of his "one sees a striking Titianesque and Italian manner of working." He adds, for good measure, that Dirck Barendsz "had a real Venetian accent in his Italian."[59]

While Van Mander expects students and apprentices in a workshop to learn from each other's efforts, their primary goal at this early stage in their career is to serve the studio's master.[60] Not just anyone should seek out an apprenticeship, much less hope to succeed in a career in drawing, printmaking, or painting. Van Mander had exceedingly high expectations for his disciples. In the "Exhortation" of his long poem *Den Grondt der edel vry schilder-const* (Foundation of the noble free art of painting), he says that "the art of paint-

ing is attractive but difficult to learn. . . . Parents easily say that they want to let their children become painters, but this is not their work." Rather, in the first instance it is up to "Nature." The student must be endowed with native talent for handling the materials of the art, whether a pencil, a stylus, or a brush. He must also have a special aptitude for pictorial representation, for the art of imitation. "Without nature, one cannot be a painter. . . . Nature marks each child best for something special." The "mountain" to climb to be a great artist is "so high that you cannot reach the top, sooner or later, unless nature benefits you." And whether or not a child has been so gifted by nature to be a good painter is apparently something evident early in life.[61]

If Van Mander was Hals's master, then the apprenticeship—whenever it may have begun—must have ended in 1603 with Van Mander's departure from Haarlem. After a brief spell in Heemskerk, where he worked on the *Schilder-Boeck*, Van Mander relocated to Amsterdam. His residency there did not last long, however; he died only three years later, at the age of fifty-eight. By that time, he was surely well aware of how nature had indeed benefited his erstwhile pupil, and fellow Antwerp exile, with a gift for handling brush and paint.

CHAPTER 3
Master Painter

In the title of his long, laudatory profile of Maerten van Heemskerck in the *Schilder-Boeck*, Van Mander calls him "artful and renowned" and numbers him among "our most important principal painters."[1] If Maarten's father had had his way, however, the young man would have ended up as just one of the Netherlands' more artistically gifted farmers. Van Mander relates that, after some initial instruction in art in Haarlem, "Maarten's father, who perhaps did not find that painting had any particular recommendation, took his son back home so as to put him to work at farming or agricultural labor."[2] A life spent milking cows was not how Maarten saw his future. With help from his mother, "who provided him with a knapsack and some travelling money," he soon made his way to Delft and finally back to Haarlem, where he took an apprenticeship under the celebrated master Jan van Scorel.

Maarten knew that sooner or later he would have to go to Rome. Like so many other painters, he wanted "to see the antiquities and the works of the great masters of Italy," says Van Mander.[3] Before leaving Haarlem in 1532, he had a parting gift for his colleagues in the city's guild of artists and artisans: a beautiful altarpiece showing the evangelist and martyr Saint Luke in the process of painting a portrait of the Virgin Mary and the Christ child. The panel, which showed the saint and his holy sitters from a low perspective, would hang high above the guild's altar in the Saint Bavo Church until the iconoclasm of the 1570s, when it was removed for safekeeping.[4]

There could not have been a more appropriate subject for such an offering. The guild in Haarlem, as elsewhere, was named the Guild

of Saint Luke. Luke became the patron saint of painters and other artists—as well as of medical doctors, students, and butchers (Luke's iconographic symbol was an ox)—just because of his role, according to legend, in making a portrait from life of Mary, the mother of Christ. Haarlem's guild chapter, one of the oldest in Holland, received its charter in 1514, although it was first mentioned in documents as a primarily religious confraternity in connection with the funding and dedication of an altar in Saint Bavo's in 1495.

A guild effectively represented a monopoly on its member trades. It regulated who could practice those crafts, the requirements for training and mastership in each, and the marketing of wares. The occupations that fell within Haarlem's Guild of Saint Luke included fine art painters (*konstschilders*); engravers and etchers; stained glass painters; goldsmiths, silversmiths, and tinsmiths; manuscript illuminators; sculptors; and mathematicians (including geometers, astronomers, and architects). Other professionals who were closely related to or dependent upon these arts—dealers, provisioners of artisanal materials, house and sign painters, faience makers, woodworkers— were also included in the guild's rolls.[5] The activities and transactions of all of these vocations were overseen by a committee of *vinderen* (directors or commissioners), who annually selected from among their ranks a *deken* (dean) and a secretary.[6]

In 1590, with the Dutch Revolt well under way, the charter of the Haarlem guild was renewed, albeit with some minor revisions. Part of the reason for these changes was the arrival of the artists and artisans from the southern Netherlands.[7] The immigration that was a boon to the textile industries turned out to be somewhat less welcome in the art world. A large number of outsiders—and, thus, nonguild members—came to Haarlem seeking to ply their trades. Of special concern were foreign-born painters, who were going from house to house selling their works on the cheap. At one point, painters of south Netherlandish origin working in Haarlem even outnumbered artists born in the city.[8] The Haarlem masters thus declared that if these Flemish interlopers wanted to market their paintings, they had to join the guild. And it would cost them. "He or she must first and before all else become a citizen, and then he or she shall

be required to pay three golden *rijnsgulden*."[9] This contribution, to be split between the city and the guild, was twice as much as a native Haarlem master had to pay to become a guild member and was meant to discourage "foreigners" (Dutch or otherwise) from bringing their business to town. Part of the guild's function was to protect the local talent.

A similar distinction was in place for those who wanted to join the profession at the entry level. Someone from outside the city seeking to line up an apprenticeship with a Haarlem master was required to pay twelve stuivers; though not a large sum, it was still more than the cost for a child of a citizen, who had to pay only six stuivers. All fees were to be submitted within six weeks of beginning the apprenticeship. As for a child of a local master painter, an apprenticeship was free.[10]

Hals, born in Antwerp, was technically a foreigner. But if the family arrived in Haarlem before 1590, when the new charter was adopted, then perhaps he was "grandfathered" in and was allowed to pay for his apprenticeship at the citizen's rate. His own sons, most of whom would go on to become painters, would receive their training in their father's studio at no charge.

A master painter was allowed no more than two apprentices at a time (unless one of those apprentices had already completed two years and was staying on for another year, in which case the master could take on a third).[11] Hals and his fellow apprentices under Van Mander would initially have been charged with the most menial and tedious tasks: grinding the ingredients for pigments, making sure each one is reduced to the right fineness; mixing these pigments with a precise amount of oil to make paint; preparing wood panels or canvases (which needed to be attached to stretchers) and priming them, all so that the master could get right to work. Such technical preparatory work was absolutely essential to making a successful painting. Inadequately prepared paint, panel, or canvas would render the finished product unstable and thus unsellable. Eventually, of course, the apprentices would learn to draw and paint, and do so according to the standards not just of the master under whom they were training but of the city's guild.

If Hals apprenticed with Van Mander, it ended, as we have seen, when Van Mander departed Haarlem in 1603. The duration of his training was presumably the mandatory three years, but possibly longer; we do not know whether or with whom he might have studied before or after his period with Van Mander. Moreover, before Hals could join the guild as a master painter himself, there was that requirement of one additional year as a journeyman working with another master; here, too, there is no record of where he may have spent that time.[12]

As it turned out, Hals did not actually join Haarlem's Guild of Saint Luke until 1610, when he was twenty-six or twenty-seven.[13] This was a relatively late age for a painter to take the next—and necessary—step to move up in the profession and open his own shop, especially someone of Hals's talent and ambition. His younger brother Joost was already registered in the guild by 1605, although not as a *konstschilder* but merely as *schilder* (a term for all artisans working with paint and brushes, including housepainters and other types of "coarse painters").[14] With a boy or girl typically beginning their apprenticeship somewhere between the ages of twelve and fourteen, and even assuming an extra long period under a master, they should be ready to enroll in the guild by their early twenties. After nine years of training in Haarlem under Jacob de Wet, the painter Job Berckheyde joined the guild at the age of twenty-three; Jacob van Ruisdael became a member when he was twenty.[15]

Why the delay in Frans's guild registration, as well as how he occupied himself in the intervening years, remains a mystery. It was not unusual for a painter who had completed his apprenticeship and minimal journeyman period to continue working in a master's shop, making both his own paintings and works directed by the master. (Such journeyman work would go unrecognized, since it was rarely signed.) It was a risky venture to open one's own studio, requiring a fair amount of capital, and maybe at this point Hals was not ready to take on that financial burden.

*

The years during which Hals was training under Van Mander (and, perhaps, with Cornelis Cornelisz and Goltzius)[16] and then beginning

his own career as a master, and until the early 1620s, when a truce that had been signed with Spain in 1609 came to an end, saw substantial changes to the Dutch economy. Just as important to a budding artist, it was a period that saw a shift in aesthetic tastes as well. Amsterdam especially—home to Dirck Barendsz; Cornelis Ketel; Cornelis van der Voort; the brothers Pieter, Aert, and Dirck Pietersz (the gifted sons of Pieter Aertsen); and a host of other painters—but also Leiden and Delft all began to play a more significant role in Holland's art world.[17] However, Haarlem, as Van Mander reported, was really second to none when it came to artistic talent. The inventive solo and group portraits, including those of families and of the boards of local civic organizations;[18] the lively "merry company" pieces; the realistic depiction of landscape, still life, and domestic interiors; the luminous rendering of "perspectives" or architectural interiors (especially churches); dramatic marine paintings or seascapes (a genre perfected by the city's artists); the sensational representation of biblical and mythological scenes ("history" painting)—in short, a high degree of excellence in so many of the genres, subjects, and techniques that strike modern viewers as the hallmarks of "Golden Age" Dutch art—all of this contributed to Haarlem's ascendancy in the art market. Its only real competition in these decades were Amsterdam—described by one art historian as "trend-setting" and blessed with "the widest choice of painters . . . and the greatest demand for portraits"[19]—and another Dutch city (in another province) that was home to a large number of Catholics: Utrecht, with its cohort of specialists in Italianate painting, especially those who worked in the chiaroscuro manner of Caravaggio.

And what an art market it was. The Dutch in general were voracious buyers and traders of paintings. One art historian has referred to this "mass enthusiasm for images" as "perhaps the most virulent passion for painting the world has ever seen."[20] Large and small pictures were acquired by citizens at all levels of society, from the wealthiest burghers collecting fine canvases to peasant families decorating their walls with cheap decorative boards.[21] They hung the works in homes, businesses, meeting halls, public buildings, even taverns and brothels. Works varied greatly in price, of course, with

some history and still-life paintings costing upward of a thousand guilders (and, later in the century, much more than that).[22] Even solo portraits, a relatively cheap kind of painting for most of the period, could run between thirty and one hundred guilders, or more, depending on size.[23] When Hals was asked in 1653 to make a copy of one of his portraits of a prominent local businessman, he charged thirty-five guilders; and Johannes Verspronck, the talented son of Cornelis Engelsz Versprongh, received sixty guilders in 1658 for a portrait of one of Haarlem's Catholic priests.[24] A quality portrait from a prominent artist, then, was really only for the affluent.[25] Still, with the average price of a portrait in the first half of the century somewhere between six and ten guilders—about $350 to $600 in today's currency—a more modest image from an unambitious, workaday master was well within the financial reach of the middle class.[26]

The French wine merchant and teacher Jean Nicolas de Parival spent the last decades of his life in Leiden, where he died in 1669. In his book *Les Délices de la Hollande* (The delights of Holland), published in 1651, he describes the recreations and hobbies of his Dutch hosts, including their skill at ice-skating. "Hollanders," he says, "have discovered the secret of doing on ice what birds do in the air."[27] Parival is especially taken by the Dutch passion for art and reports with some astonishment on the number of paintings he sees all around him. "The houses are filled with very beautiful pictures, and there is no citizen so poor that he does not want to be well provisioned with them."[28]

It was this broad constituency of ordinary citizens who constituted the base clientele for the painters of Holland and other Dutch provinces. As we have seen, there was no royal patronage in the domestic market, mainly because there was no royalty, at least in any official capacity—this was a republic, not a monarchy. There were major commissions to be sought in The Hague, the administrative capital of the United Provinces. This small town was home to the stadholder, the central political figure of the Republic—essentially a quasi-monarchical head of state, commander in chief of the armed forces, and a symbol of Dutch unity. (The occupant of the stadholdership, appointed by several provinces, by tradition came from the

House of Orange-Nassau. The first stadholder of the Dutch Repub-
lic was William I, until his assassination in 1584.) The stadholder's
court was a fruitful source of patronage, especially after 1625, when
Frederik Hendrik, one of William I's sons, assumed the position in
the dominant provinces. He and his wife, Amalia van Solms, were
great supporters of the arts, and Dutch culture flourished during his
tenure (and even after his death in 1647, through Amalia's sponsor-
ship). Their various residences in the city and the country housed
an impressive number of works of art—paintings, prints, sculptures,
and other items—including over 250 portraits.[29]

After 1621, there was another court in town as well, that of Fred-
erick V of Bohemia and his wife, Elizabeth Stuart, the daughter of
James I of England. When the Holy Roman emperor Matthias, a
Habsburg and a Catholic, died in 1619, Bohemia's Diet, or governing
assembly, refused to accept his designated successor, Ferdinand II,
as their ruler. Instead the crown was offered to Frederick, the Elector
Palatine and a Protestant. Frederick and Elizabeth's reign in Prague
lasted just one winter—hence their nickname "The Winter King and
Queen"—as they fled to the Netherlands in 1620 when Bohemia fell
to Ferdinand's army. Frederick's uncle, Maurits of Nassau and Prince
of Orange, was stadholder at the time and offered them refuge in his
land. This royal couple, too, needed portraits and history paintings
to adorn the rooms of their palace. Frederick and Elizabeth were es-
pecially partial to works by the Leiden painter Jan Lievens and the
Italianate style of Gerrit (or Gerard) van Honthorst, who was based
in Utrecht.[30]

Such high-level patronage, whether from the stadholder or mon-
archs in exile, was highly selective and relatively rare, a coveted prize
that most ordinary painters—and there were so many of them—
could not rely on to sustain a business and a family. Rembrandt,
for one, like his friend, colleague, and competitor Lievens, both of
whom as young men had impressed the stadholder's secretary Con-
stantijn Huygens on a visit to Leiden, had some success securing
support from that quarter.[31] But it was nothing like being appointed
"court painter."

Nor, as we have seen, was there any significant ecclesiastic pa-

tronage for art. In this Reformed land, the walls and altars of the pre-
ferred denomination's churches were free of images. No paintings
of crucifixions, no pietà statues, no alluring renderings of heaven or
terrifying depictions of hell to motivate churchgoers. And while aris-
tocratic families did their part to commission artists for works to
decorate their mansions and estates, there was not an order of nobil-
ity sufficiently large and wealthy to keep so many artists in business.
In the end, it was primarily the professionals, merchants, artisans,
and other members of the upper- and middle-*burgerlijk* classes who
sustained the Dutch art world. These ordinary citizens, of varying
wealth, demanded visual tributes to themselves, their land, their his-
tory, and their pastimes and occupations, and especially illustrations
of the didactic and inspirational stories from their Bible. (The *Staten-
bijbel*, or States Bible, the first complete Dutch translation from the
original languages, was not published until 1637; until then, those
who read only Dutch and did not have a copy of the 1542 transla-
tion [based mostly on Luther's German version] had to rely on partial
Dutch translations, as well as paintings and prints with stories from
the Old Testament and the Gospels.) They acquired their commemo-
rative, decorative, and edifying works through commissions, private
sales, dealers, auctions, fairs and markets, even lotteries and barter.[32]

The contribution from Haarlem to the sea of pictures circulating
in Holland was impressive. From 1600 to 1640, when almost 1.8 mil-
lion new paintings came on the market in that province, it is esti-
mated that more than two hundred thousand of them originated in
Haarlem.[33] Buyers in Amsterdam, in particular, had a taste for works
from that much smaller city.[34] It was a good time to be an artist in
Haarlem, especially for someone who would specialize in portraits.

Not that portrait painting was a particularly honored or lucrative
specialty within the profession. It certainly did not have the prestige
or profit of history painting, with its depiction of biblical, mytho-
logical, allegorical, and historical scenes (especially from antiquity,
but also those commemorating great moments in the Dutch war for
independence). In the first half of the century, the status of portrai-
ture lagged behind even that of landscapes. A commissioned por-
trait could cost more than a still life, although not always. And it

was generally more remunerative than what would later be known as "genre" paintings—those familiar, fictional scenes purportedly of everyday life (whether comic, dramatic, or romantic) set in homes, taverns, and the outdoors, often with a moralizing theme; in the period they were called *moderne beelden* (modern figures). But these less personal and often more quickly rendered subjects were, overall, much more marketable than a portrait, which would typically be of interest mainly to the sitter and his or her family.

Van Mander, for one, had a low opinion of portrait painting. He regrets that "in our Netherlands there is this deficiency or unfortunate situation . . . that there is little work to be had that requires composition so as to give the youngsters and painters the opportunity to become excellent at histories, figures and nudes through practice." Rather, he laments, "it is mostly portraits that they get the opportunity to paint; so that most of them, because of the allure of profit, or for their survival, usually take this side-road of art (that is: portrait painting from life [*het conterfeyten nae t'leven*]) and set off without having time or inclination to seek out or follow the road of history and figures that leads to the highest perfection."[35] The best way for a painter to show his talent and contribute to elevating art itself, in Van Mander's view, was through making histories.

This was not merely the cranky, nostalgic opinion of a representative of an earlier (late sixteenth-century) generation now lamenting new fads. Writing in 1678, seventy-four years later, the painter and writer Samuel van Hoogstraten, who had been a pupil of Rembrandt, says that "the portrait makers [*konterfeyters*], who make reasonable likenesses and copy fine eyes, noses and mouths, I would not put them beyond or above the first [i.e., lowest] grade [of painting]," where he also includes renderings of "flowers, fruits and other still lifes." He reserves the third or highest grade for history paintings, at least those that show "the most honorable gestures and intentions of rational men." Portraits, he insists, are beneath even landscapes and genre paintings, those "cabinet pictures" whose subjects include "present-day games and millers' pubs" and which Van Hoogstraten puts in the second grade. The only thing that might redeem a portrait (and possibly raise it to the third grade with history paintings) is a

moral content, if its *tronie*, or facial expression, "overflows with the quality of the intellectual soul."[36]

Still, that is all a matter of theory. Van Hoogstraten himself painted a lot of portraits. He also, like his teacher, worked for European courts. His opinion, too, might reflect better the artistic culture of Amsterdam, where he was active, than that of Haarlem. Either way, with the economy flourishing and a new cohort of very rich patrons and comfortable middle-class clients all looking for artistic reflections of their status and self-esteem, a young painter trying to make his way in the art world—and in society—could make a fine, steady living doing nothing but portraits for the good burghers of Amsterdam, Haarlem, and elsewhere.

The most famous names of Netherlandish art, whether Flemish or Dutch—masters such as Rubens and Rembrandt—made portraiture (including self-portraiture) only a part of their diverse oeuvres. Frans Hals, on the other hand, determined right from the start that he would be primarily, if not exclusively, a portrait painter. Of his surviving works—somewhere around 220 panels and canvases, on the most reasonable estimate—four-fifths are portraits (including ten group and family portraits), and the rest are portrait-like genre paintings.[37]

<p style="text-align:center">*</p>

The year 1610 was an eventful one for Hals, personally and professionally. At some point, possibly in late autumn, he got married. His bride was the twenty-year-old Anneke (or Annetje; both names are the diminutive form of "Anna") Harmensdr. Born in 1590, she was the daughter of Harmen Dircksz, who worked in the textile industry as a bleacher, and Pietertje Claesdr Gijblant. Both of her parents were, by the time of her marriage, deceased. Although Anneke's father was from Den Bosch, she was born in Haarlem, her mother's hometown. Her paternal grandparents probably came to Holland from Antwerp with the flood of textile workers in the 1580s. Her maternal grandparents, however, were native members of Haarlem's brewer elite. Anneke's uncle—Pieterje's brother—and, after the death of her parents, her guardian was Job Claesz Gijblant, who was a member of

the city council as well as a militiaman in Haarlem's Saint George civic guard. Anneke's family thus gave Hals a nice connection to local high society, always advantageous for an up-and-coming artist. It also brought him access to the exclusive, wealthy, and influential regent class of Amsterdam. Job's wife (Anneke's aunt by marriage) was Teuntje Jansdr Huydecoper, who came from a prominent Amsterdam patrician family. Throughout much of the seventeenth century, one member or another of the Huydecoper clan was serving as one of Amsterdam's four *burgemeesters* (burgomaster or mayor); Teuntje's powerful half brother Joan would serve six terms. From a social point of view, Hals married very well indeed.

The marriage banns for Frans and Anneke do not appear in the record book of Haarlem's Reformed consistory. This suggests that the wedding took place not in a Calvinist church but either in the town hall or at home.[38] A couple did not have to be formal members of the Dutch Reformed Church in order to be married by its pastors; marriage, like baptism, was a public service that the clergy would perform for practically anyone.[39] But it is possible that one of the members of this wedding party preferred not to be married in a Reformed ceremony. Anneke's family was, as one scholar remarks, "pure Reformed," and so if there was an outlier it was Hals.[40] It may be that his father's self-identification in Antwerp as "Catholic" was not a ruse after all.

Hals's new domestic arrangement would at least have brought him some happiness and comfort after the loss of that father earlier in the year. Franchois Hals last appears in a document of 1599, when, as we saw, he and his wife, Adriana, ceded "all their furniture goods" as surety to a butcher to whom they owed money.[41] We do not know when exactly Franchois died or what the circumstances were, but it was probably in the early spring of 1610; the record shows that as of May 1 that year, Adriana, now over sixty years old, was living on her own in a rented house; her husband must have passed away shortly before that.[42]

Also sometime that year, Hals finally became a master painter. At the advanced age of twenty-seven or twenty-eight, he was still not the oldest among the seven painters to join the Saint Luke Guild

in 1610; the other new members were Dirck van Poelenburg, Jacob Maat, Jeremias Temminck, Cornelis Verbeeck, Hans Dirks Bul, and thirty-five-year-old Floris van Dijck.[43] The *konstschilders* at this point constituted only a small group within the guild. There were about two dozen of them (including the new members), a large number of whom were Catholics. Hals and his fellow freshmen thus represented a significant enlargement of their ranks. This situation would eventually change; by 1635, there would be almost ninety *meester schilders*, and they would dominate the other professions in the guild both in numbers and in influence.

According to the 1590 charter, which was still in effect when Hals joined up, the Haarlem Guild of Saint Luke did not require new members to submit a masterpiece, a work to demonstrate one's proficiency in the relevant art or craft. An artist who had completed the required three-year apprenticeship and additional journeyman's year and wanted to now become a registered master needed only to be a citizen of the city and pay the dues. It may be that an "elegant company" painting known as *Banquet in a Park* that some scholars believe to be by Hals and that they date to around 1610 was, if not a proof piece for the guild, nonetheless, Hals's first work as a master. But the attribution to Hals of this now-lost panel, which was in Berlin in 1945 but almost certainly destroyed by bombing, is disputed.[44]

There is also a portrait of the Haarlem Reformed pastor Johannes Bogaert (Bogardus); it, too, is lost, and known only through an engraved print by Jan van de Velde II, a Haarlem printmaker. Bogaert was born in The Hague, but spent several years in Bruges. Like other Protestants, he fled that Flemish town in 1584 "to escape the threats of the enemy" (according to a Latin poem that accompanies the engraving) and ended up being a preacher in Haarlem for over thirty years. We do not know when Hals painted Bogaert's portrait, but it must have been before 1614, when Bogaert died at the age of sixty.[45]

This leaves us with a 1611 portrait of the Catholic priest Jacob Zaffius (1534–1618) as likely the first work by Hals's hand. His original, three-quarter representation of Zaffius, who was provost and archdeacon of Saint Bavo's before it was "altered" into a Reformed church and thus an important person within the Haarlem diocese, is

2. Frans Hals, portrait of Jacobus Hendricksz Zaffius, ca. 1611, Frans Hals Museum, Haarlem. Photo: Margareta Svensson.

now lost; we know it mainly from a 1630 print also by Van de Velde. There is also a panel, now in the Frans Hals Museum in Haarlem, showing a bust portrait of Zaffius, done around the same time as the one depicted in Van de Velde's engraving; it is either by Hals as well or by an anonymous painter working from Hals's original (fig. 2).[46] Hals's portrait of the cleric, with hints of the quick, suggestive brushwork that will become characteristic of his "rough" style,

shows a seventy-seven-year-old man in a contemplative moment. His left hand rests on a human skull while his right hand is open and palm up, as if the answer to life's deepest question is obvious. It is a classic memento mori. The devout Zaffius once spent time in prison and suffered corporal punishment for refusing to hand over to the Haarlem city council artworks from the Saint Bavo Cathedral that he had hidden for safekeeping during the 1578 ransacking by Protestants. In Hals's portrait, he appears to be pondering his own mortality and, we can imagine, the transience of all things of this world.[47]

*

In the late summer of 1611, Hals and Anneke welcomed their first child. The boy was baptized Harmen, after his maternal grandfather, on September 2. Present at the ceremony—in a Reformed church—was Anneke's aunt Teuntje. Despite being the young man's godmother, and (as a Huydecoper) quite wealthy, neither she nor her husband, Job Gijblant, now Harmen's great-uncle, included any legacy for Harmen in their wills. (Both Job and Teuntje would die in the 1630s.) In fact, they did not provide much help at all to Anneke and Frans over the years. Perhaps the relationship between the Gijblants and the couple was strained from the start. Was Job upset over the fact that his sister, Pietertje, had married a mere linen bleacher, while his niece Anneke ended up with a painter who was the son of a lowly textile worker—both matches that Job must have regarded as beneath their family's high social station?[48] Was Anneke pregnant at the time of their marriage, which would have brought shame on the family and which her relatives would no doubt have blamed on Hals? Or did Job and Frans have some kind of falling-out? Job seems to have gone out of his way to snub Hals. One year after Frans and Anneke married, Job had his portrait painted—not by his niece's husband, but by another Haarlem artist, Frans Pietersz de Grebber (fig. 3).[49]

Harmen Hals would eventually take up his father's career and become a *konstschilder*. Unlike Frans, who, after arriving in Haarlem as a youth, never lived anywhere else, Harmen had a peripatetic career,

3. Frans Pietersz de Grebber, portrait of Job Claesz Gijblant, 1611, Frans Hals Museum, Haarlem.

working not only in his hometown but also in Vianen, Gorinchem, Amsterdam, and Noordeloos. He enjoyed some popularity with portraits and genre paintings that were not unlike those of his father.

Not all of the Hals children would fare so well. Several, in fact, did not live very long at all. Two years after Harmen's birth, on May 12, 1613, Frans and Anneke buried a child. There is no record of a baptism, and so we do not know the infant's name; perhaps he or she died as a newborn, before being baptized. Just a few years later, in

September 1616, another child—born sometime in 1612—would pass away. In the end, Frans Hals would bury five of his fifteen children; Harmen, his eldest, would survive him by less than three years.

In the Haarlem registry of baptisms, Harmen's father is identified as "Frans Hals van Antwerpen." Once a southerner, always a southerner? More likely, the "from Antwerp" moniker was necessary to distinguish the painter Frans Franchoisz Hals from another Frans Hals in Haarlem, a weaver named Frans Cornelisz Hals. The latter was not someone with whom one would want to be confused, as he was a rather unpleasant character. Among other things, he was in the habit of assaulting his wife. In February 1616, the Haarlem burgomasters issued a resolution reprimanding him for his behavior and warning him that if he again "brings any bad things to bear on his wife or others, he will be more severely punished."[50] This was not the man's first public offense; in 1609, he had been arrested for throwing drinking glasses in a tavern.[51]

<p style="text-align:center">*</p>

In 1612, Haarlem's art world received a most talented and gifted visitor from the southern Netherlands. Peter Paul Rubens decided to make a brief and select tour of the northern provinces just a few years after his return to Flanders from an extended period in Italy. His final stop would be the city where so many fellow Flemish nationals settled after Antwerp's fall to Spain.[52]

At the time of his visit to the Republic, Rubens, who was born in 1577, was not yet a star of the European cultural and political scene. As a young painter, he had made quite an impression on his hosts during eight years living and working in Mantua, Venice, Genoa, and Rome, with a productive side trip to Spain in 1603 on diplomatic business for his employer Vincenzo Gonzaga, Duke of Mantua. He cut short his Italian sojourn in 1608, however, after learning that his mother was very ill. He did not make it back to Antwerp in time; she died before he even left Rome, although he did not learn of her death until he reached home.

After resettling in the city, Rubens received some major commis-

sions, including a number of large church altarpieces. In 1609, the Brussels-based regents of the Spanish Low Countries, Archduke Albert of Austria and his wife, Isabella Clara Eugenia, Infanta of Spain, appointed him their official court painter, a post that came with a nice annual honorarium of 500 florins. With the international renown and stature, not to mention royal patronage and wealth, he would enjoy in Spain, France, and elsewhere still to come, Rubens was nonetheless now famous enough for one Antwerp merchant to claim that "we have here a good master who is called the god of painters, Pieter Rubens."[53] The thirty-five-year-old Flemish virtuoso who arrived in the province of Holland in June of 1612 was, then, certainly no stranger to Dutch artists and scholars.

Rubens's trip was facilitated by the truce in the long war for Dutch independence that Spain and the Republic had signed three years earlier. Artistic and other exchanges across the border, especially between Antwerp and Haarlem, were also made easier by the excellent transportation networks—by road and by water—that linked Dutch cities. Thus, on a late spring day, Rubens, accompanied by a number of other painters from Antwerp—including Jan Brueghel the Elder (a son of Pieter Bruegel) and the history painter Hendrick van Balen—boarded a coach in Antwerp and headed to Dordrecht. From there the party transferred to a barge that took them, via river and canal, to Leiden and then, eventually, to Haarlem.[54]

Leiden was home to the first university in the United Provinces. This is where Rubens's late, beloved brother Philippe had studied with the eminent philosopher Justus Lipsius, an early modern promoter of Stoic thought. While there, Rubens met with several humanist scholars: the jurist and diplomat Hugo Grotius; Daniel Heinsius, a southern exile who, in addition to being professor of poetics and Greek, was the university's librarian; and the professor of rhetoric and official historian for the States of Holland, Dominique Baudier. Baudier (or, as he is better known by the Latin version of his name, Baudius), in fact, had been in contact with Rubens shortly before the painter undertook his Dutch voyage. Writing in October of 1611, after learning of the death of Philippe, he tells Rubens that "it is

not without a certain holy dread that I have contemplated the monuments of your art that in truth compete with nature. Bravo, admirable Apelles of our time. If only Alexander could have known your virtue and merits."[55]

If Rubens's time in Leiden was devoted mainly to scholarly matters, his visit to Haarlem was dedicated to artistic business. A few years earlier, Rubens had begun working with Dutch draftsmen and engravers to produce prints of his paintings. It was through such reproductions on paper that art circulated in the seventeenth century. There were no public museums—although, besides the royal collections, which were open to visitors, there were also private *kunstkamers* (art rooms) where connoisseurs showed off their acquisitions—and paintings did not travel outside the fairly closed networks of artists, dealers, and patrons. Artists like Rubens, Rembrandt, and others therefore had engraved and woodcut prints made after their works, the better to spread their fame and, not incidentally, win commissions.

In Leiden, Rubens may have met with Willem van Swanenburgh, whom he had earlier engaged as a printmaker. But his real interest, and perhaps the whole reason for the trip north, was in establishing a collaboration with Hendrick Goltzius and his Haarlem workshop of skilled engravers, including Goltzius's stepson Jacob Matham. Rubens copied one or two of Goltzius's engravings back in 1590, and he now hoped to forge an ongoing, cross-border working relationship. His quest seems to have been successful, since in the years after his visit to Haarlem some prints after Rubens's paintings were done by engravers working under Goltzius (although most of Rubens's print collaborators continued to be Flemish colleagues).

Goltzius reportedly hosted a dinner for Rubens and his entourage.[56] He must have invited a number of local luminaries, artistic and otherwise, to meet the artist, as well as to stir up interest in the projects they were planning together. There is no record of Hals having met Rubens on this 1612 visit. Still, it is tempting to imagine that, among those who gathered at Goltzius's home to toast the guest of honor from the south was a master painter newly enrolled in the

Haarlem Guild of Saint Luke, one whose family hailed from Rubens's Antwerp and who had trained under Karel van Mander, Goltzius's partner in the art "academy."

<p style="text-align:center">*</p>

Two years after the death of one of his children, Hals suffered another blow. On May 31, 1615, he buried his wife, Anneke. The circumstances of her death are not recorded, but one sad fact is: she was interred, at no cost, in a pauper's grave in a chapel of Haarlem's Hospital of the Holy Spirit, which was an almshouse and orphanage.[57] Apparently, Hals could not afford a proper burial anywhere else. Sadly, shockingly, her prosperous relatives—the couple Job Gijblant and Teuntje Huydecoper—offered no assistance for their niece's burial.

Hals's difficult financial situation was not greatly relieved from the sale, two months after Anneke's death, of four houses once owned by her grandfather, Dirck Anthonisz. The estate created by the money from the sale was split into five portions, with one-fifth going to each of Dirck's heirs or their survivors. One-fifth would have gone to Anneke's late father, Harmen, who was one of Dirck's five sons. Because Harmen himself had five children, Hals—acting as both joint heir and guardian of his and Anneke's son Harmen and a second child—received only one-fifth of Harmen's one-fifth.[58] To add insult to injury, Harmen's other children—Anneke's sisters and brothers Maria, Nicolaes, Elisabeth, and Pieter, all still minors— were represented in this affair by Job Gijblant. The uncle who could not be bothered to help provide for a decent burial for his niece Anneke was more than willing to look out for the interests of her siblings.

If Hals, now a widower, had been hoping for a windfall from the sale of his wife's family's property, he was greatly disappointed. In the end, he received about 565 guilders—a huge sum for a poor man, but not really enough to make much long-term difference in the family finances. For the rest of his life, and like his parents before him, Hals would never be free of money problems.

CHAPTER 4
Citizen Hals

There were three great European navies in the first half of the seventeenth century. Spain had the largest sailing fleet, but the ships and seamen of England and the United Provinces were certainly not to be taken lightly. Encounters on the high seas, even in times of formal peace, typically did not end well for either side. The English and the Dutch, in particular, were harassing each other well before the series of wars between the two countries in the second half of the century. Their political, military, and economic rivalry—whether it was a matter of fishing rights, competition between their respective East India Companies, conflicts arising from alliances with other nations at war (especially Spain and France), or just privateering—often led to deadly confrontations. It did not help matters that, with the signing of the Treaty of London in 1604 ending the long Anglo-Spanish war, England abandoned its Dutch ally and promised Spain that it would no longer give aid to the rebels fighting for independence.

Clashes between well-armed English and Dutch ships took place on the North Sea, the English Channel, the Atlantic and the Caribbean, and off the coasts and islands of the South Pacific. One such skirmish, in April 1605, was depicted by the Haarlem painter Hendrick Vroom in a work from 1614.[1] Vroom's dramatic rendering of the warships and their embattled sailors has a precision of detail and clarity of atmosphere that would characterize the marine and seascape genre that he and his guild colleagues—Jan Porcellis, Cornelis Claesz van Wieringen, and Cornelis Verbeeck—practically invented. Flaming cannon blasts and rifle fire are exchanged—from portholes, decks, riggings, and crow's nests—in close battle on rough

waters just off a coast. When these battles took place in sight of land, many spectators would come to observe the violent spectacle.

While the Dutch navy served the Republic's military and mercantile interests on water—it made a major difference in the long fight for independence—its powerful army, led by the stadholder of Holland and Zeeland, guarded national security on land. Between 1584, when his father, William I, was assassinated, and his own death in 1625, the holder of this interprovincial office—Holland's stadholder was usually also appointed in the provinces of Zeeland, Utrecht, Gelderland, Groningen, and Overijssel—was Maurits of Nassau, a brilliant and innovative military strategist. When the truce signed in 1609 expired after twelve years, Maurits was well prepared to resume the war against the Iberian foe.

Meanwhile, in the cities and towns it fell to the local *schout*, the bailiff or sheriff, and his men to maintain order. This job, essentially the chief of police, was an appointment made by either the province's stadholder or the local *vroedschap*, or municipal council. The *schout* was ordinarily a member of one of a city's regent families, the wealthy and influential clans that, as a self-perpetuating oligarchy, provided the lifetime members of the council and represented the city or town in the province's States. The *schout*'s loyalties to that local elite usually trumped any responsibilities he may have had to provincial or national interests.

These agents of national defense and urban law enforcement were abetted by civic guard companies. The *schutterij* (from the word *schutter*, marksman) were strictly local organizations, armed corps made up of citizens who took it upon themselves to guard their city—and, in theory, their nation—and keep it safe from both external incursions and internal disturbances. Membership in a civic guard company, in some capacity, while unpaid, was required of every male citizen between the ages of eighteen and sixty, although, given the costs involved, typically only men of property actually served.

More organized and better outfitted than vigilante groups, less professional than the Republic's paid soldiers and sailors—including the *waardgelders*, militias stationed in cities but financed by the Republic rather than the municipal government—the citizen guards-

men mostly assumed responsibility for local security and welfare. They patrolled during the day, sounding the alarm—by shaking a loud rattle—if they came across any criminal activity, and made sure the gates of the city were locked in the evening. They took on fire watch and night watch, and made themselves available to help the *schout* keep the streets safe and, if necessary, maintain peace in the taverns if things got out of hand. They might also, on occasion, get involved in municipal politics. In May 1578, the Amsterdam civic guard helped overthrow the city's Catholic-leaning leadership and replace it with a council dominated by members more sympathetic to the Dutch Reformed Church. For the most part, though, the civic guards were only rarely called upon to do any real military service, and even then its members did not take part in actual battles. Over time, the guard companies evolved from fighting and peacekeeping forces of trained civilians, who received certain privileges in return for their duty, to something more like social and sporting clubs. Drills and training became less frequent, if they took place at all; and if arms were actually used, it was in the service of friendly competition or target practice rather than military engagement or handling civil disturbances. Belonging to a guard company was more a matter of fulfilling a civic obligation (made pleasurable by rituals of male bonding) than a hazardous call of duty.

Guard companies were originally defined by their weapon of choice. A good-sized city in the sixteenth century might have three such groups: one for the crossbow fighters, another for archers, and a third for those wielding a recently invented firearm, the arquebus, a musket-like weapon that in Dutch was called a *klover*. Because a guardsman had to purchase his own weaponry and any necessary articles of clothing, as well as help defray the cost of maintaining the headquarters and the militia's training and social gatherings, serving in a civic guard could involve significant expense, especially for the officers.

By Hals's time, there were only two civic guards in Haarlem: the Saint George (Sint Joris) guard of crossbowmen, whose bailiwick was the southern half of the city, and the Saint Hadrian guard of arquebusiers (*klovenieren* or *kalivermen*), responsible for the northern

half. (After the departure of the Spanish occupation in 1580, when Haarlem's civic guards were reconstituted, the archers of the Saint Sebastian guard were absorbed into the Saint George company.) The crossbows and muskets, though, were by now primarily symbolic emblems; it is likely that some members of the guards never touched any weapons whatsoever.

Despite the fact that the civic guards were civilian groups of equal citizens, they were, like military troops, hierarchical and regimented organizations. The Saint George guard and the Saint Hadrian guard were each headed by a colonel and a fiscal (or provost). Under each of these pairs of senior officers in Haarlem there were three companies, with each company led by a captain, a lieutenant, an ensign, and two sergeants.[2] The members of a guard's officer corps (colonel, fiscal, captains) were selected by the Haarlem city council; the captains, in turn, chose their lieutenants and ensigns. A company of a guard, typically composed of more than a hundred men, was further divided into four platoons led by corporals. A civic guard in Haarlem, then, could contain well over three hundred individuals. According to one early ordinance, the officers were to be chosen from among the city's "best and most noble men."[3] In Haarlem they generally came from among the wealthy brewer and textile families; one needed to have at least 600 guilders in the bank just to qualify.

The civic guards of Dutch cities, as fond of art as other citizens, and remarkably proud of their status, regularly had their portraits painted to memorialize their service and commemorate special occasions. These group portraits—sometimes a captain, his subofficers, and guardsmen of his company, known as a "corporalship"; sometimes just the guard's top officers—would hang on the walls of their headquarters. It was a tradition that extended back to well before the Dutch Revolt. The artist Cornelis Anthonisz portrayed Amsterdam's crossbowmen in 1533, and Dirck Barendsz painted that city's arquebusiers in 1566. In the 1590s, Jacob Willemsz Delff and Michiel van Mierevelt were painting the guard companies of Delft. The most famous painting of a civic guard—and one of the most well-known paintings in history—is Rembrandt's 1642 corporalship portrait of members of Captain Frans Banninck Cocq's company responsible

4. Cornelis Cornelisz van Haarlem, *Banquet of Members of the Haarlem Kalivermen Civic Guard*, 1583, Frans Hals Museum, Haarlem. Photo: René Gerritsen.

for District 2 in Amsterdam, a work better known as *The Night Watch* (although it is unclear if the depicted activity is taking place during nighttime).

In the late sixteenth century, Cornelis Cornelisz (Cornelis van Haarlem) was a favorite artist of Haarlem's Saint George and Saint Hadrian guards—perhaps, in part, because his father, Cornelis Thomasz, had served from 1559 to 1562 as warden of the Saint George guard. In 1583, Cornelis Cornelisz painted what is apparently the city's first civic guard portrait: the officers of the Saint Hadrian guard enjoying a banquet to celebrate the end of their service (fig. 4).[4] Cornelis himself was a member of that guard, in the second platoon, and was thus painting his own officers.[5] That same year, he also produced a joint portrait of the officer corps of both of the city's guards; and, in 1599, he portrayed the Saint George officers around a banquet table.

Earlier civic guard portraits, from Amsterdam, tended to show officers and guardsmen lined up in neat rows and rigid poses, with little to distinguish one individual from another—neither in their faces nor in their clothing. The men populating Cornelis's group

portraits, by contrast, are more animated. In his 1583 rendering of the Saint Hadrian guard, Cornelis's officers, both sitting and standing, are crowded around a food-laden table. They are engaged in lively conversation as they pass around tankards of beer. Some face toward the viewer, others toward their comrades. The men gesticulate, even touch one another, while they eat and drink. It is quite a spirited gathering at a celebratory moment.

Such a banquet was a Haarlem tradition for guard officers finishing their three-year commission. The city would cover the expense of the feast, which was often quite a raucous and extravagant affair held at a significant cost—raucous and costly enough for the city to issue an ordinance in 1621 laying out some new restrictions on the festivities. The *vroedschap* stipulated that the banquets were henceforth "not to last longer than three or at most four days," with only three barrels of beer not subject to tax. Moreover, no women were allowed to be present at the banquets; nor were children permitted in the headquarters, lest their presence lead to "needless gobbling up of food and drink."[6]

In the first two decades of the seventeenth century, Frans Pietersz de Grebber (1573–1649), taking over from Cornelis Cornelisz, was the artist of choice for both the Saint George and Saint Hadrian guards. This Haarlem native, the son of a mason, was a Catholic. He trained with the landscape painter Jacques Saverij, a Mennonite from Kortrijk who was briefly in Haarlem by 1587, and became a member of the Haarlem Guild of Saint Luke around 1594. Van Mander calls De Grebber "an excellently good portraitist" whose works "are very good likenesses and are well-executed."[7] In addition to his painting of Anneke's uncle and guardian, Job Gijblant, there are a number of solo and couple portraits of leading Haarlem citizens now attributed to him.

Where De Grebber excelled, though, was in group portraits. He painted entire civic guard platoons in 1600, 1610, and 1612, and he would be called upon to portray another platoon and an officers' banquet in 1618 (fig. 5).[8] His guard portraits tend to be densely packed affairs, their subjects, like those in Cornelis's paintings, animatedly

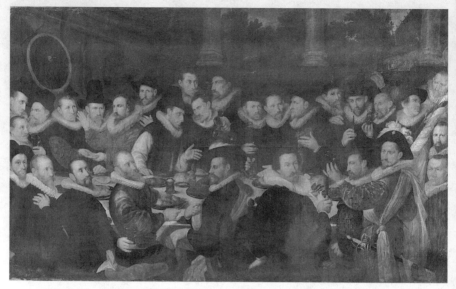

5. Frans Pietersz de Grebber, *Banquet of a Platoon of the St. George Civic Guard*, 1600, Frans Hals Museum, Haarlem.

engaged with each other and with the food and drink at hand. They are flattering pictures that do justice to the individual men (each distinguishable from his comrades) and honor their civic devotion.

Sometime in late 1615, however, six years before the city ordinance on banquets that was supposed to put a lid on things, the officer corps of the Saint George guard that had just completed its three-year term of office opted not to use De Grebber to present them at feast but turned instead to Frans Hals. The result is a painting now regarded as Hals's first real masterpiece (plate 1).[9]

As innovatively dynamic as the guard portraits by Cornelis and De Grebber had been, Hals went even further. The officers are all seated around their banquet table; some are looking at us (and this requires Captain Nicolaes Woutersz van der Meer to twist around in his chair), while others are caught in conversation with a colleague. Their placement at the table is not random: the colonel, Hendrick van Berckenrode, has the place of honor at the far left; to the colonel's right is the provost, Johan van Napels, and on his left, leaning in to tell him something, is one of the corps' captains, Jacob Lau-

rensz. The two other captains, Van der Meer and Vechter Jansz van Teffelen, occupy the middle of the table (and of the painting), while the three lieutenants are seated at right. Standing on the far right are two ensigns with their banners; the third ensign, in the center left, stands between Captains Laurensz and Van Teffelen. A steward attends them in the background to the right.

The faces in the painting are highly individual—real portraits of members of Haarlem's elite, many of whom served multiple terms as one of the seven *schepenen* (aldermen) elected from the twenty-four members of the city council, and even a term or two as one of the city's four burgomasters.[10] While all the officers are soberly dressed in black, their red-and-white sashes, along with the colonel's gold sash, and the ensigns' banners enliven the scene with strokes of bright color. The officers are shown in relaxed postures—no one seems to be striking a pose—and are broken into subgroups by proximity or by conversation. There is a lot more space between the figures, and around them, than in any previous guard paintings.

Captain Van Teffelen is in the process of cutting the roast, while several of his colleagues are waiting for the moment to pass so they can return to their drinks. All are clearly enjoying the occasion. There is a palpable sense of motion and engagement, among the sitters and even between them and the viewer; a couple of the officers are smiling as they lean ever so slightly toward us. There is an open window behind them, showing trees in full leaf and hints of sun through a typically overcast Dutch sky. One can easily imagine a breeze coming through the window to luff the ensign's banner that cuts diagonally across it.

Is it possible that the commission for this work came by way of family ties? Job Gijblant, the uncle of Hals's late wife, was, as we have seen, an influential man in the city. Not only did he sit on the Haarlem *vroedschap*, but he served five two-year terms as one of the *schepenen* from the council between 1604 and 1618. Moreover, from 1612 to 1615, Job was a corps member of the Saint George guard. Perhaps it was he who steered the commission for the painting of his own officers to his niece's husband.[11] Did Job want to make up for

having bypassed Hals in 1611, when the painter was just barely one year into his career as master painter, when he opted to have his portrait done by one of Hals's competitors?

A more likely explanation is that Hals was the natural candidate for the job. The Haarlem civic guards traditionally had their portraits painted by one of their own members (when there was an artist in the corps).[12] And in 1615, when it was time to commemorate the end of the Saint George's officers' three-year term, Hals was himself among their guardsmen. He had joined one of the platoons of the Saint George's third company, newly added to the guard when it expanded in 1612.[13] Thus, in 1615–16, in his first major commission, Hals—as Cornelis had done before him—was painting his own officers.[14]

Hals completed the painting in the spring or summer of 1616. The work went up in the Saint George guard's headquarters—called Saint George's Hall or, more often, the Nieuwe Doelen (New Shooting [or Target] Hall), because it was built to replace the old hall that had been destroyed in a fire in 1576. It quickly established Hals's reputation as a skilled and highly original portraitist. He would become especially popular among Haarlem's guards and go on to do four more paintings for them over the next two decades—two more of the Saint George officers and two of the Saint Hadrian officers. His new, dynamic and spatially open approach to group portraiture would soon be emulated by De Grebber and other Haarlem colleagues. It was not long, too, before his talents were sought by other municipal and regent bodies in Haarlem, as well as beyond the city limits. Some years later, an important and potentially lucrative commission from an Amsterdam civic guard will come his way; for both artist and patrons, it would prove to be more trouble than any of them bargained for.

*

With Anneke's death in May of 1615, Hals found himself as a single parent with two young children. This must have been especially difficult for a relatively new master painter still establishing his studio and working to gain commissions. He needed help at home. It was

probably in the summer of that year, then, that he hired a woman named Neeltje Leenders, the wife of Guilliaem de Buys, to care for four-year-old Harmen and his younger sibling.

This domestic arrangement allowed Hals, in the summer of 1616—soon after finishing the commission from the Saint George guard—to take what may have been his first journey abroad since his arrival in Holland several decades earlier. Sometime before August 6, and reversing the trip by coach and canal that Rubens had taken four years earlier, Hals left Haarlem for the southern, and still Spanish, Netherlands. His destination was the city of his birth.

Antwerp's art world survived the loss of so many artists to the Dutch provinces in the final decades of the sixteenth century and the opening decades of the seventeenth and even saw an increase in the number of painters at work in the city. It remained Flanders's second city, after Brussels—home to the court of the Spanish regents—and a vitally important northern center for painting, sculpture, and print. Late medieval Antwerp has been called the "cultural capital" of the Netherlands, and in some ways this did not change with its economic decline and the growing importance of Amsterdam in the wake of the Dutch Revolt.[15] Paintings from Antwerp studios, representing new genres and styles, continued to be sought by royalty, nobility, and ecclesiastic bodies across Europe. Wealthy patrons in Spain, England, France, Italy, and the states of the Holy Roman Empire had a strong craving for Flemish panels and canvases.

Antwerp's artists and artisans made an especially good living producing works in the service of the Catholic Church's campaign against the Reformation following the Council of Trent, whose sessions were held between 1545 and 1563. The city itself profited well from this aesthetic battle for people's hearts and souls. Painters and sculptors who remained in Antwerp after the Spanish recaptured it worked hard to restore its visual glamour, replacing pieces destroyed or lost in the iconoclasms of the sixteenth century. They replenished its churches and chapels with altarpieces, statues, and other spiritually edifying works, while engravers were busy making devotional prints and illustrations for religious tracts. But the church was not the only support for local artists. The court in Brussels, representing

the king in Spain, was a crucial source of patronage, particularly for images promoting the cause of royal absolutism, lest these Flemish subjects be tempted by the Dutch republican model just across the border. One historian has even suggested that Antwerp, in effect, played for the Spanish crown a role somewhat comparable to that which Hollywood played for American culture.[16]

Economic and cultural ties between Antwerp and Haarlem remained close in the early decades of the seventeenth century, with the traffic of artists and artisans moving in both directions. Rubens was only the most prominent art-world visitor from Flanders to Haarlem in the period, while a good number of Haarlem painters and printmakers headed south. Around the same time that Hals took his Flemish sojourn, his fellow Haarlemmer, the painter Pieter Claesz Soutman, also landed in Antwerp.

Soutman, at least ten to fifteen years younger than Hals—his birth year is unknown—was born and bred in Haarlem, the youngest son of a prominent brewer. He was a Catholic and so no doubt found the Antwerp milieu a congenial, not to mention profitable, place. He would end up staying there for eight years—taking citizenship, joining the Guild of Saint Luke as an apprentice, and training under Rubens—and later go on to become a much sought-after portraitist and history painter. In 1624, Wladislaus Sigismund III of Poland was so impressed by the portrait that Soutman made of him—it shows the Polish king sitting on his throne in full coronation regalia—that he named him official court painter and invited him to reside for a while in his country.[17] By the summer of 1628, Soutman was back in Haarlem, where he joined the guild and set up his own studio. His portraits were exceedingly popular; one contemporary notes that "many citizens, both men and women, were eager to be painted by him, he was so busy at this time that he could not serve them all."[18] Soutman painted solo portraits, of ordinary citizens and Catholic priests (including Willem Coopal, vicar of the Haarlem chapter), and group portraits of civic guard companies. At the same time, he put his engraving skills to work making portrait prints of famous historical and religious figures and continued to serve Rubens with prints of his paintings.

Such success was well in the future when Soutman made his inaugural trip to Antwerp in 1616. Two years later, he would be joined there by Hals's competitor in Haarlem for guard portraits, Frans de Grebber, accompanied by his eighteen-year-old son, Pieter. The elder De Grebber, who met Rubens during the latter's 1612 visit to Haarlem, doubled as an art dealer and had been acting as Rubens's agent in negotiations with the English ambassador in The Hague, Sir Dudley Carleton. Carleton was seeking to acquire paintings by Rubens in exchange for some tapestries and ancient sculptures, and several of the works obtained through De Grebber would end up in the collection of Charles I of England.[19] Meanwhile, the younger De Grebber, Pieter, who would go on to become an important history painter in his own right, used his time in Antwerp to study in the workshop of the great Flemish master.[20]

We can be certain that Hals took advantage of his three-month stay in Antwerp, financed by the proceeds from his portrait of the Saint George officers, to visit the studios of its established artists, as well as to see what was being produced by up-and-coming talent. It was one thing to become familiar with the works of earlier painters and contemporaries through prints and publications; it was quite another, of course, to see their paintings in person. Hals, like Rembrandt, never made the trip to Italy taken by so many other Dutch artists to experience firsthand the great masterpieces of the Renaissance in Rome, Florence, and Venice. But in Antwerp, he was able to examine the paintings not only of Rubens and his younger colleagues Anthony van Dyck and Jacob Jordaens, but of a great many other sixteenth- and early seventeenth-century northern masters as well, along with ancient and recent works of art from elsewhere in Europe now in Antwerp collections. He may also have been scouting the art market there, both the potential for getting portrait commissions from the city's citizens and the opportunities for expanding his own work as a dealer.

Although Rubens had been a member of the Antwerp Guild of Saint Luke since 1598, it was only after his return from Italy that he was able to set up and oversee a fully staffed studio. King Philip II's regents in the Spanish Netherlands made an exception to the usual

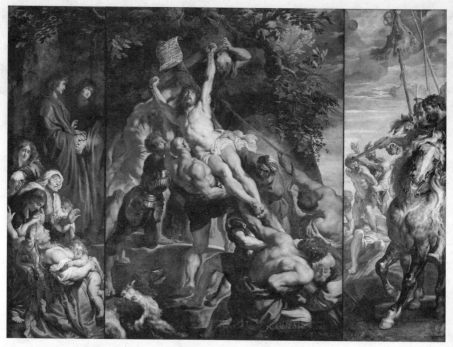

6. Peter Paul Rubens, *Elevation of the Cross*, 1611, Onze Lieve Vrouwekathedraal, Antwerp.

practice and allowed Rubens, now an official court painter, to maintain his workshop at home in Antwerp rather than relocate to Brussels. His atelier was attached to the townhouse that Rubens restored according to his own Italianate design on Vaartstraat (now Wapperstraat), fronting a canal in the center of the city (it is now the Rubenshuis museum). Here he and his apprentices and assistants worked on the lucrative royal and ecclesiastic commissions that arrived with great regularity, as well as on meeting the market's demand for print reproductions of his paintings.

Rubens, brilliant in so many genres, was, among other things, a Catholic painter par excellence. Among the early works coming out of his studio were a bold and vigorous *Elevation of the Cross*, completed in 1611 for Antwerp's Saint Walpurga Church (fig. 6),[21] followed by a triptych including, as its central panel, a moving and much more serene *Deposition from the Cross* (1614); both the *Elevation* and the *Deposition* are now hanging in the Onze Lieve Vrouwekathedral (Cathedral of Our Lady). Of course, Rubens was not merely

a painter of religious tableaux; but he brought to his art for the church the same rich palette, robust physiognomy, and drama that we find in his history paintings, mythological scenes, and portraits. His altarpieces are much more colorful and sensuous, and filled with greater pathos, than the more restrained, didactic panels of the early Counter-Reformation. Like all such art, they were meant to restore proper Catholic faith and strengthen church doctrine, in keeping with the Council of Trent's decrees about the didactic and inspirational role that art was to play in the campaign against the Protestant heresy. Whether Rubens's paintings, religious or otherwise, so chromatically luscious, vibrant, and emotionally moving, did indeed satisfy the council's demand that art keep to a simple, clear and pedagogical narrative, and that "figures shall not be painted or adorned with a beauty that excites lust" and "there be nothing seen that is disorderly or unbecoming or confusedly arranged, nothing profane or indecorous," is an open question.[22]

When Hals showed up at Rubens's studio in the late summer or early fall of 1616, he would have found a bustling, industrious scene, with the master and his many assistants attending to multiple works in progress. A Danish medical doctor named Otto Sperling was passing through Antwerp in 1621, and, as he says, "paid a visit to the very famous and eminent painter Rubens." He later described what he saw:

We found him at work and, while pursuing his labor, also reading Tacitus and dictating a letter. We kept quiet out of fear of disturbing him; but he, turning to speak to us, without interrupting his work and all the while pursuing his reading and continuing to dictate his letter, responded to our questions, as if to give us proof of his powerful faculties. He then ordered an assistant to lead us through his magnificent palace and to show us his antiquities, both Greek and Roman statues, that he possessed in considerable number. We also saw a vast room without windows but which let in the day through a large opening in the middle of the ceiling. In this room was found a good number of young painters, each occupied with a different work for which Rubens furnished a design in pencil, enhanced in

places with colors. The young men were to take these designs and execute them completely in painting, up until the point where, finally, Rubens put the finishing touch by some strokes of brush and colors.[23]

Around this time, Rubens was likely putting just those finishing touches on a number of canvases depicting confrontations between men and large cats, including the brutal *Tiger Hunt* and, at the other end of the spectrum, the exceedingly peaceful *Daniel in the Lions' Den*. Rubens would also have been at a relatively early stage of painting *The Death of Decius Mus*, showing the violent demise of the Roman general, and perhaps getting started on the *Drunken Silenus*, a panel that would later be copied by a number of other painters, including Van Dyck.[24]

Rubens's grand and majestic works often required numerous small-scale oil studies, including the anonymous head studies common in Netherlandish art and known as *tronies* (the term comes from a Dutch word for "face"). Hals would have seen examples of these, as well, by the hands of Van Dyck and Jordaens, both of whom studied under Rubens. Van Dyck, an Antwerp native, was still a young man, only seventeen years old, when Hals arrived in the city. While not yet a master—he would not join the guild for another two years—nonetheless, he was, after an apprenticeship with Hendrick van Balen and then joining Rubens's studio, already quite an accomplished painter.[25] Rubens called him "my best disciple,"[26] and Van Dyck would soon take over as the chief of the workshop. Later to become one of the century's greatest portraitists, Van Dyck, with the fluid painterly approach of coarse, visible brushstrokes that he was developing under Rubens (fig. 7),[27] clearly made an impression on Hals.[28]

Jordaens was also Antwerp born. At twenty-three around the time of Hals's visit, he was slightly older than Van Dyck and had just entered the guild. Despite being Jordaens's elder by at least ten years, Hals took away much from his study of Jordaens's bold, Rubenesque canvases, densely populated with fleshy, ruddy bodies that were finished with quick touches and strokes of the brush (fig. 8).[29] But what must have especially impressed him among Jordaens's works

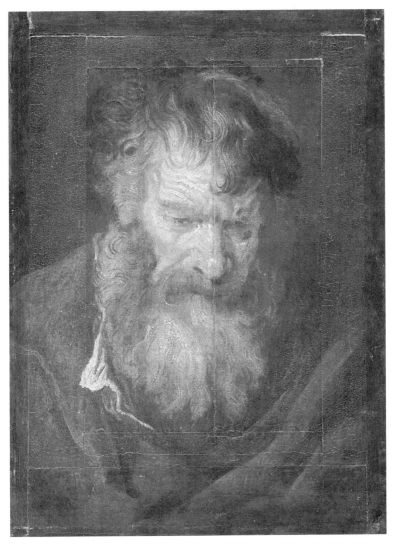

7. Anthony van Dyck, *Head of an Old Man* (study), ca. 1616–17, Musée du Louvre, Paris, France. Credit: © RMN-Grand Palais. Photo: Tony Querrec/Art Resource, New York.

were not so much the dramatic, large history paintings but the small, roughly painted head studies, typically done from live models.[30] Van Hoogstraten, writing many years later—in fact, the same year that Jordaens died—says that the painter, eschewing the careful and smooth application of paint, preferred "to mop lustily with a full brush."[31]

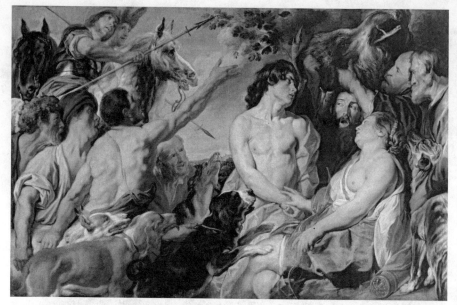

8. Jacob Jordaens, *Meleager and Atalanta*, 1618, Museo del Prado, Madrid, Spain. Credit: Erich Lessing/Art Resource, New York.

In addition to the histories and *tronies* coming out of Rubens's workshop and by Jordaens, Hals got a firsthand look at the many other genres in which Flemish painters excelled, some of which they even invented. Rubens's local circle of collaborators, who were just as famous in their time, included Jan Brueghel, a fellow court painter who lent a hand in depicting animals, landscapes, and still lifes in some of Rubens's canvases—he did the fauna in the collaborative work *The Garden of Eden and the Fall of Man* (ca. 1615); and Frans Snyders, who specialized in market scenes and animals—he painted the eagle pecking away at Prometheus's liver in Rubens's *Prometheus Bound* (ca. 1612). Hals must have paid visits to their studios as well.

He might also have seen some early or proto-*kunstkamer* pieces, a relatively new category practiced only in Antwerp and later beautifully refined by artists like Frans Francken the Younger, Jan Brueghel, and Guillam (Willem) van Haecht. These lavish interior scenes depicted grand halls filled floor to ceiling with paintings, sculptures, antiquities, and curiosities. Some of the items in the paintings, shown hanging on walls or sitting on easels or pedestals, were

imaginary, but many were real, including works by earlier Flemish masters such as Quentin Massys and Joachim Beuckelaer.[32] Perhaps Hals was even fortunate enough to gain access to one of these "art rooms," whether in the home of the Antwerp spice merchant Cornelis van der Geest (to which the Spanish king's regents Albert and Isabella paid a visit in the summer of 1615) or the domestic gallery of some other wealthy collector.

During his three months in Antwerp, then, Hals got a broad education in contemporary Flemish painting. But Hals's exposure to art on this visit was not limited to local traditions. He was able also to expand his familiarity with the Italian Renaissance beyond what he might already have known from prints and hearsay. On the walls of Rubens's studio and the home on the Vaaltstraat, he would have encountered pieces that Rubens collected during his years in Italy. Among other items, Rubens owned eight paintings (and, reportedly, two drawings) by Titian, as well as copies that he himself had made of works by the Venetian master.

From the perspective of Hals's professional development, the all-too-brief visit to the southern Netherlands—less than Soutman's eight years, shorter even than the year spent there by De Grebber and son—was an invaluable experience. He must have returned from Antwerp a changed man artistically. While Hals, like so many Haarlem artists, was familiar with Rubens's art well before his trip, his brushwork, his palette, and his sense of composition were all invigorated if not transformed by the great Flemish master and his disciples, collaborators, and colleagues.[33]

<p style="text-align:center">*</p>

Art may not have been the only thing on Hals's mind when he arrived in Antwerp in 1616. His half sister Maria—Franchois's daughter with his first wife, Elisabeth Baten—had remained in Antwerp after the rest of the family moved to Haarlem. She married her childhood friend Geeraert van Heemeren. When Maria died in 1614, Geeraert was left to care for their five children. There seems to have been another half sister (and daughter of Franchois and Elisabeth) named Barbara, who was older than Maria, and she, too, was now in

Antwerp, and may never have left.[34] And then there was a nephew, Franchois Jr., the son of Hals's half brother Carel. Franchois Jr. was born and raised in Amsterdam, but he was in Antwerp by 1614, at the age of sixteen, to marry a local girl.[35] Thus, perhaps there were family matters that motivated Hals to head to Flanders in the first place—either to visit sisters whom he might not have seen for many years, or to help Franchois Jr. and his wife in purchasing the house they bought that year, or to give his recently widowed brother-in-law Geeraert a hand with his young brood, or to handle some residual business of his late father.[36] (Does the fact that Hals's half sisters Maria and Barbara, as well as other relations, were still in Antwerp mean that the Hals family, or at least a subset of it, were Catholics? It is unlikely that Protestants would have—or even could have—stayed so long in this staunchly Catholic domain. Moreover, although Franchois Jr. and his twin sister, Lysbeth, had been baptized in the Dutch Reformed faith in Amsterdam's Oude Kerk [Old Church], the son of Franchois Jr. and his wife, Janneke Hendrickxdr Faes, Pieter, was baptized in the Saint Andries Kerk, one of Antwerp's Catholic parish churches.)

The brief journey to Antwerp was, as far as we know, the only time Hals left Holland. Unlike so many of his contemporaries in the Netherlands (north and south) seeking to broaden their artistic horizons, Hals had no urge to see much of the world or view its art in person. As we have seen, he never went to Italy. Neither did he go to Paris. Or London. Or Madrid. This kind of travel had not only aesthetic benefits but also invaluable economic ones, as a young painter could impress wealthy and influential patrons abroad and, hopefully, expand his clientele.

Rubens, of course, had an extensive international network and was often away from home for long periods, whether in Paris, Madrid, or London. Van Dyck, too, made the obligatory pilgrimages. Following a brief spell in London when he was in his early twenties, Van Dyck spent six years in Italy; and after five years back in Antwerp, he was off to London again and the court of King Charles I, where he would spend the rest of his life. The *Caravaggisti* of Utrecht—Van Honthorst, Hendrick ter Brugghen, and Dirck van Baburen, who

earned their nickname because their works resembled the chiaroscuro manner of Caravaggio and his followers—were just a few of the Dutch artists who trained in the "Italian manner" on location, in Rome, Milan, Genoa, and Florence. Abraham Bloemaert, another member of that circle, did not go to Italy, but he studied for several years in France. He was older than Van Honthorst and the others, and after a residency in Amsterdam he finally set up shop in Utrecht in 1593, where he would train many of that city's next generation of painters.

Once he departed Antwerp in November 1616, however, Hals never again crossed the borders of the Republic. He was in good company. As far as we know, Rembrandt never left Holland, not even to go to Antwerp, despite his obvious fascination, even obsession, with the work of Rubens.[37] The two greatest Dutch painters of the first half of the seventeenth century were homebodies.

<p style="text-align:center">*</p>

Back in Haarlem, things were not going well in the Hals household. Soon after Frans's departure for Antwerp, the responsibilities of Neeltje, the hired nursemaid, were sadly diminished by half. In early September 1616, a grave digger was paid a fee for "a hole for the child of Frans Hals."[38] We have no name or baptism record for this child; as a son or daughter of Anneke's, he or she had to be at least seventeen months old at the time, but certainly younger than Harmen, who was now five.

Hals was still out of town when his child died. How and when did he hear the news? Did he return for the burial? Despite the relative ease of travel between Antwerp and Haarlem, there is no evidence that he came back; and even if he did return, it would have been only a quick layover, as he was soon in Antwerp again, where he would stay until mid-November.

Meanwhile, Neeltje was complaining that Hals was in arrears in his payments to her. Several times that fall, Neeltje or her husband went to court to recoup her expenses. On October 14, according to the legal record, she claimed before the Court of Petty Sessions that he owed her "five guilders on account of calculated costs."[39] On November 8, she protested before the same magistrates that Hals owed

her thirty-seven guilders and four stuivers, as the outstanding balance of an annual allowance that he had agreed to supply her "for caring for his child," Harmen, plus expenses. Three days later, Hals, who was still in Antwerp, was represented in court by his mother, Adriana. She "acknowledged the debt" of *thirty* guilders and promised that payment in that amount would be made within a day or two, whereupon the magistrates ordered Hals to pay the thirty guilders. As for the remaining seven guilders and four stuivers, they told Neeltje that if she wanted to recover that as well, she had to provide "further proof." The magistrates then sent a clerk to the Nieuwe Doelen headquarters to collect thirty-seven guilders and four stuivers from funds the militia still owed to Hals, presumably for his portrait of its officers earlier that year. The court then directly handed at least some of the money over to Neeltje.[40]

Hals was home in Haarlem by November 15 at the latest, because on that day he was present in court himself, along with Neeltje, as they worked out their differences, the record says, "once and for all." At issue were the seven guilders and four stuivers that Neeltje had demanded but Adriana had subtracted from the amount for which she had taken responsibility. Hals and Neeltje split the difference and agreed that he would pay her three guilders and twelve stuivers, along with her expenses. A clerk was once again sent to the Nieuwe Doelen, where he collected another sixteen guilders from the militia's provost and treasurer, Johan van Napels (whom Hals had painted in the 1616 officers' portrait), from which Neeltje was paid the agreed three and twelve. Ultimately, Neeltje ended up receiving from Hals forty guilders and sixteen stuivers, probably to cover (beyond the fees he owed her) any costs she may have incurred both for caring for Harmen and for pursuing the legal case.

Hals's debts to Neeltje Leenders were not his only financial worries that year. In early August, probably just after his departure from Haarlem for Antwerp, he was sued by Pieter Ruychaver, representing the estate of Jan Fransz van Backum in bankruptcy proceedings. Many of the overdue bills that plagued Hals throughout his life stemmed from his work as an art dealer, a side occupation in which quite a few painters of the time, seeking to supplement their income,

engaged. In this case, Hals owed four guilders and fifteen stuivers for a painting he had purchased from Van Backum's estate to add to his stock. Although the suit was suspended when the court messenger reported that "the complainee [Hals] is resident in Antwerp," this was only the beginning of Hals's endless problems with creditors.[41]

*

Carleton, the English ambassador, took advantage of his time in the Dutch Republic to see the land and visit its major cities. Writing from The Hague in October 1616 to his friend John Chamberlain, he notes that "I am now againe returned from a pettie progresse having taken the opportunitie of his Ex^cies [Excellency's] absence and a Vacation of affaires to visit Harlem, Amsterdam, Utrecht, and Leyden." He was especially impressed by Haarlem. "I fownd at Harlem a whole towne so nete and clenlie, and all things so regular and in that goode order, as yf it had ben all but one house." As a collector and connoisseur (or at least speculator), and sometime art agent for high-placed patrons, Carleton's choice of cities was, presumably, informed by a desire to see, and perhaps purchase, what was coming out of the provinces' studios.[42] Again, Haarlem did not disappoint. "The painters were the chiefest curiositie; whereof there is one Cornelius for figures, who doth excelle in colouring, but erres in proportions." In addition to Cornelis Cornelisz, Carleton singles out Hendrick Vroom, another Haarlem artist who "hath a great name for representing of Ships and all things belonging to the sea." By contrast, Amsterdam, he notes, is better at collecting art than producing it. "I saw many goode pieces but few goode painters; that place being in this commoditie as in others, the ware-house rather then the worke-house."[43]

Carleton does not mention Hals in his letter. But then again, Hals was not yet in the same league as Cornelis and Vroom, who were well-established masters. Moreover, the older artists were making large "history" paintings, which would naturally have been of greater interest than portraits to a collector/agent like Carleton and his clients. Did Carleton at least get to see any of Hals's paintings? Perhaps only if he dropped by the Nieuwe Doelen and saw the brand-

new portrait of the Saint George officers (if it was already hanging there). He certainly did not get to meet Hals or visit his studio, as the painter was in Antwerp at the time of the diplomat's visit.

Still, despite the snub from Carleton, not to mention his own personal and financial woes, 1616 was a momentous year for Hals's art. The all-important visit to Antwerp in the late summer and early fall was one thing. But even before he took that trip, Hals, really for the first time, started to show his true stuff, and he did so in just the sorts of paintings in which he would make his mark. This was, in effect, the year of his debut, a stylistic coming out.

There was the Saint George civic guard portrait, where Hals took a bold and original approach to an old model. But this was also the year in which he completed what may be his earliest genre painting—one of those *moderne beelden* depicting anonymous figures engaged in an everyday activity that would become a highly popular (and affordable) category of Dutch art in the seventeenth century, and a specialty in which Hals's brother Dirck excelled.[44] The canvas now known as *Shrovetide Revellers* (plate 2) is a life-size rendering of five men and one woman celebrating Shrove Tuesday (Mardi Gras), the end of the carnival period before Lent.[45] It is a raucous, tightly packed group of ruddy-faced partyers in high spirit and costume enjoying beer, bread, and sausages. Two of the individuals are stock characters from Dutch folklore and theater. On the right side of the painting is Hans Worst, identified by the sausage hanging from his red cap; he is making a lewd gesture to the seated woman, as are the two characters in the background. To the left, and looking directly at us, is a red-faced fellow named "Peeckelhaering" (Pickleherring). He wears a strand of herring, sausages, beans, mussels, eggs, and a pig's foot around his neck and holds in his hand a foxtail, symbol of folly. On the table in front of them are various sexually suggestive items: limp sausages, a capped beer stein with its round opening exposed, and a flaccid bagpipe.

The fine, intricate details of the woman's dress and broad lace collar stand in contrast to the individual, unblended strokes of white that render the highlighted folds on her sleeves, to the simple swirls of paint (wet-in-wet) that make up the ends of Peeckelhaering's col-

lar, and to the long sweeps of gray and brown (again, blended wet-in-wet) of Hans Worst's arm that rests on the back of her chair. The loaf of bread, meanwhile, is constructed from irregular patches of color. This is an early appearance of what will become Hals's characteristic style—undisguised brushstrokes that, up close, seem so quick and effortless, even haphazard, but that from a suitable distance reveal the countenance or clothing represented.[46] At the same time, the *Shrovetide Revellers* has a very southern Netherlandish character. It is the kind of jolly company scene that Flemish artists had been painting and that was now popular in Haarlem. With its bold coloring, vivacious characters and postures, tight composition, and depiction of sensuous indulgence, it is a very Rubenesque—or, better, Jordaenesque—work, likely reflecting what Hals saw in the studios he visited in Antwerp.[47]

The same painterly approach, with a deceptive appearance of ease and swiftness concealing the great skill required to pull it off, is visible in elements of Hals's first extant solo portrait that we know for certain is by his hand. Painted on a wood panel, his picture of Pieter Cornelisz van der Morsch (1543–1628) shows an elderly man—the Latin text on the panel indicates that he is seventy-three years old—holding a fish with one hand and, with the other hand, a bundle of straw with a few more fish lying in it (fig. 9).[48] He is a sly-looking fellow, with a squint in his eye and subtle smile on his face. Parts of the painting are done in a loose, sketchy manner. This is noticeable in the hands, built up from patches and spots of unblended colors, and especially the individual stalks of straw, highlighted by thin, quick swipes of golden paint. Likewise, the sheen on the fish, a smoked herring, is done in visible daubs, while the edges of Van der Morsch's ruff and the cuffs of his shirt are nothing but curvy strokes of white.

Beside Van der Morsch's face is another text, this one in Dutch: *WIE BEGEERT*, which means "Who desires?" Van der Morsch was not a fishmonger, however, and what he is offering is not so much the herring as what it represents.[49]

A prominent citizen of Leiden who served several terms as city bailiff—his position was called De Bode metter Roede (The Beadle with the Rod)[50]—Van der Morsch was also a leading light of one of

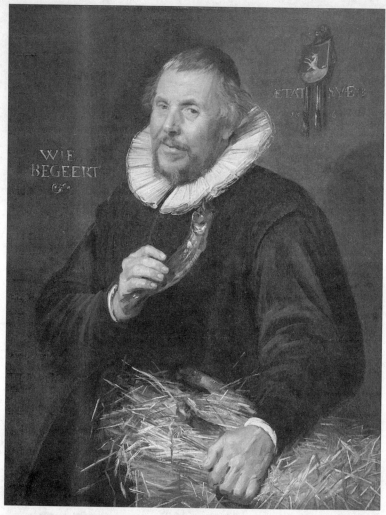

9. Frans Hals, portrait of Pieter Cornelisz van der Morsch, 1616, Carnegie Museum of Art, Pittsburgh. Acquired through the generosity of Mrs. Alan M. Scaife.

the city's *rederijckerkamers*, or Chambers of Rhetoricians. These were amateur literary and dramatic societies, popular among the middle class in many Dutch and Flemish cities. Their members wrote poetry, gave readings, and put on plays. Originally—like most guilds in the sixteenth century—they functioned as religious confraternities, but by the seventeenth century they served primarily for culture and entertainment . . . and for drinking. It was common to name *rederijcker* groups after flowers or floral themes. Amsterdam's companies

included "De Egelantier" (The Sweetbriar) and "De Wit Lavendel" (The White Lavender), and Gouda had "De Goudsbloem" (The Gold Flower). The town of 's-Hertogenbosch had no fewer than six such clubs, including "De Passiebloem" (The Passion Flower) and "De Jonge Lauwerieren" (The Young Laurels). In Haarlem, the leading *rederijckerkamer* was "Trou Moet Blycken" (Loyalty Must Show Itself), founded sometime before 1503. There was also "De Wijngaertrancken" (The Vineyard Tendrils), whose motto was *Liefd' boven al* (Love above all), and it referred to its members as "good simple burghers and craftsmen."[51]

The Chamber of Rhetoricians in Leiden to which Van der Morsch belonged was called "De Witte Accoleijen" (The White Columbines). He was well known for playing the role of the fool "Piero," a legendary comic character with a biting wit who was quick to set people straight with a shaming or rebuking remark. (In the guise of Piero, Van der Morsch was also the author of a book of moralizing verses.) As for the picture's motto and the fish, there was an early modern Dutch saying *iemand een bokking geven* (to give someone a herring), which meant to ridicule them, typically in a constructive, well-intentioned way: making fun of their faults and shortcomings so that they might correct them. An eighteenth-century watercolor copy of Hals's painting by the Haarlem artist Vincent Jansz van der Vinne identifies the subject as "Piero." And yet, it is Van der Morsch himself, rather than his theatrical alias, who, with the herring and his query "Who wants one?" reminds us that silliness and folly, and the need for corrective rebuke, are recurring motifs in life, and in art.

Van der Morsch was active in Holland's *sottenfeesten*, or Festivals of Fools. In 1596, he organized a five-day gathering in which all the "jesters" of the province's rhetorician chambers took part. In 1606, and then again in 1613, he—or, rather, "Piero"—was in Haarlem for similar events.[52] It may have been at some such occasion in 1616 that, on either Van der Morsch's initiative or Hals's, the two men agreed on a portrait. Hals was himself part of the *rederijker* network, having just joined Haarlem's "De Wijngaertrancken," but only as *beminnaer*, "friend," not as an active member. We have no record as to what contributions, if any, he made to the group's entertainment or

productions, and perhaps he was only an auditor at their meetings. These kinds of memberships traditionally ran in families, and so it is no surprise that Hals's brother Dirck would join the same Haarlem group two years later.[53]

The portrait ended up hanging in Van der Morsch's house, where visitors could admire it and be reminded of their host's fame as theatrical dispenser of wit and literary author of sage counsel.

*

When Hals returned to Haarlem from Antwerp in late November 1616, it must have been a lonely and somber time at home. It was now just Frans and Harmen, all by themselves. In light of Hals's burgeoning financial difficulties and their extended legal dispute, Neeltje was probably not around to help care for the young boy. Fortunately, this situation would soon be remedied—with a new wife for Frans and a stepmother for Harmen. The young boy, no doubt already taking art lessons from his father, would soon have many half siblings around with whom to play (or be annoyed).

CHAPTER 5

In a Rough Manner

On Pieter Wils's 1646 map of Haarlem, published by the famed Dutch cartographer Joan Blaeu, the bulk of the city sits on the west side of an S-curve in the Spaarne River as it meanders toward the IJ Bay (fig. 10).[1] Sluices on both ends of the river's path through Haarlem allow boats and barges—perhaps coming from Amsterdam to the east—to enter the urban district and its network of canals. Five bridges connect the main part of the city with the neighborhoods on the east side of the river.

In the center of the map, and dominating its surroundings as always, sits the imposing structure of the Saint Bavo Church/"Great Church," with its market square. Two blocks away, just off one of the main streets radiating outward from the church and around the corner from an ox market, is a short cross street, really more of an alleyway, called Peuzelaarsteeg, "Eaters Lane." (Was the street originally home to cafés and food shops?) This is where Hals and Anneke had made their first home, and where Hals and his son Harmen were still living when, on February 12, 1617, the master painter married a young woman living on the other side of the church plaza, on Smeestraat (today called Smedestraat), "Forge Street," likely the location of the city's blacksmiths.

Lysbeth Reyniersdr was baptized on January 31, 1593. She was the older of the two daughters of Reynier Jansz and Anna Thonisdr. The marriage between the thirty-four-year-old Hals and his twenty-four-year-old neighbor took place not in Haarlem itself but in Spaarndam.[2] This nearby village, at the mouth (and dam) of the Spaarne, may be where Lysbeth's parents were living. In the marriage banns,

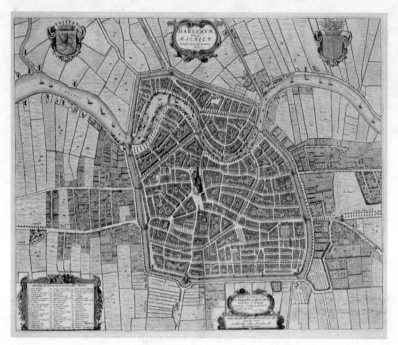

10. Pieter Wils, map of Haarlem, 1646, Collection Het Scheepvaartmuseum, Amsterdam.

published a month earlier, Hals continues to be referred to as "from Antwerp."[3] The couple obviously knew each other quite well by the time of their nuptials, for nine days after the wedding a daughter, Sara, was born. Slightly more than a year later, she would be joined by a brother, Frans Jr. Sara and Frans would be only the first two of twelve children. The witnesses at Sara's baptism were Hals's brother Dirck and Lysbeth's father, Reynier, and her younger sister Hillegond. Hillegond was also present at Frans Jr.'s baptism, as was Lysbeth's brother Gerrit.

Within the space of sixteen months, then, things quickly grew less lonely for the elder Frans and Harmen in the house on Peuzelaarsteeg. Fortunately, just as Hals found himself with an expanding family to support, he began attracting notice from leading locals who wanted their portraits painted.

Theodorus Schrevelius (Dirck Schrevel, 1572–1649) was a humanist scholar and headmaster of Haarlem's gymnasium, or Latin School, a grammar school with a focus on classical subjects. (He

was also the author of the laudatory Latin poem that accompanies Jan van de Velde II's engraving after Hals's lost early portrait of Johannes Bogaert.) In 1617, Schrevelius and his wife, Maria van Teylingen, sat in Hals's studio for companion portraits, called "pendants." Maria's portrait is lost, but the small (15.5 × 12 cm) oval painting of Theodorus, done on a copper plate—it would serve as the model for an engraving by Jacob Matham—is a bust-length image of the red-haired schoolmaster as he holds up a book, the cover of which tells us the sitter's age (forty-four) at the time (fig. 11).[4] Even more than the portrait of Van der Morsch, the Schrevelius picture, especially the millstone collar, shows Hals's launching his effectively sketchy technique in handling paint, with visible strokes and dabs of unblended colors.[5]

Schrevelius was pleased with the portrait, possibly Hals's smallest work, and took to showing it off to visitors. A few years after he sat for Hals, when he was serving as rector of the Latin School in Leiden, Schrevelius brought his picture out for a guest from Utrecht, Aernout van Buchel (also known by his Latinized name, Buchelius). Van Buchel (1565–1641), too, was a learned humanist, with a particular interest in Roman antiquity. Originally a Catholic, he converted to the Reformed faith around 1595. He also had a gift for drawing, and one of his projects was to preserve, through his sketches, works of art and architecture that had been threatened with destruction by Reformed iconoclasts. Writing in 1628, while paying a visit to Leiden, Van Buchel dropped by the Latin School, where, he says, "Rector Screvelius showed [me] his effigy by Hals, Haarlem painter, vividly [*vivide*] depicted on a small plate."[6]

Many years later, shortly before his death, Schrevelius was to compose (in Latin, followed a year later by a Dutch translation)[7] a long encomium to his hometown, to which he had returned in 1642. He gave his work the title *Harlemias*, and he devotes a good part of the sixth book to Haarlem's achievements in art, especially painting. The city has long been home to "so many excellent painters," he notes, and it belongs in history's pantheon of great artistic centers. "Just as Sikyonia was renowned among the Greeks and Florence among the Italians for their painters and artists, so, too, Haarlem, an old city in

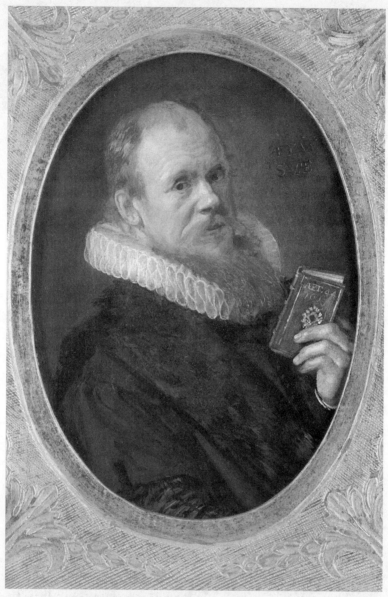

11. Frans Hals, portrait of Theodorus Schrevelius, 1617, Frans Hals Museum, Haarlem. Purchased with the support of the Rembrandt Society, Mondriaan Fund, the VSB Fund, and the Friends of the Frans Hals Museum. Photo: Margareta Svensson.

the Netherlands, has become famous for oil paintings of all sorts."[8] After a review of the great Haarlem masters of the fifteenth and six-teenth centuries—including Geertgen tot Sint Jans, Jan van Scorel, Maerten van Heemskerck, and, of course, the "academy" trio of Hendrick Goltzius, Cornelis Cornelisz, and Karel van Mander—Schrevelius turns to those artists "of our own century" who

> are also distinguished according to the subjects with which they deal. Because some paint all pictures; others paint ships driven on the sea, with the foaming water all around; others, again, paint land-scapes; others, the circles of heaven, beside the firmament where the stars stand; others paint woods and shrubs; others, pleasure gardens, stems and plants, animals in the woods and birds in the trees. Various painters depict walkers in the land, going from one village to an-other, with donkeys and carts; some go fishing or catching birds, or hunt animals, and others who work in the vineyard. Moreover, there are some artists who paint banquets, fruits or flowers. Finally, there are also those who paint glasses, embellished with color.[9]

Among the contemporary painters and printmakers mentioned by Schrevelius are Frans de Grebber and Johannes Verspronck, also a Catholic and the son of Cornelis Engelsz (Versprongh), who had trained him well in the art of portraiture. De Grebber and Verspronck are both singled out for their skill in *Conterfeiten na 't leeven*, portraits done from life.

Schrevelius also cites De Grebber's son Pieter, Hendrik Pot, Pieter Soutman, Philips Wouwerman, Hendrick Vroom, and many others. Early in the survey, however, he makes sure to take special note of two brothers.

> I cannot also let pass in silence Frans and Dirck Hals, brothers, one of whom, through an uncommon manner of painting, which is his very own, excels almost everyone; because there is in his art of paint-ing such a force and life that he seems to defy Nature with his brush. This applies to all of his portraits that he has made, unbelievably many, which are so colored that they seem to breathe and to live.

There are still various pieces in the Oude Schutters Doele [the head-quarters of the Saint Hadrian guard] in which he has painted, from life, colonels, captains, provosts, ensigns and sergeants, in full weaponry. Moreover, in another scene he shows militia brothers sitting at a table, drinking to each other's health. The other Hals [Dirck] is also a good neck [*hals*] who is very artful and pure in making small pieces and images. He, too, shows off his art in this.[10]

Schrevelius was impressed both by Frans Hals's painterly skills and, no less, by his productivity. He would have hung the portraits of himself and his wife next to each other—the man on the left, facing slightly toward his wife to his left, as was traditional for paired portraits of couples—in a conspicuous place in their home. The two pictures were joined in 1625 by a crowded family piece by a young Pieter de Grebber, showing Schrevelius, his wife, and their five daughters around the dinner table and watched over by a servant and, representing deceased children, two angels.[11]

The portrait of Schrevelius, done one year after the job for the Saint George officers, is the first extant painting certainly by Hals of a prominent, individual Haarlemmer.[12] At the age of thirty-four, this might seem a late blooming for someone aspiring to be portraitist to the city's elite. One of Rembrandt's first commissioned portraits, of the Amsterdam fur merchant Nicolaes Ruts, was done in 1631, shortly before the artist's permanent move from Leiden to Amsterdam, when he was twenty-five. But Rembrandt at the time of this commission was already in a financial relationship with Hendrick Uylenburgh, a well-established art dealer and agent in Amsterdam. He thus, in addition to his incredible talent, also benefited early on from connections with the right network. Hals, on the other hand, did not have an Uylenburgh to help launch his career.

*

With his marriage to Lysbeth Reyniersdr and the birth of a daughter, Hals in early 1617 may have found domestic happiness, or at least some relief. Meanwhile, the United Provinces were still enjoying a respite from decades of war. The 1609 truce with Spain, while not

ending the long battle for independence—real sovereignty would not come until 1648, with the Treaty of Münster, one of several agreements closing the Thirty Years Wars—had at least brought an extended pause in the conflict.

The truce was a significant moment in Dutch history. The small Republic, really just a coalition of provinces united, if not entirely by religion, then by language and their distaste for the rule of Spanish monarchs, had mustered sufficiently impressive military prowess to fight a European superpower to a standstill. The Dutch, aided by mercenaries, showed themselves a force to be reckoned with. Just as important, the truce gave the Dutch economy some breathing room, not least by allowing Holland and other provinces to redirect resources from defense to commerce. The truce also marks, and essentially allowed for, the beginning of the intellectual and artistic flourishing that distinguishes this period of Dutch culture.

The armistice would last until 1621. Peace on the international front, though, may have allowed for the unleashing of trouble on the domestic scene. In the 1610s, a controversy raged within the Dutch Reformed Church, one that would quickly bleed into the political sphere and have a tremendous effect on practically all aspects of life in the Republic. The upshot was the first of the periodic political upheavals and reversals that occur in early modern Dutch history—the Dutch call them *wetsverzettingen* (loosely translated as "overturnings of law")—and that bring a radical redistribution of power among the various political and religious camps. While the turmoil was disastrous for many people, and even deadly for some, it actually brought new opportunities for Hals and his art.

In January 1610, a group of forty-four ministers, all followers of Jacobus Arminius, a theology professor at the University of Leiden and a cleric in the Dutch Reformed Church, met in The Hague and issued a "remonstrance," or petition, in which they set forth their unorthodox views on sensitive theological questions. These Arminians, or "Remonstrants," rejected the strict Calvinist doctrines of grace and predestination. They believed that people had the capacity to contribute, through voluntary action, to their own salvation; and they denied that divine grace was irresistible, incapable of be-

ing refused or misused by an exercise of free will. Remonstrants also favored a separation between matters of faith and conscience and matters of civil government. They worried about the political ambitions of their more orthodox opponents in the church, who sought control not only over the appointment of preachers in the pulpits and professors in the theology faculties but over the membership of city councils. Like many religious reformers, the Remonstrants saw their crusade in moral terms. In their eyes, the true spirit of the Reformation had been lost by the increasingly dogmatic, hierarchical, ambitious, and intolerant leaders of the Reformed Church.[13]

Anticipating the impending reaction, the drafters of the petition also asked the States of Holland for protection. The Remonstrants had on their side Johan van Oldenbarnevelt, the *landsadvocaat* (advocate; later called the *raadpensionaris*, grand pensionary) of the States of Holland, the province's political leader. Because of the disproportionate power of Holland, its advocate was essentially the most important office in the Republic after the stadholder. With Van Oldenbarnevelt's intervention, what was initially a theological dispute within the Reformed Church and the universities quickly took on a political dimension, and not just in his province. The liberal regent elites in many (but not all) places tended to favor the Remonstrant cause, if only because it represented a limit on the political influence of the more fundamentalist and censorious Counter-Remonstrant faction. Cities became divided both within their communities and among themselves. While Leiden, Utrecht, and Rotterdam favored the Remonstrants, Amsterdam, Dordrecht, and other leading towns were staunchly Counter-Remonstrant.

The States of Holland, urged on by Van Oldenbarnevelt and the great Dutch jurist Hugo Grotius, who were now seeking to calm things down a bit, ended up giving some aid and comfort to the reformers. Among the most important of the States' directives, at least for the Remonstrants, concerned the toleration of differences of religious views—not to the extent of allowing complete freedom of belief and expression on the most essential of Christian doctrines, but enough room for public debate on various questions so that some dissent

would be allowed within the church, with the States deciding what doctrinal topics were and were not off-limits.[14]

Predictably, this ecumenical effort served only to solidify opposition to the Remonstrant movement, particularly among ecclesiastics who resented any kind of state interference in church business. The orthodox Counter-Remonstrant theologians—called "Gomarists" after one of their leaders, the Leiden professor and Middelburg preacher Franciscus Gomarus—accused the Arminians of "papism," or following the Roman Catholic confessional line, an accusation that the Remonstrants threw right back at them.[15] Van Oldenbarnevelt's political enemies, for their part—and there were many—saw his support for the Remonstrants and their politically liberal allies as an opportunity to label him a traitor who was working on behalf of Spain, the Catholic enemy.

Over time, the Remonstrant/Counter-Remonstrant battle over theology became intertwined with opposing views not only on church/state relations but also on ordinary domestic matters. Counter-Remonstrants, for example, insisted that Sundays were for attending religious services, not ice-skating parties on the frozen rivers. The controversy even had ramifications for foreign policy, especially how to conduct the war with Spain and whether to respond to the recent Protestant uprisings in Catholic France. It may be surprising that the Republic's most important, economically vibrant, and cosmopolitan city, Amsterdam, was, at least initially, a stronghold of Counter-Remonstrant activity. In fact, the regents there, as elsewhere, chose to side with the local orthodox ministers not so much out of sympathy for their religious and social principles as from political expediency. They simply wanted the influence of these religious conservatives working for their team.

In those cities where Counter-Remonstrants had the advantage, Remonstrants became second-class citizens. They were stripped of their offices and perquisites and often faced violent persecution, with some thrown into prison. By 1617, the stadholder himself, Prince Maurits of Nassau, entered the fray on the Counter-Remonstrant side. This was primarily a political move by the prince, part of his

opposition to Van Oldenbarnevelt's policies of seeking peace with Spain and staying out of French affairs.

The Synod of Dort (Dordrecht), a plenary meeting of ministers of the Dutch Reformed Church from all the provinces and abroad, was convened from November of 1618 to May of 1619 to figure out how to deal with this divisive issue. Here, too, the Counter-Remonstrants got their way, as the synod ultimately resolved to expel the Remonstrants from the church. The representatives to the synod reiterated their commitment to freedom of conscience, at least in principle, but nonetheless insisted that public worship and office-holding should be restricted to orthodox Calvinists. There was a purge of the clerical class at all levels. This was paralleled by the replacement of Remonstrants and their sympathizers in municipal and provincial civic bodies across the Republic. Meanwhile, Van Oldenbarnevelt's opponents, who saw themselves on the side of piety and virtue, took advantage of the situation to put an end to his career, and to his life. Holland's advocate was convicted of treason, imprisoned, and, finally, beheaded; his political allies, including Grotius, fled the country. Prince Maurits and his men, with ecclesiastic support, were finally in control of the Republic. The exclusion and harassment of Remonstrants would continue for a number of years. But the schism within the Dutch Reformed Church, far from being settled by the Synod of Dort, would affect Dutch religion, politics, and intellectual life throughout the rest of the century.[16]

*

During the first few years of the Remonstrant/Counter-Remonstrant tempest, Haarlem remained relatively quiet. The city appears to have been spared the harsh religious divisiveness that roiled other places. If the local ministers of the Reformed Church and members of the community disagreed over doctrine, it did not greatly disturb the peace. The Haarlem Reformed clergy remained fairly tolerant of nonorthodox Calvinists, as well as of other Protestant sects (Mennonites and Lutherans) and even Catholics. They did chafe, though, under the hand of Haarlem's civic authorities, who sought some measure of control over church affairs, including the ordination

and appointment of ministers.[17] The clergy saw this push for secular oversight on internal sectarian issues as driven by Van Oldenbarnevelt's policies on church governance, and rightly so. The Haarlem city council was dominated by a pro-Van Oldenbarnevelt faction, and this only exacerbated church-city tensions over questions of autonomy and prerogative. Still, as Schrevelius, reviewing this period of the city's history in his *Harlemias*, notes, things were heading toward a peaceful accommodation. "If now all restlessness and disturbance were quitted, and all partisanship, hatred and envy put to one side, those who sought peace and rest had everything to hope for from the church and from the political class and government." However, he ominously continues, "the joy was short-lived."

> For when the old differences and bitterness were again brought up, the minds of some were very upset and bitter, and their pettiness and disagreement was turned into rashness. From this arose complaints from the political magistrate, issuing defenses and writings on their responsibilities, and again complaints from the church, which appealed to the High Powers of the Court [Holland's provincial high court]; in sum, never was there so much evil to be lamented.[18]

In early 1618, Haarlem's pensionary Johan de Haen delivered to the States of Holland in The Hague a protest against the expulsion of Remonstrants from civic offices and other measures that were taking place in various cities. He and his colleagues on the city council regarded this intrusion of the theological division within the Reformed Church into urban politics, and especially the repressive actions taken by the orthodox Calvinists' political allies—including the stadholder—as an infringement upon secular municipal and provincial sovereignty. It was also, they insisted, a violation of the founding principles of the Union of Utrecht, article 13 of which states that "each person shall remain free in his religion and no one shall be investigated or persecuted because of his religion."

Haarlem's defiance of the Counter-Remonstrant crusade was not well received by higher authorities. By the late summer of 1619, after the removal of Van Oldenbarnevelt, Maurits and his armed forces were

marching toward the city. The Haarlem regents saw that any further resistance was futile.[19] In October, the stadholder, claiming to be acting "for the welfare of this land," purged the city council of Van Oldenbarnevelt's partisans and installed a new, more compliant leadership, one that would better toe the conservative party line.[20] Not every member of the council was removed—only those who would not swear allegiance to Maurits. Johan van Napels, for one, who was the provost among the Saint George civic guard officers painted by Hals in 1616, survived the city overhaul and would even serve as a burgomaster two years later. The stadholder must have been convinced that he was of the right religious and political persuasion. Haarlem was now a Counter-Remonstrant city beholden to the conservative Orangist party.

*

This major religious crisis in early modern Dutch history, reaching deep into the Republic's political and social life, touched Hals's family and his clientele in various ways, for better and for worse. Schrevelius, just one year after having Hals paint his portrait, was caught up in the purge and removed from his post as rector of the Haarlem Latin School in 1620; like many others on the wrong side of the dispute—including the pensionary De Haen—he and his wife left the city. He was lucky enough to land on his feet in Leiden. (Interestingly, in his *Harlemias* account of these years, Schrevelius does not mention his own fall from grace and gives a rather dispassionate, even laudatory report on the stadholder's actions in Haarlem. Maurits, he says, brought "everything to good order and peace, to the highest delight to faithful patriots and religious-minded men.")[21]

Another person who suffered a stunning reversal of fortune during the *wetsverzetting* of 1618–19 was Job Gijblant, the uncle and guardian of Hals's first wife, Anneke, and the painter's fellow Saint George guardsman. After a long term on the city council, from 1604 to 1617, including several turns as a *schepen*, three one-year terms as one of the city's four church wardens, and several terms as a regent of the Oudemannenhuis (Old Men's Alms House), Job was permanently removed from all city leadership positions. Even if he wanted

to be of help to Hals in his career—and there is no reason to think that he did—whatever leverage he might have once had was gone.

At the same time, the stadholder's reshuffling of Haarlem's ruling caste resulted in the appointment of a new cadre of rich families at the top of the political and social hierarchy—proud families who had bona fide Counter-Remonstrant credentials and who, in keeping with their enhanced status and membership on civic bodies, absolutely needed to have their portraits painted.

Many of the now ascendant clans had made their fortunes in that industry in which, as we have seen, Haarlem had long excelled all other Dutch cities: beer. The older, more established brewery clans tended to be Catholic, and so by the late sixteenth century—after the departure of the Spanish forces and the "alteration" of Haarlem into a Protestant city (albeit one with a significant Catholic population)—they were barred from holding public office, which was reserved for members of the Reformed Church. Any continued social leadership and political influence the Catholic brewers may have had was thus a matter of respect and tradition, along with wealth, rather than formal authority, which had since passed to brewers and other businessmen with at least nominal Reformed credentials.

Things changed yet again in the wake of the Remonstrant controversy. Now it was the stadholder's brewers, ostensibly more orthodox Calvinists than those they replaced, who dominated the city council, occupying twenty-one of the thirty-two seats.[22] Among the men appointed to the *vroedschap* by Prince Maurits were Cornelis Guldewagen, owner of the brewery "The Gilded Heart" (named after its owner—*gulde* means "gilded"); Dirk Dirksz Dikx, proprietor of "The Small Ship"; and Johan Herculesz Schatter, of the "The Crowned Diamond" (a *schatter* is an appraiser).

For Hals, the most significant member of the new city leadership—a man who would go on to serve five terms as *burgemeester* and an equal number of stints as alderman[23]—was Pieter Jacobsz Olycan (1572–1658), one of seven brothers originally from Amsterdam and now patriarch of a large Haarlem family. After making his fortune as a grain merchant, Olycan, once settled in a large home in the city, broadened his business interests and became the owner

of three breweries, all sitting right next to each other on the Spaarne. He and his wife, Maritge Claesdr Vooght, herself from a prominent brewer family, had fifteen children, and through their offspring's marriages the family circle (and its influence) would extend broadly within Haarlem's ruling class, and beyond. Already in 1616 two of the Olycan children had married into the brewer families of other, newly appointed council members; one daughter was married to Johan Schatter, and a son was married to the daughter of Dirk Dikx and would soon buy his father-in-law's brewery. Also among the burgomasters appointed in 1618 was Maritge's brother Willem Claesz Vooght and their brother-in-law Nicolaes Woutersz van der Meer, the husband of their sister Cornelia and also a brewer. (Both of these men were already council members and so survived the putsch under Maurits. As we have seen, Hals had painted Van der Meer as a member of the 1616 Saint George officers; he will later make pendant portraits of him and Cornelia [figs. 12 and 13].)[24] Haarlem's overlapping regent and brewer clans constituted a large but tight and inbred network. Its members unilaterally installed on the council by the stadholder would oversee the city's politics—and its economy—for decades.

The immensely wealthy Olycans and their extended relations were of great importance for Hals. Their elevation to power in 1619 brought him an impressive number of commissions. Over the years, he would end up doing eighteen portraits of Olycan family members, either as individuals or as officers or directors of one association or another. And what was good enough for the Olycans was good enough for other families of brewers, merchants, and professionals in Haarlem. This cohort of mostly young, rich businessmen, supplanting the "old money"—and looking to establish themselves as the new generation of leading burghers, with modern taste and perhaps more interested in the latest styles of painting and portraiture than their elders—would form the core of Hals's clientele for the rest of his life. As the art historian Walter Liedtke puts it, "Hals had the advantage of working in Haarlem, where some of his upper-middle-class patrons (including members of the civic guard companies) were open to novel and generally more dramatic ideas in portraiture. . . . Hals never would have become such an innovative

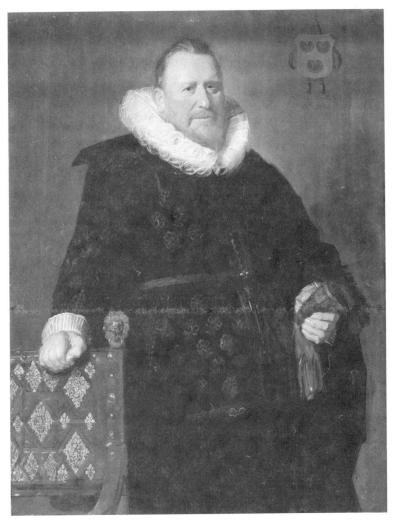

12. Frans Hals, portrait of Nicolaes Woutersz van der Meer, 1631, Frans Hals Museum, Haarlem. Photo: Margareta Svensson.

portrait or genre painter had he pursued a career in another part of the Netherlands."[25]

Hals was thus on his way to becoming the painter of choice for Haarlem's elite. The more traditional, cramped, rather staid portraits in the early manner of Frans Pietersz de Grebber or Cornelis Engelsz Versprongh were now giving way to Hals's livelier, more open and dynamic style. De Grebber and Versprongh, and later their sons, along with Salomon de Bray and Pieter Soutman—Catholics one and

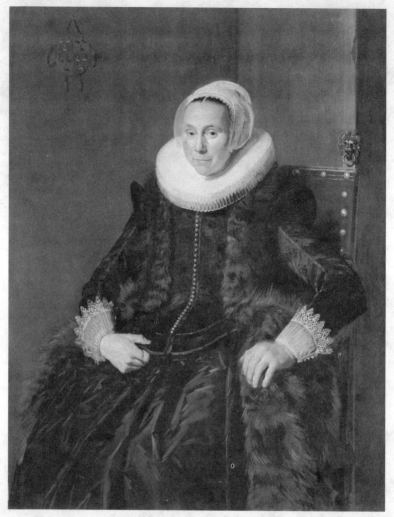

13. Frans Hals, portrait of Cornelia Claesdr Vooght, 1631, Frans Hals Museum, Haarlem. Photo: Margareta Svensson.

all—still found clients among the city's older patrician clans, as well as among the local Catholic clergy. But the new class of municipal leaders, Calvinist to the core, not to mention the Reformed ministers whose sermons they heard in church and the theologians whose works lined the shelves of their libraries, as well as a fair number of local Catholic families, preferred to have their likenesses crafted by Hals. According to the Hals scholar Seymour Slive, in the peak years

of his career Hals was doing for the citizens of Haarlem "what other artists did for kings."[26]

Ambassador Dudley Carleton may have been able to ignore Hals in that letter to John Chamberlain of 1616. So did the Haarlem cleric, historian, and poet Samuel Ampzing when, that same year, he published the first edition of his *Beschryvinghe ende lof der Stad Haerlem*. A Reformed minister, Ampzing was (like Schrevelius, and like the historian and poet Petrus Scriverius, who in a few years will also sit for Hals) part of a broad literary phenomenon devoted to promoting Dutch culture. His book, written partly in verse and addressed to every "lover of our Dutch language," is just one of several in the period that, by singing the praises of the Republic, made the case for a nation that was still years away from true independence and sovereignty. The patriotic Ampzing glorified the language, literature, and art of his native land. His hometown of Haarlem, of course, had a special place in his heart—and not only, as we have seen, because of its fabulous linen. While he was especially taken by the skill and originality of the city's artists, there is no mention of Hals in that first edition. This has changed by the book's second edition, published in 1621, when Ampzing has indeed taken notice. In his tribute to the city's "painters, plate cutters, glass writers, etc.," after acclaiming the talents of Goltzius, Van Heemskerck, Van Scorel, Mostaert, and others, he comes to his contemporaries:

What shall I also say here of [Floris] van Dijck, [Cornelis Claesz] van Wieringen, De Grebbers [i.e., Frans and Pieter], [Jacob] Matham, [Hendrick Gerritsz] Pot, Jan Jacobsz [Guldewagen], [Cornelis] Vroom and Velden [i.e., Jan van de Velde], the Halses, [Jacob van] Campen, Smit [i.e., Cornelis Verbeeck], Brey [i.e., Salomon de Bray], Bouchorst [i.e., Jan Phillipsz van Bouckhorst], and [Pieter de] Molijn.

For good measure, Ampzing notes that "the Halses" are "brothers Frans and Dirck Hals."[27] By the time he wrote his *Beschryvinghe* in 1628, Ampzing's enthusiasm for "the Halses" (and Frans's brushwork) has taken over:

> Come, Halses, come forth.
>
> Take a seat here, it is yours by right!
>
> How dashingly [*wacker*] does Frans paint people from life [*naer het leven*]!
>
> What pure little images can Dirck not give us!
>
> Brothers in art, brothers in blood,
>
> Raised by one and the same art and mother.
>
> There is a large painting by Frans Hals of some officers of the Old Doelen or Kloveniers Hall, done most boldly from life.[28]

If Hals's clients were expecting typical portraiture, then in some respects they could not have been disappointed. The pair of paintings that he did in 1620 for Paulus van Beresteyn and his third wife, Catherina Both van der Eem—Paulus was twice a widower—are three-quarter-length renderings of a soberly dressed couple on a dark, featureless background (figs. 14 and 15).[29] The large ruff collars and embroidery on their clothing are painted in fine detail, as is the embroidery of her stomacher. The recently married couple, both Catholics, are somewhat stiffly posed, with husband turned slightly toward his left, where he finds his wife in her painting partly turned toward him. Van Beresteyn was a lawyer and a native Haarlemmer; Hals must have known him in his professional capacity as legal counsel for the Guild of Saint Luke. Even in this traditional posture, Van Beresteyn's face is slightly animated, with an ever so subtle hint of a smile, while his hands and some other features are done with the quick brushstrokes that will soon become more prominent in Hals's art.[30]

Hands sculpted from unblended strokes of paint appear, too, in his portrait, also from around 1620, of Catharina Hooft and her nurse (plate 3).[31] Once again Hals has devoted careful attention to embroidery, this time on the toddler Catharina's gown, as well as to the delicate lace in her collar and tiara. The nurse's simpler ruff and cap, by contrast, are done more loosely and suggestively, brilliantly creating an impression of depth. It is a warm portrait, a masterpiece that captures a charming moment as the woman gives a piece of fruit (an apple or pear) to her smiling, two-year-old charge.

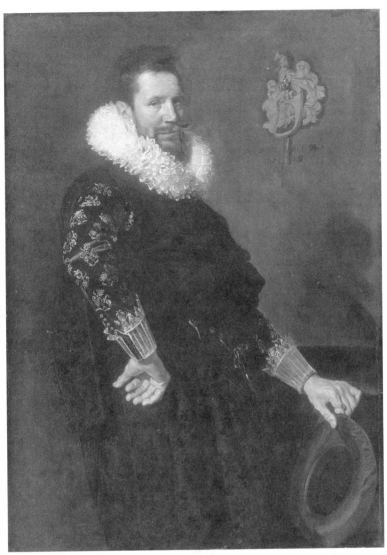

14. Frans Hals, portrait of Paulus van Beresteyn, ca. 1620, Musée du Louvre, Paris, France. Credit: © RMN-Grand Palais. Photo: Gérard Blot/Art Resource, New York.

The Hoofts were a prominent, aristocratic Amsterdam family. The extended clan included a number of burgomasters, as well as the famous poet and playwright Pieter Cornelisz Hooft. The double portrait of child and nurse was done while Catharina's parents—the physician and chemist Pieter Jansz Hooft and his wife, Geertruid Overlander—were living in Haarlem, possibly for business reasons

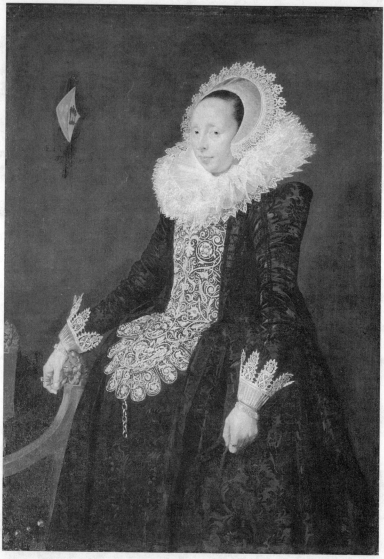

15. Frans Hals, portrait of Catherina Both van der Eem, ca. 1620, Musée du Louvre, Paris, France. Credit: © RMN-Grand Palais. Photo: Gérard Blot/Art Resource, New York.

but more likely to escape the religious turmoil in Amsterdam at the time.[32] In fifteen or so years, Catharina will do what well-bred Amsterdam women were expected to do and marry the scion of another wealthy and powerful regent family—in this case, the thirty-six-year-old Cornelis de Graeff, the son of Jacob Dircksz de Graeff, who was a friend and collaborator of Catharina's father, Pieter. De

Graeffs and Hoofts, as well as Bickers, Coymans, Huydecopers, and several other families all intermarried and ensured their continued domination of the Amsterdam *vroedschap* for generations. Catharina's husband, Cornelis, would take several terms as a *burgemeester*.

Catharina had this painting in her possession when she died in 1691; it must also have hung, for a time, in the house she and Cornelis occupied in Amsterdam after their wedding. It was shown with pride to visitors to their well-appointed home, perhaps bringing more commissions from Amsterdam to the Haarlem artist who so sympathetically rendered the young child and her now-anonymous caretaker.

The most impressive and innovative of Hals's earliest portraits is a scene with a large family in a landscape. According to a recent reconstruction of a work that at some point was divided into fragments, Hals's original composition showed thirteen, and possibly fifteen, individuals—plus a goat—enjoying a peaceful time outdoors (plates 4a and 4b).[33] The cloth merchant Gijsbert Claesz van Campen and his wife, Maria Jorisdr Palesteyn, are seated in relaxed poses, with the woman's hand resting affectionately on her husband's thigh—although the slightly annoyed look on her face and her sidelong gesture suggest that she would like her husband to do something about the rambunctious children to her left. Their brood of eleven (or thirteen), most with smiling faces, are gathered around them or frolic nearby. A couple of the older children look with some indulgence upon their playful younger siblings. Like the Saint George civic guard's officers in their group portrait, the members of the Catholic Van Campen family are engaged mostly with each other; the only ones looking at us in Hals's original are the father and the small girl in the goat cart. Most of the family are dressed in black, which serves to highlight their colorful, expressive faces. It is a groundbreaking painting, an intimate portrait in which movement and gesture reveal, to all appearance, a convivial moment for a loving family. It is also unusually large, as it must be to accommodate so many figures; the uncut canvas may have been 153.5 × ca. 330 cm, and could only have hung in the *groote sael*, or great hall, of their luxurious home on Haarlem's Kerckstraat.

This is the first of four family group portraits that Hals will do, and it evidently was of some influence on his Haarlem colleagues. Pieter Soutman, for one, would, just a few years later, render the Van Beresteyn couple and their seven offspring and a maid in a very similar manner: affectionate parents (touching each other) and playful children in a verdant outdoor setting. Hals did not finish the Van Campen painting on his own, however. A few years after his work was completed, Gijsbert and Maria had yet another child, their last. Rather than going back to Hals to add her to the picture, they asked one of his Guild of Saint Luke colleagues, Salomon de Bray, to paint in their new daughter, which he did in 1628; she sits on the ground at the lower left, and is now a third figure looking out at us.[34]

De Bray (1597–1664) was born in Amsterdam to a family from the southern Netherlands, and he received his art training in Haarlem, under Cornelis Cornelisz and Goltzius, who may still have been running Van Mander's "academy." In the same year that Hals was painting his officers in the Saint George civic guard, De Bray joined the city's other guard, the Saint Hadrian *kloveniers*, or arquebusiers. He also, like Hals, belonged to De Wijngaertrancken, the rhetorician chamber. Although he was Catholic, De Bray crossed confessional lines to marry Anneke Jansdr Westerbaen, from a Remonstrant family in The Hague and the sister of the portrait painter Jan Westerbaen.

Much of De Bray's oeuvre from the 1630s on consists of history paintings. Among his works are three versions of the biblical episode of Abraham sending off Hagar and Ishmael (done in 1633, 1656, and 1662). His early specialty, though, was portraiture, and so he was a natural candidate to make the necessary addition to Hals's painting. While De Bray would serve several terms on the board of the Guild of Saint Luke and take the lead on some important initiatives, there is no record of when exactly he entered its ranks. He first appears in the guild's rolls in 1630, but must have joined well before that; otherwise, he would not have been asked to insert the newest member of the Van Campen family into the portrait.

We do not know why the family turned to De Bray rather than the original artist. Perhaps Hals was busy with other portrait commis-

sions at this time. Or was it because De Bray, like the family, was Catholic?[35] (Then again, as we have seen, so might Hals have been.) Nor do we know what Hals thought about De Bray being asked to augment his work, but it probably mattered little to him. With so many figures in the painting, and the cost of a group portrait usually based on the number of individuals depicted, the Van Campen tableau would already have brought Hals a nice windfall, albeit well within the means of a rich merchant.

<p style="text-align:center">*</p>

As welcome as the Van Campen commission must have been, and even if there were other projects to attend to, Hals was probably not yet receiving enough jobs through made-to-order portraits alone to keep up with family expenses. Thus, around this time he began experimenting with a different type of picture—portrait-like but not really a portrait—and with a different painterly style. Instead of commissioned likenesses of fellow Haarlem citizens, these were "genre" portraits. Rather than portraying particular and identifiable individuals, genre portraits, as well as *tronies*—not unlike the ones that Hals saw in Rubens's and Jordaens's workshops in Antwerp—depict anonymous figures as types or characters. They can appear in regular dress or in costume, and are typically occupied with business of some kind, or engaged in a playful pursuit, or—like Hals's Shrovetide celebrants, perhaps the least portrait-like painting in his oeuvre—consumed by dissolute and debauched activity. Often life-size and done as a bust or half-length, this was a common and popular, and very marketable, type of image in the period.

Genre paintings were generally less expensive than formal portraits, which put them more within reach of those who were not among the wealthier citizens. Their impersonal nature—since they were not meant to be representations of any specific person, least of all the member of someone else's family—made them suitable for purchase and hanging in any home in need of decorative art, as well as in inns and other places of business. Delightful and engaging genre paintings, often with a moralizing message, were typically sold on the open market, either at a fair or an auction. Some were indeed

high-end works of art, but many others, depicting both everyday occupations and low-life pursuits, were quickly painted in quantity for the mass market.

The Utrecht Caravaggists, employing a strong contrast between illuminated and dark areas in their paintings, were especially adept at such scenes, whether amusing or serious. Ter Brugghen, Van Honthorst, and Van Baburen, all active in the 1620s and catering to the higher end of the market, were producing, along with their history and religious paintings, genre works with dramatically lit musicians, singers, gamblers, drinkers, panderers, prostitutes, and thieves (fig. 16).[36] These *vrolijke gezelschappen* (merry companies), whatever the virtues or vices on display, were popular among Dutch viewers.

The *Shrovetide Revellers* of 1616 was Hals's earliest attempt at a genre picture. He followed this up a few years later with a slightly less crowded work known as *The Rommel Pot Player* (plate 5).[37] It shows a gap-toothed man earning some change by entertaining a bevy of smiling children of various ages. His audience is delighted by the sounds produced by the improvised instrument—made by stretching a pig's bladder over a ceramic jug partly filled with water and moving a wet reed or straw through the membrane to produce a squealing sound—and are ready to hand over some coins.

Sometime around 1620, and continuing on through the decade, Hals began producing more genre pieces, only now instead of densely populated scenes with lots of activity they tended to show only one or two figures. Some of these genre portraits were true *tronies*, single head studies without any kind of story or setting. Hals was obviously taken by the challenge of depicting laughter in a convincing way, and there are quite a few extraordinary paintings of amused and giggling children, some of whom even might have been members of Hals's growing family. In one of them a boy—one of Hals's sons?—is holding a flute; in another he is playing with a bubble; in yet others he is doing nothing at all except laughing (plate 6).[38] Hals's oeuvre, in fact, may contain more laughs and smiles than that of any other painter in history. Cheery men and women, young and old, grinning at us and at each other, are shown with books, bottles, musical instruments (flutes, lutes, a violin), tobacco pipes, even animal bones—as in the

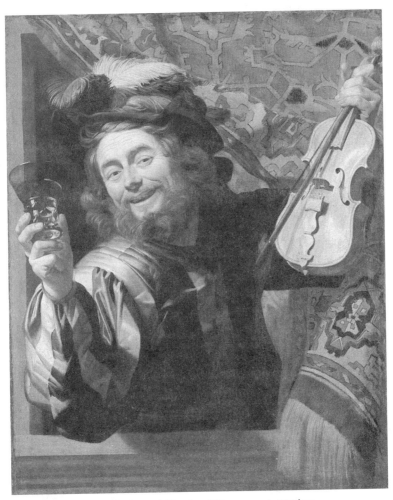

16. Gerrit van Honthorst, *The Merry Fiddler*, 1623, Rijksmuseum, Amsterdam.

painting known as *Verdonck* (fig. 17).[39] This could be a portrait of a lo-
cal Mennonite in Haarlem named Pieter Verdonck, who was known
for his stinging attacks on members of a rival Mennonite sect. In
Hals's painting—recalling how Samson used an ass's jawbone to slay
his enemies—he wields a cow's jawbone to represent his verbal or
"jawboning" skills, much as the witty Pieter van der Morsch, in his
portrait, has his emblematic herring.[40]

There is also, in Hals's genre works, drinking—lots of drinking.
Wine, in some cases, but mainly beer. Hals's figures, of all ages, im-

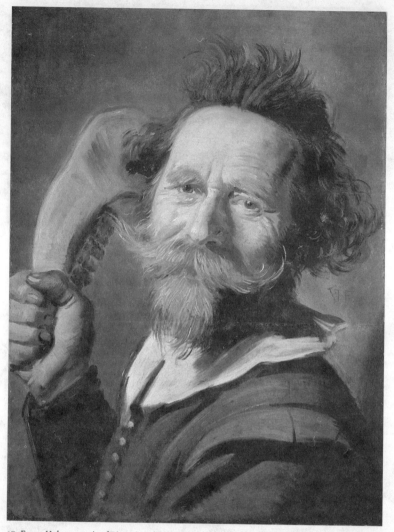

17. Frans Hals, portrait of Pieter Verdonck, ca. 1627, National Galleries of Scotland, Edinburgh, Scotland, UK. Credit: © National Galleries of Scotland, Dist. RMN-Grand Palais/Art Resource, New York.

bibe from goblets, tankards, jugs, flagons, fancy *roemers*, and just plain glasses. They are enthusiastic consumers of the beverage flowing copiously from Haarlem's breweries. There are several early paintings of young people—individuals and couples—enjoying themselves in taverns. One, from 1623 and which later gained the title *Joncker Ramp and His Sweetheart*, shows a youth and his rosy-cheek girlfriend engaged in some merrymaking (plate 7).[41] An-

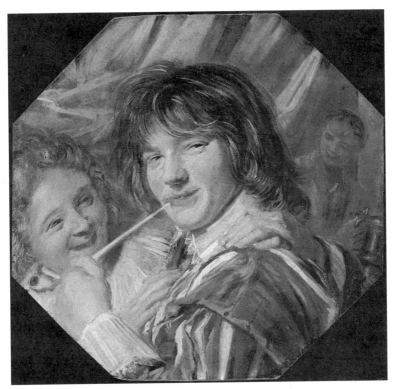

18. Frans Hals, *Boy with Pipe*, ca. 1623-25, the Metropolitan Museum of Art, New York—Marquand Collection. Gift of Henry G. Marquand, 1889.

other from around that same year depicts a youth smoking a long-stemmed clay pipe (fig. 18);[42] he looks at us as his female companion, clearly entertained by something he's done or said, has her arm around his neck. While the mood of both couples is certainly helped by fermented liquid refreshment—someone in the background of each painting holds a tankard of ale—it seems like innocent enough fun ... perhaps. It is certainly more innocent than what seems to be offered by the disheveled woman with deep decolletage in one panel painting from later in the decade, a painting that likely hung in a brothel as part of a gallery advertising the opportunities for clients (fig. 19).[43] This "gypsy," as she has often but misleadingly been la-beled, is slyly smiling at something going on—we know not what—off to her left.

We are a long way from the staid, serious, and sober world of

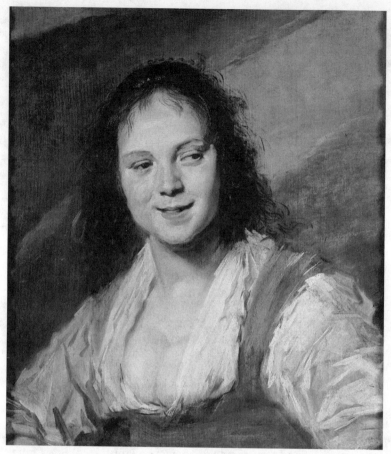

19. Frans Hals, *Gypsy Girl*, ca. 1628–30, Musée du Louvre, Paris, France. Credit: Scala/Art Resource, New York.

Hals's patrician sitters. The tone in his early genre paintings—done on both panels and canvases—is often lighthearted, although there is a certain amount of symbolic moralizing as well, to warn us of the importance of temperance and the dangers of overindulgence in such amusements. Moreover, the *vanitas* or memento mori theme— lest we forget the transience of worldly things (including ourselves) and the end to which we all are inevitably moving—is often present in subtle and, sometimes, not-so-subtle ways. The young man enjoying the pleasures of wine and women in *Joncker Ramp* is, if he does not change his ways, on the road to ruin. That the unbridled pursuit of sensual satisfaction will inevitably end in regret is a prom-

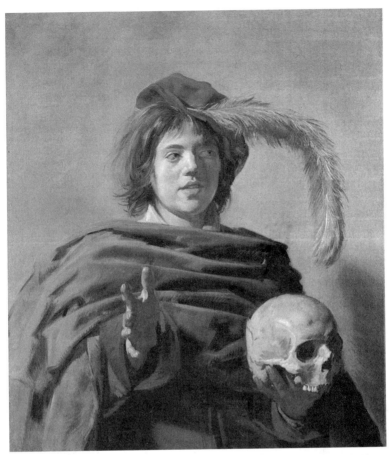

20. Frans Hals, *Young Man Holding a Skull*, ca. 1626-28, National Gallery, London, UK. Credit: © National Gallery, London/Art Resource, New York.

inent theme in early modern Dutch visual and literary culture (not to mention its religious sermons)—thus the prominence of the biblical story of the "prodigal son" story (Luke 15:11–32) in the art—and it is not hard to see this warning in many of Hals's works.[44] In one of his more Caravaggesque paintings from the mid-1620s, a young man holds a skull, à la Hamlet (fig. 20);[45] his partly open mouth suggests that this figure—is it supposed to be an actor in a play? Hamlet himself?[46]—is in the midst of offering some pearls of wisdom on human mortality.

By the early 1630s, the carousing—both its pleasures and its perils—will be supplemented by pictures of less dissolute, but still

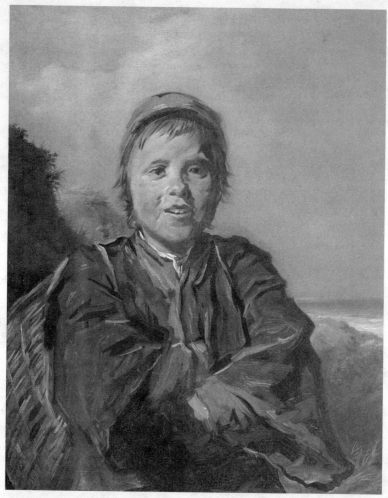

21. Frans Hals, *Fisher Boy*, ca. 1630–32, inv. no. 188, Koninklijk Museum voor Schone Kunsten, Antwerp—Flemish Community (CCO). Photo: Hugo Maertens.

smiling, characters: a fruit and vegetable seller, in a collaboration with the still-life painter Claes Jansz van Heussen,[47] a young woman quietly reading a book,[48] and, especially, a series of "fisher" children on the beach and by the sea (fig. 21).[49] These depictions of youth, boys and girls who are not wasting their time drinking, smoking, or falling into sexual entanglements but engaged in innocent and even productive activities, have their purely visual charms. And yet, like many Dutch genre paintings in the seventeenth century, these "ordinary" and naturalistic scenes may also suggest moralistic lessons,

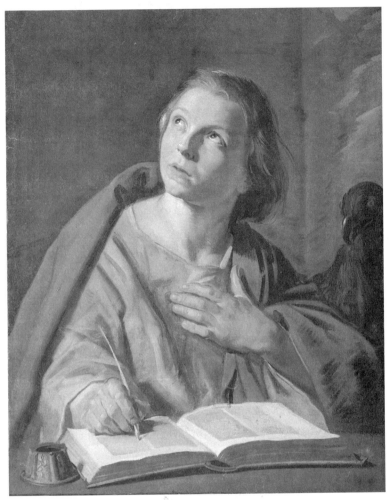

22. Frans Hals, *St. John*, ca. 1625, Getty Museum, Los Angeles. Digital image courtesy of the Getty's Open Content Program.

whether it be praise of the virtue of labor (in contrast to the vice of idleness) or a reminder of the importance of modesty.[50]

Not all of Hals's genre or *tronie*-like paintings from the 1620s have such mundane subjects. There is a series of works that, in the twentieth century, were identified as Hals's portraits of the four Evangelists of the Christian Gospels (Luke, Matthew, Mark, and John) (fig. 22).[51] Each evangelist, painted in the style Hals used for his genre portraits, is shown engaged with a book—holding, reading, or writing—and his proper emblem (a lion for Mark, an ox for Luke, an

angel for Matthew, and an eagle for John). These images are, as far as we know, Hals's only paintings with an explicitly religious theme, although their presentation is, from a sectarian perspective, rather neutral. They do not proclaim themselves as addressing either a Catholic or Reformed audience or as representing any particular religious iconographical or doctrinal tradition.[52] Why Hals made them and for whom remain open questions. Such small canvases (68.5 × 52.5 cm) might have been painted for one of Haarlem's private Catholic chapels (schuilkerken), or for the home of a Catholic or even Protestant family. Where they would certainly not have hung is in a Reformed church.

What is striking about all these paintings—the genre portraits, the tronies, and the four Evangelists—and especially in contrast with the careful detail that we find in Hals's more formal commissioned portraits in this period, is the emergence on a broad scale of what the art historian Christopher Atkins has labeled Hals's "signature style."[53] The loose, spirited brushwork that shows here and there in the portraits—in the hands or the clothing—is now, in these works, the main and unmistakable stylistic feature. Faces, especially, are as if sketched in quickly. From inches away, they appear as what they are: strokes of unblended colors, applied (often wet-in-wet) quite deliberately but with an apparent swiftness; in the dried paint you can see the individual bristles in the brushstrokes. Step back a few feet, though, and they have their intended effect. The red swaths and dark slashes on the arm of Peeckelhaering (fig. 23)[54] become the folds of his sleeve; mere zigzags of pale yellow constitute the reflection of light off the glass held by a boy, the highlights of whose hair is just a series of golden stripes (fig. 24);[55] long squiggles of red represent the ribbons on the "buffoon" costume a young man playing the lute is wearing in a half-length (fig. 25).[56] The care that Hals devoted to the intricate pattern in the fine lace on the shoulders of Catharina Hooft and the Van Campen daughters, as well as the neckwear in other portraits from the 1620s, is replaced in his genre pieces by collars suggestively built up with strokes and dabs of white, black, and gray. This is the casual looking but indeed carefully crafted style of painting—one that makes no effort to hide the fact that it is just

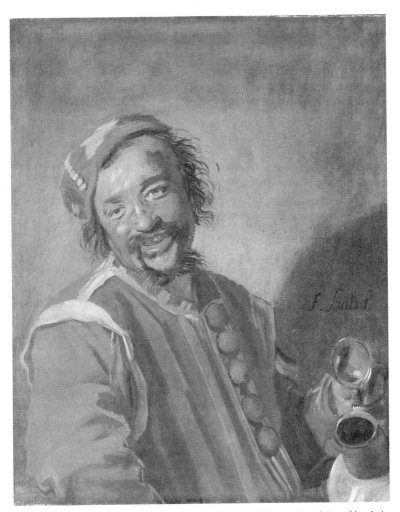

23. Frans Hals, *Peeckelhaering*, ca. 1628–30, Museumslandschaft Hessen Kassel, Gemäldegalerie Alte Meister. Photo: Ute Brunzel.

paint applied with a brush—that will eventually come to characterize even Hals's formal portraiture from the 1630s on.

Well before Hals came on the scene, Van Mander had referred to this as the "rough [*rouw*]" manner of painting. The style, Van Mander notes, is particularly to be seen "in our time," when "the paints are applied so uneven and rough that one might almost think that they are carved in stone in relief." The contrast he draws is with the "smooth [*net*]" manner, which "is praiseworthy and keeps the attention of the viewer busy longer." Van Mander holds up Titian as

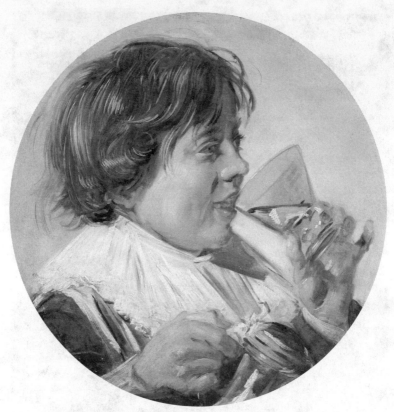

24. Frans Hals, *Boy with Glass*, ca. 1626–28, Staatliches Museum, Schwerin, Germany. Credit: bpk Bildagentur/Staatliches Museum, Schwerin. Photo: Gabriele Broecker/Art Resource, New York.

the best exemplar of the rough style. While starting out as a smooth painter, "in the end, he [Titian] carried out his work in a wholly other manner, with smears and rough strokes." The result is that his work "can be seen only from afar."[57]

In his own account of the principals of the Dutch art world, *De Groote Schouburgh der Nederlantsche Konstschilders en Schilderessen* (The great theater of Dutch painters and painteresses), Arnold Houbraken, writing in the early eighteenth century, many years after Hals's death, tells a colorful but almost certainly fictional account of a visit that Van Dyck, another master of the rough style of painting, made to Hals's studio. The story conveys the impression that Hals's work was done in a swift and carefree manner—that he could dash off a painting in no time, and impress even a Van Dyck with his skill.

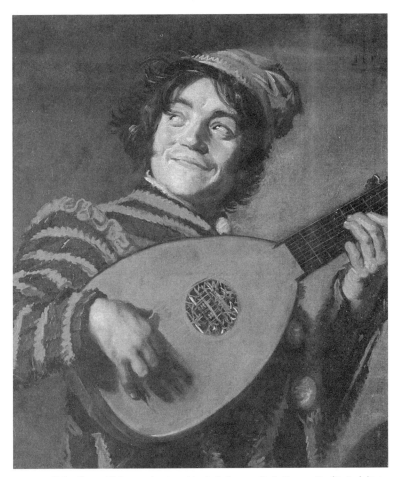

25. Frans Hals, *Clown with Lute*, early 1620s, Musée du Louvre, Paris, France. Credit: Scala/Art Resource, New York.

Anthony Van Dyck, the phoenix of his day, when in the service of King Charles the First and about to sail for England, resolved to see Frans Hals before he left. He came to Haarlem and called at his house, but it took some time to scour the taverns for him, for he never left before he had finished his tankard. Meanwhile, Van Dyck stood waiting patiently, and did not make himself known, saying merely that he was a stranger and had no time but the present, yet desired to have his portrait painted, to which F. Hals agreed without further ado.

Hals, Houbraken says, "took the first canvas that came to hand and set to work." Van Dyck did not say much during the session and kept

his identity a secret. The portrait was "soon done," and Hals asked Van Dyck what he thought of it.

> Van Dyck praised it, and spoke with him awhile, but in such a way that he might discover nothing. Among other things, he said "Is this, then, how one paints? Could I not do likewise?" And, taking up a bare canvas which he saw standing there, he placed it on the easel and asked him [Hals] to be seated. Frans saw instantly from the way in which he took hold of the palette and brushes that this was no novice, and realized that the distinguished Ulysses would reveal himself. Yet he had no inkling that it was Van Dyck, but rather some waggish painter who wished to declare himself by giving a sample of his art. It was not long before Van Dyck commanded him to rise and inspect the work. As soon as he saw it he said: "You are Van Dyck, for none but he could do this," and he fell on his neck and kissed him.[58]

It is a charming tale of artistic rivalry, recalling the ancient competitions between Apelles and Protogenes or between Zeuxis and Parrhasius.[59] Van Dyck was indeed in Holland between 1628 and 1629, and during a stay in The Hague he painted a portrait of Constantijn Huygens, secretary to the then-stadholder Frederik Hendrik and father of the scientist Christiaan Huygens, born just that year.[60] But there is no evidence that he paid a visit to Haarlem, much less to Hals's studio, and there is no extant portrait of Van Dyck by Hals or vice versa. What makes the story particularly dubious is that Van Dyck could not possibly have carried out his deception, at least not without some disguise. After all, Hals presumably met Van Dyck during his 1616 trip to Antwerp, and so would have recognized him.

Hals's characteristic manner of painting was highlighted, and certainly appreciated, by the nineteenth-century art critic and connoisseur Étienne-Joseph Théophile Thoré (he also went by the pseudonym William Bürger), who was responsible for the more positive reappraisal of Hals—and, more famously, the rediscovery of Vermeer—after almost two centuries of art historical neglect or denigration. Writing about the collection of the German entrepre-

neur Barthold Suermondt in 1860, he notes of Hals's paintings that "all his brushstrokes stand out, aimed exactly and wittily where intended. One could say that Frans Hals painted as if fencing, and that he flicked his brush as if it were a foil. Oh, the adroit swashbuckler, extremely amusing to observe in his beautiful passes."[61]

Thoré-Bürger is embellishing a bit. In fact, he is embellishing a lot. The "rough" style should not be mistaken for quick, improvisational work. It required enormous skill to pull off, as Van Mander recognized. He did not recommend it for those just starting out in their artistic careers. "Herewith, apprentices, I have placed before you two perfect manners toward which you may now guide your path according to your bent, but I should still advise you to begin by applying yourselves to the neat manner."[62] Not even Titian's followers, he notes, were able to manage the rough style with their master's skill. "They made a mistake based on a false belief, [namely] that his works were done without difficulty, whereas it was precisely that the artist's utmost powers were applied with [great] difficulty."[63]

Despite appearances, then, it is not as if Hals sat down in front of a bare canvas or wood panel and just dashed something off with "flicks" of the brush.[64] As far as we know, he did not use preliminary sketches (drawn or painted) for his works; at least, no such preparatory studies, on paper or any other medium, have survived.[65] Nonetheless, his method still involved the multistage process followed by easel painters in this period.[66] First, the canvas or panel needed to be "primed"; this meant covering or sealing it to create a smooth surface on which to paint, as well as to hide the weave of the canvas or the grain of the wood. Usually the primer was an off-white layer of a mixture of pigment and chalk with either animal glue or oil as a binder. This might be followed by a second ground or base layer—perhaps with a brown or red tint—which gives the final work its overall chromatic tone. Hals would next paint in a sketch of the person or scene, to serve as an outline for the picture. He then went over that sketch, perhaps revising it along the way, with an underpainting or "dead coloring," which laid down the basic forms with a dull, colored composition. Last came the "working up"—the term Hals apparently used was *opmaecken*—of the finished portrait. He

usually moved from background, whether featureless or with a set-ting, to the foreground figure(s), with details of the face coming last. Finally, there was the adding of highlights with those final strokes of the brush that Hals himself reportedly called "the master's touch [*het kennelyke van den meester*],"[67] and perhaps a few scratches in the wet paint with the stick end, such as we find in several of his paintings, for effect. It was not uncommon for him to make changes in design or detail at each stage of the process. Far from being a hasty slapping around of paint on canvas, it was all carefully thought out and cal-culated to have the proper look when viewed from some feet away.

Writing in the early 1660s and carrying on the tradition of Van Mander with a book titled *Het Gulden Cabinet vande Edel vry Schil-der Const* (The golden cabinet of the noble and free art of painting), including biographies of "painters in this century," Cornelis de Bie, a poet and art theorist in Antwerp, notes in his entry on Dirck van Delen that "Franchois Hals, who is still alive and living in Haar-lem, [is] a marvel at painting portraits or counterfeits [*conterfeyten*] which appear very rough and bold, nimbly touched and well com-posed, pleasing and ingenious [*gheestig*], and when seen from a dis-tance seem to lack nothing but life itself."[68] It is noteworthy that De Bie was writing at a time when the taste for the "rough" manner of painting, now well represented by Rembrandt, was giving way to a more fine-grained approach, the "smooth" manner popularized by the *fijnschilders* (fine painters) of Leiden, Dordrecht, and Amsterdam, such as Gerrit Dou, Nicolaes Maes, and Gabriel Metsu. And yet this change in aesthetic fashion did not affect De Bie's admiration for Hals's virtuosity (although that admiration by a man living far from Haarlem may have been only secondhand).[69]

*

The subjects of the "rough" genre pictures of the 1620s are, for later generations, Hals at his most recognizable—the Hals that comes most readily to mind: jocular figures enjoying the pleasures of this world, often under the influence of alcohol or tobacco. This has given rise to a certain lore about Hals himself: that he was a drinker,

given to a dissolute lifestyle, much to his and his family's great dis-
advantage.

Houbraken bears no small responsibility for this louche image.
Not only does he tell us that, when Van Dyck came calling, "it took
some time to scour the taverns" for Hals, "for he never left before
he had finished his tankard," but he also relates that Hals took from
his children the coins that Van Dyck had gifted them and used it for
drink: "Van Dyck took up his portrait, which was still wet, thanked
him, and gave liberally to his children, who remained the bankers
for but a short while, as Frans presently took this stroke of good for-
tune to his lips."[70] Houbraken goes on to say that "[Hals's] excellent
art and bold manner with the brush is what apprentices should take
as their model and example, not his manner of living, for he was not
a good driver of his life's carriage, which often veered from the cen-
ter line when he gave his passions free rein." Hals was frequently
"deep in his cups," he claims. "It was Frans's custom to fill himself
to the gills each evening," and his pupils, who "held him in great re-
spect . . . agreed that they would take turns watching over him and
escort him from the tavern, especially when it was dark or late, lest
he fall into the water or suffer some other mishap. And bringing him
duly home, they took off his stockings and shoes and helped him to
bed."[71]

Houbraken's depiction of a debauched Hals might seem to be cor-
roborated by something that Matthias Scheits says in the brief bi-
ographical sketch of Hals that he wrote in the margin of his copy of
Van Mander's *Schilder-Boeck*. Scheits says that the painter was "in
his youth, somewhat *lüstich* [sic] *van leven*."[72] The phrase *lustich van
leven* can mean several things: lusty lifestyle, but also pleasure seek-
ing or high-spirited. It has often been taken to indicate just the kind
of drunken living described by Houbraken. Scheits, as we have seen,
lived in Haarlem for a time and studied painting under Hals's own
pupil Wouwerman.[73] So perhaps Scheits heard stories about Hals's
habits from a man who himself had been one of those apprentices
that, we are to believe, used to walk the inebriated painter back to
his home.

Scheits's comment is too cryptic to be of any use, however, and Houbraken may be more interested in telling an entertaining story on the basis of flimsy (if any) anecdotal evidence than in accurately documenting Hals's character. More to the point, it is quite a leap to draw conclusions about an artist's manner of living on the basis of the subjects he or she chose to paint. One might just as well conclude—and it would be an unwarranted conclusion—that Rembrandt, the painter of so many episodes from the Bible, was among the most pious men of his age. Caravaggio, for his part, may have painted tender and moving scenes of religious faith, but he was as mean and foul tempered a man as they come—and a murderer. Still, as Slive has observed, "the erroneous idea that an artist who painted drinkers must himself have been a drunkard dies hard."[74] And who knows? Maybe in this case it was true.

Did Hals drink his family into penury? There really is no hard evidence one way or the other, just an old tradition of rumor and speculation. Perhaps, given his lifelong money woes, he was a drunk who spent too much of his time and income at the tavern. One would think, though, that if this were the case, then among his many creditors there would be more innkeepers or tavern owners. There is a significant unpaid bill, for over thirty-one guilders, submitted in 1650 by the heirs of a tavern owner. But for someone of limited means who was supposed to have had an unquenchable, even debilitating thirst for alcoholic beverage, the record is rather spare. What is certain is that he and Lysbeth faced real financial difficulties, for a variety of reasons—personal, professional, and geopolitical. There was a rapidly growing family to provide for. There was competition from Haarlem's surplus of artists. And there were the economic repercussions that came with the resumption of the Dutch war for independence after 1621. Any or all of these factors may explain why an aspiring portraitist to the wealthy would turn to the cheaper but higher volume business of genre paintings executed in the rough manner.

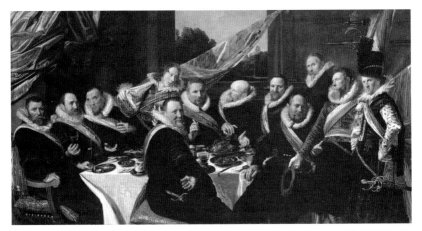

PLATE 1. Frans Hals, *Officers and Sergeants of the St. George Civic Guard*, 1616, Frans Hals Museum, Haarlem.

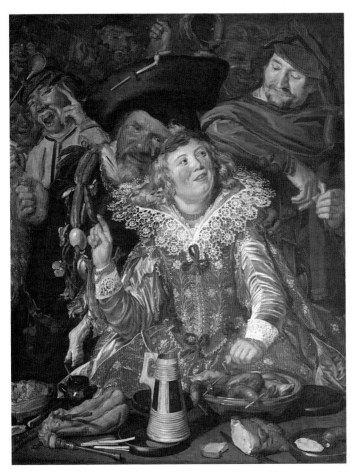

PLATE 2. Frans Hals, *Shrovetide Revellers*, ca. 1616–17, the Metropolitan Museum of Art, New York. Bequest of Benjamin Altman, 1913.

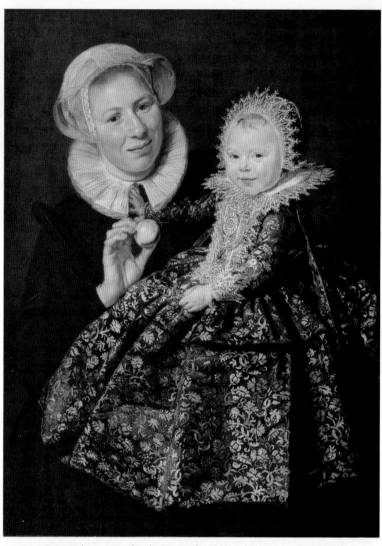

PLATE 3. Frans Hals, portrait of Catharina Hooft and her nurse, ca. 1620, Gemäldegalerie, Staatliche Museen, Berlin, Germany. Credit: bpk Bildagentur/Staatliche Museen, Berlin. Photo: Jörg P. Anders/Art Resource, New York.

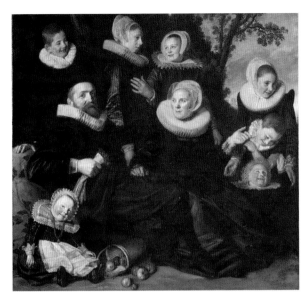

PLATE 4A.
Frans Hals, Van Campen family portrait in a landscape, early 1620s, the Toledo Museum of Art. Purchased with funds from the Bequest of Florence Scott Libbey in memory of her father, Maurice A. Scott; the Libbey Endowment; Gift of Edward Drummond Libbey; the Bequest of Jill Ford Murray, and other funds, 2011.80.

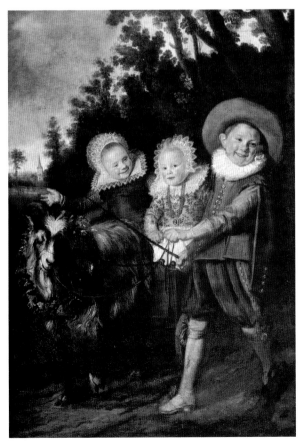

PLATE 4B.
Frans Hals, *Three Children with a Goat Cart* (Van Campen children), early 1620s, Musée Royaux des Beaux-Arts, Brussels, Belgium. Credit: © DeA Picture Library, Art Resource, New York.

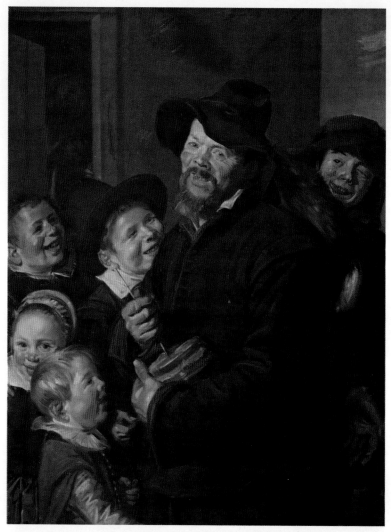

PLATE 5. Frans Hals, *The Rommel Pot Player*, ca. 1618–22, Kimbell Art Museum, Fort Worth, Texas, ACF 1951.01.

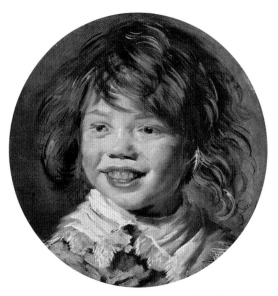

PLATE 6. Frans Hals, *Laughing Boy*, ca. 1625, Mauritshuis, The Hague.

PLATE 7. Frans Hals, *Joncker Ramp and His Sweetheart*, 1623, the Metropolitan Museum of Art, New York. Bequest of Benjamin Altman, 1913.

PLATE 8. Frans Hals, *The Laughing Cavalier*, 1624, Wallace Collection, London, UK. Credit: By kind permission of the Trustees of the Wallace Collection, London/Art Resource, New York.

PLATE 9. Frans Hals, portrait of Willem van Heythuysen, ca. 1625, Alte Pinakothek, Bayerische Staatsgemäldesammlungen, Munich, Germany. Credit: bpk Bildagentur/Alte Pinakothek, Bayerische Staatsgemäldesammlungen/Art Resource, New York.

PLATE 10. Frans Hals, portrait of Samuel Ampzing, ca. 1630. Image courtesy of the Leiden Collection, New York.

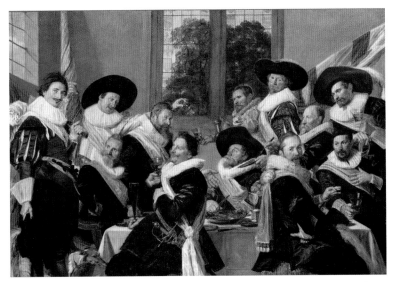

PLATE 11. Frans Hals, *Banquet of the Officers of the St. Hadrian Civic Guard*, 1627, Frans Hals Museum, Haarlem.

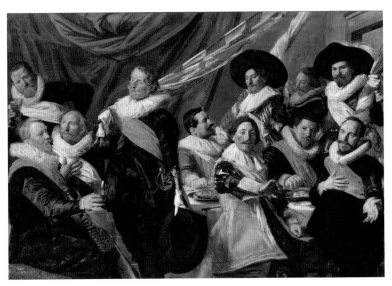

PLATE 12. Frans Hals, *Banquet of the Officers of the St. George Civic Guard*, 1627, Frans Hals Museum, Haarlem.

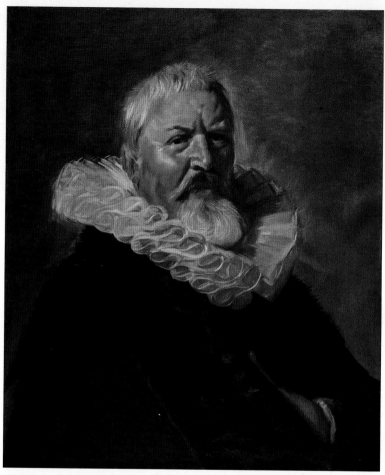

PLATE 13. Frans Hals, portrait of Pieter Jacobsz Olycan, 1629/30, private collection. Courtesy of David Koetser Gallery, Zurich, Switzerland.

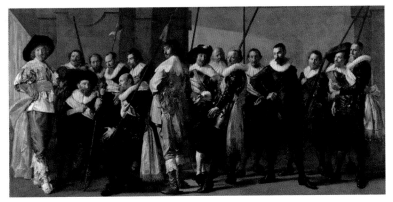

PLATE 14. Frans Hals and Pieter Codde, *Amsterdam District 11 Civic Guard Company*, 1633–37, City of Amsterdam, on loan to the Rijksmuseum, Amsterdam. Image courtesy of the Rijksmuseum.

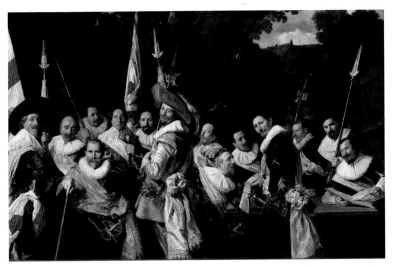

PLATE 15. Frans Hals, *Officers and Sub-Alterns of the St. Hadrian Civic Guard*, 1633, Frans Hals Museum, Haarlem.

PLATE 16. Frans Hals, portrait of Pieter Jacobsz Olycan, ca. 1639. Bequest of John Ringling, 1936, Collection of the John and Mable Ringling Museum of Art, the State Art Museum of Florida, Sarasota, Florida, SN251.

PLATE 17. Frans Hals, portrait of Maritge Claesz Vooght, 1639, Rijksmuseum, Amsterdam.

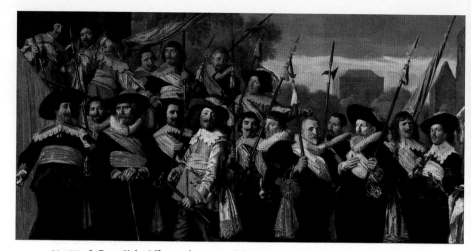

PLATE 18. Frans Hals, *Officers and Sergeants of the St. George Civic Guard*, 1639, Frans Hals Museum, Haarlem.

PLATE 19. Unknown artist, copy of Frans Hals, self-portrait, ca. 1650s, the Metropolitan Museum of Art, New York—Friedsam Collection. Bequest of Michael Friedsam, 1931.

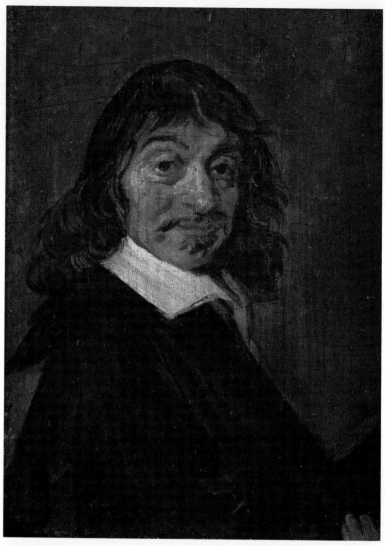

PLATE 20. Frans Hals, Portrait of René Descartes, 1649, Statens Museum for Kunst, Copenhagen, Denmark.

CHAPTER 6
"Very Boldly Done after Life"

The image of the Dutch Republic in the seventeenth century that one might get from looking at its paintings is rather idyllic. There are the lush landscapes, with quiet paths through verdant forests and country folk tending to their herds and cultivating the fertile land. Urban scenes show clean, well-ordered streets and canals, with citizens carrying on civil discourse in courtyards, churches, and market squares. In portraits we see proud, prosperous burghers, well-dressed husbands and wives. Genre paintings depict villagers pleasurably passing the time—sometimes quietly, sometimes boisterously—in homes and taverns. The well-stocked, tapestry-covered tables of still lifes overflow with bread, cheese, meat and fowl, fruit, and sweets. In winterscapes, everyone—rich and poor, man and woman, old and young—is out skating on the rivers and canals. In short, to go by the art, "Golden Age" Holland comes across as a domain of peace and plenty. The French philosopher René Descartes (1596–1650), who moved to the United Provinces in 1628 and stayed there for most of his adult life, found his home-in-exile pleasant enough, and called it "a land where, if there is not as much honey as there was in the land that was promised by God to the Israelites, there is undoubtedly more milk."[1]

This serene picture, however, hides a troubled reality. There was plenty of milk—and beer, and cheese, and flowers. But the Republic in the first half of the century was, as we have seen, a rather turbulent and unsettled place, politically, religiously, and economically. It was a land struggling for independence in what must have felt like an endless war, with only a twelve-year interlude in eighty years of

fighting. Moreover, what was at this point a relatively decentralized federation of provinces was still figuring out what kind of nation it wanted to be, where the true locus of sovereignty and power would lie: the States or the stadholder. And then there were the confessional tensions incited by the Arminian remonstrance that, while peaking in the late 1610s, still smoldered.

The *wetsverzetting* of 1618, when the Counter-Remonstrants under the protection of Maurits took over the city councils in Holland and other provinces, was only the first of the major political-religious upheavals that characterize early modern Dutch history. This was primarily an intramural affair, albeit one with ramifications for the Republic's international relations. The threat that the Dutch faced three years later, on the other hand, came from without, but it rekindled so much antagonism in domestic affairs that the external danger now seemed a mere occasion for an implosion from within.

By the spring of 1621, the truce that the Dutch Republic and Spain signed in 1609 had unraveled. The new Spanish king was the aggressor here. Soon after the death of his father, Philip III, and the formal expiration of the truce, Philip IV renewed hostilities against the crown's former Netherlandish possessions. Knowing how to hit the Dutch where it hurt, he opened with an economic assault. In April, he placed an embargo on Dutch shipping in Spanish ports and territories. This was a disaster for Dutch trade around the globe. Major industries depended on the importation of raw products from Iberia, South America, the Caribbean, northern Africa, the Levant, and the Baltics, especially sugar, salt, and wood. Spain's army, under the command of the ruthless general Ambrogio Spinola, mustered along the border in Flanders, making overland commerce impossible. Its navy guarded the Strait of Gibraltar (essential for maritime trade routes to ports around the Mediterranean) and, with the help of privateers, blockaded rivers leading into the northern provinces. In the North Sea, Spanish galleons harassed Dutch fishing, especially the indispensable herring fleet.

When military operations began in earnest, the Dutch, who had lost much territory to Spain during the early years of the revolt, were now in danger of forfeiting even more. After a year-long siege, from

the summer of 1624 to the summer of 1625, Breda, a strategic town in the southern Netherlands that had been in Dutch hands since 1590, fell to Spinola's forces, a major success for the Spanish; the victory would later be celebrated in a 1635 masterpiece by Velázquez. The inability to defend so well-fortified a town was a blow to Dutch morale. To many, it appeared that nothing less than the survival of the United Provinces was at stake.

The blockades and the renewal of war sent the Dutch economy into a tailspin. No expense was to be spared for defending the Republic, but the cost involved in fighting was enormous. The size of the army had to be increased by half again as many men and land defenses had to be fortified. This required, in turn, new taxes imposed by the stadholder and the States General. Meanwhile, the embargo severely restricted the Caribbean and South American operations of the newly created Geoctrooieerde West-Indische Compagnie (West India Company)—the Vereenigde Oost-Indische Compagnie (United East India Company) had been in operation in Asia since 1602—and caused great losses among its investors, with a natural ripple effect across many other industries and markets.

Of course, as military and economic affairs go, so go matters in the political realm. As war and recession stressed the civic fabric, barely repressed divisions between political parties—and, as always in the Dutch context, their religious allies—came to the surface. Unfortunately for the Orangists and their conservative Counter-Remonstrant partisans, the stadholder of Holland, Maurits of Nassau, an ally to their cause, died in early 1625. He was soon replaced by another son of William the Silent and Prince of Orange, Frederik Hendrik.

The new stadholder did not share his half brother's Counter-Remonstrant fervor. Indeed, Frederik Hendrik was known to be friendly to the Arminian camp and was willing to provide it with protection—up to a point. He was not only a more tolerant and cultivated person than Maurits, but also politically more astute. He knew to walk a fine line between bringing Remonstrants in from the cold and not antagonizing their more orthodox opponents. Under his shrewd leadership, the *vroedschappen* of a number of cities—

including Amsterdam, but *not* Haarlem—were soon back in Remonstrant hands. The Counter-Remonstrants were not happy about this, but there was little they could do. Religious friction continued, as it would for most of the rest of the century, with the fortunes of each camp rising or falling in part according to how well the country fared in its wars with Spain, England, and France.

By the end of the decade, Frederik Hendrik will turn things around on the military front, helped in good part by naval victories under the brilliant Admiral Piet Hein; the economy will rebound, certainly by the mid-1630s; and over time the internal political situation—if not the religious discord—will become more settled. Still, as historian Jonathan Israel notes, the 1620s was "one of the most sombre periods in the history of the United Provinces . . . a time when the Republic was effectively under siege and squeezed hard."[2] This assessment is backed up by what someone who lived through this difficult time had to say. Nicolaes van Reigersberch, the brother of the wife of Hugo Grotius and a member of the High Council of the States of Holland, wrote to his Remonstrant-sympathizing brother-in-law in exile in Paris in 1625: "We are experiencing the harshest period we have known in our entire lifetime. May God direct everything for the best."[3]

<p style="text-align:center">*</p>

The contraction of the Dutch economy in the 1620s could not but have consequences in the art world—not just financial consequences for the artists, but aesthetic ones on their canvases and panels as well.

The market for art, like other commodities, was sensitive to fluctuations in the economic health of the Republic. The lucrative high end of the market, in particular, was dependent on the wealth of the nobility (or what was left of it) and the income of the upper and upper-middle classes. This is where commissions for large history paintings and individual and group portraits—to hang in their city homes, country estates, and guild halls—came from. But it was just those families whose fortunes now, in the midst of war, took a serious hit.[4] Some degree of austerity, especially in nonessential expenditures like art and other luxuries, was necessary.

The Haarlem painter Hendrick Vroom, for one, was receiving fewer commissions for his elaborate paintings of marine scenes; and the orders he was getting were not bringing in the sums they used to. Where formerly his demand of six thousand guilders for a painting of a sea battle on a grand scale would have been readily met by a client—such as the Haarlem city council or Amsterdam's admiralty board—seeking to commemorate a significant historical event, Vroom now had to settle for doing smaller works for only a few hundred guilders.[5] Even as celebrated an artist as Cornelis Cornelisz, now in his sixties and an eminent old-timer on the Haarlem scene, had to modify his products to accommodate the reduced demand. By the 1620s, his once bold and large renderings of biblical and mythological scenes—a 1590 *Massacre of the Innocents* measured 245 × 358 cm (about 8 × 12 ft.)—had given way to works simpler in composition and smaller in size.[6]

This was also the time when Dutch landscape painters turned to a more restrained palette. Jan van Goyen (who, though based in Leiden in these years, trained in Haarlem under Esaias van de Velde), Salomon van Ruisdael, and Pieter de Molijn all helped establish Haarlem's tradition of monochromatic landscapes. Also called "the tonal phase" of landscape painting, their works were characterized by a color scheme limited mostly to shades of brown, green, gray, and yellow. Because it was possible to produce such paintings relatively quickly and at less expense, they could be marketed more cheaply to a broad public (fig. 26).[7]

These changes in the art market, along with an increase in the number of painters, must have made things somewhat difficult for Hals, who was just now finding some interest among the moneyed class but still trying to make his mark in Haarlem and, perhaps, beyond.[8]

*

In December, 1620, Frans, Lysbeth, Harmen, Sara, and Frans Jr. welcomed a new member to the household on Peuzelaarsteeg. Sadly, the child did not live long enough even to be baptized and was buried on the thirteenth of that month.

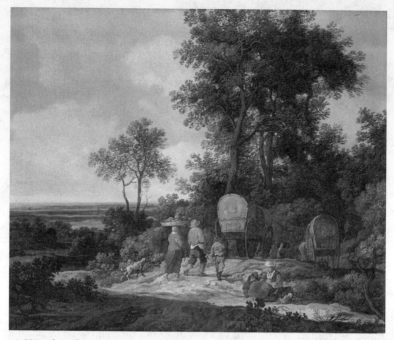

26. Pieter de Molijn, *Peasants Returning Home*, 1647, Frans Hals Museum, Haarlem. Purchased with the support of the Rembrandt Society. Photo: Margareta Svensson.

After a gap of two and a half years—were there more infant deaths?—a daughter, Adriaentje, was born. Standing witness at her baptism on July 21, 1623, was, once again, Lysbeth's sister Hillegond, as well as a Haarlem merchant and writer named Isaac Abrahamsz Massa, who would sit for a portrait by Hals four times.[9]

Then, in December 1624, just a few months after Hals served as a witness at the baptism of his niece Maria, the daughter of his younger brother Dirck, Lysbeth gave birth to a son, Jacob. Another son, Reynier, was born in February 1627—the printmaker and painter Jan van de Velde II, who would make several engravings after Hals's paintings, and the still-life painter Franchois Elout were witnesses at the baptism—and yet another son, Nicolaes, in July of the following year. Like Harmen and Frans Jr., Reynier and Nicolaes would become painters; following in a father's professional footsteps was a typical pattern within artist and artisan families of the period.[10]

With seven children, so far (and more to come), it must have been a rather crowded domestic scene. Their rented dwelling was likely

the typical narrow Dutch house of three or four stories. The family would have spent much of their time at home on the ground floor, which was divided into the *voorhuis* and the *binnenhuis*.[11] The *voorhuis* was a front hall or foyer where visitors were greeted, including Hals's clients; he may also have displayed in this small room paintings he was selling as a dealer. (It was not unusual to find, in some homes, family portraits hung in the *voorhuis*, the better to impress entering guests.)[12] The more spacious *binnenhuis* (inner house) was the family's main living room. Here they took their meals gathered in front of the hearth, which, in addition to providing heat, was where the food had been cooked; separate *keukens* (kitchens) were a luxury rarely found outside the homes of the well-to-do. The adults also had their box bed—a wooden framed chamber or cupboard with a mattress and a curtain—in the *binnenhuis*, while the children slept in rooms on the second and third stories. The young ones did not have proper bedrooms, or *slaapkamers*, but shared beds in rooms that doubled as work and storage spaces, with certainly more than one body to a bed for convenience and for warmth.

If Hals operated like Rembrandt, his studio, where he painted sitters and trained students, was on one of the upper floors, probably at the front of the house to take advantage of the windows and light. Here his younger apprentices could be found carrying out their menial tasks, grinding and mixing the pigments and preparing panels and canvases for the master, while the more advanced ones did some painting of their own. We can imagine, too, Hals's many children finding their way upstairs to run around the easels and, perhaps, get in the way of whatever work was going on.

As for Lysbeth, she would have spent most of her day shopping for groceries and preparing meals, doing laundry, tending to the children, and, above all, cleaning. If she was like other Dutch housewives, the sweeping, mopping, scrubbing, and polishing would have been a never-ending chore. As the French resident Jean Nicolas de Parival noted of Dutch women,

> they find all their glory and happiness in the neatness of their houses. . . . Practically every day they scrub the paving stones,

sprinkle them with sand, and make them so clean that strangers dare not spit on them. If the bourgeois [i.e., town] women take the trouble to keep their houses clean, the women in the villages cede nothing to them, for their cleanliness and propriety extends even to the stables. They completely polish everything, iron rings and fittings, the hinges of windows, and make them shine like silver.[13]

With such a large brood, Lysbeth had her work cut out for her.

In the current economic situation, Hals saw that he was not going to be able to put much food on the hearth and on the table for his growing family by waiting for patronage from Haarlem's citizens. In the ten years since the 1616 painting of the Saint George officers, no new orders for costly group portraits from civic guards or other municipal institutions had come in. It is likely, then, that Hals's turn to genre pictures, as well as to the rough manner in which he painted them, was indeed motivated more by mercenary than aesthetic or programmatic purposes. He joined other painters during the recession of the 1620s in supplementing large, commissioned paintings with smaller works of generic subject matter. These could be done in less time and with cheaper materials—coarser canvas or lower quality wood panels for supports; a more limited range of pigments—and thus turned out in greater number for less expense. The genre pieces and *tronies* were well suited for the open market and could be sold at a price affordable to a broad clientele. In a 1634 lottery list, an unidentified *vanitas* piece by Hals was valued at thirty-four guilders, while two *tronyen* by him were set at sixteen guilders each.[14] As we have seen, such pictures still required great skill and care; despite the appearance of spontaneity, nothing was being tossed off too quickly. But they did not require the long hours working on fine details that the formal, commissioned portraits demanded. What they lacked in smooth and meticulous execution they could make up for in volume . . . and in charm.[15]

There was, in fact, quite an urgent reason for Hals to increase production with cheaper works that could be done at will, without waiting for commissions, and sold fairly readily. The family was falling behind in its bills, and creditors were getting impatient. In De-

cember 1624, Hals was taken to court by the tradesman Jan Jansz for three guilders and six stuivers, which was owed for a "fur jacket [*bont jack*]" that Jansz had provided. In May 1626, Hals's wife, Lysbeth, was sued by the widow of Claes Huygensz, who claimed she was owed twenty guilders for wages and expenses, although the extant legal documents do not specify what service Huygensz's widow had provided. After three court sessions—Lysbeth did not show up for the first session, and the claimant did not show up for the second—the commissioners ruled that the suit should be settled by Lysbeth for six guilders.[16]

In May 1627, Hals was next sued by Cornelis Dircksz, probably a grocer, for seven guilders for "delivered butter and cheese, with expenses." That is a lot for butter and cheese. Hals must have been running up quite a tab. He apparently did not follow up, for two months later Dircksz was suing him again, this time for "costs of additional sums with costs."[17]

From here, debts began to mount. There is the four guilders owed to Abram de Nijsse for "the remnant of delivered goods . . . with expenses" in September 1628. In July 1629, five guilders and seventeen stuivers are past due to the baker Jacob Seijmensz for bread.[18] Just one month later, on August 21, Bartholomeus van Eeckhout is coming after Hals for eleven guilders and seventeen stuivers in wages and expenses for some work; Hals twice failed to appear in court, and so three days later he was being asked to pay Van Eeckhout's legal costs.[19] In October 1630, Hals ignored a court summons once again and did not show up when the widow of Octaef Jansz sued him for five guilders and five stuivers for shoes. In September 1631, Hals is in arrears to the butcher Hendrick Pietersz Gans for a significantly larger amount: forty-two guilders "for the purchase of an ox." When Hals, who again did not appear in court, claims that he has already paid Gans twenty-nine guilders, he is ordered by the commissioners to pay the balance within a month.[20]

Despite the press of creditors—and things will only get worse as time goes on—we find Hals in 1629 coming up with enough money to purchase paintings being sold at auction by his Guild of Saint Luke colleagues Frans de Grebber and Andries Snelling. Since both

of these artists were also art dealers—as we have seen, this was not an unusual arrangement in the seventeenth century; Rubens, Rembrandt, and Vermeer, among others, all engaged in dealing the works of other artists—the items bought from them by Hals may not have been by their own hands. Dirck Hals signed an unconditional bond as guarantor for anything purchased at these sales by "Frans Hals my brother."[21] We do not know whether Hals kept these pieces for his own delight or study, or—more likely, in the face of his financial problems—to serve as stock for his own art dealing, which must have included the cheaper paintings he was now producing.

Dirck, for his part, had been making quite a name for himself as a painter of genre works and the especially the "merry company" pictures that were popular in Haarlem in the 1620s and 1630s. Now nearing forty, Dirck entered the Haarlem Guild of Saint Luke at an even later age than his older brother; he was thirty-six when he formally became a master painter in 1627, after training with Frans as well as with Willem Buytewech. Moreover, it was not only into an art career that Dirck followed his sibling. From 1618 to 1624, he, too, was a member of Haarlem's Saint George civic guard, overlapping in his service with Frans; around the same time, they were both attending meetings of De Wijngaertrancken chamber of rhetoricians.

Dirck's panels—he painted almost exclusively on wood, even late in his career—typically show well-heeled people in fashionable, even elegant clothing enjoying themselves over food, drink, and music. There are rarely fewer than half a dozen people in his paintings, and sometimes as many as thirty, along with some dogs (fig. 27).[22] The setting is either a richly appointed interior—intimate domestic rooms and larger private halls, public spaces such as taverns—or outdoors, in finely cultivated gardens. Many well-off Haarlemmers had country homes within walking distance of the city, where they would retire in nice weather to enjoy nature, tend their vegetable and flower beds, and gather with friends. In Wils's 1646 map of Haarlem, their geometrically laid-out plots can be seen in the surrounding fields. Dirck Hals generally did not do portraits, and his merry company pieces are not documentary records of actual social events. Nonetheless, his works—like those of Esaias van de Velde, an earlier

27. Dirck Hals, *Fête Champêtre*, 1627, Rijksmuseum, Amsterdam.

Haarlem master of this kind of painting—do suggest ways in which Haarlem's more fortunate citizens might have partaken of life's finer pleasures both within and beyond the city walls. (Of course, the message might also be a moralistic one: a warning against the excessive indulgence in just those pleasures in a society that, as Simon Schama has shown, was occasionally embarrassed by its riches.)[23]

Samuel Ampzing, in his 1628 "description and praise" of the city of Haarlem, was not the only writer to admire the "pure little images that Dirck can . . . give us."[24] Houbraken calls Dirck Hals a "lovely painter [*fraai Schilder*]."[25] His works were in demand among collectors in Haarlem and elsewhere. Leiden *liefhebbers*, especially, admired Dirck's "companies." He clearly enjoyed greater popularity there than his brother; his name appears more than twice as often as Frans's in selected estate inventories in that city—more often even than Rembrandt's, who was a Leiden native and formerly had a studio there.[26] No doubt Dirck was well set up to stand surety for his older brother at an art sale.

*

Even in the economic downturn, true portraiture was still in demand, if on a reduced scale, and this remained Hals's specialty. Throughout

the 1620s, as he produced a steady stream of genre pictures, he continued to receive some significant and probably lucrative commissions for individual and, by the end of the decade, group portraits. A family that wanted to economize could pass over large, elaborate, and costly history paintings, including the Old Testament scenes so popular in prosperous Reformed households, but still sit for the less expensive portraits that would impress their peers and reflect their social standing.[27] Indeed, around the time that he was making pictures of laughing children, carousing couples, and stock theatrical characters, Hals found a way to expand his clientele in Haarlem's upper echelons.

The twenty-six-year-old man who posed in 1624 for the painting known as *The Laughing Cavalier*, now one of Hals's most famous and beloved works, clearly came from wealth (plate 8).[28] His flamboyant, richly embroidered doublet—shimmering with golden and red thread—and large cloth hat; the finely woven lace cuffs and collar; and his proud, almost swaggering posture, with one hand on the hilt of his rapier, not so much laughing as smirking as he looks down upon us, all proclaim him to be a very successful and satisfied member of the regent class. Most likely, the sitter—or, rather, the stander, since even in this striking half-length image we can tell that he is on his feet—was the linen and silk merchant Tieleman Roosterman.[29] He was born in Haarlem, although his grandparents had come north from Antwerp, another family among the Calvinist immigrants who, fleeing Catholic oppression under the Spanish, arrived in Holland at the end of the sixteenth century. This Flemish heritage, as well as Hals's edifying visit to Antwerp, may explain the very Van Dyck–like look of this painting, its coloring, setting, and style.[30]

In 1634, Hals will do another portrait of Roosterman, a three-quarter-length canvas in more subdued colors (fig. 28).[31] The magnate is again standing, with his hand on his sword. The expression on his face is no less confident than before, and his clothing still exudes wealth—the felt hat is this time in his hand rather than on his head—but now, as a married man, he is dressed in black. The elaborate display of costume is reserved for his wife, Catharina Brugmans, whom he wed in 1631. In a pendant now in a private collection,[32] she

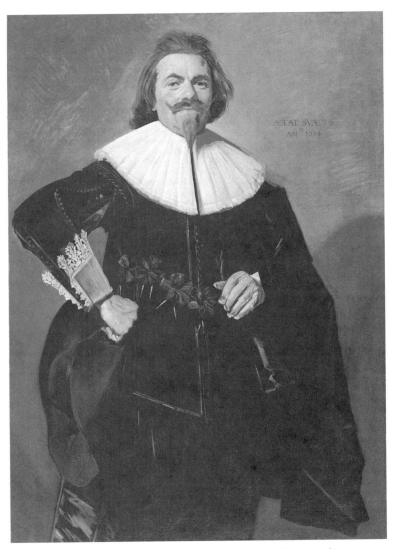

28. Frans Hals, portrait of Tieleman Roosterman, 1634, the Cleveland Museum of Art. Leonard C. Hanna, Jr. Fund, 1999.173, www.clevelandart.org.

appears richly attired, with a large and somewhat out-of-date millstone ruff that sits atop a lace collar that, in turn, matches her long lace cuffs.

One year after painting the *Cavalier*, Hals received his first direct commission for portraits of members of the powerful Olycan family. It was Jacob Pietersz Olycan, Pieter and Maritge's eldest son, and his wife, Aletta Hanemans, who, in 1625, asked Hals to paint a pair

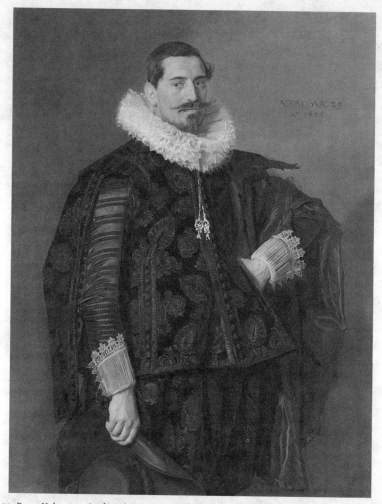

29. Frans Hals, portrait of Jacob Pietersz Olycan, ca. 1625, Mauritshuis, The Hague.

of large, three-quarter-length pendants, most likely to commemorate their marriage that year (figs. 29 and 30).[33] (The wedding ring is prominently displayed on the forefinger of Aletta's right hand.) The groom, who was twenty-nine years old, and the bride, who was nineteen, are both dressed in black, as befits a married couple. However, these are no dull Calvinist garments. Their dark clothing is florally patterned, and the sleeves are made of sheer fabric. Under her cloak is a red silk dress; her stomacher, surrounded by a gold chain, is embroidered with golden threads, which Hals renders in exquisite de-

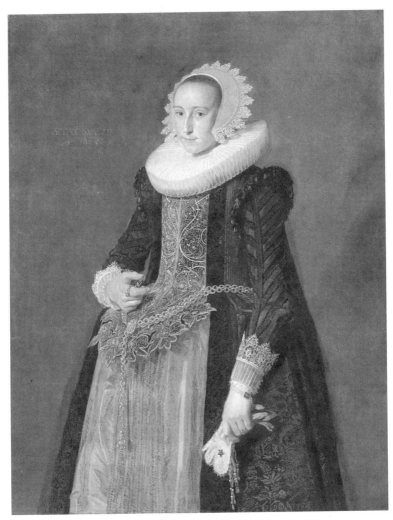

30. Frans Hals, portrait of Aletta Hanemans, ca. 1625, Mauritshuis, The Hague.

tail. Aside from the brushwork on her dress and on her right wrist cuff and on his cuffs and the folds of his cape, there is little trace of the "rough" painterly manner that Hals was now using to build up his genre paintings.

This is a very fashionable, and wealthy, young couple. Among the several breweries founded by Jacob's father, Pieter, are "De Vogel Struys" (a *struisvogel* is an ostrich) and "Het Gecroonde Hoeffey-ser" (The Crowned Horseshoe)—thus the ostrich with a horseshoe in its mouth on the coat of arms behind Jacob, who was now the

owner of the latter brewery. Jacob would live only another thirteen years. After his death, Aletta married a member of another Haarlem brewer family, Johan Claesz van Loo, whose portrait would appear in two later Hals paintings of civic guards: the Saint Hadrian officers in 1633, when he was a captain of one of its companies, and the Saint George officers in 1639, when he had moved up in the world and was that guard's colonel.

Around the time that he was painting the young Olycan couple, Hals also put "the master's touch" to his only full-length, life-size portrait. The large (204.5 × 134.5 cm), flamboyant, magnificent, and costly canvas shows a proud, very well-dressed Willem van Heythuysen (plate 9).[34] We see him—a native of Weert, in Limburg, but now just another one of Haarlem's rich textile merchants—in a pose that is not all that different from Roosterman's posture in his half-length. The Flemish style of its execution, as in Roosterman's *Cavalier* portrait, again reveals traces of Van Dyck's likely influence.[35] Van Heythuysen and Roosterman, both members of the landed gentry— Van Heythuysen had inherited the title "Heer van Edingen" (Lord of Edingen), while Roosterman was the "Heer van Issum"—were close friends. About a decade after sitting for this portrait, Van Heythuysen appointed Roosterman as executor of his will. He will later become engaged to marry Roosterman's youngest sister, Alida, with the banns published in the summer of 1647, when he is in his fifties and she in her twenties. She will die just before the wedding is supposed to take place.[36]

Van Heythuysen never served in the army or even a civic guard, but he poses in Hals's painting with a long rapier—a symbol of his aristocratic status—and holds a stiff, military stance. Like Jacob Olycan, his sleek, satin black suit is far from plain, and its floral pattern, while not nearly as loud as the colorful embroidered pattern on Roosterman, is a nice match for the rosebush beside him. The backdrop of this portrait is unusual for Hals: Van Heythuysen stands outdoors before a red cloth draped over a pilastered entryway. In the background is a pair of lovers in a garden. There is one rose, broken off from the bush, by his feet: a symbol, perhaps, of a lost love.[37]

About ten years after this first portrait, and shortly after Hals ren-

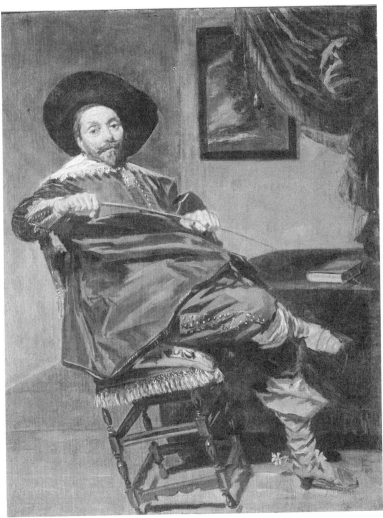

31. Frans Hals, portrait of Willem van Heythuysen, ca. 1638, Musées Royaux des Beaux-Arts, Brussels, Belgium. Credit: Scala/Art Resource, New York.

dered Roosterman for the second time, Van Heythuysen himself sat for the painter once again (fig. 31).[38] This time the visibly older textile magnate's pose is much more relaxed. Seated before his desk, his chair is tipped back as he leans with his legs crossed. He is now holding not a rapier but a riding crop. Hals's painting style is also greatly changed. The bright palette of the earlier picture has been replaced by an overall greenish-brown monochrome; the only touches of vivid color are the red in the cushion on which Van Heythuysen

sits, the blue and yellow tassels of the chair, and the highlighted skin tones on the man's face and hands. Even more noticeable is the brushwork: now much looser, as seemingly casual in its application as the man is in his setting. Where the earlier portrait was in keeping with Hals's finer style for commissions in 1620s, the circa 1635 picture—including the face—is done in the manner formerly used only for the genre pictures. The carefully painted layers of the elaborate ruff collar from the life-size work are here replaced by a more modest flat collar, in keeping with the new fashion, and much more convenient for riding a horse; it is sketched in by a series of strokes made up of lead white mixed with some black and ocher.[39]

Van Heythuysen owned a large house in Haarlem, right on the Oude Gracht (Old Canal) near a tree-lined square. The inventory made after his death in 1650—just three years after the untimely loss of his fiancée—reveals that the early portrait, described as "the effigy or large portrait of Willem van Heythuysen," hung in the great hall for all visitors to see.[40] At the time of the inventory, it had "a swathe of black drapery hanging over it," in mourning for its late owner. The smaller, softer image of Van Heythuysen, which the inventory calls "a likeness of the deceased in small, in a black frame," was kept away in more private quarters upstairs.

Those who liked the way they were rendered by Hals in his unique style often returned for additional sittings, typically with a decade or so in between. This appears to have been a bit of a tradition for some members of Haarlem's business class, especially those of Flemish stock.[41] Around 1622, a recently wed couple commissioned a large, single painting of themselves. The pair—Isaac Abrahamsz Massa and Beatrix van der Laen, a burgomaster's daughter[42]—are shown outdoors, off center to the left in casual postures very much like that of the Van Campen parents (fig. 32).[43] The couple's pose was perhaps inspired by the relaxed and affectionate way in which Rubens depicted himself and his new wife, Isabella Brant, around 1609, a double portrait that Hals could have seen, and drawn, when he was in Antwerp in 1616. Massa, like Gijsbert van Campen, is jauntily slouching back on a rock or tree root while his wife leans into him, with her arm lovingly placed on his shoulder and showing us

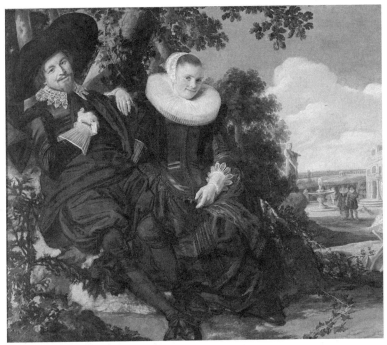

32. Frans Hals, portrait of Isaac Abrahamsz Massa and Beatrix van der Laen, early 1620s, Rijksmuseum, Amsterdam.

the wedding ring on her forefinger. In the lush background are two couples walking in a garden with statues, a fountain, and a number of buildings in classical style. The unmistakable theme here is love: the faithful, lasting love that makes for a happy marriage, reinforced by the pair of peacocks—symbol of Juno, goddess of marriage—in the garden. The happiness of this couple would be cut short in 1639, when Beatrix died, just two years after the death of their daughter.

Massa, who witnessed the baptism of Hals's daughter Adriaentje in 1623, was a family friend. His father, a textile merchant, was from Antwerp; but by 1586, shortly after the city's fall to the Spanish, the family was in Haarlem, as that was the year Isaac was baptized in the Saint Bavo Church. Isaac was often in Russia (Moscovia) on business during the early 1600s, purchasing commodities such as grain and, especially, timber. He was fluent enough in Russian to translate works into Dutch—especially studies of Siberian cartography—and he composed a history of recent political and military "troubles" in

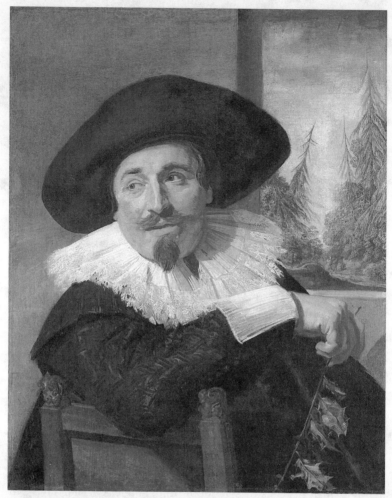

33. Frans Hals, portrait of Isaac Abrahamsz Massa, ca. 1626. © Art Gallery of Ontario, Toronto. Bequest of Frank P. Wood, 1955. Bridgeman Images.

Moscow. He even played a role in establishing diplomatic relations between Russia and the United Provinces.

Four years after painting the couple, Hals did a single portrait of Massa in a rather unusual format (fig. 33).[44] It is a half-length, but rather than depicting Massa head-on or even at a slight angle, he shows the merchant and writer seated, with his elbow slung over the back of the chair and turning to look over his right shoulder—not at us, but at something off to his right. He holds a branch of holly in his left hand and sits before what looks like a window opening out

onto a very northern-looking (Siberian?) forest scene of tall conifer-
ous trees—symbols of this wood merchant's line of work.[45]

This is one of the earliest works in which Hals's "rough" man-
ner is used throughout a formal portrait. The brushwork on Massa's
collar, his coat, and his face—which is modeled from strokes of var-
ied flesh tones mixed wet-in-wet, finished off with a few swipes of
pinkish-rose for the bloom on his cheeks and some strokes of browns
for the shadows under his brows and along his nose—is noticeably
looser than what Hals used for the face of Van Heythuysen from
around the same time.

Even rougher are the pendant portraits on panels from that very
same year of the fifty-year-old, Haarlem-born classical scholar and
poet Petrus Scriverius (Pieter Schrijver) and his wife, Anna van
der Aar (figs. 34 and 35).[46] Scriverius (1576–1660), who was active in
Leiden after attending the university there, was a Remonstrant sym-
pathizer and one of Oldenbarneveldt's partisans; he frequently got
into legal trouble for some of his writings supporting that cause.
But he was also an historian of the ancient Batavians (the name that
the Romans gave to the inhabitants of these lands) and of the mod-
ern Low Countries, as well as an outspoken champion of the Dutch
language. In an age when scholarship written in Latin and French
dominated high culture, and as his new nation was competing for
recognition, not to mention supremacy, among the great powers of
Europe, Scriverius made the case for the beauty and utility of his
native vernacular. As an editor, he brought out works by other Dutch
humanists, including poetry, drama, history, and literary criticism.
He urged fellow Dutch writers to compose in their own language,
not to "cede pride of place to ancient Greek or Roman" but to "spread
your wings now wide."[47]

Scriverius must have been a particular fan of Hals's style. His son
owned six paintings by the painter, which he presumably inherited
from his father.[48] It is quite a *rouw* portrait that Hals has produced
of this man of letters. In the small, oval image, he has made no at-
tempt to distinguish the folds and layers in the sitter's collar, and the
hair and beard are formed from separate strokes of orange, greenish-
brown, and white. The sketchy manner of the work may be because it

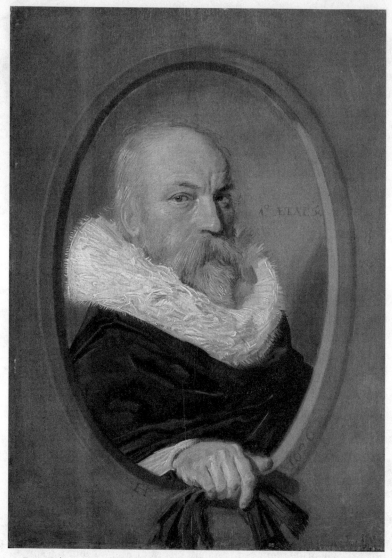

34. Frans Hals, portrait of Petrus Scriverius, 1626, the Metropolitan Museum of Art, New York—H. O. Havemeyer Collection. Bequest of Mrs. H. O. Havemeyer, 1929.

was intended as a painted *modello* for the undated engraving done by Jan van de Velde II. This would also explain the very rough, equally small portrait on panel of Massa that Hals did—his third rendering of the merchant and Russia expert—around ten years after the first solo portrait (fig. 36).[49] Massa, painted very loosely in what is practically just an oil sketch, is now shown as if speaking, with his mouth

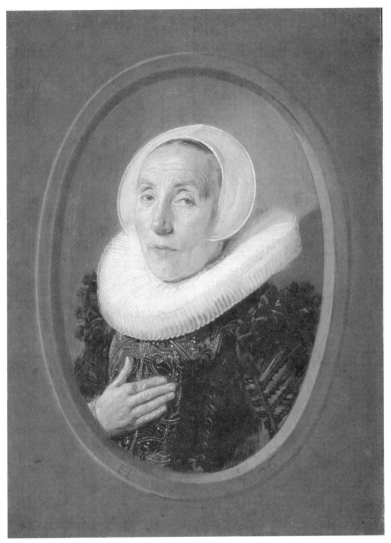

35. Frans Hals, portrait of Anna van der Aar, 1626, the Metropolitan Museum of Art, New York—H. O. Havemeyer Collection. Bequest of Mrs. H. O. Havemeyer, 1929.

open and his hands gesturing. An engraving of this piece was made by Adriaen Matham in the year the original painting was done, 1635.

The same may be true, as well, of the rather rough portrait in 1630 of Scriverius's fellow promoter of Dutch culture, Samuel Ampzing, whom the Leiden classicist aided in composing his poetic encomium to Haarlem (plate 10).[50] You can almost count the number of brush-

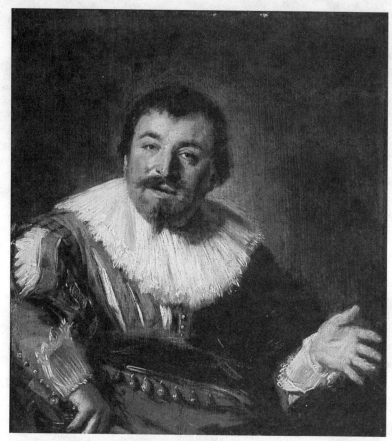

36. Frans Hals, portrait of Isaac Abrahamsz Massa, ca. 1635. © San Diego Museum of Art. Gift of Anne R. and Amy Putnam. Bridgeman Images.

strokes that make up the writer's hand. Ampzing, so generous in his praise of the Hals brothers in his *Beschryvinghe*, which appeared two years before this portrait, was especially impressed by Frans's ability to paint "from life." Hals's small painting of Ampzing on copper plate, which beautifully captures the intellectual spirit of its sitter—he is staring at us with deep concentration as his finger holds his place in a book—served for an engraving by Jonas Suyderhoef. Suyderhoef's print may reproduce Ampzing's intensity, but it does not have the vitality of the impressionistic original. Hals applied the paint to the portrait in such a way that the man, and even the plate on which he is depicted, seems to pulsate with energy.

The 1626 solo painting of Massa in his chair, on the other hand—

a much larger work on canvas—is not, as far as we know, prepara-tory for anything. What it shows is that Hals may have had enough success with his genre works that he suspected that the loose brush-work he used on them could serve just as well for portraits, if not yet in as forthright a way. Hals's visible painterly touch, that "sig-nature style," would become a kind of personal mark that both dis-tinguished his paintings from those of contemporaries and allowed patrons and collectors to show off their sophisticated connoisseur-ship and appreciation of virtuosity, of the bravura skill with paint and brushes needed to create such pieces.[51] The choice to expand his rough manner to portraits, like the turn to genre painting in the first place, might thus also have been driven as much by marketing strat-egy as by artistic vision.

<div align="center">*</div>

Portraiture was, in one sense, the most personal of all early mod-ern genres. A solo portrait from the period depicts a specific hu-man being: a token, not a type.[52] Done well, it captures the sitter in his or her unique individuality, not just physical appearance but, in the hands of a true master, perhaps something of their personality as well. Rembrandt, of course, has been rightly celebrated for this. As Constantijn Huygens, writing around 1630 in a memoir of his youth, claimed, "[Portraiture is] that branch of art that is the won-drous compendium of the whole man—not only man's outward ap-pearance but in my opinion his mind as well."[53] If the sitter remains unknown to us today, and even allowing for the idealizing improve-ments in appearance that vanity may require, contemporaries famil-iar with him or her at least should have been able to see who it is.[54]

Portraiture could also be the most *impersonal* of early modern genres. Of the many ways of applying emulsified pigment to panel or canvas, portrait painting—for the painter but also for the viewer— had the most potential to be anonymous and uninteresting. The art-ist was not recreating some familiar and meaningful story from the Bible, a dramatic turning point in history, or the heroic accomplish-ments or salacious doings of mythological figures. While in the pro-cess of representing a subject the painter may have taken the oppor-

tunity to show off his or her skill at rendering the play of light on fabric or introduce meticulously detailed studies of fruit or flowers, these were typically ancillary to the main project.[55]

A mediocre, uninspired portraitist was just painting faces and bodies and clothes, as realistically as possible, investing his or her work with little of their own spirit. After all, a client had very particular needs and expectations. They wanted to see themselves, and—just as important—for others to see them. Where, then, was there room for the painter to exercise some creativity, to separate him- or herself from all the other workaday portraitists doing practically the same thing? Perhaps in the pose or setting? Even the greatest of seventeenth-century Dutch portrait painters are, to the untrained eye, hard to distinguish one from the other. It takes study to be able to tell a Verspronck from a Soutman, a Pickenoy from a Cornelis van der Voort, or a Van den Valckert from a De Keyser.

But here was Hals's genius. He took on portraiture and owned it. When you walk through a museum and enter the gallery devoted to the Dutch Old Masters, you may be unmoved by all those homogeneous portraits of anonymous or indistinguishable people by anonymous or indistinguishable artists. But if you should happen to come upon a portrait by Frans Hals, you immediately recognize (even if you cannot name) the artist before whom you are standing. When Hals transferred the technique that worked so well for genre paintings and *tronies* to the portrayal of the good citizens of Haarlem—its merchants, its scholars and poets, its civic guards and its churchmen—he, well before Rembrandt, not only gave new life to an old genre: he reinvented it.

It took time to develop. Hals was not yet ready to abandon completely the "smooth"—or, in his case, smoother—manner in his portraits. He would continue to put in the effort for the fine rendering of faces and other details well into the 1630s, as we can see in a pair of pendants on large panels from 1631 of Nicolaes Woutersz van der Meer and his wife, Cornelia Claesdr Vooght (figs. 12 and 13).[56] Nicolaes, one of the captains in Hals's 1616 group portrait of the Saint George officers and, as we saw, among the regents carried over by Maurits in the coup of 1618, and Cornelia, the sister-in-law of Pieter

Olycan, are shown in rather staid poses, as befits these members of notable local brewer families. There are some trademark Hals features: Nicolaes's beard and collar, the fur trim on Cornelia's cloak, and their clothing and hands are all executed somewhat roughly. But Hals clearly took great care in the blending of colors to build up their only slightly animated countenances. These are portraits in the classic style, with a nod (in the case of Nicolaes) to a posture—standing by a gilded leather chair—first used by Rubens and then by Van Dyck.[57]

Not long after completing the likenesses of Nicolaes and Cornelia, Hals would abandon genre painting altogether and devote himself solely to portraits, over time fully adapting for these the rougher treatment of paint that he had reserved for all the anonymous drinkers, musicians, merry couples, and smiling children, not to mention the popular characters from Dutch theater and literature "Peeckelhaering" and "Hans Worst." When the stalled economy begins its recovery in the early 1630s, more commissions will start coming in. There would still be a few *tronies*, including the "fisher children" series. And what for us may be Hals's most indelible image, the oft-reproduced painting (including a copy in the nineteenth century by Gustave Courbet) now titled *Malle Babbe*, is from the mid-1630s (fig. 37).[58] This very loosely painted, even sketchy work on canvas shows a cackling, dissolute old woman with an owl perched on her shoulder and a very large tankard of ale in her hand. There was, in fact, a woman called Malle Babbe—nicknamed "The Witch of Haarlem"—in the city's workhouse under public charity in 1653.[59] But whether this is a portrait of her or just a random caricature is uncertain. What it is, as far as we know, is Hals's last genre piece.

*

In May 1626, perhaps around the time that Hals was painting the first single portrait of Isaac Massa, his wife, Lysbeth, was undergoing a painful treatment for what her sister Hillegond called "a certain wound or accident that she had on the right side of her face." The cause of what was apparently a burn is unknown, but Lysbeth called on a woman named Hendrickje Wetselaers to have it treated. Hendrickje gave her a salve that not only did not heal the burn, but

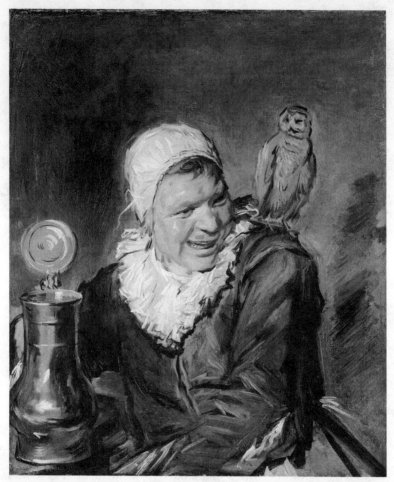

37. Frans Hals, *Malle Babbe*, ca. 1633–35, Gemäldegalerie, Staatliche Museen, Berlin, Germany. Credit: bpk Bildagentur/Staatliche Museen, Berlin. Photo: Jörg P. Anders/Art Resource, New York.

made the condition even worse. According to testimony given to a notary by Hillegond and a surgeon named Adriaen Wath, Lysbeth complained to Hendrickje about the "extreme pain and filth that she was experiencing night and day"—the "filth" must have been pus from infection—and told her that, as a result, she could not sleep. Hendrickje, who clearly was a bit of quack, was unsympathetic. She defended herself by claiming that when she used the salve on small children there was no problem, that "they could sleep if they took her medicines, which she had made for the curing of such accidents."

She said she did not know what Lysbeth was talking about and that "the devil must be at play here."[60]

The surgeon Wath told the notary, Jacob Schoudt, that by the time he visited the Hals home and saw Lysbeth's condition "mortification had set in," and that he informed Lysbeth that she should expect "even more pain, filth and discomfort" if she were to continue using Hendrickje's treatment. Hendrickje tried to pass the blame on to the woman from whom she got the recipe for the salve. For on the same day that Hillegond and Wath gave their testimony to notary Schoudt, a young textile worker, Roelant Laurensz, also swore to the same official that Hendrickje had learned how to make the salve from his mother; he insisted, though, that "she [Hendrickje] did not use the same salve but must have added to it"—that is, changed the ingredients in such a way that it caused Lysbeth her suffering. Roelant claimed that his mother was not at fault and that Hendrickje was wholly out of her depth. As further evidence of the woman's guilt, he related how once, when he went to see Lysbeth's wound—"for scientific reasons," he claimed—who should come through the door but Hendrickje. However, "as soon as she heard that he [Roelant] was in the house, she dared not enter, but immediately went away."[61] Clearly the sign of a guilty conscience.

As Hals was comforting his wife during her misery, he was also dealing with the illness and death, and subsequent legal issues, of his younger brother Joost. Joost was, if not a complete ne'er-do-well, then something of a troublemaker who led a less than stellar life. Like Frans and Dirck, he was a painter of portraits and genre scenes, although no works by his hand have yet been identified with certainty. When he was around twenty-three years old, he was hauled before the Haarlem magistrates for having assaulted a city official. The *burgemeesters'* record book indicates that on June 21, 1608, "Joost Hals, from Antwerp, yesterday evening approached the watch and hurt one of the guards on the Kleine Houtbrugge [the bridge crossing the Oude Gracht on the Kleine Houtstraat] with a stone to his head." Joost was ordered to pay three guilders to the injured watchman as reparations and compensation for lost pay during his recuperation.[62]

Like Frans, Joost also had difficulty keeping up with his creditors.

In November 1619, Joost—now identified in the record as a *schilder*, painter (but not *mr. schilder*, or master painter)—is in arrears to the tune of five guilders and fourteen stuivers to the widow Knyer Dircx for "consumed goods," food and drink. When he protests that he owes her only six shillings (a *schelling* is worth six stuivers), he is ordered to pay up at least that amount, and the court asks for some evidence regarding the remainder. (It is not clear whether the magistrate wants proof from him that he does not owe Dircx any more or from Dircx that he does indeed owe her more.)[63]

A few years after this legal tussle, Joost put an attachment on the "estate and goods" of Karel van Mander the Younger, the son of the painter and writer who was Frans's teacher and a moderately successful artist in his own right. Van Mander fils had died in February 1623, and Joost immediately stepped forward with a claim as one of his creditors. The nature of Van Mander's alleged debt to Joost is not known. (The fact that the younger Van Mander lived, worked, and died in Delft, while Joost lived in Haarlem, only adds to the mystery.)[64] Nor did Joost ever get what he thought he was owed. The records of notary Schoudt reveal that on October 16, 1626, "Frans Hals, master painter and citizen of this city, acting for himself and standing in for Dirck Hals, his brother, as joint heirs of their late brother Joost Hals," declared that they are now "renouncing and quitting" any claims and attachments that Joost had levied on Van Mander's estate. Joost must have died shortly before Frans and Dirck took this step. If their brother did have a legitimate claim on Van Mander, then, given Frans's unstable financial situation, it is surprising that, as one of Joost's heirs, he did not pursue the matter. Perhaps Joost's original action was frivolous; or maybe Frans and Dirck saw that the funds their brother was expecting were just not worth the legal costs of retrieving them.

Joost's whole estate, such as it was, could not have been worth very much at the time of his death. No matter, as Hals's ten-year dry spell for lucrative public commissions was about to come to a profitable end.

*

In late 1622, Haarlem's two civic guard companies—the Saint George crossbowmen and the Saint Hadrian arquebusiers—had experienced some unusual, but ultimately uneventful, activity. Soon after the resumption of the war with Spain, they were sent off on military duty. In the fall of that year, while Prince Maurits was still stadholder and commander of Dutch forces, he needed fighters to help lift Spinola's siege of Bergen op Zoom, a town near the border with the Spanish southern Netherlands and not far from Antwerp. For this dangerous task he called upon mercenaries who had been stationed in a garrison in the town of Hasselt, in Overijssel. The Haarlem civic guards, in turn, were sent to Hasselt, about 175 miles away from home, to take the place of the absent soldiers. The guardsmen remained quite far from any battlefield, though, and did not see any combat.

A second military mission came their way a few years later, when Spinola began his siege of Breda. Maurits this time brought in Dutch troops stationed in Heusden, near 's-Hertogenbosch, to try to repel the Spanish army. Civic guards from Haarlem and The Hague were dispatched to Heusden to stand in for the professional soldiers in protecting that town from foreign forces to the east. Once again, it was a safe assignment and, in the end, no real fighting was required. (As we have seen, the Dutch effort to save Breda failed when, after three and a half decades in Dutch hands and ten months of resistance, it fell back to the Spanish.)

The Saint George and Saint Hadrian officers who oversaw that caretaker mission to Heusden finished their three-year terms in 1627. Upon being relieved of their duties, each group turned to Hals for a portrait to hang in their headquarters to commemorate their honorable service (plates 11 and 12).[65] The colonels, fiscals (provosts), captains, lieutenants, and ensigns are shown in the paintings—like the Saint George officers from 1616—as if at the celebratory banquet that the city customarily threw for retiring officers. While the men in both portraits are dressed mostly in black, their white collars, orange and blue sashes, and red-stripped banners make for a colorful tableau. The room of the Saint Hadrian officers is filled with natural light coming in from two windows; this gives the painting a clear, bright, almost shimmering atmosphere.

Like the earlier civic guard portrait, each of these new works shows a lively gathering, with plenty of motion, gesture, and mutual engagement. Some of the men look out at us while others are turned toward their colleagues, perhaps reminiscing nostalgically about their recent quasi-military adventure. The 1627 banquets are certainly not as staid as the meal that the Saint George officers enjoyed in 1616. There is less food and more drinking. And whereas in the earlier painting pretty much everyone is seated, now half the men are standing as they reach over each other for something to eat or for a glass to be filled. (At the front of the 1627 Saint George group, having drained his glass and now holding it upside down, sits Captain Michiel de Wael, whose single portrait Hals had painted two years earlier.)[66] While the two new pictures seem to show crowded gatherings of randomly posed men, both scenes are carefully balanced horizontally. Moreover, the participants are, once again, ordered according to rank, with the colonel and fiscal at the far left, captains in the middle, and lieutenants on the right. There is also a nice place for the dog that the Saint Hadrian colonel has brought along for the meal.

Hals's future sitter Samuel Ampzing, who had so much praise for the Hals brothers in his literary tribute to Haarlem, saw the Saint Hadrian painting soon after it was made, when it hung in the guard's headquarters in the Oude Doelen (Old Shooting Hall). He heartily approved its execution. Writing in 1628, he notes that the "great piece" is "very boldly done after life."[67]

*

By the late 1620s, with these civic guard portraits, as well as a number of single and double portraits, Hals had less and less need for producing paintings on spec for the open market. Among the private commissions are *conterfeytsels* of the Haarlem preacher Johannes Acronius,[68] who died shortly after he sat for Hals, and the Voorschouten theologian Michiel Jansz van Middelhoven.[69] Both of these men were conservative Reformed ecclesiastics with patent Counter-Remonstrant credentials. But Hals really did not care much about the religious persuasion of a client. He painted Counter-Remonstrants,

but he also painted Remonstrant sympathizers; he painted Catholics, he painted Mennonites, and he painted Huguenots. For all we know—so many of his portraits are of unidentified sitters—he also painted Jews. Haarlem did not have a Jewish community of its own. It had rejected a petition from "Portuguese merchants" to settle there in 1605, mainly because there were not enough of them to meet the minimal number set by the city for establishing a synagogue. But the larger, more established, and relatively well-off Portuguese-Jewish community in Amsterdam had the financial resources, the social awareness, and the desire for portraits. We know this because several of them turned to Rembrandt for just this service.

By far, the real coup for Hals in these years—at least in terms of individual sitters—was a commission for pendant portraits of Pieter Jacobsz Olycan, *pater familias* of the brewer clan (plate 13), and his wife, Maritge Claesdr Vooght.[70] When Hals painted them, probably around 1629, Pieter was at the end of one of his many stints as Haarlem alderman (*schepen*) and about to assume the first of his five terms as *burgemeester*; in a couple of years, he would be Haarlem's representative to the States General.[71]

This is the first of two sets of portraits that Hals would make of this most distinguished couple. While Pieter was originally shown in three-quarter-length, the wood panel was at some point cut down and now presents its subject in a bust format. Despite the relatively small size of the painting in its current form, the beer magnate, at this point in his late fifties, comes across as a rather imposing figure, not someone to be trifled with. With a broad chest clothed in a fur-lined cloak, he exudes confidence and power as he glares down at us.[72] This is a proud man—presently the colonel of the Saint Hadrian civic guard—who knows his place in the world. The featureless background, a mottled gray, brown, and tan, serves only to highlight Olycan's silver hair and beard and his ruddy face. Hals painted the large collar in swirls of white, and the tufts of fur in short black and gray strokes. He took care with the details of the brewer's face, however, departing from his rough manner only enough to show us the unmistakable visage—knitted brow, sharp eyes, tight mouth—of a serious and successful man of business. A somewhat less severe Maritge, in

white cap and also wearing a fur-lined garment, has a large, starch-stiffened millstone ruff around her neck. A sartorial item that was frequently the object of opprobrium by conservative Calvinists for its ostentation, such oversized neckwear was already on its way out of style. Maritge, a model of piety, holds up a clasp-closed book—a family Bible, perhaps—chest high in her right hand.

<center>*</center>

Olycan could afford to pay Hals well for these paintings, and the painter must have set a premium price on them. (It was not unknown for artists to set the fee for a portrait based on what they thought the sitter could pay.) Still, the debts continued, as they would throughout Hals's life. But at least he was able to supplement the income that came from portrait commissions and sales of genre pictures by taking some additional jobs on the side, both for the Guild of Saint Luke and for the city of Haarlem.

This kind of extracurricular work was not unusual for Dutch artists. The guild or the municipality often called upon painters to do things other than paint and train other painters. They might ask them to assist in adjudicating claims among artists or resolving disputes between artists and patrons. These were typically administrative matters, such as deciding whether a master painter was engaging in some unfair business practice or determining whether an apprentice has violated his agreement with a master. Their expertise might also be requested to appraise the value of a painting or help identify artist or subject matter when the collection in a lately deceased individual's estate was being inventoried.

Sometimes, though, a professional aesthetic judgment was needed. In 1654, Diego d'Andrade, a member of Amsterdam's Portuguese-Jewish community, filed a complaint with a public notary about the portrait of "a certain young girl"—presumably his daughter—that he had commissioned from Rembrandt and for which he had paid an advance of seventy-five guilders. The still unfinished painting, d'Andrade insisted, "shows no resemblance at all to the appearance or face [tronie] of the young girl." D'Andrade, familiar with Rembrandt's style, may have had some suspicion that

this would happen, since he claims he had given Rembrandt "suffi-cient warning beforehand." He now asks that Rembrandt be ordered "to alter and retouch the painting or portrait . . . so that it will be her proper likeness." If the artist is not willing to do this, then he should keep the painting for himself and refund the money. Rembrandt, not surprisingly, refused both options—not out of artistic integrity, but only because he would not do anything to the painting until "the claimant pays him the balance due or guarantees full payment by giving a security." The painter insisted, as well, that it was essen-tially his word against d'Andrade's as to whether or not the portrait looked like its subject. He thus suggested that, once he has finished the painting, the matter be put to "the judgment of the board of the Saint Lucas Guild whether the painting is a likeness of the girl or not." If they decide it is not, then he will change it as necessary; and if d'Andrade is still not satisfied, then he will keep the painting for himself and sell it at a future auction.[73]

Hals's work for Haarlem did not involve anything so rancorous. In 1629, he made good money, twenty-four guilders, for *verlichten ende veranderen*—literally, "enlightening and altering"—some paintings that once belonged to the local chapter of the Knights of Saint John but had been confiscated by the municipal authorities, along with other art from Catholic churches and cloisters, after the city became a Reformed stronghold.[74] The works now hung in the Prinsenhof, the local residence of the stadholder that also functioned as a kind of public gallery, and were in need of cleaning and restoration.

That same year, Hals was summoned once again by the Haar-lem regents, this time to assess whether a cell in the *werckhuys*—the house of correction—could reasonably function as an artist's studio. The still-life painter Johannes Symonsz van der Beeck, also known as Johannes Torrentius, was serving a sentence for (allegedly) being a member of the Rosicrucian Brotherhood. This was less a real broth-erhood or formal society than a diffuse movement of like-minded thinkers involving esoteric religious views. Rosicrucians, who were said to have never identified themselves as such, claimed to be the inheritors of a secret wisdom combining mysticism and gnosticism. They were vilified as "atheists," even "satanists," by mainstream

Christian churches and their ideas were banned throughout Europe. Of course, not everyone accused of being a Rosicrucian was one, but Torrentius raised enough suspicion that he was confined to the workhouse and his paintings burned. He apparently insisted that he should be able to continue to earn a living, or at least keep in practice with his craft, while incarcerated. Thus, Hals, along with two other artists from the guild—Pieter de Molijn and Jan van de Velde II—were asked "to inspect the suitability of the chamber of Johannes Torrentius in the workhouse of this city for painting and to provide the magistrates with a report and written advice."[75] Their report is lost, so we will never know whether Torrentius was able to set up his easel in his cell.

*

When, in 1621, the war for independence had resumed and commerce between the Dutch Republic and the southern Netherlands had fallen off, a number of Holland's cities and towns that depended on trade with the south—and, by extension, the Spanish colonial world—were affected hard. By the end of the decade, they were urging for a negotiated peace. Amsterdam, Rotterdam, and other entrepôts where business relied heavily on shipping were especially anxious to see maritime embargoes ended. Other Dutch cities, however, benefited from the wartime blockades that the Republic had laid on Flemish ports, including those whose economies depended heavily on textile production, and thus they welcomed the lack of competition from the south. The local industries of Haarlem and Leiden, in particular, managed just fine in this period.[76]

Despite the barriers to free trade and the difficulties of crossing the border between the southern and northern Netherlandish provinces, someone with the right credentials could nonetheless travel easily. And no one had better credentials than Peter Paul Rubens. The great Antwerp painter was sick and tired of the drawn-out war, and especially what it had done to his beloved hometown. Writing to a friend in 1627, he notes that "we are exhausted and have endured so much hardship that this war seems without purpose to us."[77] Rubens

was especially frustrated with Philip IV's intransigence; the Spanish king was not willing to make the concessions needed to bring peace. "If Spanish pride could be made to listen to reason," he insisted, "a way might be found to restore Europe."[78]

European peace was one of Rubens's driving ambitions. Thus, in July 1627, despite his reluctance to travel in wartime but having secured a "safe conduct" pass, he made his way back to the north. The pretext for the journey was negotiations with Ambassador Carleton for the sale of Rubens's collection of ancient marble statues and some paintings to the Duke of Buckingham. Rubens also wanted to tour Holland's leading art cities and visit the studios of artists, to see what they were doing and to engage in some picture buying of his own. In truth, it was primarily a diplomatic mission. Rubens had been involved in treaty negotiations between Spain and England, but these were stalled. Some of the participants now hoped to get things moving again, in part by bringing in the Dutch and concluding a three-way alliance, with France left to its own devices. The sticking point for the Dutch was sovereignty. Any negotiations involving Spain had to lead to independence. But Rubens figured that if the Dutch were granted de facto independence, they might drop their demand for more formal recognition. As Rubens puts it in a letter to Balthasar Gerbier, who would be his traveling companion to the Republic, the States General "want to possess in name what they have in reality."[79]

In the end, the diplomacy came to naught. Despite the initiative from the Spanish regents in Brussels, Rubens did not have official authorization from Philip IV for the negotiations—thus the need for an art-buying cover story. In fact, he never even made it to The Hague, where the stadholder held court. This was too bad for both parties, as Frederik Hendrik, with several of Rubens's paintings in his collection, was clearly a great admirer.[80]

On the other hand, the art tourism was a great success. Rubens managed to renew his acquaintance with Holland's painters and graphic artists on a grand scale. His first stops in the north were in Rotterdam and Delft, then a couple of days in Amsterdam. These

were followed by a very productive stay in Utrecht. The German painter and art chronicler Joachim von Sandrart was an assistant in the Dutch Caravaggist Gerrit van Honthorst's studio there at the time of Rubens's visit. Rubens expressed admiration for a painting Sandrart was working on, and so the young man was engaged to show the guest of honor around the city. They went to the studios of Abraham Bloemaert, Hendrick ter Brugghen, and Cornelis van Poelenburgh, among others. Then, to give Rubens a proper farewell, Van Honthorst threw a banquet to which he invited Utrecht's leading artists and other local luminaries.

Sandrart ended up accompanying Rubens on his remaining travels through Holland. In a volume published in 1675, he reports that Rubens met "many and excellent painters of whom he had heard and whose works he had seen." From Utrecht the party "travelled first to Amsterdam and other places in Holland where, within fourteen days, he [Rubens] saw everything that was praiseworthy."[81] The Flemish master was mightily impressed, especially with the art of Utrecht.

> Among others he highly praised on this journey Van Honthorst's perfect manner of painting, especially night pieces; Bloemaert's noble draughtsmanship and Poelenburgh's well-proportioned small figures which were accompanied in Raphael's manner by delicate landscapes, ruins, animals and some such, and of which Rubens commissioned several examples.[82]

Sandrart does not mention a visit to Haarlem. But given that city's high reputation for art, it is hard to believe that the group did not make a stop there, if only for a day. And if there was a layover in Haarlem, Rubens would have been directed to the studio of its now celebrated portrait painter, someone whom he had met ten years earlier when a less-accomplished Hals visited Antwerp.

All in all, just another episode in what the art historian Gary Schwartz has called "a Low Countries artistic culture that covered all seventeen provinces of north and south"[83]—a culture that, despite the religious differences that gave Dutch and Flemish art their respective flavors, paid very little respect to geopolitical borders.

CHAPTER 7

Debts and Disputes

One of the broad streets leading into the market square around the Saint Bavo Church in the center of Haarlem is the Smedestraat. In the 1630s, when it was called Smeestraat, several of Hals's sitters lived here, including Paulus van Beresteyn and the "laughing cavalier," Tieleman Roosterman. It also was the site of the tavern and inn "De Coninck van Vranckrijk" (The King of France). This establishment was for decades a popular watering hole for members of the city's regent class; Job Gijblant was a regular.[1] It also accommodated the artists who portrayed them. No doubt many a deal was made between patron and painter over drinks and victuals at one of its tables.

Among the members of the Guild of Saint Luke dropping in from time to time would have been Adriaen Brouwer, a peripatetic painter from Flanders who spent several years in Haarlem in the 1620s and early 1630s, and the prolific Adriaen van Ostade, a Haarlem native.[2] Houbraken says that both Brouwer and Van Ostade trained with Hals, although their styles, very much alike, are quite different from his.[3] Hals is supposed also to have done a portrait of Van Ostade, one of his late works.[4] Both Brouwer and Van Ostade devoted their careers to genre painting, with a special gift for "low-life" scenes, often set in ramshackle homes, barns, and stalls, but especially in taverns and inns. These latter pictures show peasants gathered around long, heavy tables, sitting on chairs, benches, and stools, although some stand at a counter where the barmaid fills ceramic pitchers with beer. There is food, too, although drinking is clearly the main item of business. As these men and women while away the time with cards and board games, the air fills with smoke from their long-stemmed

clay pipes. The stench in the air, from tobacco and whatever these country folk might have brought in from the fields and roads on their clothing and shoes—at a time when personal hygiene left much to be desired—must have been quite overwhelming.

The scenes conjured by Brouwer and Van Ostade are, of course, totally imaginary—entertaining, perhaps moralizing, fictions "to instruct and delight."[5] Yet villagers around the Dutch countryside must have spent many hours in establishments very much like the ones we find in their paintings and drawings. Haarlem's The King of France might not have been all that different from these rural pubs, although in the heart of the city it must have been quite a bit cleaner and better furnished, and less malodorous.

It also catered to a more refined clientele, both in terms of socio-economic status—it is hard to image a Job Gijblant patronizing one of Brouwer's places—and in terms of aesthetic taste. The tavern's steady customers over the years included Hendrick Goltzius, Frans de Grebber, the still-life specialist Willem Claesz Heda, the marine or seascape painter Cornelis Claesz van Wieringen, and Jacob Matham, the engraver who did occasional work for Rubens.[6] They and their colleagues from the Guild of Saint Luke often traded finished works for beer and wine. When an early owner, Nicolaes Anthonisz, died in 1613 he had a decent collection of twenty-seven paintings and prints throughout his house, not to mention a number of accounts in arrears from his artistic clientele.[7]

The King of France was also where Frans and Dirck Hals could often be found quenching their thirst after (or during) a day of painting. The brothers were on quite friendly terms with the present owner, Hendrick Willemsz den Abt. They helped him out by serving as witnesses for him in March 1630, when he testified before a notary that one Jan Pieckeyen, a local landlord, had been arrested in Den Abt's home by the city's bailiff a year earlier. Pieckeyen's offense is not recorded.[8]

Den Abt had on hand an even larger store of art than the tavern's previous owner. When he applied to the city's *burgemeesters* for permission to hold an auction, he submitted to them an inventory of over eighty-five paintings and a dozen drawings that he hoped

to sell. It was an impressive list. They were mostly Haarlem artists, past and present, both established names and up-and-coming young masters. (In the first half of the seventeenth century, Haarlemmers favored the hometown talent. As the art historian Pieter Biesboer has shown, the paintings that appear in the estate inventories of Haarlem residents in this period are almost exclusively by the city's own artists.)[9] Den Abt's catalog included a pair of paintings by one of the Van Ruisdael brothers, listed without a first name (it is either Salomon or Isaack) and without mention of genre but undoubtedly landscapes; a Jan van Scorel; two landscapes by Esaias van de Velde; and "two large canvases" by the marine painter Cornelis Verbeeck.

He was also offering to bidders four original paintings by Hals: one work without any specification as to format or subject; "2 ronden" (oval panels), probably *tronies*; and one of the jolly genre pieces from the late 1620s, *Peeckelhaering*. In addition, Den Abt had "various copies after Frans Hals," testifying to the popularity that the painter now enjoyed; after all, no one makes or buys copies of paintings by a nobody. Den Abt, moreover, seems to have acted as an agent for the Hals family at large. Also on his list were "6 pieces by Dirck Hals," "various copies after Dirck Hals," and "five pieces by the young Hals," presumably Frans's son Harmen, now twenty years old.[10]

Whether Den Abt owned all of these pieces or was selling some on consignment, he was catering to various levels of the market: wealthy *liefhebbers* looking to score a masterpiece (such as the Van Scorel) and middle- to lower-class clients in search of something cheaper, either an anonymous "Brabant landscape"—Den Abt had twelve of these—or a small genre portrait, or one of the unattributed copies of something by somebody.[11]

*

If you wanted to buy art in the Dutch Republic, you had a number of options. You could go directly to the artist's studio and either commission something new—typically, this would be a portrait or a history painting—or select a finished panel or canvas or a work in progress from the stock on hand. You could also go through a dealer, who might show you things by a variety of artists, both Dutch and

foreign. Haarlem had its coterie of professional dealers, mostly men originally from the southern Netherlands, like Hendrick Lodewycksz Noe and Johannes Coelembier.[12] But art dealing was a sideline for many other professions as well: wine merchants, innkeepers, booksellers, and artists all sold paintings. Den Abt, for one, was obviously supplementing his income as a tavern owner by selling art.

A less intimate, and assuredly less expensive, approach to purchasing a painting would involve visiting one of the weekly markets or attending a fair, where artists from the local guild would have their wares on display in a stall. In Haarlem, there were also the semiannual "free market" days. On Saint John's Day (June 24) and Saint Luke's Day (October 18), artists and artisans from anywhere could come to the city and sell what they wanted.

An important part of the broad secondary market for paintings was auctions, such as the one held by Den Abt. Some of these were public art auctions held under the auspices of the city or the Guild of Saint Luke and were often intended to raise money for charitable organizations. The Haarlem Home for Destitute Children, an orphanage housed in what was in Catholic times the Convent of Mary Magdalene, received a good deal of funding in this way. But one could also pick up some art, often at reasonable prices, at the estate auctions of the recently deceased. Unlike auctions today, which usually start with a set minimum value and then use bidding to drive the price upward, Dutch auctions began with a top price that was lowered until someone offered to pay it. This worked in favor of the collector but against the artist if no one was willing to make a bid until the price got rather low.[13]

Another way for a burgher to acquire paintings—one that was more problematic, at least in the eyes of the clergy and some members the guild—was a lottery.[14] The city of Haarlem sponsored lotteries of various sorts to generate funds for public projects. Money raised by a municipal lottery in 1606 was used to support the building of the Old Men's Alms House. But officially, and partly under pressure from the more orthodox wing of the Reformed Church, which frowned on gambling, the magistrates forbade private lotteries. In typical Dutch manner, however, the city council often turned

a blind eye to these affairs, and lotteries—sometimes held in inns outside the city walls, beyond the council's jurisdiction—took place in what one scholar has called "the twilight zone of regulations."[15] Indeed, some members of the *vroedschap* were known to collude with artists or dealers in organizing private lotteries.

Selling art by way of drawing lots was an old Flemish method. It arrived in Haarlem toward the end of the sixteenth century with the émigré dealers and artists from the southern provinces. In an art lottery, the organizer buys up or takes on credit a stock of paintings, as many as several dozen, at less than their full market value. He then either has them appraised by the guild or does it himself. Next, he sells lots, with more lots available than there are paintings, and at a price per lot gauged according to the total appraised value of the collection. In this way, a profit is guaranteed. For example, if the organizer bought (or was consigned) all the paintings for 500 guilders, but as a result of appraisal their market value came to 1,000 guilders, he might aim to sell one hundred lots at ten guilders apiece, for a gain of 500 guilders. (This would actually be an unusually high price for lots, making for a very exclusive lottery; but even less expensive lotteries, where tickets cost between two and six guilders, were not within the budget of most citizens.)[16]

There was risk on both sides, of course. The organizer of the lottery might not sell enough lots, although this was unlikely; and if it did happen, he could always call off the lottery and either return the paintings to the artists or keep them for later sale. For the buyer, his lot might not come up in the drawing, in which case he left the lottery empty-handed; or he might end up with a painting that was appraised at less than the cost of the lot. On the other hand, he could conceivably walk away with a work of art worth several times what the lot (or lots) cost him. As an added incentive to join the lottery, those who bought multiple lots were often treated to a special premium—perhaps a meal or a free painting.

Few artists were above selling their paintings through the lottery system. Hals, for one, eagerly took advantage of it. This was a good way to unload works other than commissioned portraits to a relatively well-off crowd. In a 1634 lottery held at another inn on the

Smeestraat, "De Basterdpijp" (The Bastard Pipe), and co-organized by his brother Dirck—with a collection of paintings that included landscapes by Pieter de Molijn, Salomon van Ruisdael, and Jan van Goyen; a still life by Willem Claesz Heda; eleven genre pieces by Dirck himself; and works by emerging artists such as Judith Leyster and Adriaen van Ostade—Frans contributed, as we have seen, a *vanitas* (perhaps a man holding a skull) and two *tronyen*, one of which depicted a *ruyter* or lowlife.[17]

*

It was not only the strict Calvinists who opposed the lotteries. The Guild of Saint Luke itself, concerned not so much with citizens' spiritual well-being as with the economics and aesthetics of art, was worried about the effects of lotteries, auctions, and other forms of public and private art dealing on the prices and qualities of paintings. Unlike the commissioning and direct sale of works in an artist's studio or their purchase either through a professional dealer's showroom or an exhibition organized by the guild, the overseers of Haarlem's art world had little control over what was offered on the open market and by whom it was made. Despite the regulations, it was all fairly unregulated. Artists from outside Haarlem were selling their paintings and graphic works within the city limits, competing with the local talent and, by significantly increasing the supply, undercutting their prices. Moreover, the quality of what they were offering, especially during fairs and on market days, was, in the eyes of Haarlem's master painters, not up to the high standards of the city's glorious tradition.

In September 1630, the *deken* (dean) and *vinderen* (directors) of Haarlem's Guild of Saint Luke, in light of "the multitude of public auctions, lotteries and raffles of paintings, now so quickly one after another . . . and apparently in even greater abundance to come, for the individual's [i.e., organizer's] benefit," petitioned the city magistrates "sharply to forbid and prevent all such public auctions, raffles and similar plagues upon art," and to do so as soon as possible, "in order to prevent the utmost spoiling and ruin of art." The guild lead-

ers were especially concerned about "foreign works," that is, art and artists coming from other cities and flooding the market with cheap and inferior products.[18]

The city council evidently did not take any action in response to this request for protectionism, as lotteries and auctions continued through the 1630s. Perhaps the *vroedschap* was waiting for the guild itself to take some first steps. Earlier that year, in April, the burgomasters had ordered the guild to get its house in order. In response, the dean and directors—Jan Bouchorst (dean), Pieter de Molijn, Willem Claesz Heda, Hendrick Pot, and Outgert Aris van Akersloot, along with Salomon de Bray acting as "authorized representative of the body of painters" and Cornelis Cornelisz as a respected elder of the artistic community—drafted a new guild charter to replace the old one from 1590. Among the problems that moved the guild to take this radical step, aside from the city's demand, was the fact that the guild really was in disarray. The drafters of the new charter mention "the negligence and absence of concern, for a long period of time, of the former governors and regents of the guild." Over the years, oversight of the profession had become lackadaisical. There were rarely meetings, and the guild was plagued by frequent disputes among members, mismanagement of funds, and misuse of guild property (such as the furniture in the guild hall).

The guild's long and detailed new charter—signed by its drafters in May 1631, approved by the guild members one month later, but not submitted to the city for approval until March 1632—expanded, but nonetheless closely followed, the 1590 regulations. Many of the articles concerned the training of pupils and apprentices. Among other things, the charter reiterated that in order to become a master painter, one had to serve at least three years as a pupil and then as apprentice, followed by a year earning income as a journeyman in a master's workshop or as an independent artist. The new regulations did set a minimum age of twenty for becoming a master, but this could be waived if the work of a younger artist was deemed by the guild leadership to be "extraordinarily excellent."[19] Another new requirement was that in order to be admitted to the guild as

a master, an artist had to submit, "for the benefit of the guild," a masterpiece—that is, "a new, fully completed piece of painting by his own hand, of at least two square feet."[20]

The most consequential result of the new charter was that Haarlem's Guild of Saint Luke was now primarily a fine artists guild, with other professions traditionally belonging to the guild subordinated to "the superior part consisting of those [working in] art [konst]." And at the top of that "superior part," above all other kinds of artists, are the schilders (more specifically, the konstschilders), those working with paint on panel or canvas, and especially the meester schilders. "In the first class under this Guild of St. Luke, as the foremost main part and by which the guild is predominantly constituted, are the painters."[21] Only master painters may now serve as dean, or vinder. Just below the painters are practitioners of "related arts," such as engravers, etchers, illuminators, architects, and surveyors, and those working in "dependent arts," including grofschilders or coarse painters (that is, house and sign painters), gilders, upholsterers, and mirror makers. At the bottom of the guild hierarchy are "artisanal crafts," a category that includes goldsmiths and silversmiths, bookbinders and printers, and makers of organs.[22]

The new charter proclaims that "our first and greatest concern is the renewal of the ancient luster of the art of painting, which the kings and princes of old always held in the highest esteem." But an equally important purpose was to bring greater clarity to the structure of the guild and its training of artists and some regularity to its wide-ranging operations. Among other things, the charter lays down rules as to who can make money doing what. "No one may do another art or engage in a craft or any work other than that of his own art." House painters, for example, are not allowed to accept commissions to do "fine art [fijn schilderwercken]."[23] Master fine art painters, on the other hand, can do any work they wish.

There was also the matter of decorum. And among the more contentious problems giving rise to disputes among the guild brothers concerned—and the language here echoes the wording of the 1630 request to the burgomasters to prevent lotteries and auctions—"all extra-ordinary manner of selling . . . such as happens by public auc-

tion and calling out, as also with all lotteries, raffles, and similar sorts of plagues and unusual and sought-after ways of dispersing and selling, which [contribute] not only to the disreputation and decline of the arts, but also to the general corruption and ruin of daily house- and shopkeeping." Thus, the new charter decrees, for the common good of the city, its citizens, and the guild, "it is strictly forbidden to all and one, both in and outside the guild . . . and those that come from outside the city, [to engage in] any such extra-ordinary ways of dispersing or selling as those just named."[24]

The problem of lotteries will trouble the Haarlem guild over the next decade, setting members against each other and leading nearly to a schism in 1642. As for the new charter, just one month after the guild submitted it to the city council, it was sent it back to the guild for revision. The council members complained that the document was too long and complicated. Another version, apparently unabridged, was resubmitted in November 1634, but it is unclear whether the city ever actually ratified it.[25]

<p style="text-align:center">*</p>

By studio commission, by dealer, or in the open market, a painter in the seventeenth century could potentially do quite well for himself. Or *herself*—after all, there were a fair number of accomplished European women artists in the period: Artemisia Gentileschi and Elisabetta Sirani in Italy, Judith Leyster and Clara Peeters in the Dutch Republic, Michaelina Wautier in the southern Netherlandish provinces, and many others.

It did not hurt to have, aside from extraordinary talent, the right connections and a wealthy patron. Velázquez was the favorite of Philip IV of Spain; Van Dyck was well settled in Charles I's court in England; and Nicolas Poussin served both Louis XIII in France and Cardinal Francesco Barberini in Rome. In a class by himself was the fabulously wealthy Rubens. His work was in demand in the highest royal and aristocratic circles of the Continent and the British Isles. He had a richly appointed home in Antwerp and a magnificent country estate, both of which were filled with art (his own and that of others).

For a mere portrait painter working in a land without deep networks of royal, ecclesiastic, and aristocratic patronage, things could be a bit more of a challenge. Private commissions from ordinary citizens were really the only way to get by. And it was not necessarily a highly remunerative practice. It all depended on who wanted their likeness painted and what kind of picture they wanted.

It has been suggested that, at least in the early modern period, portraits served better the fame and fortune of the sitter than that of the painter.[26] As we have seen, in the grand artistic scheme of things—canonized by Van Mander and other theorists—portrait painting had a relatively low status. Throughout the seventeenth century, as Dutch preferences changed and history painting and landscape jockeyed for supremacy—histories had the advantage in the first half, landscapes in the second—portraiture continued to rank further down on the scale, although still above still lifes and genre scenes.[27]

Nonetheless, vanity and esteem—as well as love and memory—being what they are, there was, and always would be, a steady demand for portraits. The early and middle decades of the century, which saw the economic rise of the middle class, witnessed a boom in portraiture, with artists in Amsterdam, The Hague, Utrecht, Delft, and especially Haarlem seeing an increase in business.[28] Estate inventories reveal that by 1630, nearly one-quarter of the paintings hanging in private homes in Amsterdam were family portraits; in Haarlem it was only slightly lower, about one-fifth.[29] Even less well-off households—those that would have had trouble affording a history painting or a landscape, whether made-to-order or even a relatively inexpensive one at market price—still found a way to commission a portrait or two, usually on the cheap.

Painting individual portraits of ordinary people would not bring an artist Rubenesque wealth. On average, portraits earned one much less than any other kind of painting. Still, it was possible to get by, and even make a comfortable living. What portrait painting lacked in stature and price it could make up for in volume. The cost of a commissioned portrait was dependent on several factors: size, of course, but also the number of figures depicted; whether they are

shown as busts, half-lengths, three-quarter-lengths, or full-lengths; the level of detail, both in the figures and in the background; degree of finish; the cost of materials (canvas or panel, support, paints); the range of colors; and, not least, the reputation of the artist. Another factor might be the artist's assessment of what the client could pay. A fabulously wealthy aristocrat or regent might get charged somewhat higher than what a middle-class burgher—whose annual income was likely to be around 350–500 guilders, possibly reaching a high of 1,000 guilders—would be asked to pay.[30]

Generally, as we have seen, prices for single portraits in the first half of the century ranged anywhere between six and sixty guilders, although a life-size, full-length portrait could cost 150 guilders or more.[31] Rich couples were often willing to pay several hundred guilders for paired portraits. Bartholomeus van der Helst (1613–70), who was born in Haarlem but moved to Amsterdam in his twenties and there became a leading portraitist—eclipsing even Rembrandt in popularity and critical acclaim—earned 330 guilders (coming to about eight guilders per day, over six weeks) in 1650 to make pendant half-length portraits of the nobleman Willem Vincent van Wyttenhorst and Wilhelmina van Bronckhorst, whom Van Wyttenhorst had married four years earlier.[32] This was on top of room and board, as Van der Helst lodged with the couple for the entire time that he worked on the canvases.

Family and group portraits could bring in quite a bit, depending on the number of people. Rembrandt received 560 guilders in 1642 for a double portrait of Abraham van Wilmerdoncx, a director of the Dutch West India Company, and his wife, Ann van Beaumont (500 guilders, plus another sixty for the canvas and frame).[33] Ten years later, Pieter van de Venne initially agreed on a price of 1,000 guilders for Van der Helst to paint him, his wife, Anna du Carpentier, their daughter, and a dog. (Van de Venne subsequently had a change of mind and refused to pay that much; after twelve years of legal wrangling, the painter settled for 460 guilders.)[34] Van der Helst did better in 1656 with the family of Rijckloff van Goens, who was the governor-general of the Dutch East Indies. His portrait of Van Goens, Jacobine Rosegaard, their two sons, and a servant netted him

1,400 guilders.[35] The Leiden painter Pieter van Slingelandt, meanwhile, received 1,500 guilders in 1668 for his portrait of the family of Johannes van Meerman, one of the town's burgomasters; Van Slingelandt had been asking an even higher price, whereby Van Meerman took him to court to settle on something he insisted was more "reasonable."[36] Prices varied among cities, and were higher in Amsterdam than elsewhere.[37] On average, around fifty to sixty guilders per sitter seems to have been the going rate for multiperson portraits in Haarlem; it is what Salomon de Bray's son Jan got in 1663 for painting the regentesses of the Armekinderhuis (Poor Children's House) there.[38]

Overall, a relatively successful professional portrait painter in the middle of the seventeenth century who was able to keep a steady flow of business could count on earning up to several thousand guilders per year, making him (or her) fairly well-off by contemporary standards, a secure member of the middle class. This is about what most fine artists working in other genres or media could expect annually to earn from their work. By contrast, an unskilled laborer, like a maid or servant, was earning just several stuivers a day, while the average daily wage for a skilled worker was around one guilder. (A ship's carpenter, for example, would bring in about thirty guilders monthly.)[39] That anticipated income for portrait painters is also more than four times what other, non-*konstschilder* members of the Guild of Saint Luke—such as decorative painters or makers of faience—generally made.[40]

The competition in the early 1630s was impressive. Among the more prominent and sought-after portraitists were Thomas de Keyser and Nicolaes Eliasz Pickenoy in Amsterdam, Michiel van Mierevelt in Delft, and Van Honthorst and Paulus Moreelse in Utrecht. In 1629, Jan Lievens, at work in his studio in Leiden, received a high-profile commission from the stadholder's retinue in The Hague: a portrait of Frederik Hendrik's secretary Constantijn Huygens, a central figure in the international Republic of Letters. Just a few years later, Lievens's former studio mate, Rembrandt, now based in Amsterdam, was receiving commissions for portraits from wealthy merchants in the city, such as Nicolaes Ruts and Marten Looten. This is also when

he painted his first group portrait, the *Anatomy Lesson of Dr. Nicolaes Tulp*, depicting a number of men around the prominent physician as he uses the cadaver of a recently executed criminal to reveal the workings of the human muscular and nervous system.

Meanwhile, in Haarlem, there were still Cornelis Cornelisz, Frans de Grebber, and Cornelis Engelsz Versprongh to contend with. Only now these well-established masters were being joined, and even surpassed, by a very talented next generation.

Pieter de Grebber (1600–1652/53), Frans de Grebber's eldest son, was back in Haarlem after the year in Antwerp and some time in Denmark,[41] and he was now coming into his own. He had trained both with his father and with Goltzius, and began producing his own work when he was in his early twenties and assisting in his father's workshop. He did not join the guild until 1632, but then quickly established himself as skilled history painter. The younger De Grebber's oeuvre consists mostly of religious works, drawn from both the Hebrew Bible and the Christian Gospels, and historical tableaux, including decorations for two rooms in the town hall depicting episodes in the life of the medieval Holy Roman emperor Frederick Barbarossa. Prolific across genres, Pieter also took on quite a few portrait commissions, including staid, pious paintings of Catholic clerics in Haarlem and elsewhere. Among his sitters was the Delft priest Adriaan Uyttenhage van Ruyven; Philippus Rovenius, the apostolic vicar to the Holland Mission from 1614 to 1651 (fig. 38);[42] and one of Rovenius's successors, Boudwijn Cats. There are also a number of charming genre portraits and *tronies* by his hand.

In his *Harlemias*, Schrevelius claims that "Pieter de Grebber far surpassed his father," and that he is "as skilled in devising inventions as he is neat in painting, and so deserves to be counted among the best painters of our century."[43] Pieter himself was confident enough in his own expertise to compose a guide for would-be artists, the *Regulen: Welcke by een goet Schilder en Teyckenaer geobserveert en achtervolght moeten werden* (Rules: Which should be observed and followed by a good painter and draftsman).[44] Among the eleven rules in the manual are "It is necessary to know where it is that what to be made is to be hung, for various reasons: to do with the lighting, and

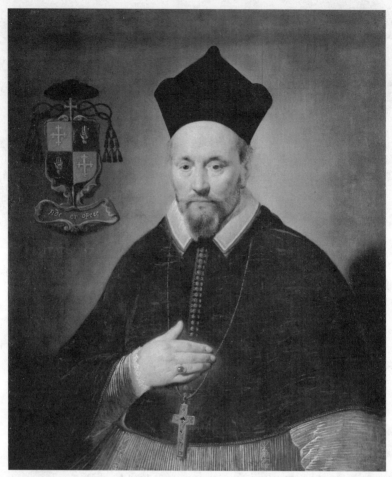

38. Pieter Fransz de Grebber, portrait of Philippus Rovenius, 1631, Museum Catharijneconvent, Utrecht.

because the height of the spot," and "It is necessary to read through the narrative [to be depicted] properly, especially if it is a Scriptural or true history," and "Avoid entangling the figures, the arm or leg or hand; anything belong to one [figure] should not appear to belong to another."[45]

Also among the up-and-coming cohort is Cornelis Engelsz Versprongh's son Johannes Verspronck (1601?–62).[46] In addition to training with his father, Verspronck may have worked under Hals, either as apprentice or assistant. He joined the guild the same year as Pieter de Grebber. Unlike Pieter, though, Johannes specialized only

in portraits. In later years the younger man would be among Hals's chief rivals for commissions in Haarlem, especially group portraits of the directors of civic bodies. In 1641, he will paint the regentesses of the Saint Elisabeth's Hospital; one year later, he will do the regentesses of the Heilige Geesthuis (House of the Holy Spirit), an orphanage and almshouse. Schrevelius, again expressing his admiration of this new generation of Haarlem painters, notes that "the son of Cornelis Engelsz . . . has by far surpassed his father in art with an airy leap [een luchtighe sprong]."[47]

De Grebbers, Versprongh and son, Salomon de Bray (a slightly older contemporary of Pieter de Grebber and Johannes Verspronck; he would soon be joined by his son Jan), Pieter Soutman, all working in Haarlem in the 1630s: it made for a tight sellers' market in portraiture. Nonetheless, with portraits still in great demand, there was enough work to go around.

Hals was now not only indisputably a star in his hometown, but was also attracting notice—and commissions—in other cities. It could not have come at a better time. His eldest son, Harmen, was in his early twenties, but there were still nine children at home under the age of fifteen, including an infant: a daughter, Maria, was born in November 1631. Yet another daughter, Susanna, will come along in January 1634.

Even by the standards of the time, it was a large family to feed and clothe. Moreover, one of those children, Pieter, suffered from mental illness—in contemporary documents he is referred to as *innocente*, perhaps best translated as "simpleminded."[48] His upkeep must have been rather costly, since in 1637 the family sought help from the city council in caring for the boy. They were eventually granted an annual stipend of 127 guilders, to be provided by three of the city's charitable institutions—the Saint Elisabeth's Hospital, the Leper House, and the poor relief fund—but on the condition that Pieter be housed *buyten de stadt*, outside the city.[49]

It did not help matters that the family could not get entirely free of creditors impatient to have bills settled. Bouwen Fransz was coming after Hals for twenty-three guilders and seventeen stuivers for bread he had delivered. The baker originally had taken a painting as

collateral, but now wanted his money.[50] A few months earlier, Hals was himself a creditor when he sued his sister-in-law, Lysbeth's sister Hillegond, who had been present as witness for several baptisms of Frans's and Lysbeth's children. He was demanding from her fifteen guilders, the balance of some funds that she owed him, for reasons unknown.[51] Around the same time, he was falling into arrears in paying his dues to the Guild of Saint Luke. It was only four stuivers (less than one-quarter of a guilder), but the guild had to make a special effort to collect.[52] Much more onerous was the ninety guilders that Frans and his brother Dirck owed to the estate of the late Arent Jacobsz Coets, a butcher—as well as the innkeeper of the Saint George civic guard that Hals painted in 1627—for "their shared responsibility for the purchase of an ox."

<div style="text-align:center">*</div>

Under the strain of these financial burdens, it must have been quite welcome, a relief even, when Hals received a special invitation from Amsterdam. In 1633, he was engaged by Captain Reynier Reael and Lieutenant Cornelis Michielsz Blaeuw, of the civic guard company of that city's District 11—one of twenty such districts (wijken)—to "make a particular piece of painting, namely, the portrait [conterfeytsel] of all the officers of the company."[53] While Haarlem civic guard portraits are typically of a guard's most senior-ranking officers—for example, the colonel, fiscal/provost, three captains, three lieutenants, and three ensigns of the Saint George guard in Hals's 1616 picture—Amsterdam guard portraits tend to focus on one of a guard's many companies, with its captain, lieutenant, ensign, sergeants, corporals, and some regular guardsmen.[54]

This was an unusual request. Amsterdam civic guards rarely went outside the city for a painter to commemorate their service.[55] In 1616, the officers and guard members of the company of District 3 did ask the Utrecht artist Paulus Moreelse to do their portrait. Generally, though, the Amsterdam musketeers, crossbowmen, and archers had a strong preference for local talent. In 1630, the Amsterdam portraitist Nicolaes Eliasz Pickenoy portrayed the company of District 5, un-

der Captain Matthijs Willemsz Raephorst and Lieutenant Hendrick Lauwrensz. In 1632, the year before Hals received his charge from Reael and Blaeuw, Pickenoy did the same for the District 9 company of Captain Jacob Backer and Lieutenant Jacob Rogh. Also that year, Pickenoy's Amsterdam colleague Thomas de Keyser was painting the company of District 18, led by Captain Allaert Cloeck and Lieutenant Lucas Jacobsz Rotgans; he followed this up a year later with a portrait of the company of Captain Jacob Symonsz de Vries and Lieutenant Dirck de Graeff. For Captain Reael and his comrades to go to a Haarlem painter for their portrait, then, is testimony to Hals's wide and highly favorable reputation by the early 1630s.

For Hals, it was a potential windfall, at least by Haarlem standards. He was to receive sixty guilders per figure, plus expenses. While this was less than the one hundred guilders or so that Rembrandt would receive for each member of Captain Frans Banninck Cocq's *Night Watch* company of Amsterdam's District 2 in 1642, and apparently below the going rate in Amsterdam, still, with sixteen figures planned, Hals's Amsterdam commission promised to bring in a tidy sum, over 1,000 guilders.[56]

The agreement, at least according to Reael in a later legal deposition, was that Hals would come to Amsterdam to paint the men's heads and then finish off the setting and other details back in his Haarlem studio.[57] Hals was reluctant to be away from home, especially if it required several extended trips, as this commission would. Going from Haarlem to Amsterdam was not an especially burdensome voyage. The new tow canal linking the two cities, the Haarlemmertrekvaart, had been completed in 1632, making for more direct and quicker travel either by horse-drawn barge or by carriage on the towpath. (Previously, to go to Amsterdam from Haarlem by water rather than overland required taking a boat up the Spaarne River to the IJ Bay and then sailing into Amsterdam.)

No matter the ease or speed of the journey: Hals preferred to work at home, in his own studio with his assistants, and sleep in his own bed. Nonetheless, the inconvenience would be worth it, given the income and high profile of the commission. And so began Hals's

brief, potentially profitable but, in the end, troublesome time in Amsterdam.

<p style="text-align:center">*</p>

For the Dutch, 1632 was something of a banner year. In terms of births alone, it was a remarkably rich twelve months. In Amsterdam, there was the philosopher Bento (Baruch) de Spinoza. In 1656, he would be excommunicated (put under *herem*) with great prejudice from that city's Portuguese-Jewish community at the age of twenty-three for his "abominable heresies and monstrous deeds" and then go on to compose what his many critics would call the most "scandalous," "heretical," and "soul-destroying" treatises ever written.[58] In Delft were born both the scientist Antonie van Leeuwenhoek, whose research with lenses and the microscope would lead to the development of microbiology, and Johannes Vermeer, the painter of luminous genre works who, like Hals himself, would be restored to his rightful place in art history only in the nineteenth century.

This was also the year in which Rembrandt entered on the next stage of his career when he moved permanently from Leiden, where he had been born (in 1606) and was running a studio, to Amsterdam, where he would spend the rest of his life. By January 1632 he was in the full-time employ of Hendrick Uylenburgh. Uylenburgh was an art dealer, but he also oversaw a workshop, where an ensemble of artists copied paintings and produced new ones.[59] Rembrandt was engaged to take over as chief of the studio and oversee the execution of commissions that Uylenburgh brought in. It was his second residency in the city, after a brief apprenticeship with the master painter Pieter Lastman in 1625.

Initially, Rembrandt lodged in Uylenburgh's home, on the Sint Antoniesbreestraat, at the corner by the lock (*sluis*).[60] This "broad street," a main thoroughfare in Captain Reael's District 11, was the center of Amsterdam's art world. Many of the houses on the long block were owned or rented by artists and art dealers. The street, and the adjacent Vlooienburg island beside the Houtgracht (Wood Canal), was also home to the city's growing Jewish population, at

this point mostly Sephardim whose families had fled the Spanish and Portuguese Inquisitions in the sixteenth and early seventeenth centuries. (Within the decade, these "Portuguese Jews" would be joined by increasing numbers of Ashkenazim, German and Eastern European Jews escaping poverty, persecution, and war in the lands of the Holy Roman Empire, Poland, and Lithuania; the Sint Antoniesbreestraat was also then known as the Jodenbreestraat, or Jews' Broad Street.)

It was only four months or so after settling in with Uylenburgh that Rembrandt put the finishing touches on his painting of Dr. Tulp's anatomy lesson, a commission brought his way by Uylenburgh and his connections in Amsterdam society. (By the time of the painting, Tulp had been a member of the city council for a decade, and he would later serve several terms as *burgemeester*.) Rembrandt immediately afterward began work on a portrait of Amalia van Solms (fig. 39),[61] the wife of Stadholder Frederik Hendrik, a project that required traveling several times to The Hague. This was followed, still in that year, by commissions to paint a beautiful double portrait showing the shipbuilder Jan Rijcksen, at work at a table, with his wife, Griet Jans, who is handing him a note; and a portrait of the Protestant minister Johannes Wtenbogaert. A leading Remonstrant theologian, Wtenbogaert returned from exile in France after the death of Prince Maurits and the inauguration of a more tolerant stadholdership under his half brother, who as a young man had been Wtenbogaert's student.

Because Uylenburgh's home and studio were located in Captain Reael's district, it was only natural that the officer should consult with the well-known dealer as to who would be suitable to paint his civic guard company. Rembrandt, of course, was right at hand. But while the young painter had done one group portrait by this time— Dr. Tulp's lesson—he had never done a civic guard group, which posed its own logistic challenges. He also had his hands full with other commissions, portraits mainly, and would have been too busy to take on such a large project.[62] Thus, Uylenburgh, who certainly knew the fifty-year-old Hals at least by reputation, and was prob-

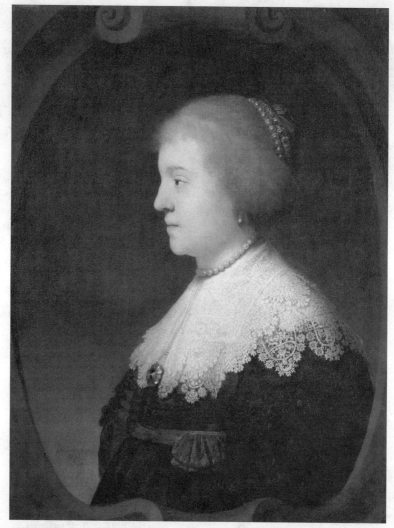

39. Rembrandt Harmensz van Rijn, portrait of Amalia van Solms-Braunfels, 1632, Paris, Musée Jacquemart-André—Institut de France. © Studio Sébert Photographes.

ably familiar with the three guard paintings he had already done, was likely the one who arranged for the job to be offered to the more experienced Haarlem portraitist.[63]

We do not know whether Hals first lodged with Uylenburgh during his stay-overs in Amsterdam. At least later in the working process, Hals was rooming at an inn, at some personal expense. Perhaps there was no longer room in the house once Rembrandt moved

his new bride, Saskia (Uylenburgh's younger cousin), to Amsterdam to live with him after their marriage in July 1634.[64] Either way, since Hals did not have a studio in Amsterdam, he must have used Uylenburgh's, with the District 11 guard members dropping in to pose for him. He would continue to come to Amsterdam to work on the painting through the summer of 1634, presumably sharing working space with Rembrandt and the other members of the workshop.[65]

During periods in Amsterdam, Hals was far from idle between sittings for the civic guard painting. In 1633, he made small, rough portraits on panels of the three adult sons of the brewer Jacob Pietersz Nachtglas: Pieter, Elbert, and Claes.[66] The following year he used canvas to make a larger painting of Nicolaes Hasselaer, another Amsterdam brewer who was sitting on the city council at the time, and a pendant of his wife, Sara Wolphaerts van Diemen. Hals may also have been in Uylenburgh's studio when he completed several portraits of members of the well-connected Soop family,[67] as well as the likeness of Pieter van den Broecke (fig. 40),[68] an admiral of the Dutch East India Company (VOC) who served in Java, India, and Persia, that he painted around the same time.[69] Van den Broecke, like Hals, was born in Antwerp, and he had family in Haarlem as well. The two men must have struck up a friendship, for the following year Van den Broecke came to Haarlem to serve as a witness at the baptism of Hals's daughter Susanna.[70] Hals's rendering of the retired trader and military man, in the now mature "rough" style, shows him in a very casual pose, sitting in a chair, much like Massa and Van Heythuysen in their later portraits. Proudly sporting the gold chain with which the company rewarded his years of service, he wears a kindly smile, quite different from the smirk on the face of Roosterman in his earlier, "laughing cavalier" moment.

When he was not painting portraits in Amsterdam, whether group, couple, or solo, Hals was buying art. This might have been for his own private collection, which was not especially large—besides some of his own works, it included, in later years, a couple of paintings by his sons, one by Van Mander, and one by Van Heemskerck[71]—but was more likely for his ongoing business as a dealer. In the summer of 1634, we find Hals attending an auction run by Daniel Jansz van

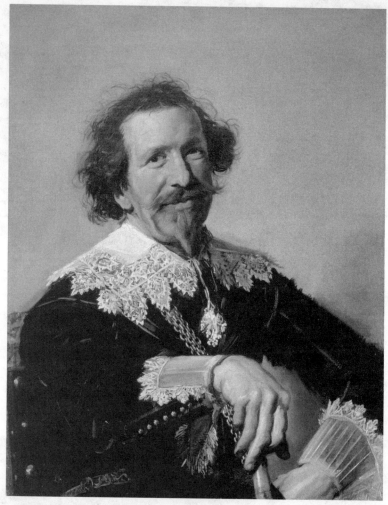

40. Frans Hals, portrait of Pieter van den Broecke, ca. 1633, Kenwood House, the Iveagh Bequest, London, UK. © Historic England. Bridgeman Images.

Beuningen in a bookstore owned by Emanuel Colijn, in Amsterdam's Dam Square. Hals was the winning bidder on a painting by Hendrick Goltzius, at eighty-six guilders. Unfortunately, Hals did not have sufficient funds on him to pay right then and there—in a contemporary record it is noted that "he [Hals] insinuated at the time that he did not think he had so much money with him"—and so he went off to borrow some cash, perhaps from Uylenburgh. By the time he got back to the bookstore, Van Beuningen, for reasons unknown, would not give him the painting. Hals filed a complaint with a notary, who

in turn went to Van Beuningen's to pass along the money and get him to turn over the work. The notary was initially able to speak only with the auctioneer's wife, who told him that Van Beuningen was not home. "I will tell my husband," she added, "but I will not accept this money." Eventually, the notary did talk with Van Beuningen, who replied that the painting was no longer in his possession. "The doctor has the painting," he told the notary, presumably referring to the original owner of the work, "so speak with him."[72] We do not know whether Hals ever succeeded in getting his hands on the Goltzius painting.[73]

<center>*</center>

The commission for the portrait of Captain Reael's Amsterdam civic guard company did not have a happy outcome. The painting, of course, is magnificent (plate 14).[74] But it turned out to be a lot of trouble and certainly did not bring Hals all the income he had been anticipating. Then again, he seems to bear most of the responsibility for the deterioration in relations between artist and clients.

After working on the painting for a year and a half or more, Hals had made some progress. The heads of many of the officers were partially done, as were some of their bodies. However, by early 1635 at the latest, Hals stopped coming to Amsterdam altogether; and by June of that year the painting remained unfinished. The company's officers were growing impatient and exacted from Hals a promise to complete it soon. Still, by March of 1636—three years after the commission, and (according to the record) "notwithstanding various pleadings"—no further work had been done. Reael and Blaeuw, representing the other officers and guardsmen of the company, had had enough. They went to the Amsterdam notary Frans Bruijningh and filed a complaint to demand that Hals do what he had been paid to do, and do it "in decent form." They gave him two weeks to come to Amsterdam and finish the painting. If he still refused, they threatened to have "another good master from here" (that is, an Amsterdam painter) complete it and to sue Hals for the money already paid, "all costs, damages and interest."[75]

The problem was what *they* thought Hals had been paid to do was

different from what Hals himself thought he had been paid to do. When a Haarlem notary, Egbert van Bosvelt, presented Hals with the Amsterdammers' complaint at his new residence—the family had moved from the Peuzelaarsteeg to Groot Heiligland, a bit farther from the Saint Bavo Church, in a house close by the Kampersingel canal and near the former south wall of the city[76]—the painter was laid up in bed "with a bad leg." He replied to the notary that, in fact, the original agreement was that he would paint the group portrait in Haarlem, not Amsterdam. Still, Van Bosvelt's report reads, "although not obliged to do so, he was willing to begin the heads in Amsterdam and then complete them in Haarlem, just as he had begun to do and would have finished." The problem all along, Hals complained, was that he could not get the officers together in the studio, and so he wasted a good deal of time waiting around in Amsterdam for their cooperation. "With the result," the notary recorded, "that he therefore much neglected his house and consumed much in the inn in Amsterdam, for which it was said he would be recompensed."[77] Nevertheless, Hals offered to honor his commitment and complete the painting, just as long as the officers would come to Haarlem. According to the notary, Hals was insistent that "it would be done with more spirit [lust] in Haarlem than in Amsterdam because he would be in his house and could keep an eye on his people [i.e., apprentices]."[78]

When Captain Reael and Lieutenant Blaeuw heard what Hals had said, they were nonplussed. They had a very different take on the matter and called Hals's response "frivolous and untrue."[79] They protested, in April, that Hals had indeed agreed (and therefore, contrary to what he claimed, was obliged) to "begin all the heads [troinges, i.e., tronies] in this city [i.e., Amsterdam] and complete them in Haarlem, for which he would earn sixty guilders for each person." To motivate the painter, the guard company even increased their offer to sixty-six guilders "for each character or portrait," on the condition that Hals "paint, and perfectly complete, all the persons, their bodies as much as their heads, and such as is proper, here in this city and not in Haarlem, just as he already has begun to do with some of the characters here in this city."[80] They now gave Hals ten days to come to Amsterdam to finish the job and demanded that he say *jae oft*

neen (yes or no) to this offer, "so that [we] might know what we have to do."[81]

For unknown reasons, Hals was not presented with Reael and Blaeuw's reply for three months, no doubt much to the officers' consternation. And what he had to say to the notary that July did not satisfy them at all. He stood by his original reply. In a somewhat conciliatory gesture, he offered to have the painting transferred to his house in Haarlem—it must have been standing untouched in Uylenburgh's Amsterdam studio for some time—where he would first finish the "unpainted clothing," and then, "that being done, do the heads of any persons willing to come here to Haarlem to his house." He added that if there are six or seven officers who are unwilling to do this, then he would bring the painting back to Amsterdam and do their heads there.[82]

This is the last documented communication between Hals and the company of Amsterdam's District 11. Perhaps the officers continued to negotiate, or plead with, or threaten the painter a little longer, but it was clearly to no avail. Seeing insufficient paint on the canvas, Reael and Blaeuw saw the writing on the wall, and so they carried out their threat to have an Amsterdam artist finish the work. There were enough outstanding local portraitists to choose from, as we have seen: De Keyser, Pickenoy, Rembrandt. In the end, they went with Pieter Codde, probably at Uylenburgh's recommendation. Not only was the thirty-seven-year-old Codde an accomplished painter of portraits and genre scenes, including elegant gatherings and "merry company" pieces, but he resided in the same district of Amsterdam looked after by Reael's company. He may even have been a member of that guard and possibly one of its men portrayed in the painting.[83] He was thus a natural choice to finish the portrait, despite the strong stylistic differences between his usual work and that of Hals.

The income Codde received for finishing Hals's painting, while unexpected, must have been quite welcome. At the time, he was fresh off a very public scandal. His marriage was strained, as his wife thought he had been paying too much attention to their servant woman, twenty-two-year-old Aefge Jans. Then, on Three Kings Day (Epiphany) in January 1636, Codde, after a night of heavy drinking,

came home and, Aefge charged, raped her. Both Codde and Aefge were imprisoned in the town hall overnight and then questioned, under some undue pressure, about what had happened. The magistrates were convinced by Aefge's testimony. Codde was released on bail of 1,000 guilders, but told to remain available for further questioning. Shortly thereafter, he and his wife separated and divided their property. (Among the couple's items was a "small vanitas" painting by Hals.)[84] With his home life in disarray, Codde would need the extra guilders brought by the Reael commission.

Distinguishing Hals's hand from that of Codde in the finished work is a rather difficult matter. It was once believed that Codde worked mainly on the right side of the large canvas, putting in seven officers that Hals did not get around to painting. This now seems unlikely, in light of both recent technical analysis and the implausibility that Hals would have worked up only one side of the painting at a time, going from left to right. What Codde almost certainly did do, at the very least, was complete some of Hals's own work and retouch other parts, overpainting elements and adding details here and there, and perhaps filling in the architectural background.[85] The finished painting shows Captain Reael seated on the left, with a large black hat and blue sash. Standing just beside him, to his right, is an ensign who has wrapped the magnificent orange banner he carries into a sash around his waist. Blaeuw, Reael's lieutenant, also with a blue sash but hatless, is seated just to his superior's left. Everyone else is standing and depicted full length.

Vincent van Gogh, for one, found the Hals/Codde portrait of Captain Reael's civic guard company, however contingent and unplanned a collaboration it may have been, a great success. Writing to his brother Theo in October 1885, just after a visit to Amsterdam and the newly opened Rijksmuseum, he gushed over the painting.

I don't know whether you remember that to the left of the Night watch [by Rembrandt] . . . there's a painting—it was unknown to me until now—by Frans Hals and P. Codde, 20 or so officers full length. Have you noticed it??? In itself, that painting alone makes the trip to Amsterdam well worth while.

What especially impressed Van Gogh, colorist par excellence, was the painters' use of color. In his expert analysis, the various items on and around the guardsmen are broken down into their component pigments.

There's a figure in it, the figure of the standard-bearer in the extreme left corner, right up against the frame. That figure is in grey from top to toe, let's call it pearl grey—of a singular neutral tone—probably obtained with orange and blue mixed so that they neutralize each other—by varying this basic color in itself—by making it a little lighter here, a little darker there, the whole figure is as it were painted with one and the same grey. But the leather shoes are a different material from the leggings, which are different from the folds of the breeches, which are different from the doublet—expressing different materials, very different in color one from another, still all one family of grey—but wait! Into that grey he now introduces blue and orange—and some white.

Van Gogh can hardly contain his enthusiasm. "It's something marvelous. Delacroix would have adored it—just adored it to the utmost. I stood there literally rooted to the spot."[86]

By the time Van Gogh saw the painting, it had earned a nickname: the "Meager Company." Jan van Dijk, a painter and art restorer in Amsterdam, as well as the first keeper of the city's art collection, coined the phrase in 1758 after he saw the work hanging in the town hall. He was struck by how the figures "all are so withered and slender, that one could rightly call them the meager Company."[87] This is especially true of the tall, thin officer in the center, who wears a yellow jacket and red sash and, with his hand on his hip, stands with his back to the viewer. Codde, for reasons unknown, appears to have significantly reworked this figure from Hals's original.[88]

<p style="text-align:center">*</p>

We do not know how Hals felt about the outcome of the affair, and especially the idea that "his" painting was being finished by another artist. He was not opposed in principle to collaborating with others.

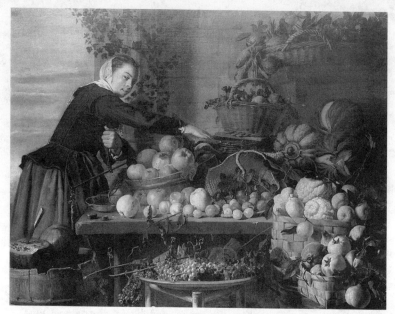

41. Frans Hals and Claes van Heussen, *Fruit and Vegetable Seller*, 1630, Viscount Boyne, Bridgnorth, Shropshire.

He worked with his Haarlem colleague Claesz Jansz van Heussen on the large 1630 painting of a fruit and vegetable seller (fig. 41);[89] Hals painted the figure of the woman while Van Heussen did the large still life that dominates the work. Hals also collaborated with another Haarlem painter, Willem Buytewech, on a pair of pendant portraits of the grandparents of the Haarlem artist Nicolaes de Kemp, with Buytewech painting borders around the sitters; and Pieter de Molijn may have been responsible for the landscape backgrounds in several of Hals's portraits, including the northern forest seen through the window in the early picture of Isaac Abrahamsz Massa.[90]

Such partnerships were not unusual in the period. A large number of Dutch and Flemish paintings were not solo projects. Netherlandish artists, many of whom specialized in one pictorial genre or another—landscape, still life, marine settings—often worked together, taking advantage of each other's skill set. Dirck Hals did at least five paintings with Dirck van Delen, who specialized in architectural interiors and did the settings for some of Dirck Hals's merry companies. Even the great Rubens joined forces with Jan Brueghel the

Elder on two dozen or so paintings, with Brueghel contributing his talents in landscape, still life, and animals to Rubens's history and religious canvases.[91]

Still, it was one thing to solicit the assistance of a fellow painter with complementary talents on a project to which each had something to contribute; it was quite another to have a painting taken out of your hands (even if you were happy to be rid of it) and completed by another artist—and with your name associated with (if not signed to) the final work! This was the second such experience for Hals, after the more benign case of Solomon de Bray being asked to add a child to the Van Campen family portrait.

More puzzling is why Hals refused to acknowledge what, despite his deposition to the contrary to notary Van Bosvelt, almost certainly were the original terms of the agreement with the Amsterdam guard company: that he would do most of the painting in Amsterdam, at least the heads, and finish it up in Haarlem. And why did he end up abandoning such a potentially lucrative commission? Was it really, as he claimed, the inconvenience of traveling to Amsterdam and the trouble he had in getting the officers together to pose?

The art historian Ben Broos has suggested that Hals's refusal to come to Amsterdam to finish the "Meager Company" can be interpreted either as a case of "artistic fickleness" or "a lack of artistic and social ambition."[92] Hals just did not care, on this view, either about the commission or about his reputation; he was uninterested in or not willing to take advantage of an opportunity to further increase his renown beyond Haarlem, with the high-profile jobs from Amsterdam and elsewhere that could follow. Perhaps he was under no illusions as to his status as a painter—unlike Rubens and Rembrandt, he was just a maker of *conterfeytselen*—and so what did an abandoned commission really matter?

But in the early modern art world income follows reputation, and thus Hals—who was never not in pecuniary need—could not have been totally unconcerned with his fame. A more likely explanation for the breakdown in the Amsterdam project is that Hals was overcommitted and could not afford all the time traveling to and staying in Amsterdam that this commission required. Perhaps sixty (or sixty-

six) guilders per figure was not enough to justify the extra trouble and expense, not to mention being away from his studio and neglecting other projects. The art historian Norbert Middelkoop suggests that Hals would have been justified in feeling underpaid, at least by Amsterdam standards. Just one year before Hals took on this job, De Keyser was paid sixty-one guilders to paint a half-figure in the background of another Amsterdam civic guard portrait; he was likely getting upward of one hundred guilders to do some of the life-size, full-length figures in the foreground.[93]

And then there were the obligations and opportunities that Hals had in Haarlem. In 1634, he was painting the pendant portraits of Tieleman Roosterman and Catharina Brugmans. The following year, when he was supposed to be working on the Amsterdam civic guard painting, he was doing large portraits of the wealthy Mennonite couple Lucas de Clercq and Feyntje van Steenkiste, who are shown in their pendants in sober black dress (figs. 42 and 43).[94] He was also that year or the next busy with an elaborate family portrait of a now-anonymous husband and wife and their two young daughters in a verdant indoor/outdoor setting (fig. 44).[95] In 1636, he was painting Nicolaes Pietersz Duyst van Voorhout, owner of Haarlem's "Swaenhals" (Swan's Neck) brewery, in a proud hand-on-hip pose much like that of Willem van Heythuysen a decade earlier.[96]

Moreover, in 1633, around the time he accepted the Amsterdam commission, Hals was still working on his life-size portrait of the officers of Haarlem's Saint Hadrian civic guard, his second painting of this group and the fourth so far of his Haarlem guard pictures (plate 15).[97] Quite unconventionally, he now shows the arquebusiers outdoors. They are standing or seated around a bare table—no banquet this time—in a courtyard behind their headquarters in the Oude Doelen. The space is cloistered by a tall wooden fence and trees; in the background are two low-rank sentinels standing at the gate and, above them, the rooftops of nearby houses. As in the earlier (1627) painting of the Saint Hadrian officers, most of the men are hatless. However, in this later rendering there is less agitation and activity. The colonel, seated (as per convention) at the left with a large, boldly colored sash, stares at us imperiously; there is no ques-

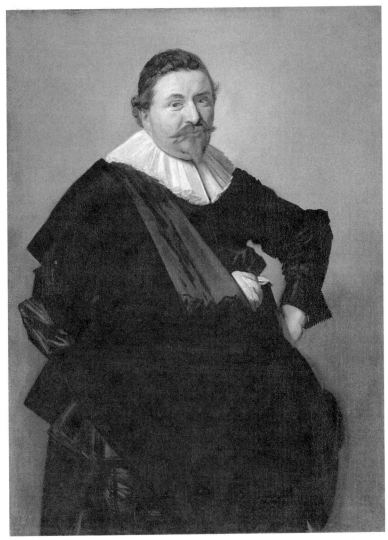

42. Frans Hals, portrait of Lucas de Clercq, 1635, City of Amsterdam, on loan to the Rijks-museum, Amsterdam.

tion who is in charge here. While there is still some chatter going on to the right, most of the other officers have stopped their conversations or whatever else they were doing and appear in what looks like a pose for the artist.

Hals might seem to have been a curious choice for this commission. Not because the company did not admire his work—after all, they had him portray their officers once before—but because they

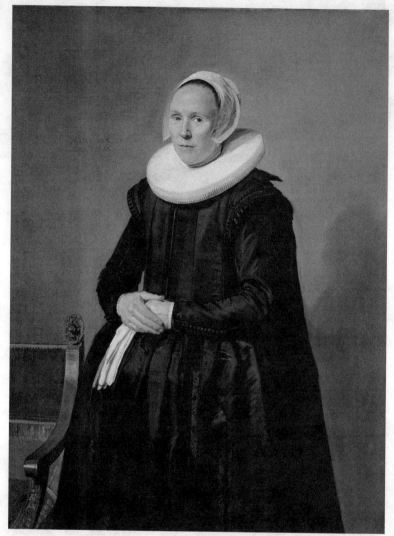

43. Frans Hals, portrait of Feyntje van Steenkiste, 1635, City of Amsterdam, on loan to the Rijksmuseum, Amsterdam.

had their own in-house painter. Among the Saint Hadrian officers in 1633, and depicted at the far right in Hals's portrait, seated with a book in his hands, is the artist Hendrick Gerritsz Pot (1580–1657). Pot, like Hals, had been a pupil of Karel van Mander. He painted this guard's officer corps (including the sergeants) three years earlier (fig. 45),[98] when he was dean of Haarlem's Guild of Saint Luke.[99]

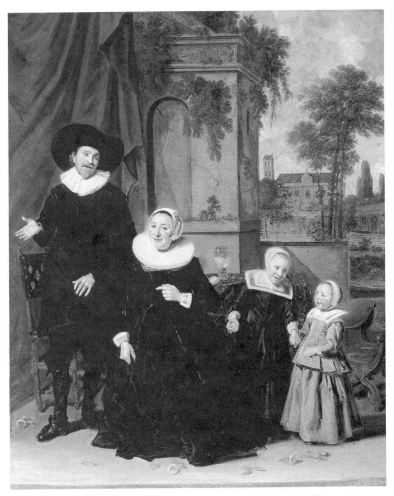

44. Frans Hals, *Family Portrait*, ca. 1635. © Cincinnati Art Museum. Bequest of Mary M. Emery. Bridgeman Images.

Pot may be the one to have come up with the idea of having the men pose outdoors; in his painting they are grouped on the stairs in front of their headquarters, the Kloveniersdoelen. (The colonel of the Saint Hadrian guard at the time was none other than Pieter Jacobsz Oly-can, who stands in Pot's picture second from the left, wearing an or-ange sash; Olycan's son Nicolaes, a sergeant in one of the companies, is also there, off to the right.) Given the very fine, albeit somewhat crowded, portrait that Pot made of his own officers, why did they

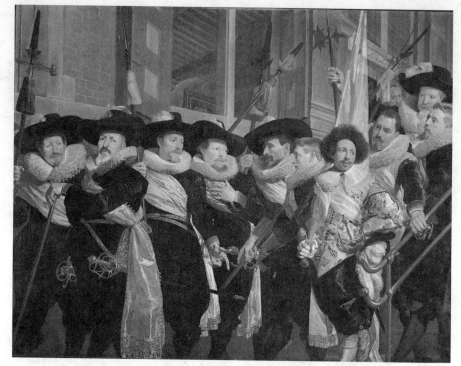

45. Hendrick Gerritsz Pot, *Officers and Sub-Alterns Leaving the Kalivermen's Headquarters in Haarlem*, 1630, Frans Hals Museum, Haarlem. Photo: Margareta Svensson.

bypass him in 1633 and go with Hals? Almost certainly because Pot was not in Haarlem at the time the commission was offered. In 1632, he had left Haarlem for London to paint portraits of King Charles I and Queen Henrietta Maria; he would not return to Haarlem until sometime in 1633—too late for the Saint Hadrian guard commission but just in time to sit for Hals, now as one of its officers.

In a few more years, Hals would be asked to do yet another portrait of the local Saint George civic guard, his third of that group. It may be, then, that the Amsterdam commission for Reael's company simply came at an inconvenient time. Nor was it providing the entrée to the right social circles and lucrative commissions in Amsterdam that Hals had anticipated. The portrait work he did find in the city at this time was either not especially prestigious (the Nagtglas family had fallen on hard times) or was likely due to Haarlem connections (the Soops, Van den Broeck, and Hasselaer).[100] All this, on

top of the demands of other projects, the inconvenience of frequent travel to work on the painting in another city, and the expense of his accommodations in Amsterdam: it just was not worth it.[101] At a certain point, one had to prioritize. And for Hals, Haarlem took precedence over Amsterdam.

CHAPTER 8

Pandemics

The plague hit the Dutch Republic especially hard in 1635. It was the second major outbreak within a decade, but more severe, with a significantly higher death toll, than in the mid-1620s. Eight thousand died in Amsterdam in 1635, plus another seventeen thousand the following year, one-fifth of the city's population. Leiden lost eighteen thousand; Utrecht, four thousand.[1] As for Haarlem, it buried over seven thousand of its citizens. The epidemic lasted through the summer of 1636. Hals's refusal to go to Amsterdam to work on the painting of Captain Reael's civic guard company may have had something to do with the danger of traveling during the contagion.

To make matters worse, Haarlem was undergoing another economic downturn in the mid- to late 1630s. This was partly the result of increased competition in the textile industry. While the dunes and fields along the coast and near the city remained a preferred locale for the bleaching of linen, weaving and other routines of production were moving elsewhere, where labor was cheaper. Flanders, especially, a textile powerhouse before the mass emigration at the end of the sixteenth century, was again playing a significant role in the manufacture of cloth.

Haarlem was also holding a shrinking share of the domestic market for beer, that long-standing mainstay of its economy. With more breweries cropping up in other cities, there was less demand around the provinces for the Haarlem product. Moreover, the Spaarne was proving too shallow for the new, larger breed of merchant ships, which had a deeper draft, and so the city's brewers had a difficult time exporting their quality drink beyond the Republic's borders.[2]

Haarlem's losses were Amsterdam's gains. Entrepreneurs, merchants, professionals, and other members of Haarlem's wealthy elite started making their way to that larger city for its opportunities. This was bad news for Haarlem's art world, as the prospects for commissions and sales migrated with those families. Thus, quite a few painters and dealers followed the money and decamped for Amsterdam as well. There were over forty master painters in Haarlem's Guild of Saint Luke in 1625 (up from twenty-seven in 1615); while that number would continue to climb over the next ten years, by 1640 the guild's registry of *konstschilders* would—because of attrition and death—be down to barely over twenty members.[3]

It did not help that, soon after the plague had died down and in the midst of Haarlem's difficulties around its most important trades, Holland and other provinces were subject to another infection—this time not bacterial but horticultural, making for one of the more remarkable financial episodes in history. If the economic impact of this event was not as dramatic and far-reaching as some contemporary accounts and later authors would have us believe, nonetheless, it was not without consequence for many families of the middle and upper-middle classes, as well as for the art world they patronized.

The madness centered on a commodity that, like so many others that quickly became staples in European households in the early modern period—tea, coffee, chocolate, tomatoes, potatoes—was a foreign transplant. It, too, landed in and dispersed around the Continent through a combination of enterprise, military venture, diplomacy, and scientific and scholarly fascination.

The tulip is widely regarded (and marketed) today as a product of Dutch ingenuity and culture. Along with windmills, it is practically a national symbol of the Netherlands. The tulip is not, however, native to the Low Countries. It was imported in the sixteenth century from Turkey and Asia Minor, brought northward by traders, but it did happen to flourish in the Dutch soil and climate. The flat and open lands around Haarlem were especially good for growing large quantities of flowers. It did not take the Dutch long to become adept at cultivating the tulip and cataloging (with quaint and picturesque names) variations in the blossoms' color, size, and shape.

The tulip quickly became *the* fashionable flower of northern Europe and an object of great aesthetic and scientific admiration. Interest in the tulip soon spread beyond the circle of horticultural specialists and professional gardeners to the general public. Members of the Dutch Republic's middle class were especially taken by both its beauty and marketability. They saw in the flower not just an attractive way to spruce up a small garden or decorate a house, but also an object of specialized connoisseurship and, not least, an investment opportunity. Unlike rarer and more expensive goods, such as gold, silver, diamonds, and porcelain, the trade in tulips—particularly the less extraordinary varieties—was something in which the lesser classes could engage, although on a much more modest scale than wealthy merchants. Buying and selling tulip bulbs, solo or by the basket, became an enticing opportunity to make a couple of guilders.

In the mid-1630s, when the market in bulbs started to become less a straightforward exchange of money for merchandise on hand and more a matter of speculation, many were drawn into what was, increasingly, an exercise in high-risk gambling.[4] The tulip is planted in September and, depending on the variety, comes up and flowers in the early to late spring. Once the flowering is done, the bulb is taken out of the ground, cleaned and dried, and stored for safekeeping; it is put back in the ground in September, and the cycle repeats. There is thus only a brief period during which one can actually examine the blossoms and, after that, hold the bulb in hand.

It was not uncommon for people to buy bulbs and make deals well out of season, several months in advance of a delivery date and without the buyer seeing any bulbs (whether in bloom or in storage) or even a sample of the variety being promised. As the value of tulips increased, many investors, between the signing of the deal and the delivery of the goods, would sell their interest in those bulbs to a third party at an anticipated profit. No money actually changed hands at the time; it was just a promise to deliver and a promise to pay, with the deal traditionally sealed by a glass of wine.

This market in tulip futures rapidly expanded, with more and more people playing the game. The number of transactions (via promissory notes) surrounding a single bulb or cluster of bulbs, and

thus the number of committed parties, would multiply as the secondary buyers turned around and offered their interest to others. It was just a matter of time before this activity around the paper became a market in its own right, with the interests themselves, rather than any actual tulip bulbs, being the real object of speculation. The fact that much of the middle class had few opportunities to invest their savings—shares in the Dutch East India Company, for example, were offered only to an exclusive group of wealthy merchants—made it all the more tempting for some of them to put their money in this attractive new commodity.

All of this sent tulip bulb prices skyrocketing, especially for the fancier varieties. There had always been quite a variety in quality and value. Ordinarily, a nice bulb might cost around twenty guilders, while a single specimen of the "Semper Augustus"—a highly prized tulip whose petals were red stripes on white—could go for over 1,000 guilders. In early 1637, however, a Semper Augustus reportedly sold for 13,000 guilders. The price of another sought-after tulip, the yellow and red "Switser," went from 125 guilders in December 1636 to 1,500 guilders by the following February.[5]

The value of the paper interests climbed ever more steeply as spring approached and the date of delivery of the bulbs drew near. Envisioning a big return on their money, people went to extremes to get in on a particularly good-looking deal. The poet Jacob Cats, in his *Sinne- en Minnebeelden* (Images of morality and love), a book of pictorial emblems with moral significance, tells us that one person, presumably a farmer, paid 2,500 guilders for a single bulb, in the form of two bundles of wheat, four of rye, four fat oxen, eight pigs, twelve sheep, two oxheads of wine, four tons of butter, a thousand pounds of cheese, a bed, some clothing, and a silver beaker.[6] This may be a case of literary exaggeration by one of many contemporary critics of the exuberance, but it must reflect to some extent what was going on.

As the day of reckoning approached, it was like the children's game of "hot potato": one did not want to be the last in line holding the original paper when the delivery date arrived. Rather than making a profit, the final buyer would be stuck with a bunch of tulip

bulbs bought at a ridiculously high price. When the crash came—and, with such an artificially inflated market, come it would—people were going to be hurt.

Just how much money was at stake and for how many people has been a subject of scholarly debate.[7] The enthusiasm, which was limited mostly to the province of Holland, was primarily a middle- to upper-middle-class phenomenon. The admiration and pursuit of tulips for beauty and profit was greatest among merchants and master craftsmen, most of whom could afford it. Very few grand fortunes were actually on the line with all the speculation. Still, whatever was happening was significant enough to attract attention from the magistrates in The Hague. The High Court of Holland was troubled to see so many usually sober-minded citizens engage in such an investment frenzy. When rumors that the authorities were about to intervene began circulating, prices started falling as people tried quickly to unload their tulip interests.

The panic reportedly began at a tulip auction in Haarlem in February 1637, where a florist hoping to sell bulbs at 1,250 guilders per pound could not even get a bidder when he dropped the price to less than 1,000 guilders. Within only a few days, the alarm spread to the rest of the province. A bed of tulips that a few weeks earlier might have fetched over a thousand guilders now went for six.[8] Few people wanted to invest in tulip futures or even meet obligations they had already made. In April, the court, hoping to forestall a debacle as buyers and sellers started defaulting on their commitments, nullified all deals made after the planting of 1636; any disputed contracts would have to be resolved amicably through arbitration or taken up with local magistrates. As for the tulip growers and dealers, it took some time for them to recover both their losses and their damaged reputations, as many citizens blamed them for fueling the mania in the first place.[9]

In the end, the "tulip mania" seems not to have been the broad financial disaster it has often been made out to be. People lost money, of course, but it did not leave many in the destitute and bankrupted condition described by more fanciful accounts of the affair.[10] The effect on the national economy, as well, was fairly limited. Rather, as

the historian Ann Goldgar has argued, something even more import-
ant than money was lost. "The tulip trade," she says, "evoked not a
financial crisis but a cultural one."[11] With both sellers and buyers re-
neging on deals—either in the hope of finding another buyer willing
to pay more or because of a loss of confidence either in the quality
of the product one promised to buy or in its profitability—what was
really damaged was trust, credit, and honor, the foundations of social
and economic well-being in a capitalist society. Personal fortunes
may not have been ruined, but good names were.

Haarlem was, along with Amsterdam and Enkhuizen, one of the
more fevered centers of the tulip craze. And it was the city's textile
manufacturers and merchants and its professionals that made up the
bulk of the flower's local traders—precisely the same people who
were commissioning and buying art.[12] As Goldgar notes, "the collect-
ing of art seemed to go with the collecting of tulips."[13] The *bloemis-
ten*, like the art *liefhebbers*, were all part of the same socioeconomic
world of bourgeois connoisseurs who prized and collected beautiful
objects—for knowledge, for aesthetic enjoyment, for status, and for
profit. It was not just Haarlem's art patrons who got involved in the
tulip business; its artists did as well. Frans de Grebber, the popular
landscape painter Jan van Goyen (who had served a brief appren-
ticeship in Haarlem under Esaias van de Velde in 1610, and then was
briefly active in the city again between 1634 and 1635), and the still-
life specialist Willem Claesz Heda, among others, were all caught up
in the rage.

We can only imagine, then, that whatever financial effects the tu-
lip mania did have on the general populace was not without conse-
quence for Haarlem's art world. Money spent on, or at least prom-
ised for, tulips was money not spent on paintings; and money lost on
tulips was no longer available for portraits. People still bought art, as
always. Paulus van Beresteyn, who sat for Hals in 1620, was an avid
participant in the tulip trade, but he was still purchasing works in
the mid-1630s, adding to a collection that included paintings by Van
Heemskerck and Goltzius.[14] Moreover, we owe to the Dutch passion
for tulips an invigorated taste for floral still-life painting, with tulips
often the main—and sometimes sole—subject of the "portrait."[15]

Still, we should not overlook the opinion of one contemporary song-
ster, who, troubled by the relatively brief but damaging obsession
with a mere flower, wrote, perhaps with a bit of overstatement, that

> those who previously had an interest in paintings, in books,
> In the great sciences, that is now all finished.
> They would rather see nothing stand before them but a tulip.[16]

*

All in all, then, the late 1630s represented the beginning of another
difficult period for Haarlem, not excepting its artists. Even someone
like Hals, now a specialist of high reputation whose portraits were
still in demand, had to contend not just with pestilence, a slump-
ing economy, and a passion for flowers that distracted patrons away
from investing in art, but also with increased competition for com-
missions and open market sales. There were many new painters on
the scene, both locally trained and coming from elsewhere. Over
the course of a decade, the number of *konstschilders* in the city had
risen dramatically. By 1635, forty-two master painters had joined the
thirty-four still in the ranks of the Haarlem guild.[17] And then there
were those who chose not to become guild members at all. There
were now over eighty fine art painters at work in Haarlem, almost
twice as many as ten years earlier.[18] Although, as we have seen, the
number would decrease over the next several years with the exodus
to Amsterdam, Hals undoubtedly felt the pressure.

On top of all this, there were, on a more personal and immediate
level, the family's debts. Hals was still having trouble staying ahead
of his creditors. In May 1636, he owed eighty guilders in back rent
to his landlord, Jacob Pietersz van der Meer; fortunately, the lawyer
Symon de Bray, brother of Hals's Saint Luke colleague Salomon de
Bray, stood surety for him on that account. There was also fifty-three
stuivers and ten pennings overdue that same month to the grocer
Hercules Jansz for *eetwaren* (foodstuffs); and, in August, sixteen guil-
ders, nine stuivers, and eight pennings to the baker Gerrit Govertsz
for bread. This was also the year in which Hals had to petition the
city for financial help in caring for his *innocente* son Pieter.

Aside from these professional challenges and domestic liabilities, there was yet another annoyance that Hals had to deal with around this time, a bit of trouble that came from within the guild. This fairly serious matter would cost him financially and, perhaps, in terms of his reputation as well. In the fall of 1635, he was accused of stealing a pupil from a local colleague.

There were a fair number of talented and accomplished women painters in the Dutch Republic in the seventeenth century. Anna Snellings, Sara Vroom, and Geertruijt van Veen were all active in Haarlem, but as far as we know none of them have left us any extant works. Margaretha van Godewijk, who had studied with Rembrandt's former pupil Nicolaes Maes in Amsterdam, and Maria Schalcken were both painting in Dordrecht. In Utrecht, there was Margareta Maria de Roodere and the learned scholar Anna Maria van Schurman, who, while a painter, is better known for her engravings. And in the Ter Borch family of Deventer, Gesina was following in the footsteps of her famous older brother Gerard, both of whom were taught by their father, Gerard ter Borch the Elder.[19]

These women were primarily amateurs. They painted either for their own edification and amusement or for family and friends. Several Dutch women, however, were professionals who earned a living through their art. Rachel Ruysch of Amsterdam and Maria van Oosterwijck of Delft painted lush floral still lifes on commission and for the market. In Haarlem, there was Maria de Grebber—daughter of Frans Pietersz and sister to Pieter Fransz—who produced mainly portraits and pictures of architecture.

While Maria did not join the Haarlem Guild of Saint Luke, two other women did. Sara van Baalbergen became a member in 1631, although no identifiable works by her hand are known to have survived. Two years later, she was joined by Judith Leyster, the most celebrated Dutch woman painter of the period.[20]

Leyster was born in Haarlem in 1609. She was the daughter of a one-time textile worker from the southern Netherlands, probably Antwerp. Her father ended up in bankruptcy after he purchased a brewery in a failed attempt to improve his family's finances and make a name for himself in Haarlem's social world. When her par-

ents, feeling disgraced, left the city, Leyster stayed behind and made her independent way as an artist.

We do not know for certain with whom she trained. One likely candidate is Frans de Grebber. Perhaps Judith and Maria acquired their skills together from Maria's father. This is suggested by the way in which Samuel Ampzing introduces Leyster in his *Beschryvinghe ende lof der Stad Haerlem*:

> Now I must name Grebber,
> the father and the son, and also the daughter praise.
> Whoever saw a painting by a daughter's hand?
> *Here painted another with a good and bold mind.
> [Printed in the margin: "Frans Grebber, with his son Pieter and
> daughter Maria. *Judith Leyster."][21]

Not only does Ampzing see fit to include Leyster in his praise of Haarlem and its artists—and he does so five years before she has joined the guild, so perhaps when she was still just an apprentice—but he mentions her in connection with the De Grebber family.

And yet, her paintings are not very De Grebber–like, neither in content nor in style. When he was not doing portraits of individuals and groups, including several civic guard pictures, Frans de Grebber, a staunch Catholic, painted mostly biblical and history themes, as did his son Pieter. Moreover, his works are carefully and precisely detailed. Leyster's extant oeuvre, on the other hand—about twenty paintings, according to one recent estimate—is made up almost entirely of genre pieces, made for sale on the open market.[22] One of her works was included in the lottery that Dirck Hals held in "De Basterdpijp" inn in 1634; it was valued at eighteen guilders.[23] Her pictures show people—young and old; single, couples, and groups—enjoying themselves over music, drink, and games. Some of her paintings depict smiling children, in several of which they are playing with a cat (fig. 46).[24] There are lovers, gamblers, and musicians. One unusual *vanitas* work shows two men sharing glasses with a rather animated skeleton; at some point it acquired the title *The Last Drop*.[25] There is

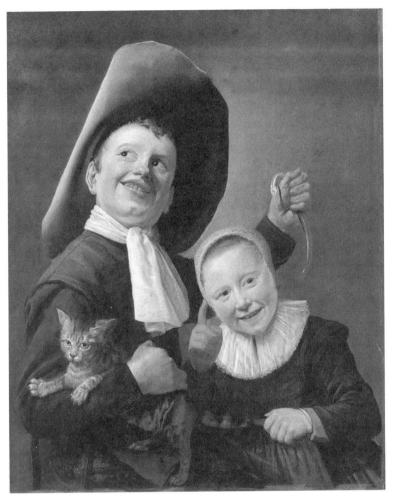

46. Judith Leyster, *A Boy and a Girl with a Cat and an Eel*, ca. 1635, National Gallery, London, UK. Bequest of C. F. Leach, 1943. Credit: © National Gallery, London/Art Resource, New York.

also a self-portrait (fig. 47),[26] a portrait of an unknown female sitter, and a still life.

There are, in fact, several influences—or, better, appropriations—evident in Leyster's oeuvre.[27] Her paintings clearly recall the "merry company" works of Dirck Hals, as well as the genre pieces of Jan Miense Molenaer, her soon-to-be husband. Leyster's panels and canvases also tend to be done in the "rough" style, with the same loose brushwork characteristic of the genre paintings and portraits

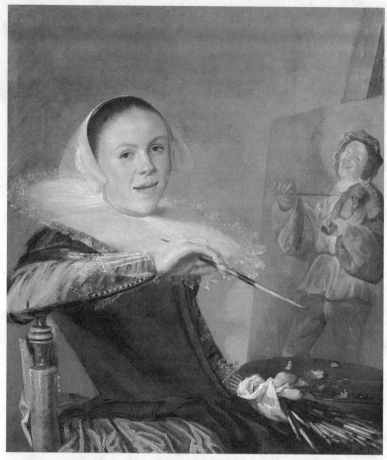

47. Judith Leyster, self-portrait, 1630. Courtesy of the National Gallery of Art, Washington DC. Gift of Mr. and Mrs. Robert Woods Bliss.

of Dirck's brother. Indeed, many of the *moderne beelden* and *tronyen* by Hals and by Leyster look, at least superficially, as if they were painted by the same hand. Some paintings from Hals's workshop have even been mistakenly attributed to Leyster. (An undated copy of Hals's much-copied *Rommel Pot Player*, in the Art Institute of Chicago, was once assigned to Leyster, but has now been reattributed to "Circle of Frans Hals.")[28] All of this suggests that Leyster, if she was not Hals's pupil, was at least working in his studio for a time, either as an apprentice or, having finished her training, as a journeywoman or paid assistant. This would have been in the late 1620s or early 1630s, precisely when Hals himself was turning out his genre scenes

and before she joined the guild in 1633. Even if Leyster did not train under or work with Hals—and some scholars reject such a tutelage on the basis of a comparative technical analysis of their paintings— there is no question that she knew his works well and, in a wise business move, sought to imitate his new and popular style.[29]

The problem is, we really have no idea who did train under or work with Hals in his studio. Naturally, there are the five of his sons who became painters: Harmen, Frans Jr., Reynier, Johannes, and Nicolaes. Dirck Hals probably received some lessons from his older brother as well. Houbraken, in *De Groote Schouwburgh der Nederlandse Konstschilders en Schilderessen*, says in his respective biographies of Adriaen Brouwer, Adriaen van Ostade, Dirck van Delen, Vincent Laurensz van der Vinne, and Pieter van Roestraten that they all were Hals's pupils. Houbraken, though, was writing fifty years after Hals's death, and there is no documentary evidence to corroborate most of these alleged apprenticeships. Only three cases are fairly certain. One is Van Roestraten, Hals's future son-in-law (he would marry Hals's daughter Adriaentje). In a notary record of 1651, Van Roestraten declares that he "worked for five years in the home of [Lysbeth Reyniersdr and her husband, Frans Hals]."[30] Documents also place an eighteen-year-old Van der Vinne, whose portrait Hals would paint in the 1650s, in Hals's workshop in 1646–47 as a pupil, but only for nine months.[31] And then there is Philips Wouwerman, not mentioned by Houbraken. As we have seen, the German painter Matthias Scheits says that Wouwerman trained under Hals—and he should know, since he trained under Wouwerman, while Hals was still alive.[32] Van Roestraten, Van der Vinne, and Wouwerman all became successful painters of still lifes, genre pictures, and landscapes, but none of them were portraitists.[33] And none took on Hals's distinctive painterly style.

As for Leyster, Houbraken does not even deem her worthy of a mention, despite the fact that his three-volume biographical treatise is devoted to "Dutch painters and painteresses [*schilderessen*]"! The only evidence we have for a personal connection (and possible working relationship) between Hals and Leyster is the fact that one of the witnesses at the baptism of Hals's daughter Maria in 1631 was

"Judith Jans," almost certainly Judith Leyster (her father was Jan Willemsz Leyster, and thus she was "Judith, Jan's daughter").[34]

The two artists crossed paths on a less celebratory occasion a few years later, after one of Leyster's pupils had forsaken her for Hals. Leyster was the only woman artist in the city to run her own workshop, which she set up in her home on Korte Barteljorisstraat shortly after being admitted to the guild. She had three *leerjonghens* studying or working under her: Davidt de Burry, Hendrick Jacobsz, and Willem Woutersz. In the late summer of 1635, Woutersz, who had been with Leyster for only a couple of days, left her to join Hals's workshop on Grote Heiligland, on the other side of town. On September 5, Leyster brought a complaint to the Guild of Saint Luke about "how an apprentice abandoned her, and who was received by Frans Hals." It is unclear whether her ire was directed only at Woutersz and his family or at Hals as well. Either way, Hals was now caught up in a complex business dispute involving another artist's student and, more to the point, the fees that accompanied him. He was ordered by the guild to let Woutersz go or he would be fined three guilders.[35]

Hals ignored the order to release Woutersz. Neither had he registered the young man as his new apprentice, as required by the guild's regulations.[36] One month later Hals was summoned to appear before the guild's dean, Hendrick Pot, and three of the *vinders* to account for his behavior. Hals's lackadaisical attitude toward regulation and protocol might explain why he, by now a well-established, long-standing member of the guild, will end up serving only one, very brief and abbreviated term on its board.

Leyster, meanwhile, was trying to get payment from Woutersz's mother for the time her son had spent in Leyster's studio. She asked for eight guilders, one-quarter of the annual fee they had agreed upon. Woutersz's mother, Anneken Willemsdr, protested, quite reasonably, that this was an "unjust" request. She claimed that young Willem had been with Leyster for only three or four days, and yet the painter was asking for three months' worth of payment. The guild officers agreed with Anneken, and, "after many words had been exchanged," they ordered her to pay Leyster four guilders and be done with it. Leyster herself was fined twelve stuivers for having failed to

declare her new pupil within the allotted six weeks of taking him on.[37] As for Woutersz, he was "free to go [study] wherever he wanted"— although presumably not with Hals—while Leyster was directed to have her servant bring Woutersz's belongings to his home.

Shortly after all this unpleasantness, in June 1636, Leyster celebrated her wedding to another Haarlem artist, Jan Miense Molenaer. A native of the city, he lived close by Leyster's home when they were growing up, so perhaps they were friends from childhood. Or it is possible that they first met in Hals's workshop, where Molenaer might have spent a year or two as a pupil. Molenaer would go on to become one of the more successful and prolific genre painters of his era. The characters that populate his panels and canvases—card players, musicians, drinkers, smokers, and yes, laughing children playing with a cat—very much resemble those painted by his wife, and by Hals.[38]

The couple left Haarlem for Amsterdam later that year, probably just after the contretemps over Woutersz, no doubt in order to take advantage of that city's expanding art market. Leyster, however, may have stopped painting altogether after the move. Perhaps it was the burden of caring for five children. Or maybe she did continue to work, but as a member of Molenaer's workshop.[39] There are only a few signed pieces by her that can be securely dated after 1636. These include a beautiful watercolor of a single Semper Augustus tulip, done for a botanist and connoisseur who wanted an example of the flower to study, that she painted in 1643, long after the mania had died down; in the eighteenth century it was bound into a tulip catalog.[40]

Leyster and Molenaer returned to their hometown in 1648, the year they also bought a summer house in nearby Heemstede.[41] She died in 1660, and her husband in 1668. Any breach in her relationship with Hals—if there was one—had apparently been repaired years earlier and all forgiven. For among the items listed in the estate inventory of the couple's goods are "two portraits of Jan Molenaer and his wife by Frans Hals—without a frame."[42] These pictures were very likely marriage pendants. Stored away, frameless, in the front room of the second floor of their house (and both now assumed

lost),[43] they had to have been painted after the couple wed, and thus after the legal tussle over Woutersz.[44]

*

In the final years of the decade, a flurry of high-profile and remunerative commissions came Hals's way. Besides the second, more relaxed portrait of a visibly older Willem van Heythuysen from around 1635, there is, four years later, a second, three-quarter-length portrait—this time on canvas—of Pieter Jacobsz Olycan, looking only slightly more aged than he did in 1629 (plate 16).[45] Olycan, now in the second of his five terms as a Haarlem *burgemeester*, is shown in a somewhat more casual pose, seated with his gloves in his hands, but he has lost none of his grandeur.[46] The rich brewer is as imposing as ever. He also commissioned from Hals another pendant portrait of his wife, Maritge Claesdr Vooght, whose sister Cornelia was painted by Hals, with her husband, Nicolaes Woutersz van der Meer, eight years earlier. The pious Maritge is once again shown with a thick metal and leather-clasped book, as in her earlier portrait, only this time rather than holding it up by her chest it rests on her lap (plate 17).[47]

By this point, Hals has captured nine members of the Olycan clan—the parents, their sons and daughters, and daughters- and sons-in-law—in a dozen individual and group portraits. Quite a few of the men appear in one or another civic guard painting: Pieter and Maritge's son Jacob in the 1627 banquet of the Saint George officers; their other son Nicolaes, as a lieutenant in the 1633 Saint Hadrian officers' portrait,[48] which also shows the husband of their daughter Maria, Andries van Hoorn, and the husband of their daughter Volckera, Johan Herculesz Schatter (who is present in the 1627 Saint Hadrian guard painting as well). Andries and Maria sat for their own pendant portraits in 1638 after their wedding, much as her brother Jacob and his wife, Aletta, had done in 1625. In the three decades since Hals joined the guild, the Olycan family has proven to be a reliable source of income for him, and they would remain so for years to come. As Seymour Slive puts it, "the Olycan family and their relatives virtually employed the artist as their family portraitist."[49]

Aside from powerful brewers and other members of the city's re-

gent class, denizens of the Haarlem intellectual and literary world—following the example of Ampzing, Scriverius, and Schrevelius—continued to turn to Hals for their likenesses. Jean de la Chambre, a local schoolmaster (he taught French) and calligrapher, used Hals's small and very rough portrait of him in the act of writing with a quill as the basis for an engraving that would serve as the frontispiece for a volume of his work.[50] De La Chambre's calligraphic colleagues Theodore Blevet and Arnold Möller also turned Hals's portraits of themselves into engravings useful for publications intended to illuminate for others, in this age of handwritten letters and texts, "how profitable it is for all men to learn respectable writing."[51]

In 1639, Hals also painted his third, and final, portrait of the officers of the Saint George civic guard (plate 18).[52] Once again Hals has posed the officers outdoors, all eighteen of them: the colonel and fiscal, the captains of each of the three companies, their four lieutenants and five sergeants, and four ensigns. The composition of the painting, while as inventive as ever, is noticeably less dynamic than his earlier guard portraits. All the men are quite still—with one exception, Michiel de Wael, the officer just off center in yellow, who seems to be moving toward his colonel, Johan Claesz Loo (a member of the extended Olycan network, as father-in-law to Pieter and Maritge's daughter Dorothea). They stand in two horizontal rows set across the picture, with the line of men in the rear slanting down a stairway at a slight angle. Some of the officers in the front row glance at their colleagues, but quite a few are just looking out at the viewer. While the back row is a bit more animated, with some gesturing going on, there are no conversations. Except for Colonel Loo, who appears to be listening to something being said by the man behind him, no one is leaning into anyone else for a private remark or reaching for something. There is, in fact, nothing to reach for, since there is no table laden with food. None of this detracts from the impression this large portrait of Haarlem civic leaders, and protectors, makes.

<p style="text-align:center">*</p>

By one reckoning, Rembrandt did over eighty self-portraits, in paintings, prints (etchings and engravings), and drawings; Rubens, while

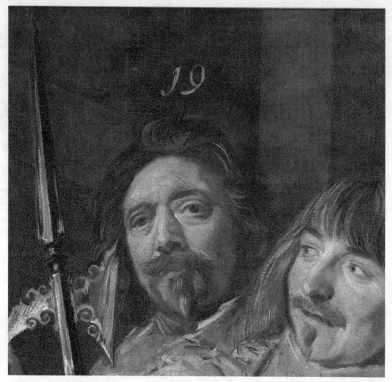

48. Frans Hals, self-portrait (detail from plate 18, *Officers and Sergeants of the St. George Civic Guard*, 1639, Frans Hals Museum, Haarlem).

not as obsessed with his own changing visage as Rembrandt, still produced a fair number of images of himself, both solo and with each of his two wives. Hals, as far as we know, did only two self-portraits, although the evidence even for these is only anecdotal.

The earlier of those self-portraits is in that final Saint George guard picture (fig. 48).[53] The painting contains a couple of more figures than the number usually included in Haarlem civic guard paintings, and one of those extras, lurking in the rear of the crowd, is believed to be Hals himself.[54] The artist, who may have been a member of the Saint George guard at the time—as he was back in 1616—has inserted a small rendering of his face in the upper left corner, peeking over the shoulder of an ensign. He was in his midfifties at the time and pretty much looks his age. He wears his full head of brown hair long, as was the style in those years; and like every single one of the officers around him he has a mustache and a small tuft of whis-

kers just under his lower lip. The facial hair frames a small mouth with full lips. His brown eyes, set wide in a round face with a slight double chin, are a little puffy top and bottom.

About five years later, Hals painted himself again, this time in a small dark portrait (plate 19).[55] The original is now lost, but there are several anonymous copies, of varied quality, from the late seventeenth and early eighteenth centuries. It is clearly the same man who is standing behind the Saint George officers and looking out at us, only now somewhat older (in his midsixties) and with a somewhat thinner face. Hals's hair is still long, with only the slightest signs of graying, and topped by a high black hat sitting on his head at a slight, jaunty angle.[56]

*

Did Hals ask the Saint George officers for the same fee he requested of the officers of Amsterdam's District 11 civic guard, sixty guilders per figure? If he did, then the painting would have brought him over a thousand guilders. Still, the commissions in the late 1630s and early 1640s did not do much to improve Hals's financial situation. Debts continued to pile up. He once again owed back rent, this time to his new landlady, the widow Commertje Jacobsdr. Sometime before 1640, Hals and his family had moved from the Groot Heiligland to a house that Commertje had inherited from her late husband, Captain Willem Tas, in an alley off the Lange Begijnestraat, way on the other side of the Grote Markt by Saint Bavo Church. In January of that year Hals was already thirty-three guilders in arrears. Twice he ignored the summons to appear in court and so was pronounced in default. He was finally given two months to settle up.[57] There was another sixty-six guilders in rent coming due in May, but Hals would likely not have had to pay this, at least not to Commertje Jacobsdr. She sold the house on May 4. Soon thereafter, the family moved yet again, and by the fall of 1642 they were living on the Kleine Houtstraat.[58] They did not stay there long, since a year later they were living on the Oude Gracht, back again on the side of the Grote Kerk from which they came.[59]

These frequent moves—which included the painting studio—

could not have been easy on a large family, either its morale or its budget. Which may explain why Hendrick Hendricksz was suing Hals for five guilders in September 1642 for the delivery of a bed, and why that same month Hals was past due in paying his annual guild dues—only four stuivers, again less than a quarter of a guilder, but apparently more than he could afford, or was willing, to part with at the moment.

There was other trouble on the home front. In the summer of 1640, Hals's wife, Lysbeth, was the victim of an assault—*eenigh gewelt* (some violence), according to the court record—by a man named Gerrit Philipsz. The details are lacking, but Gerrit was ordered to pay six guilders in penalty; the money went not to Hals, but to the city's poor relief fund. Nonetheless, Gerrit made some restitution to Lysbeth herself, and the incident was resolved amicably. The notary relates that "between Gerrit Philipsz and the wife of Mr. Frans Hals peace is made on correction [*is geleyt vreede op correctie*]."[60]

Yet more domestic crisis was in store later that year. In December, Hals's and Lysbeth's daughter Sara, now twenty-three years old, gave birth to a baby out of wedlock. The father of the girl—who was baptized Maria—was Abraham Potterloo, who was the nephew of the family friend Isaac Massa who sat several times for Hals. (Abraham's mother was Massa's sister Susanna, who had been a witness at the birth of Dirck Hals's daughter Hester.) Needless to say, this was not a good situation. The Dutch Reformed Church did not look kindly on extramarital sexual relations, and the civil authorities often treated them as a criminal offense, with the possibility of banishment from the city.[61]

Sara avoided any harsh penalty and remained with the baby in Haarlem. However, she was in trouble once again a year and a half later. In March 1642, and still unmarried, she was pregnant with her second child. There were rumors that the father this time was a baker named Pieter Woutersz. Sara denied this in official testimony before a notary, adding that she had been having sexual relations with several men. The midwife who attended Sara at the birth of Maria reported that when she asked Sara whether she had been with anyone else beside Potterloo, Sara replied "Yes, I have been with

more."[62] Still, one wonders whether Potterloo could also have been the father of Sara's second child. (There is no record of a baptism, and so the infant may have died during or soon after birth. Or perhaps, given the circumstances and out of discretion, he or she was secretly baptized somewhere outside the city.)

By this point, Sara's parents had had enough of her behavior. On March 29, Lysbeth, "acting in the name of her husband," requested of the burgomasters that "her oldest daughter, for reasons conveyed by mouth, must be handed over to the workhouse of this city, for the sake of improvement and confinement." Before taking action, the city leaders asked that Hals himself speak with the regents of the workhouse and come to some kind of agreement with them, perhaps over the cost of his daughter's incarceration. The painter did so, upon which the burgomasters ordered the captain of the night watch to arrest Sara and take her to the women's house of correction.[63]

The additional financial burden aside, this could not have been an easy thing for her parents to do. Frans and Lysbeth must have felt they had no alternative. Sara's confinement, though, would be only temporary. She apparently satisfied her parents and the authorities that her wild days were behind her. She moved to Amsterdam and lived just beyond the city's former Sint Antoniespoort (Saint Anthony's Gate), which was now the site of the Waag, or weigh house, and the headquarters for several guilds, including the painters' guild. Sometime after the move Sara found her true love, or at least a more stable and permanent relationship, for in March 1645 she and Sjoerd Eles, a sailor from Molkwerum, posted their marriage banns in both Haarlem and Amsterdam.

Equally distressing for the Hals family—and of greater expense—must have been the fate of their mentally ill son, Pieter. Just two months after Sara's incarceration, the young man had to be sent to the men's workhouse. Pieter would pass the rest of his life in a kind of solitary confinement ("in een bysondere plaetse buyten de gemeenschap van mensen," according to the relevant document—in a particular place outside the society of people) and "doing whatever work for which he is suited." In the end, he would spend twenty-five years there.[64]

49. Frans Hals, *Regents of St. Elisabeth's Hospital*, 1641, Frans Hals Museum, Haarlem. Elisabeth van Thüringenfonds. Photo: René Gerritsen.

The regents of the Saint Elisabeth's *gasthuys* or hospital—which, as a public charity, was responsible for caring not only for the sick but for the needy as well—had provided earlier financial support for Pieter's care. They now covered half of the annual cost of his confinement in the workhouse. Around 1640 or so, just before Pieter was taken away for good, they all sat together for a group portrait by Pieter's father.

Not just anyone could join one of these civic boards. You had to come from the right part of town—you had to belong to the patrician class and have the appropriate religious credentials (Reformed, of course; Remonstrant or Counter-Remonstrant, depending on the year) at the time of appointment. Thus, the current regents of Saint Elisabeth's board that Hals captured on a large (153 × 252 cm) canvas were all members of wealthy, prominent and properly affiliated families in the city (fig. 49).[65] The portrait shows five men soberly dressed in black with flat white collars; two of the collars, like the wrist cuffs, are plain, three are decorated with lace edging. The days of large, millstone ruffs around the neck were over. All of the regents are wearing black hats. Unlike the civic guard pictures, there are no col-

50. Johannes Verspronck, *Regentesses of the St. Elisabeth's Hospital*, 1641, Frans Hals Museum, Haarlem.

orful garments or bright sashes. The men sit around a cloth-covered table upon which lies a book, some pens and an ink bottle, and several coins. The only decoration in the room is a map hanging on the back wall. Still, it is an animated group, with the men, hands in motion, deeply engaged in conversation over some matter of business before them. These are serious citizens devoted to the important role they play in Haarlem society. Their women colleagues, the regentesses of Saint Elisabeth's, had their portrait painted that same year, but the job went to Johannes Verspronck rather than Hals (fig. 50).[66]

*

The issue of lotteries and auctions, so hotly disputed when the Haarlem Guild of Saint Luke was drafting its new charter in 1630, was never fully resolved. Tensions over these practices continued to simmer within the guild membership, as well as more broadly among the various constituencies of the city's art world and the civic and religious authorities. Despite the proclamation against "all extra-

ordinary manner of selling" in the revised charter, public and private sales of paintings outside the network of studios and dealerships continued to be held with some regularity, much to the dismay of the guild's officers, local dealers, and, as usual, ministers of the Dutch Reformed Church. By the early 1640s, it had once again become an openly contentious topic, and even threatened to lead to a rupture in the guild's class of fine art painters.

The ostensible problem, as before, was artists coming from outside Haarlem to sell their works in the city. Their inventory was plentiful and their prices were low, and so they were undercutting the business of the local masters. The original guild charter from 1590 excluded nonmembers from the market, but over the years this restriction was, as we have seen, inconsistently enforced. The guild's earlier request to the city council to ban lotteries—and especially the selling of "foreign works"—in order to "prevent the utmost spoiling and ruin of art" was just one attempt to maintain its monopoly over art sales in the city. The peddling of art by noncitizens, however, was not the only reason for renewed agitation for restricting the market.

It all came to a head in the early 1640s. The guild's dean at the time was the meticulous painter of architectural *perspectieven*, Pieter Saenredam. While not a Haarlem native—he was born in Assendelft—Saenredam moved to the city in 1612 at the age of fifteen to study with Frans Pietersz de Grebber. Many of his paintings of churches and other public buildings, in Haarlem and elsewhere, carefully depict both the perspectival geometry of the structural space and the play of light on different surfaces: plaster, brick, stone, and wood. The Saint Bavo Church was a favorite subject, and between the late 1620s and early 1660s he rendered its sparely decorated, light-filled interior in over a dozen panels and many drawings.

In 1642, Saenredam and the other board officers, formally renewing the antilottery campaign, drafted a request to the burgomasters for a ban on all forms of unauthorized public sale of art in the city. Lotteries and auctions not held under the auspices of the guild or the municipality, in particular, should be prohibited. The board was able to get forty-nine artists to sign onto their petition, a majority of the guild membership.

Not all the city's master painters favored limiting their trade in this way. A small group submitted a counterpetition to the city arguing against the guild's official request. They were led by Frans de Grebber, who had opposed the earlier attempt to restrict public art sales and was now, once again, an outspoken proponent for a free and open market. De Grebber was joined by his colleagues Pieter de Molijn, Cornelis van Kittensteyn, Salomon van Ruisdael, and Cornelis Vroom, as well as Frans Hals.

The De Grebber group saw the guild board's "absurd" request as an ill-advised attempt "to sweep away the free and longstanding excellent art of painting of this city and to make it a lowly, servile slave, bound hand and foot, without any freedom."[67] They looked beyond the complaint about "foreign competition" and believed that behind the guild's request lay the machinations of art dealers and others who profited from private dealing. These businessmen, they insisted, were the real "bell hammers" who wanted to keep art aficionados (liefhebbers) paying several times more for a painting than it was worth.[68]

There was some truth to this claim. In September 1641, De Molijn had sought to take advantage of the estate auction of his late brother-in-law by including some of his own paintings in the inventory for bidding. It was a clever, and not uncommon, maneuver; painters were known to unload their stock by sneaking it into estate sales. This time several art dealers protested.[69] Probably not coincidentally, the guild's petition followed soon thereafter.

In their counterpetition, De Grebber and his colleagues insisted that free and open sales, with diverse venues and opportunities for the public to purchase paintings, were essential to the health of the art market and in the best interest of artists and buyers alike. Limiting sales to the direct trade in studios and by dealers, they protested in a series of arguments, benefited only established and eminent artists and the well-heeled, veteran clients who, in the know, regularly bought their works.

First of all, such restrictions put younger painters who were not connected with dealers and whose work was not yet known or sought after at a great disadvantage and threatened to cut short their

careers. Without auctions and lotteries, a new artist just starting out in the profession would have trouble introducing their paintings to the public, so much so that they would "become desperate in their progress in art and have to turn to some other means [to make a living]."[70] Why build up an oeuvre if you have little chance of showing, much less selling, any of it. An open market, offering more ways to peddle art, was good for everyone: "extraordinary masters" as well as "common masters."[71]

Outlawing auctions and lotteries, the De Grebber group further claimed, would put a limit not only on supply but also on demand. New *liefhebbers* are "born" at public sales, they argued.[72] Such occasions allow for the exposure of more people to more work of greater variety—especially things that otherwise would not get made or sold. The guild's proposal, on the other hand, would mean that only people who are regular patrons of the studios and dealers and who know what they want would be doing the buying. Their tastes would thereby dictate what got painted. A closed market is a dying market, one that has no way of expanding or evolving, neither in the number of participants, in their socioeconomic distribution, nor in artistic style and content.

Above all, they complained, the guild's request represents an encroachment on an artist's right to make what he wishes and sell what he makes in whatever way he wants. As long as public sales were allowed elsewhere—The Hague, Amsterdam, Delft, Rotterdam, Dordrecht—it would be rather arbitrary, not to mention counterproductive, for Haarlem to depart from what is a general practice. More paintings by more artists available to more people in more ways was best for everyone, or so De Grebber, Hals, and the others maintained.

Were the signers of the counterpetition motivated by laissez-faire practice as a matter of economic and political principle? Perhaps. More likely, they had their own financial interests in mind. De Grebber profited nicely from auctions he organized and in which he participated. Hals, too, relied on lotteries and auctions for the sale of his genre paintings, as well as any works by others for which he might have been serving as a dealer. But De Grebber and Hals were relatively lucky. They were prominent portraitists enjoying high repu-

tations among the moneyed class in Haarlem and beyond. For many other painters—especially those who could not depend on commissions—livelihoods were at stake. They needed the various arenas of public sale for their income. This was thus not a trivial issue. For the guild to be so divided on a matter right at the heart of their business enterprise was a serious matter indeed.

The burgomasters were not moved by the counterpetition. In August 1644, two years after receiving both the guild's request and the De Grebber group's objections, the city council, already inclined toward protectionism, issued an ordinance restricting public sales.[73] While allowing for an unrestricted art trade on the semiannual free market days—including works by noncitizens—it banned just the kind of selling that so troubled the guild's officers. Auctions would be permitted only when the art was part of the estate of a deceased person or the stock of an artist or dealer who was going out of business. There was—at least in law—to be no more selling of paintings on the street, in door-to-door solicitations, or in unsanctioned bidding in the backrooms of inns and taverns.

De Grebber, Hals, and the others did not give up easily. They lodged a series of protests against the city's new policy, reiterating the points they made in their initial counterpetition. They reemphasized their claim that auctions and lotteries "commonly extend to low quality paintings [slechte schilderijen] and such people who would otherwise not buy any paintings, and also who in their life never come to a painting shop or art dealer," but it was to no avail. Even the argument that the ordinance would lead to artists taking such business, including public sales to fellow Haarlemmers, beyond the city walls (and thus beyond city tax receipts) did not change the burgomasters' minds.[74]

It is unclear how strictly the new regulations were enforced. Evidently, the De Grebber group's prediction—or was it a threat?—that auctions will continue, only now outside the city, was to be taken seriously. For in 1649, five years after the new city policy was announced, former members of the guild's board were summoned for an extraordinary meeting to discuss just this issue. Salomon de Bray, Pieter Saenredam, Pieter de Molijn, and several others were asked to con-

sult among themselves "in order to reply to the burgomasters about preventing auctions taking place outside the city." After discussing the matter on this special "sit day," they recommended that the best solution for "the common good" was to stand by the ordinance, but allow for some exceptions. Let the prohibition remain in place, they suggested, but permit guild brothers to sell their own work by auction "one or more times per year," on the condition that a list of works to be so offered is provided in advance to the guild board.[75]

Hals was now himself an *oude vinder* (former board member) and among that emeritus group charged with assessing the situation of extramural auctions. In January 1644, before the burgomasters had rendered their decision to ban auctions and lotteries within the city, the outgoing members of the board nominated him, along with three other painters (Jacob de Wet, Albert Sijmonsz de Valck, and Johannes Verspronck) and two craftsmen (the tinsmith Frans Sijmonsz and the glassmaker Hendrick Eymbertsz). All six men were duly approved by the burgomasters, and by the beginning of February Hals was attending his first board meeting as a *vinder* in the Guild of Saint Luke. The still-life painter Willem Claesz Heda, one of the board members whose term was continuing, was appointed to be the new dean of the guild.[76]

This was the veteran master painter's first—and last—term as a guild officer. It may have been the previous board's bid to outlaw lotteries that had moved Hals to stand for the position in the first place. He lasted only one year, an unusually short tenure. Appointees typically sat for two years and, over the course of their career, served a number of terms. Frans de Grebber was a *vinder* twice, and Pieter Soutman three times. Salomon de Bray served four terms on the board, Willem Claesz Heda five terms, and Pieter de Molijn eight terms.[77] Perhaps Hals sought the position so that he might have a hand either in revising the guild's request on lotteries and auctions or in persuading the city not to grant it. When he saw that the protest lodged by him, De Grebber, and the others was a lost cause, he must have concluded that there was no longer any point in sitting on the board.

Or it may be that having a leadership position did not suit Hals's

personal temperament or his family's needs. The administrative du-
ties it involved would have been a distraction from his main concern
at this time, as it has been all along: making money. For every debt he
cleared, a new one arrived. Just as Hals was being installed as *vinder*
he was delinquent to Jan Marchant for five guilders and two stuiv-
ers, for "coarse linen" that Lysbeth had bought. Marchant had to sue
him for payment, but Hals, as he had done on many other occasions,
failed even to show up in court. After four years of trying to get Hals
to settle his bill, Marchant took legal action once again. This time,
the painter did manage to answer the summons and was ordered by
the magistrates to pay Marchant within one month, with interest.[78]
Around the same time, Frans and Dirck together were nearly sixty
guilders in arrears to the shoemaker Otto Gerritsz; after the latter's
death, in the summer of 1647, it was up to his heirs to come after the
Hals brothers for the money.[79]

Hals's inability—or unwillingness—to meet his financial obliga-
tions on time and his propensity not to show up in court when sum-
moned seems to have been passed on to his sons. While Marchant
was after Frans Sr. for the linen, several innkeepers were pressing
Frans Jr. for payment "for provisions," that is, food and drink. The
young man was now an established Haarlem painter in his own right,
with works that, in subject and style—portraits, genre pictures, and
tronies—are very much like those of his father. In the spring and
summer of 1644, Frans Jr. owed Claes Ouwele one guilder and nine
stuivers and Jan Jooseten three guilders and ten stuivers; in the latter
case it took two writs to get him even to show up before the magis-
trate.[80]

Hals's eldest son, meanwhile, was facing a more serious overdue
payment. Harmen, now thirty-three years old, had been living away
from Haarlem, in Vianen, in the province of Utrecht.[81] This is where
he set up shop as a painter in 1642, although he would later decamp
to Amsterdam and then Noordeloos. Like his half brother, Harmen
also specialized in genre pictures, albeit using a relatively limited
palette, with colors tending toward brownish tones. His particular
forte was low-life tavern scenes, much like those painted by Adriaen
Brouwer (to whom some of his works have been attributed).

In January 1645, Harmen's landlord, Hendrick Hendricksz van Roy, was demanding a year's worth of back rent. Because Harmen's father had stood surety for his son, Van Roy was now seeking from Frans sixty guilders plus a "one day painting"—presumably something done quickly and without too much trouble—to cover Harmen's debt. Harmen did not respond to a subsequent summons from the Vianen Court of Justice to meet this obligation—likely because he had by then left town.[82] We do not know whether Hals actually had to come through on behalf of his son; that would have been a rather large balance for him to cover when he had his own debts to manage.

Despite their fiscal irresponsibility, Frans Jr. and Harmen managed also, around this time, to bring some joy to the Hals family. It must have been a rare occasion of good news when Hals, who was in his early sixties, and Lysbeth, who was around fifty, learned in 1644 that they were now grandparents to a child born in wedlock. That July, Frans Jr. and his wife, Hester Jansdr, gave birth to a daughter. She was baptized "Lysbeth," after her paternal grandmother who, along with her husband, was one of the witnesses at the ceremony. (Frans Jr. and Hester must have had a fruitful wedding night, as Lysbeth was born just nine months later.) Within a little more than a year, the couple had a second child, this time a son, whom they named Johannes.[83] And soon after the birth of Johannes, another Lysbeth was born, this time in Amsterdam, to Harmen and his first wife, Claesje Jansdr. (Harmen would end up twice widowed, three-times married.)

*

When Hals painted the regents of Saint Elisabeth's, he of course gave them that "master's touch." Their clothes, especially, show the increasingly looser application of paint with finishing highlights dabbed in so characteristic of his portraits in this period. The signature rough style that was serving Hals so well and drawing him significant commissions and recognition from connoisseurs, however, would soon be going *out* of style. Portraits done à la Van Dyck, in the more elegant, even ostentatious manner fitting for the aristocratic

British clientele of that Flemish master—and much as Hals had painted his early picture of Willem van Heythuysen and the "laughing cavalier" Tieleman Roosterman—were growing in popularity among Dutch patrons, especially around the stadholder's court.[84]

Frederik Hendrik himself favored the Flemish look of Rubens and Van Dyck. Among Dutch artists he had a preference for what Van Mander had earlier called the "smooth" style—especially the paintings coming out of the Leiden workshop of Jan Lievens (rather than those of his rough-painting, erstwhile studio mate Rembrandt) and, in Utrecht, the works of Paulus Moreelse and the Caravaggist Gerrit van Honthorst.

The real tastemaker at court and beyond was the stadholder's highly cultivated wife, Amalia van Solms-Braunfels. Born into an imperial household—her father was Johan Albrecht, Count of Solms-Braunfels—Amalia served as a lady-in-waiting to Elizabeth Stuart, wife of Frederick V. She arrived in the Dutch Republic with the family of "The Winter King and Queen" when they fled Bohemia and settled in The Hague. Frederik Hendrik, the half brother of Prince Maurits and not yet stadholder, fell head over heels in love with Amalia, and they wed in April 1625. When Maurits died shortly thereafter and Frederik Hendrik assumed the stadholdership of Holland and other provinces, Amalia's social standing improved considerably. She was now, in effect, "first lady" of Holland.

Amalia was bred in Europe's high aristocratic circles and had a royal's appetite for luxury goods. She collected jewels, tapestries, and, with a very fine and discriminating eye—and a budget to match—paintings. Rubens and Van Dyck were the couple's favorites, though they also owned a number of Rembrandts. When she married Frederik Hendrik, it was Van Dyck to whom they turned for pendant portraits, as well as, a few years later, a portrait of their son William II. Amalia also had her portrait done by Van Honthorst and by Rembrandt. Over the years, and with riches acquired by the share of captured military bounty that Frederik Hendrik was due by virtue of being commander in chief of Dutch forces, she and her husband amassed a magnificent gallery of works by the greatest Dutch and Flemish masters. The collection, hundreds of paintings dispersed

over various residences and chosen with a predilection for works done in a classicizing, Italianate manner, included histories, genre pieces, and portraits of their children and members of their court and the court of the Bohemian exiles.[85]

Amalia, while interested exclusively in Netherlandish art, had ecumenical taste, and in Dutch painting her collecting extended beyond the studios of Amsterdam and Utrecht.[86] When she, working with the stadholder's secretary Constantijn Huygens and the architect Jacob van Campen, completed the Oranjezaal ballroom in the Huis ten Bosch, her "house in the woods" retreat on the outskirts of The Hague—this was after the stadholder's death—it was decorated with paintings by several Haarlem artists, including Pieter Soutman and Salomon de Bray. Meanwhile, fellow Haarlemmers Pieter de Grebber and Cornelis Vroom provided ceiling paintings for Honselaarsdijk, the stadholder's country residence.[87]

Frederik Hendrik's wife was something of a fashion icon and influencer, at least among the upper classes of Dutch society, and thus bore a good deal of responsibility for the trend toward a more sumptuous content and polished finish in painting. Artists like Adriaen Hanneman and Jan Mijtens, working in The Hague, and Pieter Codde, Govert Flinck, Ferdinand Bol, and Bartholomeus van der Helst, all active in Amsterdam, were depicting their sitters in the "smooth" or "neat" style, often showing them in shimmering, luxurious, and obviously expensive fabrics. Through the 1640s and well into the next decade, this more refined manner of painting would become the preference for the Republic's aristocratic and regent families. Still, as the painter and writer Philips Angel noted in 1642, in his *Lof der Schilderkonst* (Praise of the art of painting), a certain "looseness"—what he calls "a nimble, bold yet sweet-flowing brush," free from "the error of stiffness"—is required even in the neat manner. "Anyone who adopts another course [than the 'neat' style performed with the 'meticulous looseness' of the Leiden *fijnschilder* Gerrit Dou] will be more mocked than praised."[88]

Hals, no stranger to Antwerp's artistic traditions and the Van Dyckian style, was not above catering to the new taste, but he did it in his own characteristic way. His portrait of Jasper Schade, a

51. Frans Hals, portrait of Jasper Schade, ca. 1645, National Gallery of Prague. Photo: © National Gallery Prague, 2021.

leading citizen of Utrecht, from around 1645 shows a young dandy very stylishly dressed—in the latest French fashion—and coiffed (fig. 51).[89] (When Jasper was in Paris some years earlier, he reportedly ran up large tailor bills.)[90] There is more than a touch of vanity and arrogance in his countenance, as befits a man with a bright political future as the representative for the province of Utrecht in the States General and, later, president of the provincial court.

No less haughty seeming is twenty-two-year-old Willem Coenraadsz Coymans, the scion of a wealthy Amsterdam regent family who, portrayed by Hals in a finely embroidered jacket and hat with

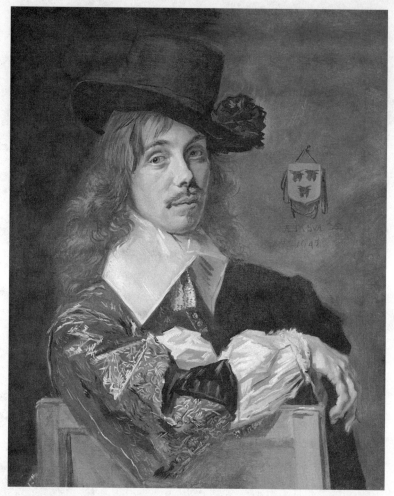

52. Frans Hals, portrait of Willem Coenraadsz Coymans, ca. 1645. Courtesy of the National Gallery of Art, Washington, DC—Andrew W. Mellon Collection.

a pom-pom on the side, turns in his chair to look back at us with a world-weary air (fig. 52).[91] Coymans's fancy attire—like that of Schade, the golden threads of whose sleeves are rendered by Hals with just a series of zigzag lines—is sketched in with the loose brushwork that befits his casual pose.

For the most part, though, Hals stuck with what he knew best: what had so far brought him acclaim, and what would continue to serve him well. We have many portraits by Hals from the early 1640s on. While these are mostly three-quarter-length likenesses

of now-anonymous men and women, to some of them we can attach names. Quite a few of the sitters came from outside Haarlem: the proud textile magnate and *burgemeester* of Rotterdam, Paulus Verschuur; the theologian Johannes Hoornbeek, a conservative Counter-Remonstrant recently appointed to a professorship at the University of Utrecht, who is shown holding a book; a jolly Daniel van Aken, playing the violin. There were, as well, a number of other Coymans besides Willem Coenraadsz. Members of this extended and extremely wealthy patrician clan, with branches in several cities, including Amsterdam, were now taking up almost as much of Hals's time as the Olycans. The Haarlem linen merchant Joseph Coymans and his wife, Dorothea Berck, appear in pendants from 1644, the same year that Hals also painted a truly charming set of marriage pendants of their daughter Isabella and her husband, Stephanus Geraertsz.[92] The newlyweds lovingly glance and smile at each other across their respective paintings; his hand reaches out as she offers him a flower.

By the late 1640s, then, Hals was not just Haarlem's painter. The commissions from other cities in Holland and beyond testify to the broad popularity of his style, even if it was no longer the cutting-edge fashion of the art world. It was not just his portraits that enjoyed such esteem. *Tronies* and genre portraits by Hals turn up in seventeenth-century collections and inventories in Amsterdam, Leiden, Utrecht, Rotterdam, and elsewhere.[93] Nonetheless, as throughout his long career, creating images that catered to the desire of patrician families to see reflections of their good taste and social stature in vivid, lifelike portraits was his true métier. Unlike other painters of portraits, and with the exception of the genre works that he marketed in the 1620s, this was really all Hals did. He was at the height of his powers and, along with Rembrandt, one of the two premier portraitists in the provinces of the Dutch Republic.[94] There were others, of course: Van der Helst, Verspronck, De Keyser, Van Honthorst. But it is perfectly reasonable that a 2007 exhibit at the Mauritshuis in The Hague and the National Gallery in London dedicated to portraiture in the Dutch Golden Age should be subtitled "The Age of Rembrandt and Frans Hals."[95]

CHAPTER 9

"A Pleasing, Good and Sincere Peace"

Among the forty-three items in Room II.8 of the Rijksmuseum in Amsterdam—a still life by Jan Lievens, a landscape by Adriaen van Ostade, a portrait of Stadholder Frederik Hendrik by Michiel van Mierevelt, and several early works by Rembrandt, including his magnificent painting of the Remonstrant preacher Johannes Wtenbogaert—is a small (45.4 × 58.5 cm) oil painting on copper plate by Gerard ter Borch on loan from the National Gallery in London (fig. 53).[1] The crowded scene shows over seventy individuals assembled in a stately room. These are the delegations and their associates sent by Spain and the Dutch Republic in May 1648 to the German city of Münster. Their task was to finalize the treaty ending eight decades of war.

The Dutch participants in the ceremony in the Münster town hall are standing on the left side of the painting, the Spanish on the right, with a table before them covered in green cloth with gold tassels. Aside from the Catholic monk on the right side and the ornamentally attired soldier on the left, a couple of attendees in embroidered cloaks and doublets, and some red capes, most of the men—both Dutch and Spanish—are dressed in black with small, flat white collars; even in the seventeenth century, fashion transcended national and religious boundaries. The leader of each delegation holds a copy of the treaty that had been signed by the two parties several months earlier, in January, and then sent to their respective homelands for approval. They are gathered now, once again, to ratify the agreement with oaths and exchange copies. The Dutch diplomats, Protestants, one from each province and led by Barthold van Gent, Lord

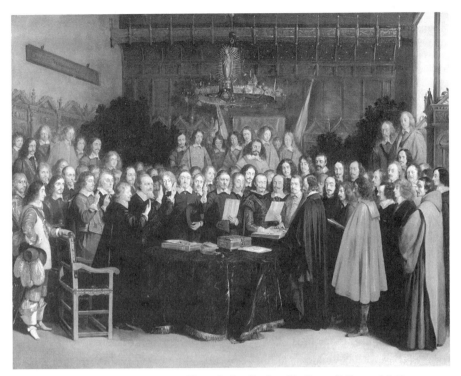

53. Gerard ter Borch, *The Swearing of the Oath of Ratification of the Treaty of Münster*, 1648, National Gallery, London, UK. Credit: © National Gallery, London/Art Resource.

of Meijnerswijck, swear with their hands in the air, their forefingers and middle fingers raised. Two of the Spanish representatives—all Catholics, of course—whose chief negotiator was Gaspar de Bracamonte y Guzman, Count of Peñaranda, rest their hands on an open Bible with a silver cross laying across its pages. Once sworn to, the documents will be put in red velvet boxes and taken home by each delegation.

The peripatetic Ter Borch was present at the ceremony and put himself in the painting as one of the observers. He was a Dutchman, born in Zwolle in the province of Overijssel. After training at home, in Amsterdam and in Haarlem, he took off for England, France, Germany, Italy, and Spain. He arrived in Münster as a member of the circle of his patron Adriaen Pauw, Lord of Heemstede, once and future grand pensionary of the States of Holland and part of the Dutch mission to the talks. By the time of the ceremony, however, the art-

ist had joined the entourage of the Count of Peñaranda, who was based in Münster for the long duration of the peace negotiations. Ter Borch kept the painting, completed later that summer, for himself, but an engraving of it by Jonas Suyderhoef circulated widely, to much acclaim.[2]

The peace between Spain and the United Provinces, years in the making, was just a part of broad European negotiations to end the series of international conflicts that have become known as the Thirty Years War (although for the Dutch and Spanish, it was an Eighty Years' War). Talks had begun in the early 1640s, with representatives from the Netherlands, Spain, France, Sweden, the Papal States, and the Holy Roman emperor meeting in Münster and Osnabrück. Not all of the Dutch provinces were in favor of negotiating with their former overlord. While the province of Holland—and Amsterdam in particular—led the pro-peace camp, there was opposition in Utrecht, Zeeland, and other quarters on political, military, and economic grounds. They feared, especially, that their commercial interests would suffer with the reopening of Flemish ports and a revival of Antwerp as a mercantile hub. In the end, as usual, Holland and its allies prevailed in the States General.

Even with the pro forma literary flourishes demanded by diplomatic protocol, the preamble to the agreement sworn to by the Dutch and Spanish on that spring day conveys just how truly exhausted both sides are by the decades of waste and destruction and how much they long to put an end to it all.

> In the name of God and in his honor. Let all persons know that, after a long succession of bloody wars which for many years have oppressed the peoples, subjects, kingdoms and lands which are under the obedience of the Lords, King of Spain, and States General of the United Netherlands, these Lords, the king and the States, moved by Christian pity, desire to end the general misery and prevent the dreadful consequences, calamity, harm and danger that the further continuation of these wars in the Low Countries would bring in their train . . . and to put in the place of such baleful effects on both sides a pleasing, good and sincere peace.

The first article of the treaty announces that "this Lord King [Phillip IV of Spain] declares and recognizes that the Lords States General of the United Netherlands and the respective provinces thereof . . . are free and sovereign states, provinces and lands upon which . . . he, the Lord King, does not now make any claim." Subsequent articles detail the terms of the peace, including such contentious matters as "shipping and trade to the East and West Indies," tariffs on bulk goods, and taxation. Spain agreed to lift the embargoes against Dutch ships, the Dutch agreed to allow Catholics to worship freely, and the two sides settled territorial claims in the southern Low Countries, with Spain—despite pressure from some Dutch quarters for a reunification of north and south—keeping whatever was presently in her possession. The treaty also stipulated that Spanish Catholics who travel to the Dutch Republic and Dutch Protestants who travel to Spain shall each be "required to conduct themselves in the matter of public exercise of religion with all piety, giving no scandal by word or deed and speaking no slander."[3]

With the oaths sworn on May 15 in the ceremony that was so elegantly captured by Ter Borch, the Treaty of Münster was fully ratified. Each side saw gains, and each side made compromises. The Dutch clearly came out ahead, though, as they had their long-awaited prize. What had been de facto was now de jure. Their republic was formally, and at long last, a truly independent and sovereign nation.

<div style="text-align: center">*</div>

In Haarlem, as elsewhere, news of independence was received with jubilation. A painting by Cornelis Beelt from around 1650, another of the many Dutch works commemorating the conclusion of the war, shows the plaza in front of the town hall.[4] A crowd from all walks of life—well-dressed city folk, some on horseback; tradesmen and shopkeepers, including a porter pushing a wheelbarrow with several barrels of beer; peasants in from the countryside, with one woman selling what looks like apples—has gathered to hear a group of local dignitaries up on the balcony read out the text of the treaty. Similar observances were held in The Hague, Amsterdam, and other towns in Holland and throughout the rest of the Republic.

Unfortunately, Frederik Hendrik, the Republic's head of state and supreme commander of its armed forces during the final two decades of the conflict, could not be present at any of these assemblies. He did not live to see the peace for which he had so ardently lobbied among the combative Dutch constituencies. In March 1647, the sixty-three-year-old stadholder, under whose shrewd and tolerant leadership there occurred such a remarkable flourishing of Dutch art and culture, died. The stadholdership of the major provinces of Holland, Utrecht, Zeeland, Gelderland, and Overijssel passed to his twenty-one-year-old son, William II, Prince of Orange and grandson of William the Silent.

The new stadholder had not been a fan of peace with Spain, and accepted it only grudgingly. He would rather have thrown the Dutch lot in with France and continued the war, not least to regain the Dutch-speaking lands of the south. His mother, Amalia van Solms, on the other hand, wished to see an end to the hostilities through which her husband had so brilliantly guided the United Provinces. This split within the family was but a mirror of a greater, and more dangerous division, in Dutch society. The Peace of Münster did not really bring much peace, at least within the Republic; it was approved by the States General, but by only a narrow majority.

William II lacked his parents' sophistication and taste for high culture. He was also a bully. Where Frederik Hendrik generally preferred the carrot, his son went for the stick. William's main adversaries were Holland's regents. Amsterdam and Haarlem, especially, were centers of opposition to William's domestic and foreign policies. Among the more delicate issues was the size of the army. William was at constant loggerheads with the liberal camp, whose leaders wanted to see a decrease in troops and in military expenditures now that the long war was over. A large standing army in peacetime was a drain on the economy, which, since the beginning of the talks with Spain and the opening up of trade routes, had begun to recover from the recession of the 1630s. Dutch ships now found ports that had previously been closed to them open. The stadholder and his Orangist allies, on the other hand, insisted that Dutch homeland security was at stake: the Republic would not be safe from its sur-

rounding enemies without strongly fortified garrisons along its borders. The clamorous debate—carried out in speeches, pamphlets, periodicals, and proclamations—was often framed in terms of patriotism, with each side accusing the other of betraying the Republic and working on behalf of its adversaries.

Equally critical was the question of religious toleration. William, while not an especially pious man, sought greater confessional (and thus national) uniformity under the Dutch Reformed Church. Thus, despite the terms agreed to in the Peace of Münster, he came down hard, very hard, on Catholics. Priests were expelled from the country, Catholic chapels and other institutions were confiscated and "cleansed," and worship was forced once again into secret. This not only violated the Republic's principle of relative toleration and its tenuous religious peace, but seriously antagonized those cities where Catholicism remained strong—like Haarlem.

What was really at stake in these final years of the 1640s was the political nature of the Dutch Republic itself. What kind of nation was it to be: a decentralized federation, with power primarily in the provincial executive bodies (the States) and a relatively weak national government, or a unified realm under a monarch-like ruler? Would true sovereignty lie in the provinces, where the regent class held sway, or in the generality, dominated by the stadholder?

In the summer of 1650, his patience with Holland and the States party at an end, the stadholder—with the support of the conservative (that is, Counter-Remonstrant) faction of the Reformed Church—went on the offensive. Following the model of his uncle Maurits's coup in Haarlem and elsewhere in 1618, William laid siege to Amsterdam with a force of ten thousand soldiers. The city councils there and elsewhere were, once again, purged of anti-Orangist agitators and Remonstrant sympathizers, with leading regents arrested and thrown into prison.

The Orangist victory was short-lived, however. By November, William II was dead, a victim of smallpox. His son William III—born shortly after his father's death and whose mother was Princess Mary of England, the daughter of Charles I—would be in his minority for some time. It would take another twenty-two years and a major

national crisis before a stadholder was installed again in Holland, Utrecht, Zeeland, Overijssel, and Gelderland.[5] The political pendulum that swung one way in 1618 and the other way in 1647, now went back again. Power devolved to the regents and the provincial assemblies. By 1653, the Republic was enjoying the period of "True Freedom," a stadholderless era (for most of the provinces) under the national leadership of the grand pensionary of the States of Holland, Johan de Witt, and his partisans.[6]

*

The cessation in hostilities and consequent economic growth that accompanied the negotiations in Münster—as well as, subsequently, the generally liberal policies pursued by the De Witt regime and the political ascendancy of the merchant and professional class and intellectuals who were the grand pensionary's natural allies—was potentially a good thing for Holland's artists. Now recovered from the slump of the 1630s, the Dutch had the means and, perhaps, the desire to invest once again in the finer (but not too ostentatious) things that adorned their homes, businesses, and public buildings.

Hals, for one, received commissions in the late 1640s for something he had not done in over ten years: a group portrait in a landscape. Even while peace was just a rumor, two well-to-do families asked Hals to paint them just as he had done the Van Campens and Isaac Massa and his wife in the early 1620s, as well as that unidentified family in 1635. As in some of the earlier works, the parents and children depicted on both of the new canvases, still unidentified, are nearly life-size. The larger of the two families—a father and mother surrounded by seven children of various ages (including a toddler and an adult daughter), along with a nursemaid—appear under a copse of trees, with farm fields and cows in the background (fig. 54).[7] Only the young daughter on the ground with a basket is looking at the viewer; the other children are engaged with one another, whether playfully gesturing or passing around flowers and fruit.[8]

The other family, also sheltered by foliage, is more elegantly attired, and there are only four of them (fig. 55).[9] The father, dressed in black cloth, strikes a jaunty pose with his outstretched leg as he

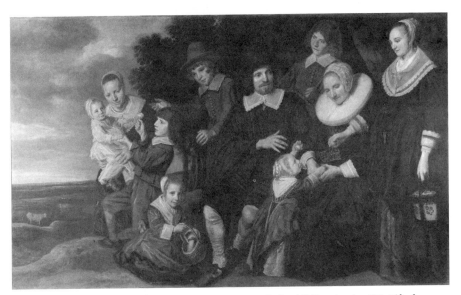

54. Frans Hals, *Family Group in a Landscape*, ca. 1647–50, National Gallery, London, UK. Gift of Lord Talbot of Malahide, 1908. Credit: © National Gallery London/Art Resource, New York.

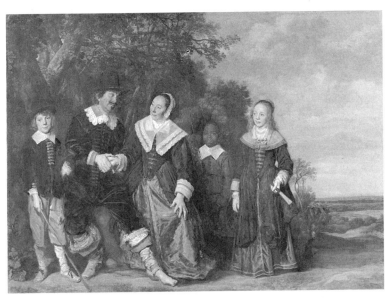

55. Frans Hals, *Family Group in a Landscape*, 1645–48. © Fundación Colección Thyssen-Bornemisza, Madrid.

takes his wife's hand; the teenage daughter, holding a fan, gazes affectionately at her parents, while her slightly younger brother looks at us with attitude, his hand on his hip and a stick in his hand.

Scholars believe that Hals sought some professional help with these two paintings—in particular, the rustic landscapes in their backgrounds. The rendering of the leaves on trees and the hill formations suggest the hand of Hals's Haarlem colleague, and fellow petitioner in favor of auctions and lotteries, Pieter de Molijn. De Molijn was born in London, in 1595, to a family that had emigrated there from Ghent. Most of his career, though, was spent in Haarlem. He joined the guild in 1616 and after a three-year stint in Italy returned for good to set up his studio. He specialized in landscapes and, as we have seen, contributed in the 1620s—along with Esaias van de Velde, Jan van Goyen, and Salomon van Ruisdael—to establishing Haarlem's monochromatic or "tonal" tradition in that genre (fig. 26).[10] Houbraken calls him "a lovely landscape painter," noting that his panels were "bright and sparse in their coloring, as well as naturally glowing in the foreground."[11] De Molijn might have painted the forest background in Hals's 1626 solo portrait of Massa, as well as the cityscape behind the anonymous family in 1635. Now, over twenty years later, he has apparently lent his talents to his friend once again.

There is something about—or, more precisely, someone in—the smaller family portrait that is unique in Hals's oeuvre. Between the mother and daughter there stands a fifth member of the group: a young Black boy.

It was not uncommon to find Black persons in earlier Netherlandish art, especially in histories depicting episodes from antiquity or stories from the Bible—for example, as one of the three kings visiting the infant Christ. But Blacks in such works were not typically rendered in a manner befitting real people. It was not portraiture but stereotype and caricature.

There is a notable change in the first half of the seventeenth century, when Blacks began appearing in Flemish and Dutch painting and drawing with more regularity, and more respect for realism, not to mention their humanity. Rubens, Jan Miense Molenaer, Pieter

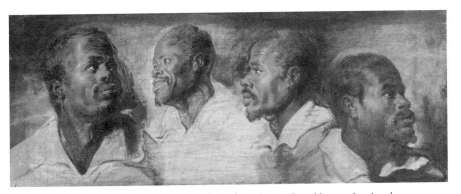

56. Peter Paul Rubens, *Four Studies of a Male Head*, ca. 1617–20, Getty Museum, Los Angeles. Digital image courtesy of the Getty's Open Content Program.

Soutman, Lievens, and (sometimes) Rembrandt, among others, all did studies or finished paintings—whether *tronies* or portraits, often done from life models—in which Blacks are depicted not with racist exaggeration or in representation of type but as specific and distinct individuals (fig. 56).[12] In Hendrik Pot's 1630 picture of the officers of the Saint Hadrian *kloveniers*, there, standing in the front row, several men to the right of Colonel Pieter Jacobsz Olycan but just a step ahead of the colonel's son, Sergeant Nicolaes Olycan,[13] stands a distinguished man of color: Salomon Hansz Colterman (fig. 45). Dressed in a beautifully embroidered coat, with a rapier at his waist and a banner on his shoulder, this Haarlem brewer with a large and unkempt hairstyle was the civic guard's ensign.

As for the Black child in Hals's painting, he is well dressed and portrayed with no less naturalism and dignity than the family members. At the same time, his presence in this family portrait calls to mind a disturbing side of Dutch history.

The freedom of the "True Freedom" was not universally shared. The Dutch, primarily through the West India Company, were heavily involved in the enslavement of Africans and their brutal and often fatal transport across the Atlantic to colonies in the Caribbean and South America. Enslaved labor was used especially on the sugar and tobacco plantations in the parts of Brazil that the Dutch had conquered from the Portuguese in 1630 (and which they would be forced

to relinquish by 1654). According to some estimates, the Dutch were responsible over the course of two centuries for enslaving and ship-ping more than six hundred thousand individuals from Africa, a number exceeded in the period only by the English. To white Euro-peans in the seventeenth century, Black lives most certainly did *not* matter.[14]

Is the African boy in the Hals painting an enslaved person? Defi-nitely not. He might be the favored son of a royal African clan who has been sent to Holland for his education and is now in the care of this family, although some scholars discount this possibility.[15] Most likely he is a servant; it was not unusual to have a serving person or attendant included in a family portrait in an intimate way.[16] Still, there were enslaved people in Holland in the period, at least unoffi-cially. Although slaveholding was illegal in the Dutch Republic itself, as it was across much of Europe, that did not prevent unscrupulous individuals from finding ways around the prohibition. Portuguese and Spanish merchants and diplomats, in particular, were often ac-companied by enslaved servants when pursuing business in the Re-public. And there is solid evidence that quite a few of the Sephardic Jews who settled in Amsterdam as members in exile of the "Portu-guese Nation"—and who played an active role in the Atlantic slave trade—had enslaved persons in their households, some of whom converted to Judaism and were buried in the Jewish cemetery in nearby Ouderkerk. There were even instances of intermarriage be-tween Portuguese Jews and converted Black Africans.[17]

It is hard to believe that the Dutch authorities were not fully aware of the presence of enslaved people among residents in Am-sterdam and elsewhere. It was something to which they must have turned a blind eye, as they did to so much else—relying, perhaps, on the ambiguity of the status of these Black servants and not ask-ing any questions. While the boy in Hals's painting may have been not enslaved but (technically) free, whether a paid servant or perhaps profiting from his time under the wing of an upper-class Dutch fam-ily, the depiction of his presence in Holland cannot but remind us, if only by his relatively privileged position, that the so-called Golden Age was not golden for everyone. (Of course, many a poor Dutch

family struggling to put food on the table would have needed no re-
minding of this.)[18]

*

An interesting, but probably not very remunerative, commission
came Hals's way in the summer of 1649 when he was asked to do a
portrait of one of the Republic's intellectual celebrities. The request
was from a third party looking to memorialize a friend who would
soon be leaving the country.

The French philosopher René Descartes was, midcentury, the
most famous thinker in Europe. His writings were widely read and
debated, in university faculties but also in the scientific societies,
private academies, and domestic literary salons that made up the
international Republic of Letters. These included the *Discourse on
Method* and its accompanying scientific and mathematical essays,
which were published in 1637; the epistemological and metaphysical
treatise *Meditations on First Philosophy* (1641), in which he establishes
that true knowledge, of oneself and of the world, is possible by prov-
ing that our rational faculties were created in us by a benevolent,
nondeceiving God; and the *Principles of Philosophy* of 1644, a grand
summa of Descartes's philosophical system in all its dimensions.
Descartes's hope was that the *Principles* would replace the old Scho-
lastic textbooks then in use in colleges and universities in France,
the Netherlands, and elsewhere. The four-part treatise presents the
general metaphysical and physical principles of his science and of-
fers explanations in mechanistic/corpuscular terms of a host of natu-
ral phenomena (gravity, magnetism, tides, earthquakes, etc.).

All of these published works were composed while Descartes was
living in the United Provinces in long-term, voluntary exile from
France. Writing in the *Discourse*, he explains why he left his native
land for Holland:

As I was honest enough not to wish to be taken for what I was not, I
thought I had to try by every means to become worthy of the reputa-
tion that was given me. Exactly eight years ago this desire made me
resolve to move away from any place where I might have acquain-

tances and retire to this country, where the long duration of the war has led to the establishment of such order that the armies maintained here seem to serve only to make the enjoyment of the fruits of peace all the more secure.

It was not only the order and security of the Republic that made it an attractive locale for Descartes to pursue his research. It was, to be sure, a small and densely populated territory with a less than inviting climate; and Amsterdam, where Descartes lived for a time, was a congested and hectic city. The difference was that the Dutch, among whom Descartes had few acquaintances, were, he says, so focused on going about their own business (and making money) that they had little interest in the doings of a French philosopher abroad.

> Living here, amidst this great mass of busy people who are more concerned with their own affairs than curious about those of others, I have been able to lead a life as solitary and withdrawn as if I were in the most remote desert, while lacking none of the comforts found in the most populous cities.[19]

All Descartes wanted was to be left alone. He sought nothing but peace and quiet to do his work, away from the responsibilities of family and the intrusions of curious strangers. That was exactly what he found among his busy Dutch neighbors—at least for a time.

The problem was that, despite its growing popularity, Descartes's philosophy was also quite controversial. It faced strong opposition from philosophers, but also from theologians and even civil authorities, both because it was seen as too novel and radical a departure from the orthodox Aristotelian philosophy that dominated the schools and because some of its theories were deemed to be inconsistent with Christian (and especially Catholic) religious dogma. In the Republic, it did not help that the Orangist camp regarded its political opponents in the States party as aligned with and supported by Descartes's Dutch philosophical partisans; progressive politics and progressive science tended to go hand in hand. Moreover, in the 1640s, the stadholder's ecclesiastic allies (called "Voetians" because

they were followers of the conservative, firebrand theologian, and one-time rector, at the University of Utrecht, Gisbertus Voetius, a rabid anti-Remonstrant and anti-Cartesian) believed their bitter rivals in the Dutch Reformed Church (the "Cocceians," associates of the liberal theologian Johannes Cocceius, of the University of Franeker) to be inspired by the principles of the "new philosophy." Rarely in the Dutch Republic did presumably secular differences on political and philosophical matters not involve sectarian religious divisions as well.

Still, despite efforts to suppress the Cartesian worldview in the Dutch, French, and German milieus, its influence across Europe continued to grow—so much so that Descartes was now, in 1649, invited by Queen Christina, the learned monarch of Sweden, to come to Stockholm to be her personal tutor in philosophy.

Having spent most of his adult life comfortably among various cities and towns in Holland, Descartes was reluctant to accept the invitation. He certainly had no desire to relocate to what he called "a land of bears among rocks and ice."[20] When the summons from Sweden came, Descartes had left Amsterdam behind and was living in a small village on the coast of the North Sea, Egmond aan Zee (Egmond on the Sea), about forty kilometers from Haarlem and close to the town of Alkmaar. A Catholic himself, he had also developed warm friendships in Haarlem with a pair of Catholic priests, Augustijn Bloemaert and Johan Albert Ban. Descartes, Bloemaert, and Ban would gather on an evening to converse on various matters and, much to the philosopher's delight, play music together.

Descartes initially declined Christina's invitation. He was not one to disturb his routine, especially his habit of staying in bed until the late morning. Moreover, he was reluctant to give up his freedom to join a royal court, with all the expectations, protocols, and intrigues that would involve. Christina persisted, as a queen would, and eventually prevailed. By the fall of 1649, Descartes was preparing to leave for Stockholm.

This was disturbing news to his Haarlem friends. Bloemaert, in particular, was sad to see Descartes leave. He wanted at least some kind of keepsake by which to remember his philosophical and mu-

sical companion. Descartes's early biographer, Adriaen Baillet, writing in 1691, describes the priest's urgency in "not [letting] Descartes leave without taking the liberty of having him captured by a painter, in order that he might at least find some light consolation in the copy of an original that he risked losing."[21] Descartes was often in Haarlem, and so on one of these occasions Father Bloemaert arranged a sitting.

The Haarlem portraitist Bloemaert chose was none other than Hals. This may simply have been because, as everyone knew, Hals was the best, the premier portraitist of the city. But there was also a personal connection. Bloemaert had a close relationship with the Van Campen family, which Hals had so beautifully captured in that large family portrait around 1620. Cornelis van Campen, who appears in the painting as a child, would, more than thirty years later, become the executor of Bloemaert's estate. He will use the funds both to commission a portrait of the priest in the year before his death (it was painted by Johannes Verspronck, not Hals) and to establish the "Broodkantor" (Bread Office), a charitable institution in Haarlem for feeding the poor.[22] It is possible, then, that Bloemaert was directed to Hals by one of the Van Campens.[23]

Hals could certainly work with some speed and spontaneity when the occasion called for it, and the coarse treatment he gave Descartes's bust-length image—on a small wood panel—might not have taken him very long (plate 20).[24] He would have needed the philosopher for perhaps an hour or two, just to do the face. Neither man would have been greatly inconvenienced by Bloemaert's request. The painting was made sometime that summer, perhaps as late as September, when Descartes finally embarked for Sweden. It must have been done before Descartes went to Amsterdam to settle some affairs and board the ship to Stockholm.

The small oil portrait may not have been intended as the commission's final product. This image of Descartes is even rougher than Hals's usual work—it really seems to be just a sketch—and ended up serving as the model for an engraving by Suyderhoef. The print, in addition to circulating as yet another collectible portrait of a famous

man, would be used as a model for several copies of Hals's painting and as a frontispiece for Descartes's writings.[25]

Bloemaert had some intimation that he would never see his friend again, and he was right. Descartes did not last long in Sweden. He was not very happy with his new situation. "I am not in my element here," he wrote to a friend on January 15, 1650, in one of his final letters.[26] The queen liked her tutorials early in the morning, even during the long Nordic winter. Descartes was forced to rise at an ungodly hour before sunrise, in a land where, he tells his correspondent, "men's thoughts freeze in the winter just like the water."[27] Less than a month later, he caught pneumonia. He died on February 11.

*

Keeping track of Hals's large brood is no simple matter. In the fall of 1650, ten of his fifteen children were still living:[28] Harmen, from his first marriage, to Anneke; and Sara, Frans Jr., Adriaentje, Reynier, Nicolaes, Maria, Pieter, Johannes, and Susanna, all with his second wife, Lysbeth.

Harmen and Frans Jr., as we have seen, were both married, parents, and enjoying relatively successful careers as painters (if occasionally bothered by unsettled debts). Sara, her days of trouble behind her, was now married and settled as well. In 1654, Adriaentje, at the age of thirty, wed Hals's former pupil Pieter van Roestraten in Amsterdam.[29] As for Susanna, the youngest, she would not marry until 1660, at the age of twenty-six; until then, she lived at home with her parents.[30] Meanwhile, *innocente* Pieter was locked away in the workhouse and would remain there until his death in 1667.

If the Jacob Hals who was buried in the Beguine Churchyard in May 1648 was indeed Frans and Lysbeth's Jacob, then he died young, only twenty-four years old.[31] Two years later, another son, Anthonie, died abroad. He was a sailor with the Dutch East India Company, serving on a ship named *The Walrus*. He perished—whether at sea or on land, we do not know—while in or near Tonkin, in Southeast Asia (now Vietnam). He must have been quite young when he signed up with the VOC in 1646, since in a deposition used by Hals and his

wife in 1650 to recover pay that was due posthumously to their son, Anthonie is still described as a *jongen* (boy).[32]

We know a bit more about the fate of Johannes (or Jan), but it is not a much happier one. In January 1648, when he was probably in his midtwenties, he married Maria Leendertsdr de Wit in Bloemendaal, a village just a short distance from Haarlem. Six months after the wedding, Maria was dead.[33] Johannes moved back in with his parents for a year, until he married again. His bride this time was Sara Gerritsdr.[34] Like his brothers Harmen, Frans Jr., Nicolaes, and Reynier, Johannes was a painter. He trained with his father, and his style and subjects were, again like his brothers, quite similar to those of Frans: mostly portraits and genre pictures, although rendered with not nearly the same skill and liveliness. His artistic career was short, however. By November 1654, both Johannes and Sara had died. Their children—four-year old Jacobus (perhaps named after his late uncle) and another child—were placed in an orphanage.[35]

Then there is the curious story of Nicolaes (Claes) Hals. In August 1653, he and a woman named Sijtje Gerritsdr tried to wed in Amsterdam, where they both were living. They registered their banns, but the city denied them permission to marry. The reason was that their declaration was full of fabrications. Nicolaes claimed that he was from Antwerp and that he was a sailor; Sijtje said she was from Groningen and neglected to mention that she had two children. Also, they both insisted that they were orphans. According to the city authority dealing with marriages,

> these persons cannot marry because Claes is from Haarlem, he still has a father and a mother, and he is a painter [not a sailor]; and Sijtje Gerrits is also from Haarlem, and also a mother with two children. They both lied intentionally about their city and he has misspoken about his vocation and his father and mother.[36]

We have no idea why the two young people—they were both twenty-three at the time—made false statements on their banns, but the truth came out when Nicolaes's mother, Lysbeth, showed up in Amsterdam and set things straight. Sijtje returned to Haarlem, where

she was arrested and sent to the women's house of correction "because she went with one Claes Franssen Hals to Amsterdam, and there, before the commissioners for marriages," acted deceptively. The city council also told Hals and Lysbeth to bring Nicolaes back to Haarlem as well, to face what he had coming to him. They refused to do so, and Sijtje was released from her punitive labors after two weeks.[37]

Nicolaes, deciding the coast was clear, did eventually come home and moved back in with his parents. Sijtje was apparently not the love of his life, for two years after the Amsterdam escapade he married Janneke Hendricksdr van Haexbergen, a widow. In November of that same year, he finally joined the Guild of Saint Luke—taking advantage of the discount on dues because he was a "master's son"—and will later serve several terms on the guild's board. Like his father, Nicolaes had trouble with debts throughout his career, despite some success with his landscape and genre paintings. Unlike his father, he was able to buy a house, almost certainly because of the money that his wife had brought to the marriage.[38]

Perhaps most disturbing of all is the case of Reynier (1627–72). The same year that Adriaentje married Van Roestraten, Reynier, also living in Amsterdam, married Margrietje Lodwijcksdr. Either Margrietje did not live long or there was a divorce, for three years later Reynier married Elisabeth (Lijsbeth) Groen.[39]

Reynier, too, had difficulty staying out of debt and legal trouble. In this he was abetted by a combative spouse. Shortly after their wedding, Reynier and Elisabeth were accused by several witnesses of "badly abusing" a pregnant and sick woman. In their defense, they claimed that Elisabeth was trying to collect money owed them by one Antonij Meijer, a surgeon, and that it was Meijer's pregnant wife, acting on behalf of her husband, who had in fact mistreated *her*. This was in November 1657. Three years later, Reynier, along with several other artists—Roelof van Vries, a landscape painter; Egbert van Heemskerck, who specialized in genre scenes; and Leonard de Laeff, who did histories—were involved in a brawl. The men were all good friends—Reynier and Elisabeth were witnesses at Roelof's wedding, while Egbert was a witness when Reynier was sick in bed

and drafted his last will and testament, "in case he should die" (he recovered)—and so it looks like the melee was not among themselves but with some other group. We have no idea as to what started the fight or who got the worse of it.

Things only go downhill from there. In July 1663, Reynier is interrogated while lying in bed recovering from "serious wounds" he suffered in another fight. The Amsterdam notary, in a document only partially legible, reports only that there was a "long story about a fight," and that "Reynier Hals received such a blow that he [suffered] a great wound . . . and he was overcome . . . a great overflow of blood." Yet another violent encounter took place on the afternoon of January 8, 1667, when Reynier's landlord, Hendrick de Vlieger, a wine merchant, accompanied by two servants (or possibly police officers), burst into Reynier and Elisabeth's rented rooms on the Koningsgracht "uninvited," according to the notary record, and ordered that two paintings be taken down from the wall. At least one of the paintings was still wet, and ended up being smudged as it was removed. A scuffle ensued, during which Reynier was wounded by one of the servants with a sword. As a crowd gathered by the door, the men made off with the paintings (which included a *tronie* by Aert van der Neer). The dispute, no doubt over money, might have been about payment for wine. But a more likely explanation is that it involved overdue rent, for ten days later Reynier and Elisabeth were living elsewhere in Amsterdam. His new landlord accepted, as partial payment of rent, three paintings: a depiction of the Trinity (perhaps the landlord was Catholic), "a biscuit baker" (a genre piece), and a history, showing Samson.

After Reynier's death (by natural causes?), Elisabeth led a rather dissolute life. She was reported to be seen wandering the street, known as "Mother Hals," and, according to one document, "earns a living procuring, assigning and providing whores and licentious people." She signed her name with a cross and also worked as a house cleaner.[40] We do not know what became of the two of their six children who lived to adulthood.

Reynier had probably the least successful artistic career of all of Hals's sons. Then again, art was not his first occupation. Sometime

in the early 1640s, when he was still in his early teens, Reynier was off to sea as a cabin boy on a ship bound for the East Indies. He was back in Holland by 1645, and only then trained under his father. Four paintings by him are known to be extant (three of which are now in the Frans Hals Museum in Haarlem). There is no evidence that Reynier ever joined the Guild of Saint Luke—not in Haarlem and not in Amsterdam—and he may have remained a journeyman his whole life.

It seems that every joy brought to Hals and Lysbeth by one or another of their children—successful careers, fine marriages, grandchildren—was compensated for by some distress from another familial quarter. Such were the tribulations and liabilities of overseeing a large household in the seventeenth century.

<p style="text-align:center">*</p>

Early modern Dutch culture was in its prime during the period of True Freedom. Art, architecture, literature, science, and music all thrived under De Witt's moderately liberal regime. Rembrandt was at the height of his powers in Amsterdam in the 1650s. In Delft, Vermeer, only in his twenties, was still painting religious and history themes; in just a few more years, he would turn to the serene but far from dull interiors for which he is now famous. Dutch commerce, too, from 1650 through 1670, was, as Jonathan Israel notes, "in a more expansive and dynamic phase than during the previous quarter-century."[41]

Peace, on the other hand—both domestic and international—was a scarcer commodity than wealth and artistic beauty. Serious opposition to the policies of the grand pensionary and the regents who supported him persisted. The States faction, led by its most powerful and influential constituency, the States of Holland, pretty much had the upper hand in most provinces, but Orangist sentiment ran strong even in some of the cities of Holland, including Haarlem. Meanwhile, by 1652, the Republic was at war once again, this time with Britain.

As long as the Dutch were occupied by the struggle with Spain, England could dominate the maritime trades, especially in the At-

lantic and around the Mediterranean. But with the end of the Eighty Years' War and the lifting of Spanish embargoes, Dutch shipping was able once again to access the routes and markets of southern Europe—especially Spain, Portugal, and Italy—as well as in the New World and Asia, much to England's disadvantage.

The English at first tried to resolve things with the Dutch diplomatically . . . sort of. They proposed a union between the two nations, albeit with the United Provinces as the subordinate party. Naturally, this offer did not get the reception in The Hague for which Parliament—now in charge after the execution of Charles I in 1649—had been hoping. Their next, more antagonistic move was the Navigation Act of 1651. This imposed broad restrictions on Dutch trade with England and its colonies. The measure effectively closed off many ports of the worldwide market to anything arriving on a Dutch vessel. This economic salvo was compounded by the harassment and commandeering of Dutch ships on the high seas by the English navy and privateers. In January 1652 alone, thirty Dutch boats were seized.[42]

Real naval skirmishing began later that year, with alarming death tolls. Politically, the conflict with England played into the hands of the Orangists. One of the lessons of modern history is that war typically incites a demand for strong and aggressive centralized leadership. The attacks on De Witt—his domestic policies, his handling of the war, even his moral character—were accompanied by calls for the installment of a stadholder. This was not just an expression of patriotic fervor for military victory over a longtime foe, but also the product of a suddenly desperate economic situation. The recovery that began in the final years of the Spanish conflict was giving way, less than a decade later, to another slump. With the seas again unsafe for the transport of Dutch goods, the Republic's manufacture and trade saw a steep decline. On top of the enormous costs of the new war, the financial strain was felt by all strata of Dutch society, from wealthy manufacturers and merchants to salaried laborers. In the end, the economic downturn would last but two years—the duration of the war—but a difficult two years it was.

Haarlem, still dependent on its textile industry, was hit especially hard. Its troubles were aggravated by continued growth in compe-

tition in the production of linen and cloth elsewhere in the Netherlands and abroad. The number of Haarlem breweries, too, which reached a high of fifty-five in 1650, started to decline again in these years. The overall effect was, just as in the 1630s, an exodus of business and money to Amsterdam. The entrepreneurs who went to the larger city took their art patronage with them; many of those who remained in Haarlem may have decided that this was not a good time for expensive art commissions.

And yet, despite the instability in the Dutch economy—the recovery that begins with the end of the first Anglo-Dutch war in 1654 would be set back again ten years later by a second conflict with England—Hals, now nearing seventy and a respected elder in the guild, continued to do what he did so well, and so much to the taste of patrons in Haarlem, Amsterdam, and elsewhere. In the 1650s, there are portraits of the Catholic priest Nicolaes Stenius and the Haarlem brewer and city magistrate Tyman Oosdorp (an Olycan son-in-law, married to Pieter and Maritge's daughter Hester). There is also a now-lost painting of the poet, historian, and Leiden theologian Jacobus Revius (Jakob Reefsen, 1586–1658). Revius was conservative and Counter-Remonstrant to the core. He was, as well, a bitter foe of Descartes's philosophy. A Hebrew scholar and deeply learned man, he was a member of the committee that produced the first complete Dutch translation of the Hebrew Bible and Christian Gospels based on the original language texts, called the *Statenbijbel*, or States Bible (because it was commissioned by the States General), which was published in 1637. Later he was appointed regent of the theological seminary at the University of Leiden, which is the position he held when Hals did his portrait.

There are also dozens of undatable portraits of unidentified men and women.[43] These canvases and panels are all painted, more or less, in Hals's characteristic style, with the aging artist using what appears to be increasingly loose brushwork, especially for elements beyond the face. The people who commissioned these paintings wanted that inimitable Hals "touch" in their likenesses, and they got it.

Also among Hals's sitters in this later stage of his career are a

number of fellow artists. The anonymous man depicted with a brush in his hand in a painting from the early 1650s must be a Guild of Saint Luke colleague.[44] There are portraits of Jan van de Cappelle, a marine painter and collector of Hals's works, of the landscape specialist Jan Asselijn, and of Adriaen van Ostade, the master of genre pictures.[45] Hals painted a portrait of his former student Van der Vinne in the late 1650s, and, according to some reports, one of the landscape artist Thomas Wijck.[46]

Around 1655, Hals also made a small bust-length portrait of Frans Post.[47] This Haarlem-born painter, who was probably trained by his father but may also have studied under Pieter de Molijn,[48] was in Dutch Brazil between 1637 and 1644. He was encouraged to go there by Johan Maurits, Prince of Nassau and a cousin to the stadholder Frederik Hendrik, who had just been appointed by the West India Company as the territory's governor-general. Johan Maurits wanted Dutch artists and writers to portray, in the finest light possible, the beauty of the land and, not least, the fruits and benefits of Dutch rule. Post produced a number of works while in Brazil—prints and drawings, and possibly some paintings—and considerably more after his return to Holland. His Brazilian landscapes depict the lush tropical vegetation and finely cultivated fields. They also confront us with the brutality of Dutch rule—as well as the Portuguese administration that preceded and followed the Dutch period—as quite a few of the pictures show enslaved Africans and indigenous peoples working on sugar plantations and in the mills. The Dutch and Portuguese colonialists regarded these inhumane practices as just another part of the natural order of things, much as their toiling victims are portrayed in Post's landscapes.[49]

*

It was time for the Hals family to move yet again. Sometime before January 1654, they had to leave their home on the Oude Gracht and find new accommodations. They ended up back on the other side of the Grote Kerk—in fact, on the other side of town—on Ridderstraat. Perhaps they could no longer afford their old lodgings, which they

had occupied for at least seven years. The unpaid bills were mounting. In November 1650, Hals had been sued by the heirs of Hendrick den Abt, late proprietor of that King of France tavern so favored by Haarlem's artists and dealers, for thirty-one guilders, ten stuivers, and four pennings. That was quite a bit of overdue money for food and drink. Hals refused to acknowledge the debt, however, and the matter was taken under investigation.[50]

Two months after that, Lysbeth was sued for four guilders that she owed to Hendrick Hendricksz for a *kasgen*, or small chest; she did not show up for the hearing and was declared in default. This Hendricksz was the same craftsman who, in 1642, took Hals to court for payment for a *slaepbanck* (bed).[51]

A much more substantial payment was overdue to Jan Ykesz, a baker, in March 1654. Ykesz was demanding 200 guilders for "bread delivered and fetched," as well as for a loan he had made to Hals. Meeting in the Rustenburg Inn—a tavern owned by Zacharias Geraertsz in the Haarlemmerhout, a wooded area on the outskirts of town—Hals on this occasion accepted the obligation. He paid it off in-kind with a consignment of personal goods:

Three beds and bolsters with their belongings; an oak chest with an oak table; and five paintings, namely: a piece by Van Mander showing the preaching of John the Baptist; a piece by Van Heemskerck in which the children of Israel gather the manna; two more pieces, one by the appearing party [i.e., Hals himself] and one by his son; and, finally, one by his eldest son [i.e., Harmen], namely, a preaching [of Saint John the Baptist?].[52]

This is a significant and rather personal collection of household items with which to pay off a bill. It indicates the financial straits into which the family had fallen. Fortunately, Ykesz allowed Hals to continue to "use and possess the aforesaid goods and paintings for a while."

No sooner had Hals settled up with Ykesz than Cornelis Gerritsz Sluys—a butcher, presumably—was after him for seventy guilders

and ten stuivers, "the balance of a larger sum for the purchase of an ox."[53] Bread, meat: Hals was still having trouble affording even the basic necessities for his family.

To put all of these debts in some perspective, it is useful to remember that, although there are no sources that tell us what Hals was earning for original single portraits in the 1650s, it might have been around forty guilders for a bust, sixty guilders for a half-length, and eighty guilders for a three-quarter-length.[54] And to put *this* in perspective, the subsistence level for a family in Holland in the first half of the century was an annual income of somewhere around 150 guilders. The 200 guilders that Hals owed to the baker was more than half of an ordinary artisan's annual income. This at a time when a three-pound loaf of bread or a pound of butter cost around five stuivers; a chicken, eleven stuivers; and a glass of beer, just eight pennings (half a stuiver).[55]

Quite a few of Hals's painter colleagues in Haarlem were very well-off. Frans de Grebber, Jan Miense Molenaer, Salomon van Ruisdael, and Floris van Dyck were even among the richest citizens in the city, each with accumulated capital of over 20,000 guilders.[56] It is unclear how much of their wealth was earned and how much was inherited or acquired by marriage. De Grebber, for one, supplemented whatever he made by painting with considerable investments in the real estate business. Over the years, he bought and sold a fair number of houses, sometimes owning several at the same time and renting them out. In April 1617 alone he bought three houses; in the following month, he bought another one.[57]

Many other painters, while not especially wealthy, earned enough to at least own their own homes.[58] By contrast, Hals, despite his fame, never lived in a house that he owned; he and Lysbeth remained renters their entire lives, although at the time renting was the rule rather than the exception for the citizens of Haarlem. The median price of a house was around 2,000 guilders; on average a comfortable enough one could be bought for about 1,000 guilders; the monthly cost of renting a home was typically somewhere between ten to twenty guilders.

How are we to account for Hals's lifelong money problems? Was

it a matter of profligacy? That is what Houbraken and some other contemporary writers—who depict an irresponsible man given to a louche lifestyle and squandering his time and guilders over drink in taverns—would have us believe. Who knows? Perhaps they are right. There was also the sheer expense of a large family. Even in the mid-1650s, three of his and Lysbeth's offspring were still living at home (they would soon marry and move out). Moreover, as we have seen, some of those children, now adults, brought extra financial liabilities, whether it be incarceration in the workhouse or confinement in a mental institution.

It may also be that Hals was not earning very much. He was among the most popular artists in the Republic. In the 1650s his paintings show up in private collections throughout the major cities of Holland. However, we do not know whether the works in these collections were direct commissions from the artist or purchased on the secondary market, in which case Hals would not have seen a stuiver. To compound matters, his clients may not all have been paying for their portraits in a timely manner. Many wealthy people in the period settled their bills only once every six months or even just once a year. Hals could have come after them for the balance, but it would have been considered unseemly for a painter to pursue a wealthy regent for unpaid fees.

What is certain is that Hals was not earning nearly as much per portrait as Rembrandt was.[59] Rembrandt received just an *advance* of seventy-five guilders for the portrait he was doing for his Jewish neighbor Diego d'Andrade; and he could ask around one hundred guilders per figure for the *Night Watch* civic guard picture. He also charged the wealthy Amsterdam regent Andries de Graeff 500 guilders for a full-length portrait in 1639, in a deal possibly arranged by Hendrick Uylenburgh.[60] Of course, Rembrandt was not painting only portraits. History paintings, especially of Old and New Testament scenes, were still high-ticket items, and Rembrandt, like so many other Dutch painters of the time, made these both to order and for the market.[61] Especially helpful for his finances was the occasional lucrative commission from The Hague. In the 1630s, he sold Stadholder Frederik Hendrik five paintings for 600 guilders each, including an *Entomb-*

ment of Christ and a *Resurrection of Christ*.[62] In the following decade, he received from the stadholder 1,200 guilders for each of two paintings, *The Birth of Christ* and *Christ's Crucifixion*.[63] None of this was enough to keep Rembrandt from having to declare bankruptcy in 1656, in part because he was living beyond his means, including purchasing a house on the Sint Antoniesbreestraat that he could not afford.[64]

Hals did not do histories. Even the four Evangelists he painted back in the 1620s were essentially *tronies*. Nor, as we have seen, was he any longer making genre pictures for the open market. Those wealthy Haarlem artists, on the other hand, had adopted a different business model, either by diversifying their work or opting for a more broadly marketable kind of picture. Frans de Grebber did portraits, but he also did religious paintings; Salomon van Ruisdael painted landscapes, which were now quite popular and pricey and which, with a limited palette, could be made fairly quickly and sold publicly; and Molenaer did very well with his tavern pictures and other genre pieces.

For Hals, portraits were not just his "bread and butter"—they were *all* he did. Some of them must have brought in a good price: the large group portraits and the pictures of families and couples. But over the course of a long career—in the end, over fifty years as a master painter—there really were not that many of these. Hals did six civic guard portraits (or, rather, five and a half), three group portraits of other civic bodies, four family groups, and one double portrait of a married couple. All the other portraits, as far as we know from what is extant, were of single individuals (with a fair number of these being paired pendants, and thus coming as a package deal).

Moreover, so many of these single portraits were not very large or elaborate, especially in the final decade of his life. No longer was Hals producing full-length portraits, such as the brilliant painting of Willem van Heythuysen from 1625. Where the portraits from the 1630s and 1640s showing single individuals tended to be within the range of 75 × 65 cm to 115 × 90 cm, with some smaller and larger works, many of his later portraits, from the mid-1650s on, were usually in the range of 30 × 25 cm to 45 × 35 cm, again with some exceptions. So it could be that Hals's paintings were not bringing in as

much income as they used to. Unfortunately, with the exception of the price per figure in the Amsterdam "Meager Company" (sixty to sixty-six guilders) and the thirty-five guilders he received in 1653 for making a copy of his own (1635) portrait of Willem van Heythuysen,[65] we really have no definite idea what Hals charged his clients. What *is* clear is that it was not enough to meet all his expenses.

Denouement

In the fall of 1655, Frans Hals, born in Antwerp and now master painter and elder statesman in Haarlem's Guild of Saint Luke, officially became a member of the Dutch Reformed Church.

Having reached his early seventies, perhaps Hals was more conscious than ever of his own mortality. Longtime colleagues, some quite a bit younger than he, were disappearing. Frans Pietersz de Grebber died in 1649; his son Pieter Fransz de Grebber, who never married and spent the last two decades of his life between a country estate and Haarlem's beguinage—close by a community of Catholic religious laypeople, usually women, devoted to caring for the poor and the sick—passed away in 1652, at the age of fifty-two. In less than a year, Hals's younger brother Dirck, who may already have been ailing, will be gone.

Or maybe formally enrolling as a Calvinist was Lysbeth's idea. She, like Hals's first wife, Anneke, had been baptized in the Dutch Reformed Church and was herself a member.[1] She might have finally prevailed upon her husband, who (as we have seen) may have been born a Catholic, to join her in the faith. Most of their children had also been baptized Reformed. But it was one thing to be blessed as an infant by a Reformed pastor and quite another to join the church as a member. Their son Nicolaes, though baptized, would not become a member until 1672, with his mother as witness.[2]

Membership did have its privileges. Public offices were open only to those who belonged to the Republic's dominant and highly favored, if not "established," church. It was possible to be a nonmember and still identify with the Reformed faith. But such *liefhebbers*, or

amateurs, were—like nonconforming Protestants (such as Quakers and Mennonites), Lutherans, and especially Catholics and Jews—precluded, at least in principle if not in reality, from sitting on city councils or being appointed as magistrates or members of municipal or provincial governing boards. Of course, this principle was often observed in the breach, especially during the De Witt era, when quite a few *vroedschappen* were populated by Remonstrants. Most Dutch citizens, in fact, did *not* belong to the Reformed Church. According to some estimates, membership for the general population across all the provinces around 1650 was about 40 percent. The number for Haarlem, with its large Catholic community, was around 20 percent in the 1620s, somewhat higher by midcentury.

Not being a member did not mean that you could not attend worship services, baptize your children, get married in the Reformed Church, or be involved in one way or another in local parish events.[3] It did mean you could not participate in Communion, or "Holy Supper." It also disqualified you from being eligible for financial aid and other welfare relief from the church. And here we may have hit upon Hals's real reason for finally joining. In light of his lifelong troubles with money, there was something tangible to be gained by formally entering the fold.

Whatever the motive, the record indicates that on October 8, 1655, and after he would have received some instruction in church dogma and discipline, "Frans Hals living on Ridderstraat, with his wife as witness," stood before the elders of the Haarlem consistory and made his profession of faith (*belijdenis*) (fig. 57).[4] By accepting the formulas of the Heidelberg Catechism (the "Confession" of the Reformed religion), he went from being an amateur or fellow traveler to being a member (*lidmaat*) of the Dutch Reformed Church.[5]

What actual difference this made to Hals, spiritual or otherwise, we will never know. It certainly mattered little to his clientele. Those who commissioned or collected or otherwise dealt in Hals's works practiced all manner of occupation: textile manufacturers and merchants, civic leaders, intellectuals, clerics and theologians, owners of small and large businesses (especially brewers), fellow artists and artisans. And they came from across those deep confessional divides of

57. Frans Hals, detail from *Album Communicant*, Kerkenraad van de Nederlands-Hervormde Gemeente te Haarlem (1647–60), Noord-Hollands Archief, access #1551, inv. no. 102.

the United Provinces. They were Protestants—whether Calvinist (of both the Remonstrant and Counter-Remonstrant variety), Lutheran, or Mennonite—and Catholics. As we have seen, we do not know whether Hals painted any Jewish sitters. The wealthy Sephardim of Amsterdam preferred to have their portraits done by local artists— like Rembrandt—and could afford it; the city's Ashkenazim, who began arriving from eastern Europe in greater numbers in the 1640s and who were much poorer and perhaps more fastidious about the Second Commandment than the "Portuguese," would have nothing to do with portraits of themselves.

Seventeenth-century Dutch writers on art, as well, did not care one way or another what Hals's religious affiliation may or may not have been. To be sure, there was the occasional harsh review. The poet Herman Frederik Waterloos had some unkind things to say about the portrait that Hals did of the stern Amsterdam Reformed preacher Herman Langelius around 1660 (fig. 58).[6] Langelius is described by one contemporary as someone who "fought with the help of God's word, as with an iron sword, against atheism."[7] Among other campaigns for the spiritual improvement of his fellow citizens, Langelius led the charge against the performance and publication of a play by Joost van den Vondel, the great Dutch author and proponent of religious toleration and a liberal thorn in the side of conservative (Counter-Remonstrant) Calvinists. Langelius, like many in the Voetian camp, regarded the theater as a threat to the virtue of

58. Frans Hals, portrait of Herman Langelius, ca. 1660, Musée de Picardie, Amiens, France.
Credit: Eric Lessing/Art Resource, New York.

good men and women. However, Waterloos's complaint about Hals's
painting of Langelius, which he penned in 1660, had nothing to do
with matters of religious faith or the morality of dramatic literature,
at least on the face of it:

> Why, old Hals, do you try and paint Langelius?
> Your eyes are too dim for his learned luster,
> And your stiffened hand too crude and artless
> To express the superhuman, peerless
> Mind of this man and teacher.
> Haarlem may boast of your art and early masterpieces,
> Our Amsterdam will now bear witness with me that you
> Have perceived not half the essence of his light.[8]

It was an early modern literary trope to criticize the painter so as to praise the sitter, and such rhetoric should often be taken with a grain of salt.[9] Still, Waterloos seems not to have been a fan of Hals's painterly style, especially as it grew increasingly looser in later years. He blames this on what he takes to be an elderly Hals's failing eyesight and hand control, although behind his art criticism there was also a bit of municipal chauvinism—Amsterdam versus Haarlem—at work.[10]

Waterloos's opinion of Hals was not widely shared. More characteristic is the praise of Hals by Cornelis de Bie in 1661, who, as we have seen, calls him "a marvel at painting portraits or counterfeits [conterfeytselen] which appear very rough and bold, nimbly touched and well composed, pleasing and ingenious, and when seen from a distance seem to lack nothing but life itself."[11] A few years later, the Frenchman Balthasar de Monconys was traveling through the Netherlands. During a stopover in Haarlem, he visited the Oude Doelen, where he admired one of Hals's portraits of the Saint Hadrian officers. In his travel journal he calls the artist "quite rightly admired as among the greatest painters."[12] And in 1680, fourteen years after Hals had died, the poet and preacher Arnold Moonen wrote these lines about a now-lost or unrecognized portrait of his fellow cleric Jan Ruyll, who was based in Haarlem:

> This is the portrait of your faithful Ruyll
> O Haarlem, your hero, your support, your church pillar and column
> Of temple peace, as naturally as if he were alive,
> Thanks to Hals, whose brush so spiritedly glided
> High and deep. Yet did the spirit of the man ever enchant you?
> Then save the lesson heard from his golden mouth.[13]

To judge from the commissions coming to Hals in the final years of his life, Haarlemmers tended to agree not with Waterloos but with De Bie, Monconys, and Moonen. The brewer Willem Croes, who was good friends with other leading Haarlem citizens who had sat for the painter (including Paulus van Beresteyn and Joseph Coymans), went to Hals for his own portrait in the early 1660s—this despite the fact

that Johannes Verspronck was apparently the preferred painter for his extended family, having done portraits of his sister Adriana, her daughter Maria, and her daughter's husband, Eduard Wallis.[14]

The Croes picture, as well as a small painting of the Haarlem brewer and burgomaster Cornelis Guldewagen, both half-lengths, stand out stylistically among portraits in this final period of Hals's career.[15] There is a kind of uniformity among the late works, both in pose and in palette. Many of them depict the busts of now-anonymous men seated slightly askew, looking at us over a forward right shoulder. They are all dressed much the same, and their black cloaks and white collars barely stand out against a mottled brownish and featureless background.[16] If their hands are visible, they are neatly folded in front of them. The sitters look pretty somber; there is no laughter or even smiling. Langelius holds a book, and Croes and Guldewagen have their gloves in one hand—this, and their relative tonal brightness, distinguishes them from most of the other panels, in which there are no props at all.

There are still, in the 1660s, occasional flashes of the old Hals and the unorthodox, easygoing postures in which he sometimes set his subjects. In the picture of Guldewagen, the brewer is facing us head-on and leaning back ever so slightly. The application of paint is as relaxed as the sitter; you can practically count the bluish-gray brushstrokes that make the sheen of his woolen cloak, and its buttons are just small splotches of the same color. Two late portraits of seated men (one in a slack, sprawling hat)[17] show them turning to look at us over the backs of their chairs, smiles on their faces and their arms slung across the seatback, much as Isaac Massa posed in the 1620s. And in a painting probably from around 1665, a man with exceedingly long, curly hair—perhaps a wig, a new style made popular by the French—is dressed in a plum-colored gown (fig. 59).[18] The rendering of the garment, as well as the white cuffs and collar and his hair, is as rough as anything Hals has ever done. The robe is sketched in as a series of red, pink, violet, and black strokes; his long locks are built up from a mess of brown and black curlicues.

It is not uncommon to find in the early Hals literature—just as in Waterloos's critique—the suggestion that the looser, even "sloppy"

59. Frans Hals, portrait of a man, ca. 1665, Museum of Fine Arts, Boston. Gift of Mrs. Antonie Lilienfeld in memory of Dr. Leon Lilienfeld, 66.1054. Photo: © 2022, Museum of Fine Arts, Boston.

technique that we see in the late portraits are the result of Hals's age. The failing eyesight and unsteady hand of an old man are supposed to explain the broad handling of the brush, the reduction of detail, and even wayward drops of paint on the canvases. The nineteenth-century French artist and critic Eugène Fromentin was a great admirer of Hals, especially of the period when the artist was "en sa pleine force," in the 1630s and 1640s. Fromentin, writing in the 1870s, called Hals "un maître incontestable."[19] However, he had some un-

kind things to say about the final group portraits. "In the end, Hals was old, very old. . . . His hand is no longer there. He is smearing rather than painting. He does not execute, he coats. . . . The colors are completely summary."[20] Hals's talent, he says, "has abandoned him."[21] In the first decade of the twentieth century, the Dutch art historian Ernst Wilhelm Moes echoed this harsh assessment of the late works: "The painter's hand, already weakening, lacked surety."[22]

Seymour Slive, on the other hand, rejects all of this as "patent nonsense." He compares it to explaining El Greco's elongated figures by a defect in his vision.[23] Slive may be right about this. There is no reason to appeal to a trembling brush to account for what we see—especially when we notice that the faces of these sitters are just as strongly and expressively rendered as those of earlier patrons. There is not as much inventiveness or variety in the very late solo portraits. Still, in his eighth decade, Hals seems to know exactly what he is doing and doing exactly what he wants.

*

It is no surprise, given the story so far, that in the final years of his life Hals continued to struggle financially. Creditors of various sorts came after him for not insubstantial sums. Some of the debt follows unwise investments that he could ill afford. In the summer of 1661, Hals, acting for himself and two other Haarlem master painters—Hendrick Aelberts Princeman and the landscape artist Adriaen Oudendijck—attended an art sale in Heemstede, just outside of Haarlem, and bought six paintings from Pieter Spijckerman, a painter of histories, and the Amsterdam artist Lambert Heyndricksz. By December, the three buyers still had not settled the bill. Hals, as the designated principal of the group, was ordered to come up with twenty-one guilders and sixteen stuivers.[24]

To supplement his income, Hals once again took on extracurricular work as an art appraiser. In April 1660, he and Pieter de Molijn were called upon to assess the value of paintings in the estate of the late Coenraad Coymans. Originally from Antwerp, Coymans, who was a textile magnate, did business for a long time from Amsterdam, where he served several terms on the *vroedschap*. In the later

years of his life, though, he settled in the vicinity of Haarlem. He was the father of Willem Coenraadsz Coymans and a relative of the Haarlem linen merchant Joseph Coymans, whose portraits Hals had done some years earlier.[25] Given the Coymans family's wealth, the art collection that Hals and De Molijn were engaged to assess must have been rather substantial; perhaps any payment they received for the work was equally so.

About a year later, Hals was similarly employed, this time as an expert mediating an exchange between two local merchants. The Haarlem public notary Lourens Baert records, on August 16, 1662, that

> The honorable merchant Emanuel Demetrius, living in this city, makes known to me that he received from the noble Abraham Engelsz, merchant in this city, the sum of one hundred and fifty seven guilders and 10 pennings, along with some paintings, brought by the aforenamed Abram Engelsz for assessment to Gisbert van Leeuwen, acting on behalf of [als goede man van] the aforenamed Abram Engelsz, and Frans Hals, acting on behalf of [Emanuel Demetrius].[26]

The two appraisers, Hals and Van Leeuwen, an art dealer, set the total value of the paintings at sixty-three guilders and three stuivers.

Whatever Hals might have earned from this administrative work, it was nothing compared to the windfall of two major commissions, among the last of his life, that came his way sometime around 1664. It was now over twenty years since Hals had painted a large group portrait—a group other than a family, that is. His 1641 painting of the regents of the Saint Elisabeth's Hospital was still hanging in their meeting room—with the portrait of that institution's regentesses painted by Verspronck nearby—when the regents and regentesses of the Old Men's Alms House decided they wanted to be similarly immortalized (figs. 60 and 61).[27]

The Oudemannenhuis was established in Haarlem in 1609. It was meant to serve as a retirement home for men over sixty years old. The pensioners were given room and board, at the expense of the city. They were not without responsibilities of their own, among

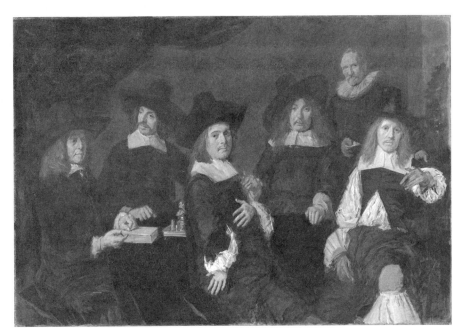

60. Frans Hals, *Regents of the Old Men's Alms House*, ca. 1664, Frans Hals Museum, Haarlem. Photo: René Gerritsen.

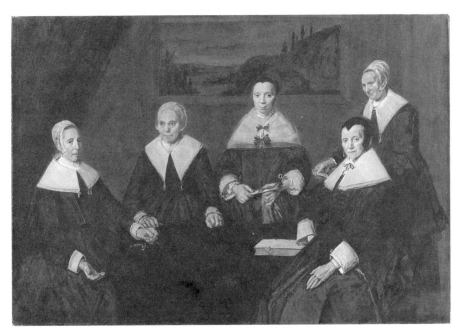

61. Frans Hals, *Regentesses of the Old Men's Alms House*, ca. 1664, Frans Hals Museum, Haarlem. Photo: René Gerritsen.

which was regular attendance at church services. Moreover, drunkenness and sexual activities (at least within the home) were prohibited; violation of the rules would result in indefinite confinement to the building. The Old Men's Alms House was intended to provide not only shelter for the body, but, when needed, restoration of the soul as well.

Hals did two paintings of the home's directors—one showing the five regents, the other with the four regentesses. Each group is shown gathered around a table on which sits a record book. The men and women in the works are seated, while an arriving attendant brings each group a written message. The dress is standard Calvinist fare: black cloaks or gowns with flat white collars and white cuffs; all of the men wear black hats, and the women have tight-fitting caps, either white lace or black felt. The only remarkable color is the splash of red stocking peeking out from under the coat of one of the regents.

These directors of a public charitable institution are all sitting quite still. Silence reigns in their boardrooms. No one is talking with, or even paying any attention to, anyone else; even the messenger is ignored. The portraits lack the animation of the earlier civic guard paintings, and even that of the painting of the Saint Elisabeth regents. They do pale in comparison to what Hals was doing with group portraits in the 1620s and 1630s. Still, no one looking at the paintings could possibly think that, in his eighties, Hals's powers have substantially deserted him. The sitters are subdued, but there is much life in those dour countenances, especially in the hands, which, in the dark setting, stand out in both canvases.[28]

The two works have come in for rough treatment over the centuries, but not because they were taken to lack "the master's touch." On the contrary, it has been suggested that Hals deliberately used his still considerable skills to paint these responsible civic leaders in as harsh and unflattering a light as possible. Their allegedly "unsympathetic" portrayal is supposed to be explained by the idea that Hals himself had suffered poor treatment while an indigent resident of their home. On this view, first expressed in the nineteenth cen-

tury, Hals took particular pleasure in rendering one of the regents with drooping eyelids, a somewhat stupefied look on his face, and a slouching hat, to alert the world to the man's drinking problem.[29] His colleagues, while more sober, might seem a stern and humorless bunch. As for the regentesses, Hals is said to have depicted them with "biting sarcasm" and "merciless observation."[30] Revenge, we are supposed to believe, is best served in paint.

As a matter of fact, Hals, despite his desperate financial situation, was never under the care of these regents and regentesses. Moreover, there is nothing at all "unsympathetic" or "merciless" in their portrayal. The paintings did darken over the centuries, lending them a dismal atmosphere that they may not originally have had and thus perhaps contributing to the poor reviews they received in the nineteenth and twentieth centuries.[31] If there is none of the animation and gaiety of earlier group portraits, it is because these men and women are charged with overseeing a very serious and important business: the housing and feeding of Haarlem's elderly poor. Besides, if the subjects of these pictures had even the slightest impression that they were being depicted in a disrespectful and negative manner, they would surely have rejected the paintings outright—which they did not. On the contrary, they set the group pendants up in their respective meeting rooms. They must have been rather pleased with their portrayals, and well they should have been. They got what they hoped for, the Hals touch, and no doubt paid the artist handsomely for his service. The two works hang today in the Frans Hals Museum, which is in the same building that the Old Men's Alms House itself once occupied.

The money that Hals earned for these two pieces probably accounts for the fact that at the beginning of 1665 he was able to stand surety for his daughter Susanna's husband, Abraham Hulst. Abraham had been in arrears for quite a significant amount of money to the dairyman (buttercooper, literally "butter seller") Pieter Jansz van der Steen: "four hundred and fifty-eight guilders and eleven stuivers for supplied butter and soap and further [provisions]," according to the notary record.[32] Payment to Van der Steen was in fact made by

the original guarantor of the debt, Adriaen Volckertsz. But now Volckertsz needed to be paid back, and this is the debt that Hals was guaranteeing for his son-in-law.

It is surprising to see Hals take on such a substantial financial obligation, one that for him could potentially be ruinous. His situation had been eased in only the most trivial way in 1661, when he was excused from any longer having to pay guild dues. "Door ouderdom," on account of his old age, Hals would now be able to save those six stuivers a year—hardly a capital reserve.[33] Indeed, by the fall of 1662, his money problems had become so bad that finally he appealed for financial assistance from the city. That September, the burgomasters, recognizing that Hals was in "urgent need," decreed that

> Frans Hals, master painter, citizen of this city and former citizen's son, at his written request, and for reasons and means therein explained, is to be granted and provided with an initial subsidy of 50 Carolus guilders to be received right away . . . and then be provided for the time of a year one hundred and fifty Carolus guilders, a fourth part all quarters of the year, to begin with the first of October of this year 1662.[34]

In other words, Hals has received a 200 guilder grant from the city, with fifty guilders paid up front and another 150 to come over the course of a year in quarterly payments. When that year was up, in October 1663, the city opted to make this a simple annuity of 200 guilders, again in quarterly disbursements of fifty guilders, "soo lange hij leeft" (for as long as he lives).[35] Those payments will be made regularly over the next couple of years. They were supplemented with additional aid in 1664, when Hals was "in need of some fire and house rent." Twice in that year—in January and in August— he was accordingly granted "three wagons of peat" to burn in his hearth. As for his rent, the burgomasters announced that "those who need to receive the house money from him, should come forward," to be paid by the city.[36]

This is a very generous subsidy that Haarlem has provided for its celebrated but impecunious artist. Hals may have had to swallow his

pride and put in the request because he was just not painting that much anymore—although with the difficulty of dating his works, especially the late ones, we cannot know for certain how many portraits he was now doing. The public welfare, then, especially the reprieve on rent, might have been necessary for him and Lysbeth to at least get by. Over the course of four years, the city's relief would amount to more than 750 guilders. This still would not have been enough to allow Hals to be the guarantor of anybody's debts, certainly not to the tune of 458 guilders. He must have figured that the fees earned from the Old Men's Alms House paintings, if the money was still in his account, would cover him in case he had to meet this obligation.

*

The Dutch economy, if not Hals's personal finances, had made a decent recovery after the end of the war with England in 1654. For the next ten, relatively tranquil years, the more severe pressures on industry and trade eased. It did not hurt that Spain was distracted and financially drained by war on several fronts as it sought both to reconquer Portugal (a lost cause) and defend itself against France and England for control of the southern Netherlandish provinces. Meanwhile, the Dutch continued to curb traffic on the Scheldt estuary—this was allowed under the Treaty of Münster—and thereby restrict the revival of Antwerp as a competing port city. Holland's trade flourished once again as it took advantage of open sea routes, while the Dutch fishing fleet could operate undisturbed in the North Sea, the Baltic, and the northern Atlantic.

A treaty ending the Republic's four-year conflict with Portugal, settling claims over Brazil, was signed in 1661. One year later, the Dutch negotiated formal alliances with both France and England. The era's superpowers had come around to respect the military might of the newly independent nation and recognize the economic advantages of being on at least nominally friendly terms with it. On the face of things, it looked like the United Provinces were in for an extended period of peace and prosperity.

In the turbulent geopolitical world of the seventeenth century,

however, alliances were always (and often quickly) subject to change. Ever lurking just around the corner from peace was yet another war. The new relationship with England was an especially fraught and unstable one. The Dutch West India Company was now in unfriendly competition with the Royal Africa Company over the gold trade and the enslavement and transport of Africans from the coast of Guinea.

Moreover, England once again had a king, Charles II. On the occasion of his installation on the throne in 1660, the States General sent across the Channel a rather generous present. It included a large carved bed, complete with linens (Haarlem's finest, no doubt); a ship, which the English would christen *The Mary*; and, perhaps most appreciated of all, a very fine collection of paintings and sculptures. The art, selected by a now aged Constantijn Huygens, involved some Dutch and German works (among them pictures by Gerrit Dou, Pieter Saenredam, and Adam Elsheimer) but especially masterpieces from the Italian Renaissance. These included paintings by Titian, Parmigianino, and Veronese that had been in the Amsterdam collection of the late brothers Gerrit and Jan Reynst and recently come on the market.[37]

If this so-called Dutch Gift was intended as a friendship offering, whatever pacifying effect it had did not last long. No sooner was Charles on the throne than he was pressing De Witt, still the Dutch political leader, for reparations for his country's losses in the East Indies.[38] The grand pensionary's negotiating position was not made any easier by the fact that, with the restoration of the English monarchy, the Orangist camp in the Republic was clamoring for the return of a Prince of Orange to the stadholdership. William III, still waiting in the wings, was the son of Mary Stuart, Charles's sister, and thus the nephew of the English king. The States party remained strongly behind De Witt, but it was hard to ignore the domestic political threat while trying to resolve international disputes.

By 1664, treaty or no treaty, England and the United Provinces were, to no one's astonishment, at war once again. The trigger, as before, was the bitter economic rivalry, especially in the East and West Indies and Africa. In addition to residual, unresolved issues from the first war, England had not fully reconciled itself to the Republic's

competitive strength. Charles reimposed protectionist policies in Great Britain and its colonies, while his navy resumed interfering with Dutch commercial traffic, including the impounding of ships and sailors. The English were, in the words of the diarist Samuel Pepys, "mad for a Dutch war," and they got it when Charles declared war on the Republic in March 1665.[39] As Jonathan Israel notes, "it was one of those wars everyone had expected, and prepared for, over many years."[40]

The Dutch, who were not as eager for another international conflict, had at least learned some lessons from the earlier contest. In the intervening years they built up their fleet significantly, both in the size, quantity, and firepower of ships and in the number of seamen. Still, things did not start out well. Despite their brilliance on the high seas, they initially struggled in the face of England's military superiority. Nevertheless, in the end—and it would take several years—the Republic's navy would prevail, under the brilliant command of Admiral Michiel de Ruyter (who managed to lead an armada up the Thames), along with some allied help from France and Denmark-Norway. By 1667, England's fleet will have suffered devastating losses, leaving Charles no option but to conclude peace. Despite victory, the two years of this second Anglo-Dutch war would take a toll on the Republic's morale—not to mention its domestic political affairs—for some time to come.

To compound the Dutch malaise, the plague was back. It began in mid-1663—Rembrandt's common-law wife Hendrickje Stoffels was likely one of the early victims—in the midst of the growing hostilities with England. This time the epidemic hit Haarlem with particular virulence. The city lost almost a third of its citizens. The painter Jan de Bray, still a relatively young man, saw most of his family die, including his father Salomon—the guild veteran who had overseen the drafting of the new charter years earlier—and most of his brothers and sisters. The regents and regentesses of the Old Men's Alms House, as well as the directors of other welfare organizations caring for the poor, the elderly, the sick, the widowed, and the orphaned, had their hands full in those dark months.

The generally gloomy atmosphere and sense of doom that hung

over the Republic in the midst of war and plague were exacerbated by the inevitable economic downturn. Like the conflict in the early 1650s, the new war was not warmly welcomed by the Republic's mercantile class. The repercussions were quickly felt on the Amsterdam exchange, where the value of shares in the Dutch East India Company dropped dramatically between March 1664, when there were merely "rumors of war," and June 1665, when the English scored a number of sea-battle victories.[41] Holland and other provinces saw a recession as shipping contracted, commodities became scarcer and more expensive, and businesses were forced to retrench. Haarlem's beer industry, for one, shrank yet again; by 1665 there were only thirty-five breweries.

The economic pain trickled down to Dutch artists. Prices declined as, once more, people cut back on commissioning expensive works or even buying paintings on the open market. At the same time—necessity being the mother of invention—new genres arose or grew in popularity. Grand history paintings gave way to fine, more intimate renderings of architecture and scenes of contemporary urban life. Pieter Saenredam's early perspectival depictions of church interiors and the facades of public buildings inspired artists like Emanuel de Witte of Amsterdam, similarly fascinated by the play of light and color on architectural forms in ecclesiastic and civic halls, and the Berckheyde brothers, Job and Gerrit, landscape and genre artists who also created luminous cityscapes. The Berckheydes' paintings include representations of Amsterdam's recent expansion—completing the Keizersgracht, Herengracht, and Prinsengracht canal rings and their upscale neighborhoods—with newly erected brick houses captured in minute detail and remarkable clarity. Active in Haarlem as well, the brothers have also given us late century images of the interior and exterior of the Saint Bavo Church and the Grote Markt beside it.

Were Haarlem's merchants and professionals still looking for flattering portraits? Evidently not to the extent that they were before the war began.[42] And most of the portrait commissions that were on offer were not going to the elderly Hals.

Jan de Bray, while specializing in histories—bold, beautiful paint-

ings in rich and warm colors, among them an allegorical scene of Frederik Hendrik, *Bringer of Peace* (1681)[43]—nonetheless did more group portraits between 1663 and 1667 than Hals. A Haarlem native, the younger De Bray did not join the guild until the age of thirty-five or thirty-six, after his father, Salomon, had died. Until then, he remained as a journeyman assistant in Salomon's workshop. In 1663, he painted the regents of the Armekinderhuis (Poor Children's House) orphanage, the regentesses of that same institution the following year, and the regents and regentesses of the Lepers' Hospital in 1667. These were accompanied by a number of solo and double portraits, including one of the Haarlem printer Abraham Casteleijn and his bride, Margarieta van Bancken, in 1663; another of Agatha van Hoorn, who sat for De Bray around the same time that her husband, Cornelis Guldewagen, sat for Hals (De Bray had also painted their son Dammas, a few years earlier); and a touching, possibly posthumous painting of overlapping profiles of his father and mother, Anna Westerbaen, from around 1664.[44]

<center>*</center>

The early 1660s, in fact, witnessed a general changing of the artistic guard, in Haarlem and elsewhere. Two former deans of the Haarlem guild—old Hendrik Pot and Hals's fellow portraitist Pieter Soutman—had both died in 1657. In 1660, Jan Miense Molenaer became a widower when his wife, Judith Leyster, died at the age of fifty. Salomon de Bray was sixty-two years old when the plague took him in 1664. This was two years after the death of sixty-two-year-old Johannes Verspronck, and one year before Saenredam, another former dean, passed away at age sixty-seven. In Amsterdam in just a couple of years, Rembrandt would be gone as well; he died in 1669, two years after his colleague Thomas de Keyser.

With the passing of a generation, a talented new one emerged. While Jan de Bray was assuming from Hals the mantle of portraitist to the Haarlem elite, Adriaen Backer, along with Rembrandt's students Nicolaes Maes and Ferdinand Bol, had joined Gerard ter Borch (based in Deventer) and Pieter Codde in painting pictures of Amsterdam's regent families.[45] There was Caspar Netscher in

The Hague, and Frans van Mieris and, on occasion, Jan Steen in Leiden, all doing portraits (among other genres) and doing them in very different and creative ways. New forms of genre painting, too, emerged in Delft, where Vermeer and Pieter de Hooch were at work. And the monochromatic tonal landscapes that Haarlem's earlier generation—which included Esaias van de Velde and the brothers Salomon and Isaack van Ruisdael—practically invented were now succeeded by the luxuriant, richly colored scenes of fields, forests, and country roads and dramatic skies painted by Jacob van Ruisdael (Isaack's son, born in Haarlem) and Meindert Hobbema, both active in Amsterdam.[46]

We will never know how much of this generational change Hals actually witnessed and what his thoughts were about it. He probably did not get around much at his age and appears never to have left Haarlem. Did he even get to see his new granddaughter, Hester, born to Frans Jr. and his wife in March 1666? We know he did not attend the baby's baptism, since only Lysbeth was present as a witness.[47] Which of the several now-anonymous portraits he painted sometime around 1665–66 was his last one, and where he and Lysbeth were living when he painted it, is also a mystery. The couple had left the rented house on the Ridderstraat by this point.

We do know, however, where Frans Hals's final resting place is. He died in the summer of 1666, in August, and was buried on September 1. He lies in grave number 56 in the choir of Haarlem's Church of Saint Bavo.

The great *meester schilder* of Haarlem did not get his own burial plot; his body was added to the grave of Nicolaas Joppen Gijblant, the grandfather of his first wife, Anneke. For a long time, he did not even have a separate headstone. Lysbeth would not have been able to afford either chamber or marker for her husband, as she was still on public assistance. A final fifty-guilder payment of the city's annuity to Hals was delivered to her on October 1, 1666.[48] She struggled after that, and for nearly ten years frequently asked the Haarlem burgomasters for financial help. Finally, in June 1675, they agreed that "on repeated instances when the widow of Frans Hals has requested some subsidy, because she has now reached high years [old

age] and fallen into poverty," she should be granted fourteen stuivers per week, to be taken from a fund for the benefit of the poor.[49]

That is the last we hear of Lysbeth Reyniersdr. She outlived five of her adult children. Three died before their father passed away in 1666. The death in February 1667 of "innocent" Pieter, still confined in an institution, may have come as something of a relief to her, if not for her own sake then for his. He was buried in a churchyard in Haarlem.[50] And Nicolaes, as we have seen, died in 1672. Lysbeth's final years were thus spent in penury and mourning. The date of her death is not recorded.

*

It would be a sorry way to end a biography of Frans Hals, a painter of so much joy and laughter, with destitution and a pitiful burial. Fortunately, the city of Haarlem has provided a fitting coda.

Hals's standing among critics, *liefhebbers*, and even in the market-place had its ups and downs in the two centuries after his death, but mainly downs. As Frances Jowell has shown, for the most part he suffered posthumous neglect until the mid-nineteenth century.[51] What she calls "the near oblivion of Hals outside of Holland" stands in stark contrast not only to the fame and popularity he enjoyed during his lifetime, but to the later attention that was given to his Dutch and Flemish contemporaries: Rembrandt and Rubens, of course, but also Van Dyck and even quite a few lesser figures. Hals's name is remarkably absent from many eighteenth- and nineteenth-century French and English art surveys and catalogs. Perhaps this was to be the fate of someone whose art was devoted almost exclusively to portraiture—but then how to explain the admiration of these authors for Van Dyck, Thomas Gainsborough, Joshua Reynolds, and other portraitists?

When Hals was not ignored, he was disparaged. This may have been due to his reputation for a debauched lifestyle. But sometimes it was based on aesthetic grounds. The French dealer Jean-Baptiste-Pierre LeBrun, writing in the 1790s, complained that "[Hals's] productions could be sold much more dearly if he had not produced so much nor painted so quickly; for in order for a painting to earn a

high price it is not sufficient that we perceive in it the mark of ge-
nius, it must also be finished."[52] LeBrun was only seconding some-
thing that the great Sir Joshua Reynolds had said twenty years ear-
lier:

> In the works of Frank Hals, the portrait painter may observe the
> composition of a face, the features well put together, as the paint-
> ers express it; from whence proceeds that strong-marked character
> of individual nature, which is so remarkable in his portraits, and is
> not found in an equal degree in any other painter. If he had joined to
> this most difficult part of the art a patience in finishing what he had
> so correctly planned, he might justly have claimed the place which
> Vandyck, all things considered, so justly holds as the first of portrait
> painters.[53]

The problem, once again, is the apparent lack of finish in Hals's
works. Taste changes, and in an age when the "smooth" and polished
manner of painting was preferred, Hals's "rough" approach was out
of fashion.

It was not really until Thoré-Bürger's "rediscovery"—or rather,
since the painter was never totally forgotten, his critical and his-
torical rehabilitation—of Hals in the 1860s that things began to
change.[54] This French critic's campaign on Hals's behalf raised his
profile among connoisseurs and on the market. Wealthy and influ-
ential collectors, particularly in Paris, began competing for Hals's
paintings at Old Master auctions—among them Lord Hereford,
who in 1865 spectacularly outbid Baron James de Rothschild for the
painting of Tieleman Roosterman we now know as *The Laughing Cav-
alier*, paying 51,000 francs for the work.[55] (Not to worry. The Roth-
schilds eventually got their own set of Hals. One year after losing out
to Lord Hereford, James purchased the later, smaller portrait of Wil-
lem van Heythuysen from Baron van Brienen van de Grootelindt of
Amsterdam at a Paris sale, for 35,000 francs.[56] And at a 1872 auction
in Vienna, Baron Anselm Mayer von Rothschild acquired the later,
1634 portrait of Roosterman, for 15,200 guilders.)[57]

Meanwhile, artists themselves began to take notice. Gustave

Courbet, Édouard Manet, John Singer Sargent, and James Ensor are just a few of the nineteenth-century painters who were inspired to copy or refer to Hals's works or details from them. Van Gogh, as we have seen, was a fan. He had no problem with the "rough" manner. Viewing some of the portraits, he wrote to his brother Theo: "Above all I admired hands by Rembrandt and Hals—hands that lived, but were not finished in the sense that people want to enforce nowadays. . . . What joy it is to see a Frans Hals like that, how very different it is from the paintings—there are so many of them—where everything has been carefully smoothed out in the same way."[58] Hals, he proclaims, "is a colorist among colorists, a colorist like Veronese, like Rubens, like Delacroix, like Velazquez."[59]

Perhaps the most beautiful tribute to Hals has come from the city in which he flourished. On Groot Heiligland, a street where Hals lived in the late 1630s, is a building that once housed the Oudemannenhuis, the charitable institution whose regents and regentesses Hals painted at the end of his life. When, in 1913, the Haarlem Municipal Museum, with its unrivaled collection of Hals's paintings, relocated there from its former home in the town hall, it was rechristened the Frans Hals Museum.[60] It is a right and proper homage to the greatest painter the city has ever seen—an artist who, though Antwerp born, will forever be associated with the Haarlem whose citizens he so uniquely and brilliantly immortalized.

Acknowledgments

As a mere *liefhebber*, I could not possibly have written this book without the scholarship of art historians and archivists who have contributed so much to our understanding of both Hals and the art world of the Dutch Republic in the seventeenth century. My debts to their work are evident throughout the work, from the notes to the reference list.

I am especially grateful to a number of people who so generously shared their expertise with me by answering my questions, pursuing some investigations on my behalf, and/or granting me access to material in their care. My thanks to Marrigje Rikken (head of collections at the Frans Hals Museum) and her research assistant Kate Darnton; Molly Harrington (who shared with me her dissertation on *schuilkerken*), Robert van Vuuren (Noord Hollands Archive), and Erma Hermens (of the Rijksmuseum and the University of Amsterdam). Henry Luttikhuizen, Jennifer Nelson, Henk van Nierop, Henriette Rahusen, Gary Schwartz, Theo Verbeek, and Arthur Wheelock provided helpful feedback on particular matters and patiently responded to my many unsolicited queries. I would also like to acknowledge Abby Armstrong Check, a graduate student in art history at the University of Wisconsin–Madison and project assistant who provided invaluable assistance in securing images and permissions.

Above all, I want to express my deepest gratitude to five people who took the time to read through a draft of the manuscript at some stage of its composition and offered extensive suggestions, criticisms, and, most important of all, corrections: Pieter Biesboer, Frances Jowell, Norbert Middelkoop, Larry Silver, and Paul Taylor.

Thanks, as well, to my good friend Henriette Reerink, who was game for a bike ride from Amsterdam to Haarlem for a visit to the Frans Hals Museum.

Finally, special thanks to the editorial and production team at the University of Chicago Press: Susan Bielstein, editor extraordinaire, who still actually edits and whose encouragement on this project I so greatly appreciated, and her assistants Rebecca Brutus and Dylan Montanari, as well as copyeditor Mark Reschke.

Notes

1. Rembrandt was the target of several lawsuits by clients. For an intimate portrait of Picasso's personality, see Gilot 2019.
2. I mostly avoid the term "Golden Age" throughout this book, and when I do use it, I use it with caution. It has become a contested and controversial label for this period of Dutch history, with the Republic engaged in the enslavement and transport of African people, horrific colonial practices, and a domestic social and political structure that effectively excluded a good part of its population from enjoying significant rights. A number of museums now refuse to use the term to refer to the art and culture of the seventeenth century.
3. Book 5, chap. 22: "het sap gelyk drek langs het Stuk neer loope" (De Lairesse 1707, 324).
4. In modern Dutch, *kunstschilder*, but in my narrative I will follow the early modern spelling.
5. On the term "amateur" and its connection with the Dutch *liefhebber*, see Taylor 2016. He shows how a distinction between amateur and expert (connoisseur) emerges at the end of the seventeenth century and the beginning of the eighteenth. Swan (2021) prefers to translate *liefhebber* as "devotee" or "admirer." Since she sees the *liefhebber* as a "learned non-professional whose knowledge of a given subject or practice enabled them to exercise discernment" (142), the term "connoisseur" as an English translation does not seem inapt.
6. For an early expression of this view, see Michel 1903, 111.
7. See, for example, Schwartz 1985, a study of Rembrandt in the context of Dutch religious and political life and his circle of patronage; and Alpers 1988, a study of Rembrandt's studio practice as a business.
8. Nadler 2013.
9. This is not my first biography set in the Dutch Republic in the seventeenth century. I have written biographies of the philosopher Baruch Spinoza (Nadler 2018b) and the Amsterdam rabbi Menasseh ben Israel, arguably the most famous Jews in the world in that period (Nadler 2018a).
10. I also refrain from intervening in specialized debates about the nature of

portraiture and its relationship to Dutch bourgeois culture in the seventeenth century. On this, see Woodall 1997 and Adams 2009.

11. See the catalog of lost paintings in Slive 1974, 3:119–27.

12. See the even longer catalog of "Doubtful and Wrongly Attributed Paintings" in Slive 1974, 3:128–58.

13. See Strauss, Van der Meulen, Dudok van Heel, and De Baar 1979.

14. Montias 1991.

15. Van Thiel-Stroman 1989.

CHAPTER ONE

1. London was certainly larger; and Lyon was about the same size as Antwerp.

2. Gay and Webb 1973, 210.

3. It is debatable whether Juana truly was "mad," or whether this was just a way for others to keep her from inheriting her husband's throne after his death in 1506.

4. On the Dutch Revolt, see Geyl 1966 and Israel 1995.

5. The father of Franchois's father, Frans (d. 1571), was also named Frans; he was one of three sons of Pieter Hals and his wife; Pieter, in turn, was the son of Jacob Hals (b. ca. 1440), a baker in Mechelen, and his wife, Catharina Gheraerts. On the Hals family history, see Dólleman 1974.

6. This background information on Franchois is from Van Thiel-Stroman's analysis of notarial and various other archival records; see Van Thiel-Stroman 1989, 372.

7. For Adriana's age, see Bredius 1914.

8. The document is a 1585 membership list of one of Antwerp's civic guard companies drawn up by the Spanish after they retook the city and sought to purge these companies of Protestants (whose loyalty would be suspect). Franchois's name appears on the list with a cross next to it, indicating a Catholic; see Van Thiel-Stroman 1989, 373, doc. 2.

9. Van Thiel-Stroman 1989, 372, doc. 1.

10. Van Roey 1957, 3.

11. For a study of this period of Antwerp's religious history, see Marnef 1996.

12. Vermeylen 2014. Vermeylen, along with other scholars, stresses that the migration was due to a combination of factors, some related to the territory from which one was leaving and some related to the destination territory, and thus represents a complex "push and pull" phenomenon.

13. Vermeylen 2014, 51.

14. Westermann 2002, 356.

15. See, for example, Van Thiel-Stroman 1989, 375, doc. 10, a Haarlem notarial record in which he is referred to as "Frans Hals van Antwerpen," probably to distinguish him from another Frans Hals in the city.

16. Maria married Geeraert Immermans in 1596 (Van Roey 1972, 158–59). It is possible that she did not leave Antwerp with the family in the first place; Van Roey (1972, 162) speculates that she was raised by the family of her late mother and also suggests that another half-sister of the artist, Barbara,

also remained in Antwerp. The oldest half-brother, Carel, would end up in Amsterdam, where he married Marytje Jansdr, the widow of Jan Gerrtisz, a basket maker (Van Thiel-Stroman 1989, 374, doc. 7.).

17. Biesboer 1996, 36.

CHAPTER TWO

1. Jacob van Ruisdael, *View of Haarlem with Bleaching Grounds*, oil on canvas, ca. 1670–75, Mauritshuis, The Hague. On the Haarlem bleaching industry, see Greup-Roldanus 1936.

2. On the basis of a seventeenth-century bird's-eye map of Haarlem, Burke (1974) identifies the various skyline landmarks in the Van Ruisdael Haarlem panorama in the Montreal Museum of Fine Art. For a fuller analysis, see Biesboer 1995a.

3. Speet 2006, 8.

4. On the Haarlempjes and their perspective views of Haarlem, see Biesboer 1995a. Burke (1974) notes that it is possible that some of Van Ruisdael's Haarlem paintings represent the view from the dunes to the west of the city.

5. Ampzing 1628, 76; translation by Stone-Ferrier 1985, 425 (modified).

6. Ampzing 1628, 340; translation by Stone-Ferrier 1985, 425.

7. For a study of the history and architecture of the Saint Bavo Church in Haarlem, see Mochizuki 2008, chap. 1. On Haarlem and Saint Bavo's, see Temminck 1996.

8. The Spanish retreat came in the wake of Amsterdam's readiness to join the Revolt.

9. In the nineteenth century, a new church was built to serve as the Catholic Cathedral of Saint Bavo.

10. Israel 1995, 364.

11. Spaans 1989, 117.

12. Israel 1995, 364.

13. Spaans 1989, 71. As Harrington (2018, 2) notes, a more accurate term is *huis-kerken* (house churches), since in Holland there was really nothing secret about these private chapels.

14. Van Thiel-Stroman 1989, 373, doc. 4.

15. Van Thiel-Stroman 1989, 374–75, doc. 8.

16. Van Thiel-Stroman 1989, 374, doc. 5.

17. See Biesboer 1996.

18. Biesboer 1989, 23; De Vries and Van der Woude 1997, chap. 8, especially 290–91.

19. Ungar 2001, 89.

20. See Yntema 2016, 270. Van Zanden puts the number even higher: fifty breweries after the end of the Spanish siege in 1573, and over a hundred by 1620 (Van Zanden 1993, 10, 19). See also Hoekstra 1936.

21. See the list of breweries compiled by Samuel Ampzing and published in 1628 (Ampzing 1628, 338–39).

22. See the chart on Ungar 2001, 78.

23. Ungar 2001, 81–82.

24. My thanks to Pieter Biesboer for this fact.

25. His name does appear as a member of the Guild of Saint Luke around 1605; see Goosens 2001, 443.

26. The statistics come from Bakker 2019, 72, and Goosens 2001, 15–38. As Goosens shows, numbers for Amsterdam are more difficult to come by in this period (2001, 19).

27. For a study of early painting in Haarlem and the emergence of its distinctive style, see Snyder 1960.

28. "Het Leven van Karel van Mander" appears in the second edition (1618) of Van Mander's *Schilder-Boeck*; see Van Mander 1994–99, 1:21. On the authorship of this biographical sketch and the argument for Karel van Mander II, see Duits 1993.

29. On Van Mander's "Mennonite roots," see Shank 2005.

30. "Het Leven van Karel van Mander," Van Mander 1994–99, 1:21–2.

31. "Het Leven van Karel van Mander," Van Mander 1994–99, 1:25.

32. Leesberg quotes one early source as saying there were "few who love art in Holland who have nothing from his hand." At the same time, she notes that "from his painted *oeuvre* it is readily evident that he was no more than a mediocre figure who played no major role in the development of Dutch painting" (Leesberg 1993–94, 5–6).

33. See the modern edition by Miedema in Van Mander 1994–99.

34. Van Mander 1604, fol. 292r; Van Mander 1994–99, 1:426.

35. Van Mander 1604, fol. 206r; Van Mander 1994–99, 1:82.

36. My thanks to Paul Taylor for correcting my impression of the import of this passage from Van Mander.

37. Van Mander 1604, fol. 229r; Van Mander 1994–99, 1:174.

38. Van Mander 1604, fol. 205v; Van Mander 1994–99, 1:81.

39. Van Mander 1604, fol. 247r; Van Mander 1994–99, 1:246.

40. Vermeylen (2014, 43) suggests that "Flemish painters were instrumental in launching the Haarlem school of painting."

41. On Cornelis, see Van Thiel 1999.

42. Ampzing 1628, 366.

43. According to a comparison of the list in Goosens 2001 (443) with the Ecartico online database.

44. Vermeylen and De Clippel 2012, 142.

45. Vermeylen and De Clippel 2012, 160.

46. Goosens 2001, 229–32.

47. *Om nae 't leven te studeeren*, "Het Leven van Karel van Mander," fol. S2r, Van Mander 1994–99, 1:26. This almost certainly did not mean live nude models, which would not have been tolerated in a Calvinist society, nor even plein air painting. McGee suggests ancient sculpture was used for models (McGee 1991, 76–77). In *Den Grondt der edel vry schilder-const* (Foundation of the noble free art of painting), Van Mander speaks primarily of *Natuur* as the source of the painter's artistic gift (Van Mander 1973, 73).

48. On this "academy," see McGee 1991, chap. 4, and Hyman 2016.

49. McGee (1991, 78) claims that "the dates of this close working relationship must fall . . . between 1583, when Van Mander arrived in Haarlem, and late 1590, when Goltzius left for Italy." However, Goltzius was apparently back in

Haarlem by 1591, although this does not necessarily imply that the collaboration picked up where it left off.

50. "Het Leven van Karel van Mander," Van Mander 1604, fol. S3r; Van Mander 1994-99, 1:30.

51. Van Mander 1604, fols. 293v and 300r; Van Mander 1994-99, 1:433 and 459.

52. For the 1590 regulations, see Miedema 1980, 1:57-61.

53. Goosens 2001, 85.

54. Van Mander died in 1606.

55. "Het Leven van Karel van Mander," Van Mander 1604, fol. S3r; Van Mander 1994-99, 1:30.

56. Van Thiel-Stroman 1989, 414, doc. 190: "Den treffelicken Conterfeiter Frans Hals van Harlem heeft geleert bij Carel Vermander van Molebeke." Scheits was writing in 1679.

57. Miedema 1980, 309-10.

58. "Het Leven van Karel van Mander," Van Mander 1604, fol. S2r; Van Mander 1994-99, 1:26.

59. Van Mander 1604, fols. 259r-v; Van Mander 1994-99, 1:294-97.

60. Goosens (2001, 79-82), based on the revised 1630 regulations in Haarlem, suggests that in Haarlem the terms *leerlingen* and *discipelen* were used interchangeably to refer to pupils serving their three years of apprenticeship, although she does suggest a distinction between more advanced apprentices (*discipelen of gevorderde leerlingen*) and beginning apprentices (*beginnende leerlingen*).

61. Van Mander 1973, 70-73.

CHAPTER THREE

1. Van Mander 1604, fol. 244v; Van Mander 1994-99, 1:236-7.

2. Van Mander 1604, fol. 244v; Van Mander 1994-99, 1:236-7.

3. Van Mander 1604, fol. 245v; Van Mander 1994-99, 1:241.

4. Around 1590 the panel was transferred to the Prinsenhof; around 1800, it moved to the town hall; and in 1862 it came to the Frans Hals Museum. For the provenance, see Kohler 2006, 497.

5. For a comprehensive list of member professions, see Willigen 1870, 1-2.

6. On the early development of the Guild of Saint Luke in Haarlem, see Goosens 2001 (especially 15-38); Miedema 1980 and 1985; and Prak 2003.

7. The actual number of immigrant artists was not especially large; Goosens estimates that of the nineteen painters associated with Haarlem in 1600, "twelve were of Dutch descent. The other seven came from elsewhere," presumably the southern Netherlands (Goosens 2001, 402).

8. Vermeylen and De Clippel 2012, 142.

9. Document A 14, February 22, 1590, Charter of the Saint Lucas Guild, in Miedema 1980, 57-58, art. j. Women were allowed to join the guild, and some did, as we will see.

10. Document A 14, February 22, 1590, Charter of the Saint Lucas Guild, in Miedema 1980, 58, art. ij.

11. Document A 14, February 22, 1590, Charter of the Saint Lucas Guild, in Miedema 1980, 58-59, art. v. See also Goosens 2001, 74.

12. Document A 14, February 22, 1590, Charter of the Saint Lucas Guild, in Miedema 1980, 58, art. iiij.

13. The only documentary evidence for this date is in the notebook initially compiled by the painter Vincent Laurensz van de Vinne in 1677, transcribed and annotated by his son Isaak van de Vinne in 1702, *Schilders by't St. Lucas Gild ingeschreven*, now in the archive of the Guild of Saint Luke, Haarlem (Noord-Hollands Archief), items 217 and 218. Hals is listed on ms. p. 23. My thanks to Robert van Vuuren of the Noord-Hollands Archief for his assistance in gaining access to these notebooks.

14. Bijlage (Appendix) 2a in Goosens 2001, 443.

15. Goosens 2001, 85–86.

16. Goltzius was a printmaker who took up painting only as of 1600, so his influence on Hals as a painter was probably minimal. My thanks to Larry Silver for making this point.

17. See Israel 1995, 559–60.

18. It was Amsterdam that first developed the civic guard group portrait; the genre did not appear elsewhere until after the outbreak of the Dutch Revolt (Ekkart 2007, 19–20).

19. Ekkart 2007, 22.

20. Taylor 2016, 522. Some personal collections of paintings were remarkably large, especially in the second half of the century. As Fock (2021) has shown, a select sampling of household inventories in Leiden show an average of 110 paintings, with a couple of households owning more than two hundred works; one brewer, for example, owned 237 paintings.

21. Montias (1982, 269–70), however, has shown that the notion that in the early modern Dutch Republic even peasants were buying art on a significant scale is not tenable.

22. Paul Taylor tells me that the most expensive painting he has found in the early decades of the seventeenth century is a flower piece by Ambrosius Bosschaert, which sold for 1,000 guilders.

23. Ekkart (2007, 57) estimates the approximate prices of portraits as follows: a life-sized bust portrait, 36 to 40 guilders; a life-sized half-length, 60 guilders; a life-sized three-quarter-length ("knee length"), 80 guilders; a life-sized full-length, 100 to 150 guilders.

24. Biesboer 2001, 31.

25. Ekkart claims that for "ordinary workers, shopkeepers and farmers and the sizable urban proletariat . . . the costs [of a portrait] were prohibitive" (Ekkart 2007, 52).

26. Chong 1987, 116; North 1997, 99.

27. Parival 1669, 475.

28. Parival 1669, 21.

29. Adams 2009, 1. For a survey of the paintings in Frederik's and Amalia's respective quarters in the Oude Hof, Paleis Noordeinde, the stadholder's official residence, ca. 1632, see Treanor 2012, 38–45.

30. Jardine 2008, 129–32.

31. On Rembrandt's brief relationship with the House of Orange, see Schwartz 1985, 86–90.

32. For an overview of patronage in Dutch art, see Bok and Schwartz 1991.

33. Van der Woude 1991, 315.

34. Montias 1991, 341–42. In 1620, the population of Haarlem was around forty thousand, while the population of Amsterdam was over one hundred thousand.

35. Van Mander 1604, fol. 281r; Van Mander 1994–99, 1:382. He does qualify this harsh assessment in the next sentence: "This word side-road or byway might leave me open to blame and appear too hard to some people, and must therefore be given a soft polishing with a sable-brush or a feather. Therefore I say that one can also make something worthwhile from a portrait: that a face, after all the most important part of the human body, contains quite enough so as to be able to disclose and reveal the quality and efficacy of art, as many masters whom we have already discussed have also done."

36. Van Hoogstraten 1678, 87.

37. The number of paintings attributed to Hals by scholars varies between around 100 (Trivas 1941) and over 300 (Valentiner 1935). Other estimates include 270 (Hofstede de Groot 1910), 299 (Bode and Binder 1914), 145 (Grimm 1990), and 220 (Slive 2014, who estimates another 20 have been lost). Part of the problem is that Hals only rarely signed his paintings.

38. Pieter Biesboer has suggested to me that this may be because at the time of the wedding Anneke was pregnant. The banns for Hals's later marriage to Lysbeth Reyniersdr are in the church registry of marriages, even though at the time Hals was not (yet) a member.

39. My thanks to Henk van Nierop for his help on this matter.

40. On Anna Harmensdr, see Dólleman 1973.

41. Van Thiel-Stroman 1989, 374–75, doc. 8.

42. Van Thiel-Stroman 1989, 376, doc. 12.

43. According to the manuscript of *Schilders by 't St. Lucas Gild ingeschreven* (see note 13 above).

44. Slive (1989, 31) says that "it is no longer possible to take a categorical stand about the attribution. Nevertheless, there is good reason to believe that Hals, not [Willem Pietersz] Buytewech [a contemporary painter of "merry companies"], painted the work around 1610." This was also Slive's opinion in the earlier catalog, where he insists that that "there is excellent reason" to ascribe the work to Hals and date it around 1610 (1974, 3:114–15). Atkins (2012), among others, rejects the attribution. The RKD (Netherlands Institute for Art History) lists its status as "*verbrand* [burned]."

45. See Slive 1974, 3:120.

46. Circa 1611, oil on panel, 54.5 × 41.5 cm, Frans Hals Museum, Haarlem. Slive (1989, 130; 2014, 26) insists that the extant portrait is "probably" by Hals, "his own partial copy of his three-quarter length [original]"; Biesboer agrees that it is "an original portrait for which Zaffius posed anew" (2008a, 90). Van Thiel (1993), on the other hand, argues the case for an anonymous copyist.

47. There is a pair of portraits—"pendants," meaning they go together, in this case because they depict a married couple—that some scholars also date to 1611 (e.g., Slive 1989, cats. 2 and 3 [133–37]). Other scholars argue they are later; Grimm (1990), for example, puts them around 1617–18. Van Thiel (1993) "endorses" Slive's earlier dating, but admits that it cannot be established conclusively.

48. This is the suggestion by Biesboer (1989, 26).
49. Frans Pietersz de Grebber, portrait of Job Claesz Gijblant, 1611, oil on wood panel, Frans Hals Museum, Haarlem.
50. Bredius 1921.
51. Slive 2014, 17.
52. On the dating of Rubens's trip to the Netherlands, see De Smet 1977.
53. Monballieu 1965, 196.
54. On Rubens's voyage to, and ongoing relationship with, Haarlem, see Stechow 1927; De Smet 1977; and Vermeylen and De Clippel 2012.
55. Letter CXXX, October 4, 1611, in Rooses and Ruelens 1898, 2:43–44.
56. White 1987, 129.
57. Van Thiel-Stroman 1989, 376, doc. 14.
58. Van Thiel-Stroman 1989, 376–77, doc. 15.

CHAPTER FOUR

1. Nederlands Scheepvaartmuseum, Amsterdam, inv./cat. no. A 0002.
2. The Amsterdam civic guards, on the other hand, were divided into twenty companies, one for each district of the city.
3. Cited at Slive 2014, 34. On the organization of Haarlem's civic guards, see Levy-Van Halm and Abraham 1989, 94.
4. Cornelis Cornelisz van Haarlem, *Banquet of Members of the Haarlem Kalivermen Civic Guard*, 1583, oil on wood panel, Frans Hals Museum, Haarlem.
5. Köhler 2006, 130.
6. Slive 2014, 36.
7. Van Mander 1604, fol. 300r; Van Mander 1994–99, 1:458.
8. Frans Pietersz de Grebber, *Banquet of a Platoon of the St. George Civic Guard*, 1600, oil on canvas, Frans Hals Museum, Haarlem.
9. 1616, oil on canvas, 175 × 324 cm, Frans Hals Museum, Haarlem.
10. See the dated lists in *Namen van de Regeerende Heeren Burgermeesteren, Schepenen, ende Thesauriers, Geweest binnen Haerlem*.
11. See Biesboer 1989, 26.
12. Levy-Van Halm and Abraham 1989, 95.
13. Van Thiel-Stroman 1989, 375–76, doc. 11.
14. As we have seen, it is not his first portrait. Among known works before this first group portrait, and aside from the portrait of Zaffius and those other single portraits of anonymous sitters from around 1611, there is also the lost portrait of Johannes Bogaert, which must have been done before 1614 (when Bogardus died). It is now known only through an engraved print by Jan van de Velde II.
15. Liedtke 2011, 20.
16. Huvenne 2013.
17. It is unclear whether Soutman actually did reside in Poland for four years, as some accounts claim, or merely made several visits there. According to Van Thiel-Stroman, this portrait was made while Soutman was still in Antwerp, during the Polish king's visit there (Köhler 2006, 305).
18. Schrevelius 1648, 383–84.
19. See De Smet 1977.

20. On Pieter de Grebber, see Dirkse 1978.

21. Peter Paul Rubens, *Elevation of the Cross*, 1611, oil on wood panel, Onze Lieve Vrouwekathedraal, Antwerp.

22. Twenty-Fifth Session of the Council of Trent, December 3–4, 1563, "On the Invocation, Veneration and Relics, of Saints, and on Sacred Images." For a study that finds Rubens's work for the church perfectly in keeping with Counter-Reformation orthodoxy, see Sauerländer 2014.

23. A French translation of Sperling's text is in Rooses and Ruelens 1898, 2:156.

24. Keith (1999) argues that the copy of Rubens's *Drunken Silenus* now in the National Gallery, London, is by Van Dyck.

25. There is debate over whether Van Dyck, between apprenticing with Van Balen and working with Rubens, had set up his own workshop; see the discussion in Roland 1984.

26. "Il meglior mio discepolo" (Rooses and Ruelens 1898, 2:137).

27. Anthony van Dyck, *Head of an Old Man* (study), ca. 1616–17, oil on paper, Musée du Louvre, Paris.

28. For discussion of the influence that Rubens, Jordaens, and Van Dyck may have had on Hals, see Slive 1970–74, 1:10; Liedtke 2011, 23–24 (who gives more credit to Jordaens than to Rubens or Van Dyck); and Atkins 2012, 138–47.

29. Jacob Jordaens, *Meleager and Atalanta*, 1618, oil on canvas, Museo del Prado, Madrid, Spain.

30. See Liedtke 2011, 23.

31. Van Hoogstraten 1678, 233. "Beter is 't zachticheyt met een vol pinseel te zoeken, en, gelijk het Jordaens plach te noemen, lustich toe te zabberen."

32. For a thematic study of *kunstkamer* paintings, see Schwartz 1996.

33. Scholars disagree as to whether Hals had developed his "rough" style of brushwork before the trip to Antwerp. Atkins, for example, taking issue with Slive's view that the style already appears in the 1611 portrait of Zaffius, notes that "roughly treated passages first appear in Hals's early portrait of Pieter Cornelisz. van der Morsch from 1616," but then insists that "the rough manner that we associate with Hals blossomed in the master's genre paintings from the 1620s and 1630s" (Atkins 2003, 301).

34. Van Roey 1972, 159–60.

35. On Hals's family relations still in Antwerp, see Van Roey 1972, 162–63.

36. This is the explanation proposed by Van Roey 1972, 163.

37. On the Rembrandt-Rubens relationship, see Schama 1999.

38. "Een opening voor 't kint van Frans Hals," Van Thiel-Stroman 1989, 377, doc. 18.

39. For the documents related to this case, see Van Thiel-Stroman 1989, 377–78, docs. 19–22.

40. Since the magistrates had so far accepted only Neeltje's claim of thirty guilders, it is unclear why they collected the full thirty-seven guilders and four stuivers; perhaps the additional money was to be kept in escrow until she provided the requested "proof."

41. For the document on this case, see Van Thiel-Stroman 1989, 377, doc. 17.

42. For a more cynical account of Carleton as "connoisseur," see Hill and Bracken 2014.

43. Carleton's letter of October 4–14, 1616, to Chamberlain is in Sainsbury 1859, 12–13.
44. A *Banquet in a Park* from ca. 1610, destroyed in Berlin during World War II, has been attributed to Hals, but its authorship is disputed; see Slive 2014, 31.
45. Circa 1616–17, oil on canvas, 131.4 × 99.7 cm, the Metropolitan Museum of Art, New York.
46. One art historian has labeled it Hals's "signature style" (Atkins 2012).
47. The dating of the *Shrovetide Revellers* has been put variously at "about 1615–16" (Atkins 2012, 28) and "1616–17" (Slive 2014, 31), with Liedtke (2011, 17) suggesting, on stylistic grounds, that it dates to after the Antwerp trip.
48. 1616, oil on canvas, transferred from wood panel, 87.5 × 69.2 cm, the Carnegie Museum of Art, Pittsburgh.
49. The decisive study of this portrait, and especially its symbolism, is Van Thiel 1961. See also Slive 1989, 138–40.
50. Van Thiel 1961, 158.
51. Goldgar 2007, 272.
52. Van Thiel 1961, 159.
53. Van Thiel-Stroman 1989, 377, doc. 16.

CHAPTER FIVE

1. Pieter Wils, map of Haarlem, 1646, Collection Het Scheepvaartmuseum, Amsterdam.
2. Unlike Hals's first marriage, the banns this time were registered in the Dutch Reformed Church; see Van Thiel-Stroman 1989, 378, doc. 23.
3. Van Thiel-Stroman 1989, 378, doc. 23.
4. 1617, oil on copper, 15.5 × 12 cm (oval), Frans Hals Museum, Haarlem.
5. Studies of the Schrevelius portrait are in Slive 1989, 141–43, and Bijl 2005. Schrevelius had the small painting made into an engraved print by Jacob Matham in 1618.
6. Van Thiel-Stroman 1989, 383, doc. 42.
7. The Latin edition was published in 1647, the Dutch in 1648.
8. Schrevelius 1648, 421.
9. Schrevelius 1648, 442.
10. Schrevelius 1648, 444.
11. Now in the Museum Willet-Holthuysen, Amsterdam, on loan from the Stedelijk Museum Alkmaar.
12. This is on the assumption that the extant panel portrait of Zaffius is not by Hals's hand but a copy.
13. See Kolakowski 1987, chap. 2.
14. Israel 1995, 430–31.
15. A leading Remonstrant polemicist, Johannes Wtenbogaert, claimed that the Counter-Remonstrants wanted, like the pope, to place the church in charge of secular society.
16. For a good discussion of the Remonstrant crisis, see Geyl 1971, 1:38–63. Schwartz (1985) demonstrates the importance of this crisis, and especially of Amsterdam's evolution into a pro-Remonstrant town, for understanding the career of Rembrandt; see also Dudok van Heel 2006.

17. In his account of Haarlem in this period, Schrevelius notes that "some unrest grew between Church personnel and especially members of the community. There was no real difference over articles of faith, and there was an understanding in the purity of doctrine; but there was some difficulty over the calling of Church ministers and the selection of elders" (Schrevelius 1648, 185 [Derde Boeck]).
18. Schrevelius 1648, 191–92.
19. Spaans 1989, 220–23.
20. The text of Maurits's speech to the Haarlem leadership is in Schrevelius 1648, 192–93. The list of newly installed members of the *vroedschap* is on 193–94.
21. Schrevelius 1648, 195.
22. The stadholder expanded the number of seats on the *vroedschap* to 32 from 24. For these social aspects of Haarlem politics, see Biesboer 1989, especially 23.
23. These are recorded in the *Namen Van de Regeerende Heeren Burgermeesteren, Schepenen, ende Thesauriers, Geweest binnen Haerlem* of 1665, which lists the officeholders between the years 1430 and 1665.
24. Both 1631, oil on wood panel, Frans Hals Museum, Haarlem.
25. Liedtke 2012, 34–35.
26. Slive 2014, 64.
27. See also Van Thiel-Stroman 1989, 379, doc. 28.
28. Ampzing 1628, 371; Van Thiel-Stroman 1989, 382, doc. 41.
29. Both ca. 1620, oil on canvas, Musée du Louvre, Paris.
30. Grimm disputes the attribution of Catharina's portrait to Hals (Grimm 1990, 101).
31. Circa 1620, oil on canvas, 91.8 × 68.3 cm, Gemäldegalerie, Staatliche Museen, Berlin. For the identification of the child, see Dudok van Heel 1975.
32. This is the claim of Dudok van Heel (2006, 337).
33. Circa 1620, oil on canvas, now divided into three or four pieces. The larger extant canvas (151 × 163.6 cm) showing the parents and seven children is in the Toledo Museum of Art. The pieces identified as two smaller fragments depict (a) the three children, half of another child, and the goat cart (152 × 107.5 cm, Musée Royaux des Beaux-Arts de Belgique, Brussels); and, scholars generally agree, (b) another son (54 × 47.4 cm, private collection). A reconstruction suggested by Liesbeth de Belie includes, tentatively, a fourth, lost fragment showing another adolescent and a small child; see De Belie 2018. For an identification of the family portrayed, see Biesboer 2013 and 2018. Slive (1969; 1989, 160) claimed that there was only a painting showing ten children, but that sometime before the early nineteenth century it was cut up, with the large main section showing two parents and seven children and the three children and goat cart on the right divided from the rest and sold at auction as a separate work; he maintains that view in Slive 2014, 70–71. Grimm (1972, 1990) was the first to argue that the painting was in fact divided into three, with the third part depicting another three children. For a discussion of the variety of opinion on the fate of the original canvas, see De Belie 2018.
34. De Bray's signature and the date are painted on the girl's left foot.

35. I owe this suggestion to Arthur Wheelock.

36. Gerrit van Honthorst, *The Merry Fiddler*, 1623, oil on canvas, Rijksmuseum, Amsterdam.

37. Circa 1618–22, oil on canvas, 106 × 80.3 cm, Kimbell Art Museum, Fort Worth, Texas, ACF 1951.01.

38. Circa 1625, oil on wood panel, 30.4 cm diameter, Mauritshuis, The Hague.

39. Circa 1627, oil on wood panel, 46.7 × 35.5 cm, National Galleries of Scotland, Edinburgh.

40. On the significance of the jawbone and an interpretation of the *Verdonck* painting, see Van Thiel 1980. The identity of the subject as "Verdonck," rather than being just an anonymous tronie, is based on Jan van de Velde II's engraving after the painting made around the same time. For a discussion of the blending of portraiture with elements from genre painting in Hals (and Jan Steen), see Westermann 1995.

41. 1623, oil on canvas, 105.4 × 79.4 cm, Metropolitan Museum of Art, New York.

42. Circa 1623–25, oil on wood panel, 46.7 × 49.5 cm (octagonal), Metropolitan Museum of Art, New York.

43. Circa 1628–30, oil on wood panel, 58 × 52 cm, Musée du Louvre, Paris. On this painting's alleged commercial purpose, see Adams 2009, 4.

44. For a moralistic reading of *Joncker Ramp*, see Haeger 1986.

45. Circa 1626–28, oil on canvas, 92.2 × 80.8 cm, the National Gallery, London.

46. Shakespeare's play, written around 1600, likely saw its first production a few years after that. The first complete Dutch translation of his plays was published in the late eighteenth century. I have not been able to find any evidence that there was a Dutch translation of Hamlet near the time of this painting.

47. 1630, oil on canvas, 157 × 200 cm, Collection of Viscount Boyne, Bridgnorth, Shropshire.

48. Circa 1626–30, oil on wood panel, 18.2 × 18.4 cm (diamond-shaped), the Ivor Collection, Mr. and Mrs. Thomas A. Saunders II, New York.

49. Circa 1630–32, oil on canvas, 74 × 61 cm, Koninklijk Museum voor Schone Kunsten, Antwerp.

50. Grimm (1971 and 1990) has denied Hals's authorship of a large number of these genre paintings, including the "fisher children"—attributing them to a "Halsian" follower—but his conclusions are rejected by most scholars. For a moralizing "emblematic" reading of the fisher children paintings, see Koslow 1975.

51. All ca. 1625, oil on canvas. Saint Luke (70 × 52.2 cm) and Saint Matthew (70 × 55 cm): Museum of Western and Oriental Art, Odessa; Saint Mark (68 × 52 cm), private collection; Saint John (70.5 × 55 cm), J. Paul Getty Museum, Los Angeles. Hofstede de Groot (1910, 9, items 4–7) mentions all four paintings in his catalog, but apparently without having seen them. The discovery of the Saint Luke and Saint Matthew was made by the Russian scholar Irina Linnik; the Saint Mark was identified by Grimm (1974); Saint John was not identified until 1997; see Slive 1989, 193–97 (writing before the discovery of the Saint John).

52. Some of Hals's paintings have been connected, rather speculatively, with biblical themes. For example, the *Joncker Ramp* painting has been alleged to

be a depiction of the "prodigal son" from Luke 15:11–32; see, for example, Valentiner 1923, 307. Haeger (1986), however, argues convincingly against that identification.

53. Atkins 2012.

54. Circa 1628–30, oil on canvas, 75 × 61.5 cm, Museumslandschaft Hessen Kassel, Gemäldegalerie Alte Meister.

55. Circa 1626–28, oil on wood panel, 38 cm diameter (circular), Staatliches Museum, Schwerin.

56. Early 1620s, oil on canvas, 70 × 62 cm, Musée du Louvre, Paris.

57. Van Mander 1973, 258/fol. 48r.

58. Slive 1989, 17–18.

59. The tale of Apelles vs. Protogenes is told in Pliny the Elder, *Natural History*, 35:81–83; the tale of Zeuxis vs. Parrhasius is at 35:65.

60. Van Gelder 1959.

61. Quoted in Jowell 1989, 65.

62. Van Mander 1973, 261/fol. 48v.

63. Van Mander 1973, 261/fol. 48v.

64. According to Groen and Hendriks (1989, 109), "roughly three-quarters of [Hals's] surviving attributed works are on canvas and the rest on wood panel."

65. See Slive 2014, 29–30.

66. On Hals's working method, see Bijl 1989 and 2006, and Groen and Hendriks 1989.

67. According to Houbraken (1976, 1:92); translation in Slive 1989, 17. There is a nice summary of Hals's working method in Liedtke 2011. See also the technical analysis in Groen and Hendriks 1989.

68. De Bie 1662, 281–82; see Van Thiel-Stroman 1989, 409, doc. 163.

69. De Bie, living and working in Antwerp, may never actually have seen a Hals painting in person and might only be repeating what he has heard from others. His treatment of Hals is relatively short—just four lines.

70. Houbraken 1976, 1:90–92; translation in Slive 1989, 17 (I have modified his translation of "Frans die buitekans voort op de lippen nam").

71. Houbraken 1976, 1:93; translation in Slive 1989, 18.

72. The text of Scheits's remark, which he wrote sometime between 1662 and 1679 (in a Dutch/German mash-up), is in Bode 1871, 64: "hei is in sein Jeiigt wat lüstich van leven geweest."

73. That Wouwerman trained with Hals is reported by De Bie in his *Het Gulden Cabinet der Edel Vry Schilderconst* (De Bie 1662, 281–82); it is, however, disputed by scholars.

74. Slive 2014, 17. See also Broos 1977.

CHAPTER SIX

1. In a letter to Brasset, April 23, 1649 (Descartes 1974–83, 5:349).

2. Israel 1995, 478.

3. March 3, 1625; Grotius 1928–2001, 17:247 (accessible online: http://grotius.huygens.knaw.nl/letters/0951).

4. On the correlations between the art market and the economic situation, see Bok 1994; Montias 1987; Israel 1997; and Atkins 2012, 118–27.

5. Russell 1983, 187–89; Israel 1997, 453.

6. Israel 1997, 455.

7. Pieter Pietersz de Molijn, *Peasants Returning Home*, 1647, oil on canvas, Frans Hals Museum, Haarlem.

8. According to Paul Taylor's analysis based on Thieme and Becker, there were around 750 painters active in the United Provinces in the 1610s; in the 1620s, this had increased to almost 1,000. Another 200 will be added in the 1630s, and by the 1660s there will be nearly 1,600. See Taylor n.d.; Thieme and Becker 1907–50)

9. Van Thiel-Stroman 1989, 379–80, doc. 29. Portraits of Massa by Hals are in the Rijksmuseum, Amsterdam; the Art Gallery of Ontario, Toronto; the San Diego Museum of Art; and Chatsworth House (if the Hals portrait there is indeed of Massa).

10. Documents related to these births (and deaths) are in Van Thiel-Stroman 1989, 379–83, docs. 29, 30, 31, 38, 43.

11. For a discussion of seventeenth-century Dutch domestic interiors, see Loughman and Montias 2000, 22–27.

12. Estate inventories of the period indicate that family portraits were hung in this front hallway; see Dudok van Heel 2017.

13. Parival 1669, 25.

14. Van Thiel-Stroman 1989, 387, doc. 65.

15. They also involved lower cost in production, with canvases and wood panels of lesser quality; see Atkins 2012, 118–27.

16. For these cases, see Van Thiel-Stroman 1989, 380–81, docs. 32 and 34–36. Van Thiel-Stroman notes that it is not certain that the "Frans Hals" and the "huysvrou van Frans Hals" cited in these documents is Frans Hals the painter and his wife, Lysbeth. However, it does seem to be likely, given that, both in these cases and in the other debt cases in which Frans Hals the painter *is* certainly involved, he is not identified in any additional manner (e.g., "van Antwerp").

17. Van Thiel-Stroman 1989, 382, docs. 39–40. Here, too, Van Thiel-Stroman claims that "the relevance of this court record is doubtful, for there is no evidence that it relates to Frans Hals the painter" (but see note 16 above).

18. Van Thiel-Stroman 1989, 383–84, docs. 44 and 48 (again, with Van Thiel-Stroman's reservations about relevance).

19. Van Thiel-Stroman 1989, 384, docs. 49–50 (again, with Van Thiel-Stroman's reservations about relevance).

20. Van Thiel-Stroman 1989, 385, docs. 55–56.

21. Van Thiel-Stroman 1989, 384, doc. 47.

22. Dirck Hals, *Fête Champêtre*, 1627, oil on panel, the Rijksmuseum, Amsterdam. The Frans Hals Museum in Haarlem recently acquired a superb example of Dirck Hals's work: the large (92.5 × 157 cm) painting *Festive Company in a Renaissance Room* (1628), one of at least five collaborations with Dirck van Delen, who painted the architectural setting in it.

23. Schama 1988.

24. Ampzing 1628, 371; Van Thiel-Stroman 1989, 382, doc. 41.

25. Houbraken 1976, 1:92.

26. See Fock 2021.

27. According to Goosens (2001, 285), the mean appraised price of a history painting by Cornelis Cornelisz van Haarlem in inventory sales until ca. 1660 was "something more than 70 guilders," which is quite high as an average; after 1660, however, this was almost halved. What Cornelis charged for the original commission is unknown. Large history canvases could cost several hundred guilders, and sometimes well over a thousand guilders; so could flower paintings. Portraits of individuals or couples, on the other hand, tended to range between less than ten guilders (for a cheaper work of lower quality) and up to fifty guilders or more; the Delft painter Michiel Jansz van Miereveld seems to have charged between eighteen guilders and sixty guilders, depending on size and format, full-length vs. half-length (Montias 1982, 193). Group portraits, naturally, cost quite a bit more. For his 1633 group portrait of the Amsterdam civic guard company, which included sixteen individuals, Hals initially charged sixty guilders per head.

28. 1624, oil on canvas, 83 × 67.3 cm, the Wallace Collection, London.

29. This is the identification made by Biesboer (2012).

30. Biesboer notes how Hals reserves this particular "flamboyant and loose" mode of presentation for wealthy Haarlem merchants of Flemish background (2012, 135).

31. 1634, oil on canvas, 117 × 87 cm, the Cleveland Museum of Art, Ohio.

32. According to the provenance listed by the RKD, the painting of Catharina is in the collection Andrzej graaf Mniszech, in Paris.

33. Both ca. 1625, oil on canvas (Jacob, 124.8 × 97.5 cm; Aletta, 123.8 × 98.3 cm), Mauritshuis, The Hague.

34. Circa 1625, oil on canvas, 204.5 × 134.5 cm, Bayerische Staatsgemäldesammlungen, Alte Pinakothek, Munich.

35. I use the term "influence" here with full acknowledgment of Michael Baxandall's lament about the inadequacy of the term to describe the nature of artistic agency; see Baxandall 1985, 58–59.

36. Ekkart and Buvelot 2007, 114n3; Biesboer 2012, 135 and n19.

37. The suggestion is from Slive 1989, 178. On the two portraits of Van Heythuysen, see also Steingräber 1970; Boot 1973; and Biesboer 1995b.

38. Circa 1638, oil on wood panel, 47 × 36.7 cm, Musées Royaux des Beaux-Arts, Brussels, Belgium.

39. My thanks to Pieter Biesboer for this analysis of the color.

40. Biesboer 1989, 29.

41. In Roosterman's case (assuming that he is the subject of *The Laughing Cavalier*), there is good reason for the second portrait: to celebrate his marriage to Brugmans.

42. The identification of the couple as Massa and Van der Laen, established by De Jongh and Vinken (1961), was questioned in the literature; see the discussion in Slive 1989, 162–65. While Slive later says he still does "not find [the identification] fully convincing" and that it remains "debatable" (2014, 72), it is now fairly widely accepted; see, for example, Ekkart 2007, 106. The Rijksmuseum, which owns the painting, labels the Massa/Van der Laen identification "probable." See also Smith 1986, who relates the double portrait to Rubens's 1609 portrait of himself and Isabella Brant.

43. Early 1620s, oil on canvas, 140 × 166.5 cm, Rijksmuseum, Amsterdam.

44. Circa 1626, oil on canvas, 79.7 × 65 cm, Art Gallery of Ontario, Toronto.
45. Slive suggests that the landscape was in fact painted by the specialist Pieter de Molijn (1989, 192), with whom Hals collaborated on other works.
46. Both 1626, oil on wood panel, 22.2 × 16.5 cm, Metropolitan Museum of Art, New York.
47. Quoted in Levine 2012, 200.
48. Van Thiel-Stroman 1989, 409, doc. 166. On the Scriverius portraits, see Wolleswinkel 1977.
49. Circa 1635, oil on wood panel, 21.3 × 19.7 cm, the San Diego Museum of Art.
50. Circa 1630, oil on copper, 16.2 × 12.3 cm, the Leiden Collection, New York.
51. This is the thesis of Atkins 2012.
52. The distinction is that between a *kind* of thing and an individual *instance* of that kind. "Human being" is a type; Frans Hals is a token of that type.
53. Huygens 1987, 87; translation in Schwartz 1985, 75–76.
54. On "idealizing" vs. "naturalistic" (warts and all) portraits, see Adams 2009, 59–78.
55. Obviously these remarks cannot apply to portraiture in the "modern" era. What later artists—Manet, Renoir, Berthe Morisot, Cézanne, Picasso, Francis Bacon, Andy Warhol, Alice Neel, David Hockney, Chuck Close, etc.—do in portraits is a different matter altogether: different from their early modern forerunners and from each other.
56. Both 1631, oil on wood panel (Nicolaes: 128 × 100.5 cm; Cornelia: 126.5 × 101 cm), Frans Hals Museum, Haarlem.
57. See Tummers 2013, 108.
58. Oil on canvas, 75 × 64 cm, Gemäldegalerie, Staatliche Museen, Berlin. Slive (1989, 236) dates it to ca. 1633–35; Grimm (1990, 231) puts it around 1640.
59. Van Thiel-Stroman 1989, 395, doc. 94.
60. The documents concerning this case are in Van Thiel-Stroman 1989, 380–81, docs. 33a and 33b. See also Van Hees 1959.
61. Van Thiel-Stroman 1989, 381, doc. 33b.
62. Bredius 1923–24a, 19–20.
63. Bredius 1923–24a, 20.
64. Pieter Biesboer has suggested to me that Joost may have been making designs and cartoons for a tapestry workshop that Van Mander II had taken over.
65. Plate 11: *Banquet of the Officers of the St. Hadrian Civic Guard*, 1627, oil on canvas, 183 × 266.5 cm, Frans Hals Museum, Haarlem; plate 12: *Banquet of the Officers of the St. George Civic Guard*, 1627, oil on canvas, 179 × 257.5 cm, Frans Hals Museum, Haarlem.
66. Circa 1625–28, oil on canvas, 46.75 × 37.5 cm, Taft Museum of Art, Cincinnati. Slive had originally claimed that Hals was not the author of the De Wael portrait, done around 1625; but he was later convinced by the arguments of De Winkel 2012 (Slive 2014, 73).
67. "Seer stout naer 'tleven gehandeld" (Ampzing 1628, 371).
68. 1627, oil on wood panel, 19.4 × 17.2 cm, Gemäldegalerie, Staatliche Museen, Berlin.
69. Circa 1626, oil on canvas, 87 × 79 cm, private collection.

70. Pieter: 1629/30, oil on panel, 66.2 × 56.2 cm, private collection; Maritge: 1629/30, oil on panel, whereabouts unknown.

71. The dating of these portraits is disputed among art historians. For the portrait of Pieter Olycan, Biesboer argues, based in part on dendrochronological research on the panel, for ca. 1629/30 (Biesboer 2006, 9), as does Atkins (2012, 186), while Tummers dates it to 1635 (2013, 138); Slive (1974, 3:69) dates them both to after 1639 (see below). The questions about the pendant showing Maritge, which was separated from Pieter's portrait at auction in 1967 and whose location is presently unknown, are more complicated. Scholars disagree as to (a) whether it is an original Hals or a copy made by another artist from the later (1639), three-quarter-length portrait of her now in the Rijksmuseum; and (b) if it is an original Hals, when it was painted. Biesboer (2006) regards it as a Hals original, but is uncertain as to when it was done, in part because, without access to the panel, technical examination is not possible. Slive (1974, 3:69) originally regarded both paintings, of Pieter and Maritge, as copies of the later pendants, and did not change his opinion in Slive 2014.

72. Biesboer suggests that the black fur-lined cloak was added as an overpainting during the painting process after Pieter became burgomaster in 1630, on the premise that such a garment was a burgomaster's "customary" attire (2012, 9). Tummers, however, disputes this point (2013, 138).

73. The notarial document dates from February 23, 1654; transcribed in Strauss et al. 1979, 1654/4, accessible online at http://remdoc.huygens.knaw.nl/#/document/remdoc/e1661. D'Andrade's name in the original written document appears as "D'Andrada."

74. Van Thiel-Stroman 1989, 383, doc. 45. The document actually has the payment in pounds, but a pound was equivalent to a guilder at the time. What Hals was asked to do with this painting (*veranderen*) is exactly what Rembrandt was asked by d'Andrade to do to the portrait of his daughter.

75. Van Thiel-Stroman 1989, 383, doc. 46.

76. Israel 1995, 506–10.

77. Letter to Pierre Dupuy, October 21, 1627, in Rubens 1991, 209.

78. Letter to Pierre Dupuy, May 6, 1627, in Rubens 1991, 179.

79. Letter to Balthasar Gerbier, May 19, 1627, in Rubens 1991, 181–82; Van Gelder 1950–51, 134–35.

80. On a later trip to the north, in 1631, Rubens did show up at the stadholder's court in The Hague, but unannounced; for political/diplomatic reasons, and despite his admiration for Rubens, Frederik Hendrik could not entertain such a spontaneous, unofficial Flemish visit and the meeting was cut short.

81. Sandrart 1675, 2:291 (book 3, chap. 16). It is actually unclear whether Rubens traveled back to Amsterdam after the Utrecht visit, as Sandrart claims; see Swillens 1945–46, 111.

82. Sandrart 1675, 2:291 (book 3, chap. 16). For a translation, see Wood 2019, 45. On Rubens's 1627 visit to the Republic, and especially his time in Utrecht, see Swillens 1945–46.

83. http://www.garyschwartzarthistorian.nl/wp-content/uploads/2018/04/TLC_26_Thema_G_Schwartz.pdf.

CHAPTER SEVEN

1. Biesboer 2002, 58.
2. The RKD database has him in Haarlem only from 1625 to 1626, but his activity, if not residency, in that city must have extended to just before 1631, when he returned to Antwerp.
3. Houbraken 1976, 1:347.
4. This is the painting in the National Gallery, Washington DC.
5. The phrase *tot lering en vermaak* comes from De Jongh (2000) and his interpretation of the symbolic and moralizing content of seventeenth-century Dutch genre painting.
6. Some of these names appear on a list of debtors to the previous owner of the tavern, Nicolaes Anthonisz, from 1613; Archiefdienst voor Kennemerland, 1617: Notariële protocollen en akten van notarissen te Haarlem, notary Egbert Lucasz van Bosvelt, #69, November 15, 1613, accessible online: https://noordhollandsarchief.nl/bronnen/archieven?mivast=236&mizig=210&miadt=236&micode=1617&milang=nl&miview=inv2#inv3t1.
7. See the source in note 6; and Biesboer 2001, 58-59.
8. Van Thiel-Stroman 1989, 384, doc. 52.
9. Biesboer 2001, 29.
10. A transcription of Den Abt's list of works to be auctioned is in Van Hees 1959, 38.
11. For a discussion of this, see Boers 1999, 202.
12. Goosens 2001, 408.
13. De Marchi and Van Miegroet 1994, 453.
14. For a detailed study of the art lottery in the Netherlands, and especially Haarlem, see Boers 1999, 203-8.
15. Boers 1999, 204 (the term she uses is "schemergebied van de regelgeving").
16. Boers notes that in 1623 a lottery in Haarlem organized by Jacob Jacobsz de Jongh was selling lots for eight guilders apiece, which she says was "not for every citizen" (Boers 1999, 204-5). However, in a lottery organized by Claes Claesz van Leeuwen in Utrecht in 1626, lots cost even more: a whopping twenty-five guilders (Atkins 2012, 123)!
17. Van Thiel-Stroman 1989, 387, doc. 65. A *ruyter* could also be an equestrian, but in this context it seems to have its slang meaning.
18. The text of their request is in Miedema 1980, 88-89. What is interesting is that one of the signers of this request, Frans Pietersz de Grebber, who was dean of the guild at the time, was an active organizer of lotteries, and will oppose a later guild attempt to ban lotteries, in 1642.
19. Article 3, in Miedema 1980, 96.
20. Article 3, in Miedema 1980, 96.
21. Article 1, in Miedema 1980, 94.
22. See the map from the charter in Miedema 1980, 94.
23. Articles 30-31, in Miedema 1980, 114.
24. Article 21, in Miedema 1980, 108. See also article 50 (Miedema 1980, 129-30).
25. According to Taverne (1972-73, 51), it was ratified in November 1634; according to Boers (1999, 74) it was never ratified.
26. Broos 1977.

27. At a certain point, the popularity of still lifes and genre scenes eclipsed that of works with a biblical theme among most collectors. Biesboer notes, from his study of the archives, including inventories, that "after 1625 the number of paintings with biblical subjects in the documents decreases, and still-life, landscape and genre paintings come to predominate" (2001, xiii).

28. Ekkart 2007, 22. For figures representing the demand for portraits in various cities and towns, see Adams 2009, 11–12.

29. Adams 2009, 12. Adams (referring to studies by Montias, Goosens, and Loughman) shows that the demand for portraits in Amsterdam, Haarlem, Leiden, Delft, and Dordrecht was relatively stable throughout the period, despite the economic ups and downs.

30. On seventeenth-century Dutch incomes, see De Vries and Van der Woude 1997, 563.

31. Montias 1982, 193; Adams 2009, 15. See the chart in Ekkart 2007, 57.

32. Van Gent 2011, 213–15 (nos. 53 and 54). Ordinarily, a pair of pendants would have cost between 120 and 160 guilders (Ekkart 2007, 57). By contrast, Jan van Goyen earned 650 guilders for the large landscape *View of the Hague (from the Southeast)*, painted for that city's magistrate in 1651. On the secondary market, based on estate sales and auctions, portraits generally cost on average significantly less than most other genres (see the chart in Chong 1987, 116).

33. Adams 2009, 15.

34. Van Gent 2011, 227–28 (no. 64).

35. Van Gent 2011, 261–62 (no. 88).

36. Ekkart 2007, 56.

37. Middelkoop (2019, 2:82–88) shows that prices for group portraits were considerably higher in Amsterdam.

38. Biesboer 2001, 27.

39. Israel 1995, 352–53.

40. See the figures in Montias 1990.

41. A period in Denmark is mentioned by Schrevelius (1648, 382).

42. Pieter Fransz de Grebber, portrait of Philippus Rovenius, 1631, oil on canvas, Museum Catharijneconvent, Utrecht.

43. Schrevelius 1648, 382.

44. The work was written in 1649.

45. A transcription of the treatise is in Van Thiel 1965.

46. On Johannes Verspronck, see Ekkart 1979.

47. Schrevelius 1648, 382.

48. The date of his birth or baptism is unknown.

49. Van Thiel-Stroman 1989, 392, docs. 80–81.

50. Van Thiel-Stroman 1989, 387, docs. 63 and 64.

51. Van Thiel-Stroman 1989, 386, doc. 60.

52. In May 1635; Van Thiel-Stroman 1989, 388, doc. 69.

53. Van Thiel-Stroman 1989, 389, doc. 73.

54. This is not a hard-and-fast rule, of course. Some Haarlem guard portraits (including ones by Hals) also include sergeants; and Pieter de Grebber painted several portraits of entire platoons. My thanks to Norbert Middelkoop for his help in clarifying this.

55. On Amsterdam *schuttersstukken*, see the essays in Middelkoop et al. 2013.

56. For a comparison of prices per figure between Amsterdam and Haarlem, see Middelkoop 2019, 1:84.

57. Van Thiel-Stroman 1989, 390, doc. 75.

58. On Spinoza's life and thought, see Nadler 2018b.

59. This, at least, is the view of Schwartz (1985, 142) and the members of the Rembrandt Research Project, who speak of a "pool of labour . . . in Uylenburgh's workshop" (Bruyn et al. 1982–89, 2:48). See also Lammertse and Van der Veen 2006, 136. Dudok van Heel, on the other hand, suggests a more limited range of artists and activity in the studio. There were, he argues, few "Uylenburgh employees"; rather, the dealer recruited artists (like Rembrandt) to do particular projects for him and his clients (Dudok van Heel 2020, 132, 142). It is unclear, however, whether Dudok van Heel means there were no other *portraitists* (besides Rembrandt) employed by Uylenburgh in his studio or no other painters at all.

60. Uylenburgh rented this house from 1626 to ca. 1638. For a biography of Uylenburgh, see Lammertse and Van der Veen 2006, 13–59.

61. Rembrandt Harmensz van Rijn, portrait of Amalia van Solms-Braunfels, 1632, oil on canvas, Musée Jacquemart-André, Paris.

62. On the portrait and other projects with which Rembrandt was occupied during his first years under Uylenburgh, see Lammertse and Van der Veen 2006, 126–60.

63. This narrative of the origin of the commission is suggested by Dudok van Heel (2017, 22–23).

64. Van Thiel-Stroman 1989, 389–90, doc. 74. The "Saskia" explanation for Hals's move from Uylenburgh's home is suggested by Dudok van Heel (2017, 23–24).

65. Dudok van Heel (2017) finds much grist for the mill in this studio sharing between Hals and Rembrandt, especially regarding Hals's possible influence on Rembrandt's portraiture style. On this, see also Atkins 2013.

66. Dudok van Heel 2017, 25–28.

67. See Grijzenhout 2015 and Dudok van Heel 2017. It is unclear, in fact, when exactly the Soop portraits were done and whether they were painted in Amsterdam or Haarlem; Dudok van Heel suggests the latter.

68. Circa 1633, oil on canvas, 71.2 × 61 cm, Kenwood House, the Iveagh Bequest, London.

69. The 1633 dating of the Van den Broecke portrait was established by Van Gelder 1938.

70. As Dudok van Heel suggests, in light of these Haarlem connections, the portrait of Van den Broecke might have been painted there rather than Amsterdam (2017, 28).

71. Van Thiel-Stroman 1989, 406, doc. 147.

72. Van Thiel-Stroman 1989, 387, doc. 66.

73. Gonnet (1877) says that Hals did end up with the Goltzius painting, which he identifies as *Tityus* (although he dates the auction to 1630), and then sold it to the Haarlem painter and dealer Nicolaes Suycker, who in turn sold it to the city of Haarlem. While the city did indeed purchase from Suycker a Golt-

zius work titled *Tityus* in 1630, Gonnet provides no documentary evidence that this is the painting that Hals bid on in Amsterdam in 1634.

74. 1633-37, oil on canvas, 209 × 429 cm, City of Amsterdam, on loan to the Rijksmuseum.

75. Van Thiel-Stroman 1989, 389, doc. 73.

76. The site of the house on Groot Heiligland now forms part of the annex buildings of the Frans Hals Museum.

77. Van Thiel-Stroman 1989, 389, doc. 74.

78. Van Thiel-Stroman 1989, 390, doc. 74.

79. "Frivole ende onwaerachtige," Van Thiel-Stroman 1989, 390, doc. 36.

80. Van Thiel-Stroman 1989, 390, doc. 75.

81. Van Thiel-Stroman 1989, 390, doc. 75.

82. Van Thiel-Stroman 1989, 390-91, doc. 78.

83. See Van Eeghen 1974. Middelkoop (2019, 3:799-800) indicates that the third man from the right is "possibly" Codde.

84. Van Thiel-Stroman 1989, 389, doc. 72. On these events, see Van Eeghen 1974, 140.

85. For discussion of Hals's and Codde's respective contributions to the painting, see Bijl 1989; Slive 1989, 252-57; and Ekkart and Buvelot 2007, 120-22. I am grateful to Erma Hermens of the Rijksmuseum for her consultation on this point.

86. Jansen et al. 2009, letter 534, to Theo van Gogh, Nuenen, ca. October 10, 1885, http://vangoghletters.org/vg/letters/let534/letter.html.

87. "Ze all zo dor en rank zyn, dat men ze met recht de magere Compagnie zoude kunnen noemen," quoted in Slive 1989, 252.

88. Bijl 1989, 105.

89. 1630, oil on canvas, 157 × 200 cm, Viscount Boyne, Bridgnorth, Shropshire.

90. On the collaboration with Buytewech, see Van Thiel-Stroman 1989, 407, doc. 153. On Buytewech and Hals, see Martin 1925; on these pendants, Van Hees 1959. The collaboration between Hals and De Molijn is suggested by Slive (1989, 192, 272, 318).

91. On Rubens and Brueghel's collaborative relationship, see Woollett and Van Suchtelen 2006. Rubens also collaborated with Frans Snyders.

92. Broos 1978-79, 120.

93. Middelkoop 2019, 1:82-84.

94. Both ca. 1635, oil on canvas (Lucas: 126.5 × 93 cm; Feyntje: 123 × 93 cm), City of Amsterdam, on loan to the Rijksmuseum.

95. Circa 1635, oil on canvas, 111.8 × 89.9 cm, Cincinnati Art Museum. On these paintings, see Slive 1989, 264-67 (De Clercq/Van Steenkiste), 270 (family).

96. Circa 1636-38, oil on canvas, 80.6 × 66 cm, Metropolitan Museum, New York. See Liedtke 2011, 7.

97. 1633, oil on canvas, 207 × 337 cm, Frans Hals Museum, Haarlem.

98. Hendrick Gerritsz Pot, *Officers and Sub-Alterns Leaving the Kalivermen's Head-quarters in Haarlem*, 1630, oil on canvas, Frans Hals Museum, Haarlem.

99. Norbert Middelkoop informs me that the attribution of this painting to Pot is disputed.

100. Pieter Biesboer has suggested to me another inconvenience for Hals: Uylen-

burgh may have sold his house and studio on the Sint Antoniesbreestraat, thereby depriving Hals of a regular place to work while in Amsterdam. The problem is that we do not know when, exactly, Uylenburgh made such a move. According to Lammertse and Van der Veen, it was "sometime between 1635 and 1638" that he sold the Breestraat house and moved to another one further up the street; however, on the basis of documents and circumstances they surmise that "the move may have taken place on 1 May 1638" (2006, 54), thus after Hals had abandoned the civic guard project.

101. Biesboer (2012, 133) and Middelkoop (2019) come to a similar explanation for Hals's refusal to finish the Amsterdam commission.

CHAPTER EIGHT

1. Israel 1995, 625.
2. My thanks to Pieter Biesboer for bringing this fact to my attention.
3. For the guild's membership rolls, see Goosens 2012, 445–49, and the narrative in Goosens 2012, 28–31; see also Biesboer 2001, 41 and Miedema 1980, 1:419. For the effects of the economic downturn on Haarlem's art world, see Biesboer 2001, 40–41.
4. Just how many people were caught up in the "tulip mania" is subject to debate. Contrary to the older view that it was a mass phenomenon affecting the national economy and many strata of Dutch society, Goldgar (2007) argues that it was limited to a circle of well-off merchants and that the financial consequences were not very substantial at all. My discussion of the "tulip mania" is indebted to her revisionist account.
5. Goldgar 2007, 202.
6. Cited in Schama 1988, 358.
7. Goldgar (2007), for one, insists that the high numbers bandied about by most accounts are a gross exaggeration based on a simplistic reading of contemporary propaganda.
8. Dash 1999, 163, 165.
9. In addition to the illuminating discussions of the episode in Schama, Dash, and Goldgar, see Posthumus 1929.
10. This, at least, is what, according to Goldgar (2007), the archival records indicate.
11. Goldgar 2007, 270.
12. Goldgar 2007, 166–67.
13. Goldgar 2007, 67.
14. Schrevelius 1648, 370.
15. On Dutch floral painting in the seventeenth century, see Taylor 1995. The genre especially grew in popularity in the decades after the tulip craze, with painters such as Jan Davidsz de Heem.
16. Quoted in Goldgar 2007, 130.
17. This increase occurred over the period from 1625 to 1635. From the guild membership of 1625, when there were forty-four members, thirty-four were still active in the guild in 1635; over those ten years, they were joined by forty-two others. For the data on this, see Goosens 2001, 28–31, 446–47.

18. Goosens 2001, 28–31, 446–47.
19. Kloek 1993, 62–63. It is also worth mentioning Clara Peeters. While she did spend some time in the United Provinces, she worked mostly in Antwerp.
20. Rachel Ruysch (1664–1750), of the next generation, may have enjoyed greater popularity in the latter decades of the century.
21. Ampzing 1628, 370.
22. Biesboer 1993, 86. In correspondence with me, Biesboer now puts the number even lower and says that only about fifteen paintings could now "reliably" be called works by Leyster. In the most recent *catalogue raisonné* (Hofrichter 1989), the number is put at forty-four. But specialists have since determined that many of these are not by Leyster's hand, and some have now been attributed to Hals's workshop ("Circle of Hals"); see Welu and Biesboer 1993, 344–73.
23. The inventory of the lottery is listed in Willigen 1870, 18.
24. Judith Leyster, *A Boy and a Girl with a Cat and an Eel*, ca. 1635, oil on wood panel, National Gallery, London.
25. It is in the Philadelphia Museum of Art.
26. Judith Leyster, self-portrait, 1630, oil on canvas, National Gallery of Art, Washington DC.
27. Again, using the term "influence" with hesitation; see Baxandall 1985, 58–59. Given Baxandall's warning that the term suggests a relationship of active agent to passive recipient, rather than recognizing the active contribution of the "influenced" party, it seems especially slighting when describing the relationship between a male painter (Hals) and female painter (Leyster).
28. Welu and Biesboer 1993, 356.
29. At one point Biesboer allowed that Leyster "might have been temporarily active in [Hals'] workshop as an assistant or collaborator," but found it "unlikely" that Leyster "received her training in his studio" (1993, 76). However, in correspondence with me, he now rejects even that relationship, on the basis of more recent technical examination that he and Martin Bijl have carried out. On Leyster's career, see Hofrichter 1989 and Wijsenbeek-Olthuis and Noordegraaf 1993.
30. Van Thiel-Stroman 1989, 403, doc. 138.
31. Sliggers 1979, 15.
32. De Bie also reports that Wouwerman was Hals's pupil, in *Het Gulden Cabinet der Edel Vry Schilderconst* (De Bie 1662, 281–82).
33. They may have used their time with Hals to learn how to paint the lively figures we find in their genre works.
34. Van Thiel-Stroman 1989, 385, doc. 57. As Van Thiel-Stroman elsewhere points out, however, there were several women named Judith Jans in Haarlem at this time, so it is possible that the baptism witness is not Leyster (Welu and Biesboer 1993, 234). However, in contemporary documents, Leyster is referred to as "Judith Jansen," while the other Judith Jans, a Haarlem midwife, is referred to as "Judith Jansdr" (a trivial difference, but perhaps a way to distinguish two individuals with the same name).
35. The documents on this case are transcribed in Bredius 1917; Miedema 1980, 432; and (partially) in Van Thiel-Stroman 1989, 388, docs. 70–71.

36. On this regulation, see Miedema 1980, 58.

37. This is indicated in a marginal comment to the document, transcribed in Miedema 1980, 432.

38. On the question of influence here, see Levy-Van Halm 1993, 72–73.

39. Broersen 1993, 23. An alleged self-portrait by Leyster, dated to the early 1640s, was sold by Christie's in London in 2016 (December 18, lot 16); it is now in a private collection. If it is indeed her self-portrait—see Crenshaw 2021; and the subject is portrayed with a brush and palette, and so is clearly an artist—this would indicate that Leyster did, to some extent, continue painting after her marriage.

40. See Welu and Biesboer 1993, 217–19.

41. See the biographies of Leyster and of Molenaer in Köhler 2006, 223-24, 241.

42. Hofrichter 1989, 99, item #267: "2 conterfeijtsels van Jan Molenaer ende sijn huysvrou van Frans Hals—sonder lijst." See Gratama 1930.

43. Crenshaw (2021) has argued that a pair of portraits by Hals—one in the Metropolitan Museum of New York and one in the Frick Museum—are the pendants of Leyster and Molenaer.

44. They could have been painted just before the couple left that year for Amsterdam or after they returned to Haarlem in 1648. Slive suggests that the fact that they were stored away, unframed, upstairs (he calls it an "attic") is evidence that relations between Hals and Leyster remained strained (Slive 1970–74, 1:20). Hofrichter, on the other hand, suggests that because (in her view) the portraits were painted after the dispute, this is "clear evidence of an ongoing relationship between Leyster and Hals" (Hofrichter 1989, 16). Biesboer (1993, 89n25) suggests that there never was any breach between Hals and Leyster, as the quarrel was not really between Leyster and Hals, but between Leyster and Woutersz's mother.

45. 1639, oil on canvas, 111.1 × 86.7 cm, the Collection of the John and Mable Ringling Museum of Art, the State Art Museum of Florida, Florida State University, Sarasota.

46. Pieter Biesboer insists (in correspondence) that Olycan is standing in this portrait. However, the angling of his legs in the bottom part and the position of his hands relative to his body strongly suggest that he is seated.

47. 1639, oil on canvas, 128 × 94.5 cm, Rijksmuseum, Amsterdam.

48. In Hendrick Pot's portrait of the officers of this same guard three years earlier, Nicolaes was a sergeant; he has since been promoted.

49. Slive 1989, 181.

50. 1638, oil on wood panel, 20.6 × 16.8 cm, National Gallery, London.

51. Taken from the epithet on the engraving of Blevet's portrait; see Slive 2014, 180.

52. 1639, oil on canvas, 218 × 421 cm, Frans Hals Museum, Haarlem.

53. Self-portrait (detail from plate 18, *Officers and Sergeants of the St. George Civic Guard*, 1639, Frans Hals Museum, Haarlem).

54. This, at least, is the consensus in much of the literature; see, for example, Valentiner 1925; Grimm 1990, 65; and Slive 2014, 257, among others.

55. Copy of Hals's self-portrait by an unknown artist, ca. 1650s, oil on wood panel, 32.7 × 27.9 cm, Metropolitan Museum of Art, New York.

56. On this self-portrait and its copies, see Coutré 2017. Slive (2014, 257) argues

that any doubts that the extant copies are from an original self-portrait are "unjustified."

57. See docs. 86–88, in Van Thiel-Stroman 1989, 393.
58. See Van Thiel-Stroman 1989, 395, doc. 95.
59. Van Thiel-Stroman 1989, 396, doc. 98.
60. Van Thiel-Stroman 1989, 393, doc. 90.
61. Van der Heijden 2016, 106, 111.
62. "Jae, ick hebbe bij meer geweest," Van Thiel-Stroman 1989, 394, doc. 93.
63. Van Thiel-Stroman 1989, 394, doc. 92.
64. Van Thiel-Stroman 1989, 394, doc. 94.
65. Circa 1641, oil on canvas, 153 × 252 cm, Frans Hals Museum, Haarlem.
66. Johannes Verspronck, *Regentesses of the St. Elisabeth's Hospital*, 1641, oil on canvas, Frans Hals Museum, Haarlem. It is possible that the regentesses did originally offer the commission to Hals, but that he declined it, given how busy he was.
67. Miedema 1980, 1:250, doc. A120, which presents the full text of the De Grebber group (1:246–53). Discussion and analysis of this episode are offered in Boers 1999, 198–200; De Marchi and Van Miegroet 1994, 458–60; and Prak 2003, 246–47.
68. Miedema 1980, 1:252, doc. A120, item 29.
69. Miedema 1980, 1:225, doc. A110, and 2:529. On this, see Boers 1999, 198.
70. Miedema 1980, 1:251, doc. A120, item 16.
71. Miedema 1980, 1:252, doc. A120, item 23.
72. Miedema 1980, 1:251, doc. A120, item 18.
73. Miedema 1980, 1:253–55, doc. A122.
74. Miedema 1980, 1:281, doc. A130a.
75. Van Thiel-Stroman 1989, 402, doc. 133. De Molijn was not present at the meeting itself.
76. Van Thiel-Stroman 1989, 396, docs. 99–102.
77. See the records in Willigen 1870, 18–24.
78. Van Thiel-Stroman 1989, 397, doc. 103; 402, docs. 130–31.
79. Van Thiel-Stroman 1989, 400, doc. 121.
80. Van Thiel-Stroman 1989, 397, docs. 104 and 107. It is possible, as Van Thiel-Stroman notes, that these debts belonged to another Frans Hals, but this seems to me unlikely.
81. Bredius 1909.
82. Van Thiel-Stroman 1989, 397–98, doc. 108. While we do not know how much rent was due, this episode may say something about the value of a one-day painting (*een dach schilderen*) by Frans Hals, which by itself was not sufficient to cover the debt.
83. Van Thiel-Stroman 1989, 397, doc. 105; 398, doc. 112.
84. Slive 2014, 251; Ekkart and Buvelot 2007, 132, 138–40, 164.
85. On the collection of the House of Orange, see Treanor 2012.
86. On Amalia van Solms as art collector, see Treanor 2012 and Beranek 2017.
87. On the collection of Frederik Hendrik and Amalia van Solms, see Van der Ploeg and Vermeeren 1997 and Treanor 2012.
88. Angel 1642, 56; Angel 1996, 248–49. At the same time, Angel strongly recommends not following anyone's style or manner of painting. Rather, the artist

should "follow life as closely as possible" and imitate nature, so as to avoid "putting too much of himself into [his painting]." Ideally, he claims, "it will be impossible to say who made the work" (248).

89. Circa 1645, oil on canvas, 80 × 67.5 cm, National Gallery of Prague. On this portrait, see Damsté 1985.

90. Slive 2014, 256.

91. Circa 1645, oil on canvas, 77 × 64 cm, National Gallery of Art, Washington, DC, Andrew W. Mellon Collection.

92. Isabella's portrait (116 × 86 cm, oil on canvas) is in a private collection; Stephanus's portrait (115 × 87 cm, oil on canvas) is in the Koninklijk Museum voor Schone Kunsten, Antwerp. For the dating of these marriage pendants, see Biesboer 1989, 37.

93. Van Thiel-Stroman 1989, 392, doc. 84; 393, doc. 89; 399, doc. 115; 400, doc. 119; 401, doc. 126.

94. It should be noted, though, that Rembrandt was not painting many portraits between 1642 and 1655. My thanks to Norbert Middelkoop on this point.

95. Ekkart and Buvelot 2007.

CHAPTER NINE

1. Gerard ter Borch, *The Swearing of the Oath of Ratification of the Treaty of Münster*, 1648, oil on copper plate, National Gallery, London.

2. For a study of Ter Borch's painting in its historical and art historical context and as documenting an actual event, see Kettering 1998.

3. A translation of the text of the treaty is in Rowen 1972, 179–87.

4. Cornelis Beelt, *The Promulgation in 1648 of the Peace of Münster*, 1650s, the State Hermitage Museum, Saint Petersburg.

5. William III will be installed as stadholder in 1672 in the wake of the calamitous French invasion of the Republic.

6. William Frederik of Nassau, a descendant of William the Great's brother Count Jan of Nassau, remained stadholder in Friesland, Groningen, and Drenthe.

7. Circa 1647–50, oil on canvas, 148.5 × 251 cm, National Gallery, London.

8. See the studies on Hals's family portraits in De Belie and Nichols 2018.

9. Circa 1645–48, oil on canvas, 202 × 285 cm, Thyssen-Bornemisza Museum, Madrid.

10. On De Molijn, see Boers 2017.

11. Houbraken 1976, 1:215.

12. Peter Paul Rubens, *Four Studies of a Male Head*, ca. 1617–20, oil on panel, Getty Museum, Los Angeles. On Blacks in early modern Dutch painting, see Kolfin 2008 and the exhibition catalog Kolfin and Runia 2020.

13. This was before Nicolaes's promotion to lieutenant, as he appears in Hals's 1633 portrait of the Saint Hadrian officers.

14. On Dutch involvement in the Atlantic slave trade, see Postma 1990 and Emmer 2003.

15. My thanks to Paul Taylor and Elizabeth McGrath for sharing their views on this. According to McGrath, "the likelihood that he is an African prince or suchlike is so remote that it can be ruled out altogether." It is also possible

that the youth may have come to the north as part of an African diplomatic mission; see De Belie and Nichols 2018, 45.

16. Massing (2011, 234-35) claims that he is most likely a servant who may have been acquired by the husband during business or some other travel abroad.

17. See Hondius 2008.

18. In connection with this, it is interesting to note that the Amsterdam Museum decided in 2019 no longer to use the term "Golden Age" to describe this period of history.

19. *Discourse on Method* 4, Descartes 1974-83, 6:31.

20. Letter to Brasset, April 23, 1649, Descartes 1974-83, 5:349.

21. Baillet 1691, 2:387.

22. See Biesboer 2018, 90-91.

23. Another possibility is that the intermediary between Bloemaert and Descartes, on the one hand, and Hals, on the other hand, was the third member of the trio, Ban. In the 1630s, Ban was responsible for commissions to several Haarlem artists for portraits of local priests, and Hals received one of those commissions. See Biesboer 1989, 34.

24. 1649, oil on panel, 19 × 14 cm, Statens Museum for Kunst, Copenhagen.

25. For a more extensive discussion of Hals's portrait of Descartes, see Nadler 2013. On the question of whether Descartes actually sat for Hals, see Nordström 1957-58 (who argues that he did not) and Slive 1970-74, 1:166-68 (who argues that he did).

26. Descartes 1974-83, 5:467.

27. Descartes 1974-83, 5:467.

28. Three children died as infants: two from his marriage to Anneke (Van Thiel-Stroman 1989, 376-77, docs. 13 and 18) and one from his marriage to Lysbeth (Van Thiel Stroman 1989, 379, doc. 27). Two died as adults: Jacob and Anthonie.

29. Van Thiel-Stroman 1989, 406, doc. 148.

30. Van Thiel-Stroman 1989, 409, doc. 161.

31. Van Thiel-Stroman 1989, 402, doc. 128.

32. Van Hees 1959, 40; Van Thiel-Stroman 1989, 403-4, doc. 138.

33. Van Thiel-Stroman 1989, 401, doc. 123.

34. Köhler 2006, 186.

35. Van Thiel-Stroman 1989, 402, doc. 132.

36. Van Thiel-Stroman 1989, 404, doc. 141. The words in brackets were struck out in the original document.

37. Van Thiel-Stroman 1989, 404-5, docs. 142-43.

38. Köhler 2006, 174-75.

39. Van Thiel-Stroman 1989, 405, 408, docs. 144-45, 155.

40. All of these documents related to Reynier and Elisabeth are in Bredius 1923-24e. See also Köhler 2006, 187-88.

41. Israel 1995, 863.

42. Israel 1995, 715; on the first Anglo-Dutch War, see 713-26.

43. As Slive notes, many of these portraits from the 1650s cannot be dated with much reliability. "Documentary evidence to establish a firm chronology for works done during the last period of our artist's life is virtually nonexistent" (Slive 2014, 303).

44. This is the painting now in the Metropolitan Museum of Art, New York (Slive 2014, 304).
45. While the naming of the sitters in these two portraits is not certain, some scholars are confident enough in the identifications; see Slive 2014, 308–9, and Grimm 1970.
46. Slive 2014, 308–9.
47. Circa 1655, oil on panel, 27.5 × 23 cm, the Worcester Museum.
48. See Larsen 1962, although his view on De Molijn's role is not widely shared. More recently, there is the *catalogue raisonné*, Correa do Lago and Correa do Lago 2007.
49. For a study of Post's Brazil paintings from a social and political perspective, see Oliver 2013.
50. Van Thiel-Stroman 1989, 403, docs. 135–36.
51. Van Thiel-Stroman 1989, 403, doc. 137.
52. Van Thiel-Stroman 1989, 405–6, doc. 147.
53. Van Thiel-Stroman 1989, 406, doc. 149. This document, Van Thiel-Stroman notes, might apply not to Frans Hals but to his son Frans Jr.
54. These are the figures suggested by Ekkart (2007, 57). The thirty-five guilders that Hals charged in 1653 was for making a copy of one of his own portraits (see chap. 3); it was not what he charged for the original portrait itself.
55. Montias 1982, 112.
56. On painters' wealth and income, see Goosens 2001, 185–228.
57. Goosens 2001, 192–94.
58. Goosens 2001, 193–94.
59. In order to contrast the value of a Rembrandt painting (and portrait) with the likely value of a Hals painting (portrait) in the period, it is useful to consult the Montias database (https://research.frick.org/montias). Granted, the data is limited to inventories from Amsterdam (up to 1681). Moreover, these figures are based on either the appraised values of paintings for estate or bankruptcy purposes or the prices paid for paintings sold at auctions (when these are known). The numbers thus do not tell us what either Rembrandt or Hals received for a commissioned work or for something sold directly or through a dealer in the primary market. They do, however, provide a relative indication of the value that buyers might have placed on works by each artist, and some relative idea of the difference between what each painter might have asked for a painting. The average value of the 225 listed works by Rembrandt based on available prices is 135 guilders; the portraits average 130 guilders. For Hals, the data is more questionable and unlikely to represent the true average selling price or appraisal of his work. First, he was a Haarlem, not an Amsterdam, artist, and thus more likely to be unfamiliar to whoever was doing the inventory, leading to some misattributions; Montias himself seems uncertain about some of the paintings. Moreover, Hals's reported presence in the inventories included in the database is much smaller than Rembrandt's (fifteen works: one portrait [*conterfeytsel*] and a number "genre" and other pieces). With those caveats, we find that the database reports that the average for a Hals painting is 9.5 guilders. My thanks to Paul Taylor for his help on this.
60. Strauss et al. 1979, *The Rembrandt Documents*, 1659/21: http://remdoc.huygens .knaw.nl/#/document/remdoc/e12837.

61. Landscapes were also more remunerative than portraits at this time.
62. Strauss et al. 1979, *The Rembrandt Documents*, 1639/7: http://remdoc.huygens
.knaw.nl/#/document/remdoc/e4463.
63. Strauss et al. 1979, *The Rembrandt Documents*, 1646/7: http://remdoc.huygens
.knaw.nl/#/document/remdoc/e4545.
64. On Rembrandt's bankruptcy, see Crenshaw 2006.
65. See Biesboer 1995b, 120–21.

CHAPTER TEN

1. She would not have been able to serve as a witness at either Hals's or their
son Nicolaes's confession for membership if she had not been a church
member.
2. Van Thiel-Stroman 1989, 414, doc. 188.
3. Parker 2008, 26.
4. "Album Communicant," fol. 141, Kerkenraad van de Nederlands-Hervormde
Gemeente te Haarlem (1647-60), Noord-Hollands Archief, access #1551, inv.
no. 102.
5. My thanks to Henk van Nierop for helping me understand various distinc-
tions relative to membership in the Dutch Reformed Church.
6. Circa 1660, oil on canvas, 76 × 63.5 cm, Musée de Picardie, Amiens.
7. Quoted in Slive 2014, 315–16.
8. It is published among the poems collected by Van Domselaar (1660, 408).
9. See Slive 2014, 316.
10. The rivalry hypothesis comes from Slive (2014).
11. De Bie 1661, 282. De Bie's remark occurs in his biography of Dirck van
Delen, although in the context of mentioning that Philips Wouwerman was
Hals's pupil. Since De Bie lived in Antwerp, we do not know how well ac-
quainted he actually was with Hals's paintings.
12. De Monconys 1666, 159.
13. Moonen 1700, 679–80.
14. Hals's portrait of Croes: early to mid-1660s, oil on wood panel, 47.1 × 34.4
cm, Alte Pinakothek, Bayerische Staatsgemäldegalerie, Munich. For discus-
sion of this portrait, see Biesboer 1989, 33–34; and Slive 1989, 350 and 2014,
315. The dating of the portrait is uncertain, and estimates range between
1658 and 1666. As Slive, who favors a very late dating (1666), points out, it is
possible that when Croes gave the commission to Hals, Verspronck was no
longer available, having died in June 1662. Biesboer also dates the painting
late, ca. 1665.
15. Circa 1660, oil on wood panel, 40.6 × 30.5 cm, Krannert Art Museum, Uni-
versity of Illinois, Urbana-Champaign.
16. The backgrounds have probably darkened over the centuries and may origi-
nally have shown more features than they now do.
17. The landscape in this painting, partly visible through a window, was added
later by another artist; technical analysis revealed it was not in Hals's origi-
nal composition.
18. Circa 1665, oil on canvas, 85.8 × 67 cm, Museum of Fine Arts, Boston. Slive
(1989, 358, and 2014, 320) identifies his gown as a Japanese kimono and sees

a reflection of a "Dutch kimono craze" in the period. In fact, it is not a ki-mono but a domestic gown, to be worn at home and in private, inspired by the Japanese garment.

19. Fromentin 1896, 167.

20. Fromentin 1896, 310. Fromentin is discussing the two final group portraits, of the regents and regentesses of the Old Men's Alms House, painted in 1664, the final year of Hals's life.

21. Fromentin 1896, 311.

22. Moes 1909, 67 ("La main du peintre, déja fléchissante, manqua de sûreté"). He is discussing the "portrait of a man" in the Mauritshuis and suggests that this might be the portrait of Ruyll mentioned by Moonen; Slive dissents from this identification (1974, 3:107–8). See also Bode 1883.

23. Slive 2014, 314.

24. Van Thiel-Stroman 1989, 410, doc. 167.

25. Van Thiel-Stroman 1989, 409, doc. 160.

26. Van Thiel-Stroman 1989, 410–11, doc. 169.

27. Both ca. 1664, oil on canvas, 172.3 × 256 cm, Frans Hals Museum, Haarlem.

28. Pieter Biesboer reports that these paintings have been recently technically examined with reflectography and cleaned of yellowed varnish layers, and the result is that almost 80 percent of the costumes are overpainted. The examination/restoration team decided to keep the old retouching and not remove them. Only the faces, the hands, and some white areas have been preserved in their original (Hals) state, but they have lost some of their fin-ishing touches.

29. De Vries 1877, 254. For a refutation of this reading of the portrayal of the man, and a critical discussion of the tradition of interpreting both portraits in such a negative light, see Vinken and De Jongh 1963 and Slive 1989, 367.

30. Baard 1962, 21.

31. Slive 1989, 362. In 2015 the painting of the regentesses underwent a major restoration at the Frans Hals Museum.

32. Van Thiel-Stroman 1989, 412, doc. 179.

33. Van Thiel-Stroman 1989, 409, doc. 164.

34. Van Thiel-Stroman 1989, 411, doc. 170.

35. See Van Thiel-Stroman 1989, 411–15, docs. 174, 176, 178, 181, 185.

36. Van Thiel-Stroman 1989, 411–12, docs. 175 and 177.

37. Jardine 2008, 139–40.

38. Israel 1995, 755.

39. Pepys 1970–83, 5:59.

40. Israel 1995, 766.

41. Israel 1995, 848 (chart showing the fluctuations in VOC share prices on the Amsterdam exchange).

42. At least to judge by the number of solo or pendant portraits being painted by the city's leading and most popular portraitists—Hals, Verspronck, Jan de Bray—relative to previous decades. My thanks to Pieter Biesboer for this information.

43. Frans Hals Museum, Haarlem.

44. On the De Brays, see Biesboer 2008b.

45. Bol apparently painted very little from 1669, after his second marriage, until his death in 1680.

46. The monochromatic tonal landscape tradition really found its perfection in the works of Van de Velde's onetime pupil in Haarlem Jan van Goyen (1596–1656), who was later active primarily in Leiden and The Hague; his paintings still enjoyed great popularity into the 1650s (see Sluiter 2021).

47. Van Thiel-Stroman 1989, 413, doc. 182.

48. Van Thiel-Stroman 1989, 413, doc. 185.

49. Van Thiel-Stroman 1989, 414, doc. 189.

50. Van Thiel-Stroman 1989, 414, doc. 186.

51. Jowell 1989.

52. LeBrun 1792–96, 1:71.

53. Reynolds 1867, 60.

54. See Bürger 1868; Golliet 1979; Jowell 1974 and 1989.

55. Jowell 1989, 66.

56. According to a provenance provided by Sotheby's (London), which sold the painting in July 2008 for 7 million British pounds (https://www.sothebys .com/en/auctions/ecatalogue/2008/old-master-paintings-evening-sale -l08033/lot.26.html).

57. According to a provenance provided by the Cleveland Museum of Art, which shows a sale in Vienna on March 14, 1872, to the dealer Georg Plach, working on behalf of Rothschild.

58. Jansen et al. 2009, letter 535, to Theo van Gogh, Nuenen, ca. October 13, 1885, http://www.vangoghletters.org/vg/letters/let535/letter.html.

59. Jansen et al. 2009, letter 536, to Theo van Gogh, Nuenen, ca. October 20, 1885, http://www.vangoghletters.org/vg/letters/let535/letter.html.

60. The Haarlem Municipal Museum was founded in 1862. On its early history, see Chu 1987.

References

Adams, Ann Jensen. 2009. *Public Faces and Private Identities in Seventeenth-Century Holland: Portraiture and the Production of Community.* Cambridge: Cambridge University Press.

Alpers, Svetlana. 1988. *Rembrandt's Enterprise: The Studio and the Market.* Chicago: University of Chicago Press.

Ampzing, Samuel. 1628. *Beschryvinge ende lof der stadt Haerlem in Holland.* Haarlem: Adriaen Rooman.

Angel, Philips. 1642. *Lof der Schilderkonst.* Leiden: Willem Christiaens.

Angel, Philips. 1996. "Praise of Painting," translated by Michael Hoyle. *Simiolus: Netherlands Quarterly for the History of Art* 24:227–58.

Atkins, Christopher. 2003. "Frans Hals's Virtuouso Brushwork." *Nederlands Kunsthistorisch Jaarboek* 53:281–307.

Atkins, Christopher. 2012. *The Signature Style of Frans Hals: Painting, Subjectivity and the Market in Early Modernity.* Amsterdam: Amsterdam University Press.

Atkins, Christopher. 2013. "Frans Hals in Amsterdam and His Impact on Rembrandt." In *Frans Hals: Eye to Eye with Rembrandt, Rubens and Titian,* edited by Anna Tummers, 55–70. Haarlem: Frans Hals Museum.

Baard, Henricus Petrus. 1962. "Inleiding." *Catalogus Frans Hals-tentoonstelling.* Haarlem: Frans Hals Museum.

Baard, Henricus Petrus. 1981. *Frans Hals.* Translated by George Stuyck. New York: Harry N. Abrams.

Baard, Henricus Petrus, and Seymour Slive. 1962. *Frans Hals.* Haarlem: Frans Hals Museum, 1962.

Baillet, Adriaen. 1691. *La Vie de Monsieur Des-Cartes.* 2 vols. Paris: Daniel Horthemels.

Bakker, Piet. 2019. "Rembrandt and the Emergence of the Leiden Art Market." In *Leiden circa 1630: Rembrandt Emerges*, edited by Jacquelyn N. Coutré. Kingston, ON: Agnes Etherington Art Centre, 66–95.

Baxandall, Michael. 1985. *Patterns of Intention: On the Historical Explanation of Pictures*. New Haven, CT: Yale University Press.

Beranek, Saskia. 2017. "Strategies of Display in the Galleries of Amalia van Solms." *Journal of Historians of Netherlandish Art* 9, no. 2: https://jhna.org/articles/strategies-display-galleries-amalia-van-solms/.

Biesboer, Pieter. 1989. "The Burghers of Haarlem and Their Portrait Painters." In *Frans Hals*, edited by Seymour Slive, 23–44. Washington, DC: National Gallery of Art.

Biesboer, Pieter. 1993. "Judith Leyster: Painter of 'Modern Figures.' In *Judith Leyster: A Dutch Master and Her World*, edited by James Welu and Pieter Biesboer. Worcester: Worcester Art Museum, 75–92.

Biesboer, Pieter. 1995a. "Topographical Identifications for a Number of 'Haerlempjes' by Jacob van Ruisdael." In *Shop Talk: Studies in Honor of Seymour Slive*, edited by Alice I. Davies, Cynthia P. Schneider, and William W. Robinson, 36–39. Cambridge, MA: Harvard University Press.

Biesboer, Pieter. 1995b. "Willem van Heythuysen en zijn twee portretten." In *Hart voor Haarlem: Liber Amicorum voor Jaap Temminck*, edited by H. Brokken, 113–26. Haarlem: Schuyt.

Biesboer, Pieter. 1996. "De Vlaamse immigranten in Haarlem 1578–1630 en hun nakomelingen." In *Vlamingen in Haarlem*, edited by Pieter Biesboer, G. Th. Kothof, H. Rau, J. J. Temminck, and J. B. Uittenbout, 35–60. Haarlem: De Vriesborsch.

Biesboer, Pieter. 2001. *Collections of Paintings in Haarlem, 1572–1745*. Los Angeles: Getty Publications.

Biesboer, Pieter. 2006. "Pieter Jacobsz. Olycan: A Portrait and a Burgomaster Revealed." In *A Portrait of Pieter Jacobsz. Olycan: Frans Hals Re-Discovered*, edited by Pieter Biesboer and Martin Bijl, 7–16. Zurich: David Koetser Gallery.

Biesboer, Pieter. 2008a. *De Gouden Eeuw begint in Haarlem*. Haarlem: Frans Hals Museum/NAI Uitgevers.

Biesboer, Pieter, ed. 2008b. *Painting Family: The De Brays, Master Painters of 17th Century Holland*. Zwolle: Waanders Uitgevers; Cambridge: First Editions.

Biesboer, Pieter. 2012. "De Laughing Cavalier van Frans Hals: Een moge-lijke identificatie." In *Face Book: Studies on Dutch and Flemish Portraiture of the 16th–18th Centuries*, edited by R. E. O. Ekkart, 133–40. Leiden and The Hague: Primavera Pers.

Biesboer, Pieter. 2013. "The Identification of a Family Portrait by Frans Hals Recently Acquired by the Toledo Museum of Art." *Burlington Magazine* 155:72–76.

Biesboer, Pieter. 2018. "The Identification of a Family in a Group Portrait by Frans Hals: New Documents." In *Frans Hals Portraits: A Family Reunion*, edited by Liesbeth de Belie and Lawrence W. Nichols, 84–97. Toledo, OH: Toledo Museum of Art; Brussels: Royal Museums of Fine Arts of Belgium.

Biesboer, Pieter, and Martina Sitt, eds. 2003. *Satire en Vermaak: Het genrestuk van Frans Hals en zijn tijdgenoten 1610–1670*. Haarlem: Frans Hals Museum.

Bijl, Martin. 1989. "'The Meagre Company' and Frans Hals's Working Method." In *Frans Hals*, edited by Seymour Slive, 103–8. Washington, DC: National Gallery of Art.

Bijl, Martin. 2005. "The Portrait of Theodorus Schrevelius." In *The Learned Eye: Regarding Art, Theory and the Artist's Reputation*, edited by Marieke van den Doel, Marieke van Eck, Anna Tummers, and Thijs Weststeijn, 47–58. Amsterdam: Amsterdam University Press.

Bijl, Martin. 2006. "The Technical Study in Revealing the Original Painting by Frans Hals." In *A Portrait of Pieter Jacobsz. Olycan: Frans Hals Re-Discovered*, edited by Pieter Biesboer and Martin Bijl, 17–25. Zurich: David Koetser Gallery.

Blankert, Albert, Friso Lammertse, and Jeroen Giltaij, eds. 1989. *Dutch Classicism in Seventeenth-Century Painting*. Rotterdam: Musum Boijmans van Beuningen.

Bode, Wilhelm von. 1871. "Frans Hals und seine Schule." *Jahrbüch für Kunstwissenschaft* 4:1–66.

Bode, Wilhelm von. 1883. *Studien zur Geschichte der holländischen Malerei*. Braunschweig: Friedrich Vieweg und Sohn.

Bode, Wilhelm von, and Moritz Binder. 1914. *Frans Hals, His Life and Work*. Translated by Maurice Walter Brockwell. 2 vols. Berlin: Photographische Gesellschaft.

Boers, Marion. 2017. "Pieter de Molijn (1597–1661): A Dutch Painter and the Art Market in the Seventeenth Century." *Journal of Historians of Netherlandish Art* 9: https: //jhna.org/articles/pieter-de-molijn-dutch -painter-art-market-seventeenth-century.

Boers-Goosens, Marion. 2006. "Prices of Northern Netherlandish Paintings in the Seventeenth Century." In *In His Milieu: Essays on Netherlandish Art in Memory of John Michael Montias*, edited by A. Golahny, M. M. Mochizuki, and L. Vergara, 59–71. Amsterdam: Amsterdam University Press.

Bok, Marten Jan. 1993. "Art-Lovers and Their Paintings: Van Mander's *Schilder-boeck* as a source for the History of the Art Market in the Northern Netherlands." In *Dawn of the Golden Age: Northern Netherlandish Art, 1580–1620*, edited by Ger Luijten, Ariane van Suchtelen, Reinier Baarsen, and Walter Kloek, 151–66. New Haven, CT: Yale University Press.

Bok, Marten Jan. 1994. *Vraag en aanbod op de Nederlandse kunstmarkt, 1580– 1700*. Utrecht: CIP-Gegevens Koninklijk Bibliotheek & Universiteit van Utrecht.

Bok, Marten Jan, and Gary Schwartz. 1991. "Schilderen in opdracht in Holland in de 17e eeuw." *Holland: Regionaal-historisch tijdschrift* 23: 183–95.

Boot, Marjan. 1973. "Über Willem van Heythuysen, seinen Nachlaß und die symbolische Bedeutung des Porträts von Frans Hals in München." *Pantheon* 31:420–24.

Bredius, Abraham. 1909. "Herman Hals te Vianen." *Oud Holland* 27:196.

Bredius, Abraham. 1914. "De ouders van Frans Hals." *Oud Holland* 32:216.

Bredius, Abraham. 1917. "Een conflict tusschen Frans Hals en Judith Leyster." *Oud Holland* 35:71–73.

Bredius, Abraham. 1919. *Künstler-Inventare. Urkunden zur Geschichte der Holländischen Kunst des XVIten und XVIIIten Jahrhunderts*. The Hague: Martinus Nijhoff.

Bredius, Abraham. 1921. "Heeft Frans Hals zijn vrouw geslagen?" *Oud Holland* 39:64.

Bredius, Abraham. 1923–24a. "Archiefsprokkels betreffende Frans Hals." *Oud Holland* 41:19–31.

Bredius, Abraham. 1923–24b. "Archiefsprokkels betreffende Dirck Hals." *Oud Holland* 41:60–61.

Bredius, Abraham. 1923–24c. "Archiefsprokkels betreffende Herman Hals." *Oud Holland* 41:62.

Bredius, Abraham. 1923–24d. "Eenige gegevens over Frans Hals den jonge." *Oud Holland* 41:215.

Bredius, Abraham. 1923–24e. "Oorkonden over Reynier Hals." *Oud Holland* 41:258–62.

Bredius, Abraham. 1923–24f. "Oorkonden over Jan Hals." *Oud Holland* 41:263–64.

Broersen, Ellen. 1993. "'Judita Leystar': A Painter of 'Good, Keen Sense.'" In *Judith Leyster: A Dutch Master and Her World*, edited by James Welu and Pieter Biesboer, 15–38. Worcester: Worcester Art Museum.

Broos, Ben. 1977. "De mythe van de vrolijke Frans." *Vrij Nederland* 38 (November 26): 27.

Broos, Ben. 1978–79. "Review of Seymour Slive, *Frans Hals.*" *Simiolus: Netherlands Quarterly for the History of Art* 10:115–23.

Bruyn, Josua, Bob Haak, Simon H. Levie, Pieter J.J. van Thiel, and Ernst van de Wetering. 1982–89. *A Corpus of Rembrandt Paintings*, vols. 1–3. Stichting Foundation Rembrandt Research Project. The Hague: Martinus Nijhoff.

Bürger, W. 1868. "Frans Hals." *Gazette des Beaux Arts* 24:219–30, 431–48.

Burke, James D. 1974. "Haarlem vue par Ruisdaël/Ruisdael and His Haarlempjes." *Quarterly Review of the Montreal Museum of Fine Arts* 6:3–11.

Chong, Alan. 1987. "The Market for Landscape Painting in Seventeenth-Century Holland." In *Masters of 17th-Century Dutch Landscape Painting*, edited by Peter C. Sutton, 104–20. Philadelphia: University of Pennsylvania Press; Boston: Museum of Fine Arts.

Chu, Petra ten Doesschate. 1987. "Nineteenth-Century Visitors to the Frans Hals Museum." In *The Documented Image: Visions in Art History*, edited by Gabriel Weisberg and Laurinda Dixon, 111–44. Syracuse, NY: Syracuse University Press.

Correa do Lago, Pedro, and Bia Correa do Lago. 2007. *Frans Post, 1612–1680. Catalogue Raisonné*. Milan: Five Continents Editions.

Coutré, Jacquelyn N. 2017. "The Rise and Fall of a Self-Portrait: Valen-

tiner, Liedtke, and the Metropolitan Museum of Art's *Portrait of Frans Hals*." *Journal of Historians of Netherlandish Art* 9, no. 1. DOI: 10.5092/jhna.2017.9.1.6.

Crenshaw, Paul. 2006. *Rembrandt's Bankruptcy: The Artist, His Patrons, and the Art Market in Seventeenth-Century Netherlands*. Cambridge: Cambridge University Press, 2006.

Crenshaw, Paul. 2021. "Frans Hals's Portrait of an Older Judith Leyster." In *Women, Aging and Art: A Crosscultural Anthology*, edited by Frima Fox Hofrichter and Midori Yoshimoto, 63–71. New York: Bloomsbury.

Damsté, P. H. 1985. "De geschiedenis van het portret van Jaspar Schade door Frans Hals." *Oud Holland* 99:30–43.

Dash, Mike. 1999. *Tulipomania: The Story of the World's Most Coveted Flower and the Extraordinary Passions It Aroused*. New York: Three Rivers Press, 1999.

De Belie, Liesbeth. 2018. "A New Reconstruction of Frans Hals's Earliest Family Portrait." In *Frans Hals Portraits: A Family Reunion*, edited by Liesbeth de Belie and Lawrence W. Nichols, 54–83. Toledo, OH: Toledo Museum of Art; Brussels: Royal Museums of Fine Arts of Belgium.

De Belie, Liesbeth, and Lawrence W. Nichols, eds. 2018. *Frans Hals Portraits: A Family Reunion*. Toledo, OH: Toledo Museum of Art; Brussels: Royal Museums of Fine Arts of Belgium.

De Bie, Cornelis. 1662. *Het Gulden Cabinet vande Edel vry Schilder Const*. Antwerp: Jan Meysens.

De Jager, Ronald. 1990. "Meester, leerjongen, leertijd: Een analyse van zeventiende-eeuwse Noord-Nederlandse leerlingcontracten van kunstschilders, goud- en zilversmeden." *Oud Holland* 104:69–111.

De Jongh, Eddy. 1990. "De Dike en de dunne Hals." *Kunstschrift* 34:2–3.

De Jongh, Eddy. 2000. "To Instruct and Delight." In Eddy de Jongh, *Questions of Meaning: Theme and Motif in Dutch Seventeenth-Century Painting*, 83–103. Leiden: Primavera Pers.

De Jongh, Eddy, and P. J. Vinken. 1961. "Frans Hals als voortzetter van een emblematische traditie. Bij het Huwelijksportret van Isaac Massa en Beatrix van der Laen." *Oud Holland* 78:117–52.

De Lairesse, Gérard. 1707. *Het Groot Schilderboek*. Amsterdam: Willem de Coup.

De Marchi, N., and J. J. M. van Miegroet. 1994. "Art, Value and Market Practices in the Netherlands in the Seventeenth Century." *Art Bulletin* 76:451–64.

De Monconys, Balthasar. 1666. *Journal des voyages de Monsieur de Monconys*, Second Partie. Lyon: Horace Boissat et Geroge Remius.

Descartes, René. 1974–83. *Oeuvres de Descartes*. Edited by Charles Adam and Paul Tannery. 12 vols. Paris: J. Vrin.

De Smet, R. 1977. "Een nauwkeurige datering van Rubens' eerste reis naar Holland in 1612." *Jaarboek Koninklijk Museum voor Schone Kunsten Antwerpen*, 199–220.

De Vries, Jan, and Ad van der Woude. 1997. *The First Modern Economy: Success, Failure, and Perseverance of the Dutch Economy, 1500–1815*. Cambridge: Cambridge University Press.

De Winkel, Marieke. 2012. "Frans Hals's Portraits of Michiel de Wael and Cunera van Baersdorp and of Jan de Wael and Aeltje Dircksdr. Pater Identified." In *Face Book: Studies on Dutch and Flemish Portraiture of the 16th–18th Centuries: Liber Amicorum Presented to Rudolf E. O. Ekkart on the Occasion of His 65th Birthday*, edited by E. Buijsen, C. Dumas, and V. Manuth, 141–50. Leiden and The Hague: Primavera Press.

Dirkse, Paul. 1978. "Pieter de Grebber: Haarlems schilder tussen begijnen, kloppen en pastors." *Jaarboek Haarlem*, 109–27.

Dólleman, M. Thierry de Bye. 1973. "Nieuwe gegevens betreffende Anneke Hermansdr., de erste echtgenote van Frans Hals." *Jaarboek Haarlem*, 249–57.

Dólleman, M. Thierry de Bye. 1974. "Vier verschillende families 'Hals' te Haarlem." *Jaarboek Centraal Bureau voor Genealogie* 28:182–211.

Dudok van Heel, S. A. C. 1975. "Een minne met een kindje door Frans Hals." *Jaarboek Centraal Bureau voor Genealogie en het Iconographisch Bureau* 29:146–59.

Dudok van Heel, S. A. C. 2006. *De jonge Rembrandt onder tijdgenoten*. PhD thesis, Radboud Universiteit Nijmegen. Rotterdam: Veenman Publishers.

Dudok van Heel, S. A. C. 2017. "Rembrandt and Frans Hals Painting in the Workshop of Hendrick Uylenburgh." In *Rembrandt and His Circle: Insights and Discoveries*, edited by Stephanie S. Dickey, 17–43. Amsterdam: Amsterdam University Press.

Dudok van Heel, S. A. C. 2020. "Rembrandt's Surprising Start as a Portrait Painter: Hendrick Uylenburgh's Role in the Production of Portraits in Amsterdam." In *Rembrandt and Amsterdam Portraiture, 1590–1670*, edited by Norbert Middelkoop, 129–43. Madrid: Fundación Colección Thyssen-Bornemisza.

Duits, H. 1993. "Het Leven van Karel van Mander: Kunstenaarsleven of Schrijfversbiografie." *De Zeventiende Eeuw* 9:117–30.

Ekkart, Rudolf. 1979. *Johannes Cornelisz. Verspronck: Leven en werken van een Haarlems portretschilder uit de 17de eeuw*. Haarlem: Frans Hals Museum.

Ekkart, Rudolf. 2007. "Portraits in the Golden Age" and "Portraiture in Practice." In *Dutch Portraits: The Age of Rembrandt and Frans Hals*, edited by Rudi Ekkart and Quentin Buvelot, 17–64. The Hague: Royal Picture Gallery Mauritshuis.

Ekkart, Rudolf, and Quentin Buvelot, eds. 2007. *Dutch Portraits: The Age of Rembrandt and Frans Hals*. The Hague: Royal Picture Gallery Mauritshuis.

Emmer, P.C. 2003. *De Nederlandse Slavenhandel, 1500–1850*. Amsterdam: De Arbeiderspers.

Fock, C. Willemijn. 2021. "Art Ownership in Leiden in the Seventeenth Century," translated by Anne Baudouin. *Journal of Historians of Netherlandish Art* 13, no. 1.

Fromentin, Eugène. 1896. *Les Maîtres d'autrefois: Belgique, Hollande*. 8th ed. Paris: E. Plon.

Gay, Peter, and Robert K. Webb. 1973. *Modern Europe: To 1815*. New York: Harper and Row.

Geyl, Pieter. 1966. *The Revolt of the Netherlands, 1555–1609*. New York: Barnes and Noble.

Geyl, Pieter. 1971. *The Netherlands in the Seventeenth Century*. 2 vols. New York: Barnes and Noble.

Gilot, Françoise. 2019. *Life with Picasso*. New York: NYRB Classics.

Goldgar, Anne. 2007. *Tulipmania: Money, Honor, and Knowledge in the Dutch Golden Age*. Chicago: University of Chicago Press.

Golliet, Pierre. 1979. "La Redécouverte de Frans Hals: Thoré-Bürger, Edouard Manet, Eugene Fromentin." *Colloque Eugène Fromentin, Publications de l'Université de Lille* 3:53–87.

Gonnet, C. J. 1877. *Sint Lucas Gilde te Haarlem*. Haarlem: North Holland Archives.

Goosens, Marion E. W. 2001. "Schilders en de Markt: Haarlem 1600–1635." PhD thesis, University of Leiden.

Gratama, G. D. 1930. "Het Portret van Judith Leyster door Frans Hals." *Oud Holland* 47:71–75.

Greup-Roldanus, S. C. Regtdoorzee. 1936. *Geschiedenis der Haarlemmer Bleekerijen*. The Hague: Martinus Nijhoff.

Grijzenhout, Frans. 2013. "Frans Hals: The Portraits of a Mennonite Watchmaker and His Wife." *Rijksmuseum Bulletin* 61:122–39.

Grijzenhout, Frans. 2015. "De Oude Kapitein Soop en Zijn Zonen." *Amstelodamum* 102:14–29.

Grimm, Claus. 1970. "Ein meisterliches Künstlerporträt: Frans Hals' Ostade-Bildnis." *Oud Holland* 85:170–76.

Grimm, Claus. 1971. "Frans Hals und seine 'Schule.'" *Münchner Jahrbüch der bildenen Kunst* 22:147–78.

Grimm, Claus. 1972. *Frans Hals: Entwicklung, Werkanalyse, Gesamtkatalog*. Berlin: Mann.

Grimm, Claus. 1974. "St. Markus von Frans Hals." *Maltecnik/Restauro* 80:21–31.

Grimm, Claus. 1990. *Frans Hals: The Complete Work*. Translated by Jürgen Riehle. New York: Harry N. Abrams.

Groen, Karin, and Ella Hendriks. 1989. "Frans Hals: A Technical Examination." In *Frans Hals*, edited by Seymour Slive, 109–27. Washington, DC: National Gallery of Art.

Grotius, Hugo. 1928–2001. *Briefwisseling van Hugo Grotius*. 17 vols. Edited by P. C. Molhuysen, B. L. Meulenbroek, P. P. Witkam, H. J. M. Nellen, and C. M. Ridderikhoff. The Hague: Martinus Nijhoff; accessible online: http://grotius.huygens.knaw.nl.

Gudlaugsson, S. J. 1954. "Een Portret van Frans Hals Geïdentificeerd." *Oud Holland* 69:235–36.

Haeger, Barbara. 1986. "Frans Hals's So-Called Joncker Ramp and His Sweetheart Reconsidered." *Kunsthistorisk Tidskrift* 15:141–48.

Harrington, Margaret Rose. 2018. "Picturing Devotion in Dutch Golden Age Huiskerken." PhD thesis, University of Maryland.

Hendriks, Ella. 1998. "Johannes Cornelisz. Verspronck: The Technique of a Seventeenth-Century Haarlem Portraitist." *Leids Kunsthistorisch Jaarboek* 11:227–67.

Hill, Robert, and Susan Bracken. 2014. "The Ambassador and the Artist." *Journal of the History of Collections* 26:171–91.

Hoekstra, P. 1936. *Het Haarlemse brouwersbedrijf in de 17e eeuw.* Haarlem: n.p.

Hofrichter, Frima Fox. 1983. *Haarlem: The Seventeenth Century.* New Brunswick, NJ: Jane Voorhees Zimmerli Art Museum, Rutgers University.

Hofrichter, Frima Fox. 1989. *Judith Leyster: A Woman Painter in Holland's Golden Age.* Doornspijk: Davaco.

Hofrichter, Frima Fox. 1993. "The Eclipse of a Leading Star." In *Judith Leyster: A Dutch Master and Her World*, edited by James Welu and Pieter Biesboer, 115–22. Worcester: Worcester Art Museum.

Hofstede de Groot, Cornelis. 1910. *A Catalogue Raisonné of the Works of the Most Eminent Dutch Painters.* Vol. 3, *Frans Hals and Isaac van Ostade.* London: MacMillan & Co.

Hofstede de Groot, Cornelis. 1915. "Een Portret van Jacob van Campen door Frans Hals." *Oud Holland* 33:16–18.

Hondius, Dienke. 2008. "Black Africans in Seventeenth-Century Amsterdam." *Renaissance and Reformation/Renaissance et Réforme* 31:87–105.

Honig, Elizabeth Alice. 1998. *Painting and the Market in Early Modern Antwerp.* New Haven, CT: Yale University Press.

Hoogewerff, G. J. 1947. *De geschiedenis van de St. Lucasgilden in Nederland.* Amsterdam: P. N. Van Kampen.

Houbraken, Arnold. 1976. *De Groote Schouburgh der Nederlantsche Konstschilders en Schilderessen.* 3 vols. Amsterdam: B. M. Israël. First published 1718–21.

Huvenne, Paul. 2013. "Rubens's Flemish Heritage." *CODART e-zine*, no. 3 (Autumn), https://www.codart.nl/feature/curators-project/rubenss-flemish-heritage/.

Huygens, Constantijn. 1987. *Mijn Jeugd.* Translated (into Dutch) by C. L. Heesakkers. Amsterdam: Querido's Uitgeverij. First published ca. 1630.

Hyman, Aaron M. 2016. "Brushes, Burins and Flesh: The Graphic Art of Karel van Mander's Haarlem Academy." *Representations* 134:1–28.

Israel, Jonathan I. 1995. *The Dutch Republic: Its Rise, Greatness, and Fall, 1477–1806.* Oxford: Oxford University Press.

Israel, Jonathan I. 1997. "Adjusting to Hard Times: Dutch Art during Its Period of Crisis and Restructuring (c. 1621–c. 1645)." *Art History* 20: 449–76.

Jansen, Leo, Hans Luijten, and Nienke Bakker, eds. 2009. *Vincent van Gogh—The Letters.* Amsterdam and The Hague: Van Gogh Museum and Huygens ING; accessible online: http://vangoghletters.org.

Jardine, Lisa. 2008. *Going Dutch: How England Plundered Holland's Glory.* New York: Harper.

Jowell, Frances Suzman. 1974. "Thoré-Bürger and the Revival of Frans Hals." *Art Bulletin* 56:101–17.

Jowell, Frances Suzman. 1989. "The Rediscovery of Frans Hals." In *Frans Hals,* edited by Seymour Slive, 61–86. Washington, DC: National Gallery of Art.

Keith, Larry. 1999. "The Rubens Studio and the *Drunken Silenus Supported by Satyrs.*" In *National Gallery Technical Bulletin 20: Painting in Antwerp and London: Rubens and Van Dyck,* 96–104. London and New Haven, CT: Yale University Press.

Kettering, Alison McNeil. 1998. "Gerard ter Borch's Swearing of the Oath of Ratification of the Treaty of Münster as Historical Representation." In *1648: War and Peace in Europe,* edited by Klaus Schilling and Heinz Bussmann, 605–14. Münster: Westfälisches Landesmuseum.

Kloek, Els. 1993. "The Case of Judith Leyster: Exception or Paradigm." In *Judith Leyster: A Dutch Master and Her World,* edited by James Welu and Pieter Biesboer, 55–68. Worcester: Worcester Art Museum.

Köhler, Neeltje, ed. 2006. *Painting in Haarlem, 1500–1850: The Collection of the Frans Hals Museum.* Ghent: Ludion; Haarlem: Frans Hals Museum.

Kolakowski, Leszek. 1987. *Chrétiens sans église: La conscience religieuse et le lien confessionnel au XVIIe siècle.* Paris: Gallimard.

Kolfin, Elmer. 2008. "Zwarte modellen in de Nederlandse kunst tussen 1500 en 1800: Feit en fictie." In *Black Is Beautiful: Rubens tot Dumas,* edited by Elmer Kolfin and E. Schreuder, 70–87, 364–66. Amsterdam: De Nieuwe Kerk.

Kolfin, Elmer, and Epco Runia, eds. 2020. *Black in Rembrandt's Time.* Zwolle: W. Books.

Koslow, Susan. 1975. "Frans Hals's *Fisherboys*: Exemplars of Idleness." *Art Bulletin* 57:418–32.

Lammertse, Friso, and Jaap van der Veen. 2006. *Uylenburgh and Son: Art and Commerce from Rembrandt to De Lairesse, 1625–1675.* Zwolle: Waanders; Amsterdam: Rembrandthuis Museum.

Larsen, Erik. 1962. *Frans Post, interpète du Bresil.* Amsterdam: Colibris Editora.

LeBrun, Jean-Baptiste-Pierre. 1792–96. *Galeries des Peintres Flamands, Hollandais et Allemands.* 3 vols. Paris: Poignant.

Leesberg, Marjolein. 1993–94. "Karel van Mander as Painter." *Simiolus: Netherlands Quarterly for the History of Art* 22:5–57.

Levine, David. 2012. "Frans Hals and the Vernacular." In *The Transformation of Vernacular Expression in Early Modern Arts,* edited by Joost Keizer and Todd M. Richardson, 180–203. Leiden: Brill.

Levy-Van Halm, Koos. 1993. "Judith Leyster: The Making of a Master." In *Judith Leyster: A Dutch Master and Her World,* edited by James Welu and Pieter Biesboer, 69–74. Worcester: Worcester Art Museum.

Levy-Van Halm, Koos, and Liesbeth Abraham. 1989. "Frans Hals, Militiaman and Painter: The Civic Guard Portrait as an Historical Document." In *Frans Hals,* edited by Seymour Slive, 87–102. Washington, DC: National Gallery of Art; Haarlem: Frans Hals Museum.

Liedtke, Walter. 2011. *Frans Hals: Style and Substance.* New York: Metropolitan Museum of Art.

Loughman, John, and John Michael Montias. 2000. *Public and Private Spaces: Works of Art in Seventeenth-Century Dutch Houses.* Zwolle: Waanders Uitgevers.

Marnef, Guido. 1996. *Antwerp in the Age of Reformation: Underground Protestantism in a Commercial Metropolis, 1550–1577.* Baltimore: Johns Hopkins University Press.

Martin, W. 1925. "Buytewech, Rembrandt en Frans Hals." *Oud Holland* 42:48–51.

Massing, Jean-Michel. 2011. *The Image of the Black in Western Art.* Vol. 3, *From the "Age of Discovery" to the Age of Abolition, Part 2: Europe and the World Beyond.* Series edited by David Bindman and Henry Louis Gates Jr. Cambridge, MA: Harvard University Press.

McGee, Julie L. 1991. *Cornelis Corneliszoon van Haarlem (1562–1638): Patrons, Friends and Dutch Humanists.* Nieuwkoop: De Graaf.

Michel, Émile. 1903. *Rembrandt: His Life, His Work and His Time*. Translated by Florence Simmonds. London: William Heinemann.

Middelkoop, Norbert. 2019. "Schutters, gildebroeders, regenten en regentessen. Het Amsterdamse corporatiestuk, 1525-1850." PhD thesis, Universiteit van Amsterdam.

Middelkoop, Norbert, ed. 2020. *Rembrandt and Amsterdam Portraiture, 1590-1670*. Madrid: Fundación Colección Thyssen-Bornemisza.

Middelkoop, Norbert, Judith van Gent, Marten Jan Bok, and Wouter Kloek, eds. 2013. *De Amsterdamse schuttersstukken: Inrichting en gebruik van de doelengebouwen in de zeventiende eeuw*. Amstelodamum Jaarboek 105. Amsterdam: Bas Lubberhuizen.

Middelkoop, Norbert, and Anne van Grevenstein. 1988. *Frans Hals: Leven, Werk, Restauratie*. Haarlem: Frans Hals Museum.

Miedema, Hessel. 1980. *De archiefbeschieden van het St. Lukasgilde te Haarlem: 1497-1798*. 2 vols. Alphen van Rijn: Canaletto.

Miedema, Hessel. 1985. "De St. Lucasgilden van Haarlem en Delft in de zestiende eeuw." *Oud Holland* 99:77-109.

Mochizuki, Mia M. 2008. *The Netherlandish Image after Iconoclasm, 1566-1672: Material Religion in the Dutch Golden Age*. Hampshire, UK: Ashgate.

Moes, Ernst Wilhelm. 1909. *Frans Hals: Sa Vie et son oeuvre*. Translated (into French) by J. de Bosschere. Brussells: G. van Oest.

Monballieu, Adolph. 1965. "P. P. Rubens en het 'Nachtmael' voor St.-Winoksbergen (1611), een niet uitgeroerd schilderij van de Meester." *Jaarboek Koninklijk Museum voor Schone Kunsten Antwerpen*, 183-205.

Montias, John Michael. 1982. *Artists and Artisans in Delft: A Socio-Economic Study of the Seventeenth Century*. Princeton, NJ: Princeton University Press.

Montias, John Michael. 1987. "Cost and Value in Seventeenth-Century Dutch Art." *Art History* 10:455-66.

Montias, John Michael. 1990. "Estimates of the Number of Dutch Master-Painters, Their Earnings and Their Output in 1650." *Leidschrift* 6:59-74.

Montias, John Michael. 1991. *Vermeer and His Milieu: A Web of Social History*. Princeton, NJ: Princeton University Press.

Montias, John Michael. 1998. "Art Dealers in the Seventeenth-Century

Netherlands." *Simiolus: Netherlands Quarterly for the History of Art* 18: 244–56.

Moonen, Arnold. 1700. *Poëzij*. Amsterdam and Utrecht: François Halma and Willem van de Water.

Nadler, Steven. 2013. *The Philosopher, the Priest and the Painter*. Princeton, NJ: Princeton University Press.

Nadler, Steven. 2018a. *Menasseh ben Israel: Rabbi of Amsterdam*. New Haven, CT: Yale University Press.

Nadler, Steven. 2018b. *Spinoza: A Life*. 2nd ed. Cambridge: Cambridge University Press.

Namen van de Regeerende Heeren Burgermeesterern, Schepenene, ende Thesauriers, Geweest binnen Haerlem zedert den Iare 1430 tot den Iare 1665. Haarlem: Pieter Casteleyn, 1665.

Nordström, Johan. 1957–58. "Till Cartesius Ikonographie." *Lychnos: Lärdomshistoriska samfundets årsbok*, 194–250.

North, Michael. 1997. *Art and Commerce in the Dutch Golden Age*. New Haven, CT: Yale University Press.

Oliver, Liza. 2013. "Frans Post's Brazil: Fractures in Seventeenth-Century Dutch Colonial Landscape Paintings." *Dutch Crossing* 37:198–219.

Parival, Jean de. 1669. *Les Délices de la Holland*. Amsterdam: Jean de Ravestein.

Parker, Charles H. 2008. *Faith on the Margins: Catholics and Catholicism in the Dutch Golden Age*. Cambridge, MA: Harvard University Press.

Pepys, Samuel. 1970–83. *The Diary of Samuel Pepys*. 11 vols. Edited by Robert Latham and William G. Matthews. London: Bell.

Posthumus, N. W. 1929. "The Tulip Mania in Holland in the Years 1636 and 1637." *Journal of Economic and Business History* 1:434–66.

Postma, Johannes Menne. 1990. *The Dutch in the Atlantic Slave Trade, 1600–1815*. Cambridge: Cambridge University Press.

Prak, Maarten. 2003. "Guilds and the Development of the Art Market during the Dutch Golden Age." *Simiolus: Netherlands Quarterly for the History of Art* 30:236–51.

Reynolds, Sir Joshua. 1867. *The Works of Sir Joshua Reynolds, Containing His Discourses, Idlers, A Journey to Flanders and Holland, and His Commentary on Du Fresnoy's Art of Painting*. Edited by Edmond Malone. Edinburgh: W. Forrester.

Riegl, Alois. 1999. *The Group Portraiture of Holland*. Translated by Evelyn Kain and David Britt. Los Angeles: Getty Research Center. First published 1902.

Roland, Margaret. 1984. "Van Dyck's Early Workshop, the Apostle Series and the Drunken Silenus." *Art Bulletin* 66:211–23.

Rombouts, P., and T. van Lerius. 1864–65. *De liggeren en andere historische archieven der Antwerpsche Sint Lucasgilde*. 2 vols. Antwerp: Baggerman.

Rooses, Max, and Charles Ruelens, eds. 1898. *Correspondance de Rubens et documents épistolaires concernant sa vie et ses oeuvres*. 6 vols. Antwerp: Jos. Maes.

Rowen, Herbert H., ed. 1972. *The Low Countries in Early Modern Times: A Documentary History*. New York: Palgrave.

Rubens, Peter Paul. 1991. *The Letters of Peter Paul Rubens*. Translated and edited by Ruth Saunders Magurn. Evanston, IL: Northwestern University Press.

Russell, Margarita. 1983. *Visions of the Sea: Hendrick C. Vroom and the Origins of Dutch Marine Painting*. Leiden: Brill.

Sainsbury, W. Noël. 1859. *Original Unpublished Papers Illustrative of the Life of Peter Paul Rubens, Artist and a Diplomatist*. London: Bradbury & Evans.

Sandrart, Joachim von. 1675. *Teutsche Academie der Bau-, Bild-, und Mahlerey-Kunste*. Nuremberg: Johann-Philipp Wallenberger.

Sauerländer, Willibald. 2014. *The Catholic Rubens: Saints and Martyrs*. Translated by David Dollenmayer. Los Angeles: Getty Research Institute.

Schama, Simon. 1988. *The Embarrassment of Riches: An Interpretation of Dutch Culture in the Golden Age*. Berkeley: University of California Press.

Schama, Simon. 1999. *Rembrandt's Eyes*. New York: Knopf.

Schrevelius, Theodorus. 1648. *Harlemias, ofte, om beter te seggen, de eerste stichtinghe der stadt Haerlem*. Haarlem: Thomas Fonteyn.

Schwartz, Gary. 1985. *Rembrandt: His Life and Paintings*. New York: Viking.

Schwartz, Gary. 1996. "Love in the *Kunstkamer*: Additions to the Work of Guillam van Haecht (1593–1637)." *Tableau* (Summer).

Shank, David A. 2005. "Karel van Mander's Mennonite Roots in Flanders." *Mennonite Quarterly Review* 79:231–49.

Sliggers, Bert, ed. 1979. *Dagelijckse aantekeninge van Vincent Laurensz van der Vinne*. Haarlem: Fibula-Van Dishoeck.

Slive, Seymour. 1961. "Frans Hals Studies." *Oud Holland* 76:173–200.

Slive, Seymour. 1969. "A Proposed Reconstruction of a Family Portrait by Frans Hals." In *Miscellanea I. Q. van Regteren Altena*, 16:114–16, 314–15. Amsterdam: Scheltema & Holkema.

Slive, Seymour. 1970–74. *Frans Hals*. 3 vols. London and New York: Phaidon.

Slive, Seymour, ed. 1989. *Frans Hals*. Washington, DC: National Gallery of Art; Haarlem: Frans Hals Museum, 1989.

Slive, Seymour. 2014. *Frans Hals*. London and New York: Phaidon.

Sluiter, Eric Jan. 2021. "Jan van Goyen: Virtuoso, Innovator, and Market Leader." *Journal of Historians of Netherlandish Art* 13, no. 2. DOI: 10.5092/jhna.13.2.4.

Smith, David R. 1986. "Courtesy and Its Discontents: Frans Hals' Portrait of Isaac Massa and Beatrix van der Laen." *Oud Holland* 100:2–34.

Snyder, James E. 1960. "The Early Haarlem School of Painting: I. Ouwater and the Master of the Tiburtine Sibyl" and "The Early Haarlem School of Painting: II. Geertgen tot Sint Jans." *Art Bulletin* 42:39–55, 113–32.

Spaans, Joke. 1989. *Haarlem na de Reformatie: Stedelijke cultuur en kerkelijk leven, 1577–1620*. The Hague: Stichting Hollandse Historische Reeks.

Speet, Ben. 2006. *Historische atlas van Haarlem: 1000 jaar Spaarnestad*. 2nd ed. Amsterdam: SUN/Noord Hollands Archief.

Stechow, Wolfgang. 1927. "Zu Rubens' erster Reise nach Holland." *Oud Holland* 44:138–39.

Steingräber, Erich. 1970. "Willem van Heythuysen von Frans Hals." *Pantheon* 28:300–308.

Stone-Ferrier, Linda. 1985. "Views of Haarlem: A Reconsideration of Ruisdael and Rembrandt." *Art Bulletin* 67:417–36.

Strauss, Walter L., Marjon van der Meulen, S. A. C. Dudok van Heel, and P. J. M. de Baar, eds. 1979. *The Rembrandt Documents*. New York: Abaris Books. Online resource from Radboud Universiteit Nijmegen: http://remdoc.huygens.knaw.nl/#/document/remdoc/e4545.

Stukenbrock, Christiane. 1993. *Frans Hals: Fröliche Kinder, Musikanten und Zecher*. Frankfurt: Peter Lang.

Swan, Claudia. 2021. "Liefhebberij: A Market Sensibility." In *Early Modern*

Knowledge Societies as Affective Economies, edited by Inger Leemans and Anne Goldgar, 141-64. London and New York: Routledge.

Swillens, P. T. A. 1945-46. "Rubens' bezoek aan Utrecht." *Jaarboekje van Oud-Utrecht*, 105-25.

Taverne, E. 1972-73. "Salomon de Bray and the Reorganization of the Haarlem Guild of St. Luke in 1631." *Simiolus: Netherlands Quarterly for the History of Art* 6:50-69.

Taylor, Paul. 1995. *Dutch Flower Painting, 1600-1720*. New Haven, CT: Yale University Press.

Taylor, Paul. 2016. "The Birth of the Amateur." Special issue of *Nuncius: The Varied Role of the Amateur in Early Modern Europe* 31:499-522.

Taylor, Paul. n.d. "The Demography of Art in Western Europe, 1300-1899." Unpublished manuscript.

Temminck, J. J. 1996. "Sint Bavo en Haarlem." In *Vlamingen in Haarlem*, edited by Pieter Biesboer, G. Th. Kothof, H. Rau, J. J. Temminck, and J. B. Uittenbout, 29-34. Haarlem: De Vriesborsch.

Thieme, Ulrich, and Felix Becker. 1907-50. *Allgemeines Lexikon der bildenden Künstler von der Antike bis zur Gegenwart*. 37 vols. Leipzig: Wilhelm Engelmann (vols. 1-4); Verlag E. A. Seemann (vols. 5-37).

Treanor, Virginia C. 2012. "Amalia van Solms and the Formation of the Stadhouder's Art Collection, 1625-1675." PhD thesis, University of Maryland.

Trivas, Numa S. 1941. *The Paintings of Frans Hals*. London: George Allen & Unwin.

Tummers, Anna, ed. 2013. *Frans Hals: Eye to Eye with Rembrandt, Rubens and Titian*. Haarlem: Frans Hals Museum.

Ungar, R. W. 2001. *History of Brewing in Holland, 900-1900: Economy, Technology and the State*. Leiden: Brill.

Valentiner, Wilhelm. 1923. *Frans Hals, des meisters Gemälde*. 2nd ed. Stuttgart, Berlin, and Leipzig: Deutsche Verlags-Anstalt.

Valentiner, Wilhelm. 1925. "The Self-Portraits of Frans Hals." *Art in America* 13:148-54.

Valentiner, Wilhelm. 1935. *Frans Hals*. Detroit: Detroit Institute of Arts.

Van der Heijden, Manon. 2016. *Women and Crime in Early Modern Holland*. Leiden: Brill.

Van der Ploeg, Peter, and Carola Vermeeren. 1997. *Princely Patrons: The*

Collection of Frederick Henry of Orange and Amala of Solms in The Hague. The Hague: Mauritshuis; Zwolle: Waanders.

Van der Willigen, A. 1870. *Les artistes de Harlem: Notices historiques avec un précis sur la Gilde de St. Luc.* 2nd ed. Haarlem: Bohn; The Hague: Martinus Nijhoff.

Van der Woude, Ad. 1991. "The Volume and Value of Paintings in Holland at the Time of the Dutch Republic." In *Art in History, History in Art: Studies in Seventeenth-Century Dutch Culture,* edited by David Freedberg and Jan de Vries, 284–329. Santa Monica, CA: Getty Center for the History of Art and the Humanities.

Van Domselaar, T. 1660. *Hollantsche Parnas, of Verscheide Gedichten.* Amsterdam: Jacob Lescaille.

Van Eeghen, Isabella H. 1974. "Pieter Codde en Frans Hals." *Amstelodamum* 61:137–41.

Van Gelder, J. G. 1938. "Dateering van Frans Hals' Portret van P. v. d. Broecke." *Oud Holland* 55:154.

Van Gelder, J. G. 1950–51. "Rubens in Holland in de zeventiende eeuw." *Nederlands Kunsthistorisch Jaarboek/Netherlands Yearbook for History of Art* 3:102–50.

Van Gelder, J. G. 1959. "Anthonie van Dyck in Holland in de zeventiende eeuw." *Bulletin van de Koninklijke Musea voor Kunst en Geschiedenis* 8: 43–86.

Van Gent, Judith. 2011. *Bartholomeus van der Helst (ca. 1613–1670). Een studie naar zijn leven en werk.* Zwolle: Waanders.

Van Hees, C. A. 1959. "Archivalia betreffende Frans Hals en de zijnen." *Oud Holland* 74:36–42.

Van Hoogstraten, Samuel. 1678. *Inleyding tot de Hooge Schoole der Schilderkonst.* Rotterdam: Fransois van Hoogstraeten.

Van Mander, Karel. 1604. *Het Schilderboek.* Haarlem: Paschier van Wesbusch.

Van Mander, Karel. 1973. *Den Grondt der edel vry schilder-const,* part 1. Edited by Hessel Miedema. Utrecht: Haentjens Dekker & Gumbert.

Van Mander, Karel. 1994–99. *The Lives of the Illustrious Netherlandish and German Painters, from the First Edition of the Schilderboek (1603–1604).* 6 vols. Edited by Hessel Miedema, translated by Derry Cook-Radmore. Doornspijk: Davaco.

Van Roey, J. 1957. "'Frans Hals van Antwerpen': Nieuwe gegevens over de ouders van Frans Hals." *Antwerpen: Tijdschrift der Stad Antwerpen* 3:1–4.

Van Roey, J. 1972. "De familie van Frans Hals: Nieuwe gegevens uit Antwerpen." *Jaarboek van het Koninklijk Museum voor Schone Kunsten Antwerpen*, 145–70.

Van Thiel, Pieter J. J. 1961. "Frans Hals' Portret van de Leidse Rederijkersnar Pieter Cornelisz. van der Morch, alias Piero (1543–1628)." *Oud Holland* 76:153–72.

Van Thiel, Pieter J. J. 1965. "De Grebbers regels van de kunst." *Oud Holland* 80:126–31.

Van Thiel, Pieter J. J. 1980. "De betekenis van het portret van Verdonck door Frans Hals: De ikonografie van het kakebeen." *Oud Holland* 94: 112–40.

Van Thiel, Pieter J. J. 1993. "Het Portret van Jacobus Hendriksz. Zaffius door Frans Hals." *Oud Holland* 107:84–96.

Van Thiel, Pieter J. J. 1999. *Cornelis Cornelisz. van Haarlem 1562–1638: A Monograph and Catalogue Raisonné*. Dornspijk: Davaco.

Van Thiel-Stroman, Irene. 1989. "The Frans Hals Documents: Written and Printed Sources, 1582–1679." In *Frans Hals*, edited by Seymour Slive, 371–414. Washington, DC: National Gallery of Art; Haarlem: Frans Hals Museum.

Van Valkenburg, C. C. 1959. "De Haarlemse schuttersstukken," part 1, "Maaltijd van officieren van de Sint Jorisdoelen (Frans Hals, 1616): Identificatie der voorgestelde schuttersofficieren." *Jaarboek Haarlem*, 59–68.

Van Valkenburg, C. C. 1961. "De Haarlemse schuttersstukken," part 4, "Maaltijd van officieren van de Sint Jorisdoelen (Frans Hals, 1627)"; part 5, "Maaltijd van de officieren van de Cluveniersdoelen (Frans Hals, 1627)"; part 7, "Officieren en onderofficieren van de Sint Jorisdoelen (Frans Hals, 1639)." *Jaarboek Haarlem*, 46–76.

Van Ysselsteyn, Gerardina T. 1946. *Van Linnen en Linnenkasten*. Amsterdam: P. N. van Kampen & Zoon.

Van Zanden, J. L. 1993. "Economic Growth in the Golden Age: The Development of the Economy of Holland, 1500–1650." In *The Dutch Economy in the Golden Age*, edited by Karel Davids and Leo Noordegraaf, 5–27. Amsterdam: Netherlands Economic History Archives.

Vermeylen, Filip. 2014. "Greener Pastures? Capturing Artists' Migrations during the Dutch Revolt." In *Kunst en Migratie: Nederlandse kunstenaars op drift, 1400–1750*, edited by Frits Scholten, Joanna Woodall, and Dulcia Meijers, 40–57. Leiden and Boston: Brill.

Vermeylen, Filip, and Karolien de Clippel. 2012. "Rubens and Goltzius in Dialogue: Artistic Exchanges between Antwerp and Haarlem during the Revolt." *De Zeventiende Eeuw. Cultuur in de Nederlanden in interdisciplinair perspectief* 28:138–60.

Vinken, P. J., and Eddy de Jongh. 1963. "De boosaardigheid van Hals' regenten en regentessen." *Oud Holland* 78:1–26.

Welu, James, and Pieter Biesboer, eds. 1993. *Judith Leyster: A Dutch Master and Her World*. Worcester: Worcester Art Museum; Haarlem: Frans Hals Museum.

Westermann, Mariët. 1995. "Jan Steen, Frans Hals and the Edges of Portraiture." *Nederlands Kunsthistorisch Jaarboek/Netherlands Yearbook for History of Art* 46: *Beeld en Zelfbeeld in de Nederlandse Kunst/Image and Self-Image in Netherlandish Art, 1550–1750*. Leiden: Brill, 298–331.

Westermann, Mariët. 1996. *A Worldly Art: The Dutch Republic, 1584–1718*. London and New Haven, CT: Yale University Press.

Westermann, Mariët. 2002. "After Iconography and Iconoclasm: Current Research in Netherlandish Art, 1566–1700." *Art Bulletin* 84:351–72.

White, Christopher. 1987. *Peter Paul Rubens: Man and Artist*. New Haven, CT, and London: Yale University Press.

Wijsenbeek-Olthuis, Thera, and Leo Noordegraaf. 1993. "Painting for a Living: The Economic Context of Judith Leyster's Career." In *Judith Leyster: A Dutch Master and Her World*, edited by James Welu and Pieter Biesboer, 39–54. Worcester: Worcester Art Museum.

Wolleswinkel, E. J. 1977. "De portretten van Petrus Scriverius en zijn familie." *Jaarboek Centraal Bureau voor Genealogie en het Iconographisch Bureau* 31:105–19.

Wood, Jeremy, ed. 2019. *Lives of Rubens*. Los Angeles: J. Paul Getty Museum.

Woodall, Joanna. 1997. "Sovereign Bodies: The Reality of Status in Seventeenth-Century Dutch Portraiture." In *Portraiture: Facing the Subject*, edited by Joanna Woodall, 75–100. Manchester: Manchester University Press.

Woollett, Anne T., and Ariane van Suchtelen. 2006. *Rubens and Brueghel: A Working Friendship.* Los Angeles: J. Paul Getty Museum.

Yntema, Richard. 2016. "The Union of Utrecht, Tariff Barriers and the Interprovincial Beer Trade in the Dutch Republic." In *The Political Economy of the Dutch Republic*, edited by Oscar Gelderblom, 255–90. New York: Routledge.

Index

Note: The name "Hals" without a first name refers to Frans Hals.

Drunken Silenus (Rubens), 80
Duke of Alba, 15, 18
Duke of Parma, 19, 21
Dutch East India Company (VOC), 66,
 191, 209, 255, 282, 284
Dutch Reformed Church: Amster-
 dam civic guard and, 68; Catholics
 of Haarlem and, 29; christening of
 Hals's son Dirck in, 31; Hals be-
 coming member in 1655, 268–69;
 most Dutch citizens not belong-
 ing to, 269; opposed to auctions
 and lotteries, 228; privileges of
 membership in, 269; public offices
 requiring membership in, 268–69;
 Saint Bavo Church and, 27; William
 II seeking uniformity under, 245.
 See also Calvinists; Remonstrant/
 Counter-Remonstrant battle
Dutch Republic in seventeenth century:
 as brilliant but cruel era, 9; choice
 to invest power in States or stad-
 holder, 134; currency of, 11; names of
 individuals in, 10; in period between
 wars with England, 281–83; polit-
 ical organization of, 10–11; power
 residing in provinces after death of
 William II, 246; with serene image
 hiding troubled reality, 133–36;
 "True Freedom" by 1653 without
 stadholder, 246, 249, 259. *See also*
 economy of Dutch Republic
Dutch Republic of the United Prov-
 inces, 10, 19
Dutch Revolt, 15–16; Holland's role in,
 15, 28; joined by Antwerp, 14, 17; mi-
 gration from southern Netherlands
 and, 19, 48–49
Dutch war for independence (Eighty
 Years' War): abandoned by ally
 England in 1604, 66; Antwerp as
 casualty of, 13, 14, 16, 19; in brilliant
 but cruel era, 9; celebrations on
 conclusion of, 243; Dutch navy in,
 66–67, 136; economic assault of 1621
 by Philip IV, 134, 135, 168; economic
 recovery in final years of, 260; ended
 by Treaty of Münster, 99, 240–43,
 281; English loss of trade at end of,
 259–60; history paintings of great
 moments in, 54; improved situation
 under Frederik Hendrik, 136; mari-
 time embargoes in, 168, 243, 260; re-

sumed in 1621, 132, 133–36; Spanish
 military operations at end of truce,
 134–35; Spanish victory at Breda, 135,
 163; truce signed in 1609, 67, 98–99
Dutch West India Company, 135, 181,
 249, 262, 282
Duyst van Voorhout, Nicolaes Pietersz,
 200

ecclesiastic patronage for art, 41, 53–54,
 75, 78–79
economy of Dutch Republic: damage
 inflicted by Spain in 1620s, 134, 135;
 downturn during first war with
 England, 260–61; downturn during
 second war with England, 261, 284;
 expansive commerce from 1650
 through 1670, 259; rebound by mid-
 1630s in, 136, 159; recession of 1620s
 in, 136–37, 140, 143–44; recovering
 after end of first war with England,
 281
Eighty Years' War. *See* Dutch war for
 independence (Eighty Years' War)
Eles, Sjoerd, 225
Elevation of the Cross (Rubens), 78
El Greco, 275
Elizabeth Stuart, 53, 235
Elout, Franchois, 138
Elsheimer, Adam, 282
Engelsz, Abraham, 276
Engelsz, Cornelis. *See* Versprongh, Cor-
 nelis Engelsz
England: conflict on high seas before
 Anglo-Dutch wars, 66; disadvan-
 taged by end of Eighty Years' War,
 259–61; Dutch Gift on installation of
 Charles II in, 282; first Anglo-Dutch
 war from 1652 to 1654, 259–61, 281;
 second Anglo-Dutch war from 1665
 to 1667, 261, 282–83, 284
engravers: of Antwerp after Spanish re-
 capture, 75; Soutman's work as, 76
engravings of paintings: of Ampzing
 portrait by Jonas Suyderhoef, 156; of
 Hals's work by Jan van de Velde II,
 138; made for fine artists to circu-
 late, 64; made for Rubens by Jacob
 Matham, 172; made for Rubens by
 Soutman, 76; painted models for,
 154–56
enslaved Africans: Anglo-Dutch com-
 petition over, 282; in Dutch Brazil,